Film Noir and Los .

This book combines film studies with urban theory in a spatial exploration of twentieth-century Los Angeles. Configured through the dark lens of noir, the author examines an alternate urban history of Los Angeles forged by the fictional modes of detective fiction, film noir, and neo noir.

Dark portrayals of the city are analyzed in Raymond Chandler's crime fiction through to key films like *Double Indemnity* (1944) and *The End of Violence* (1997). By employing these fictional elements as the basis for historicizing the city's unrivaled urban form, the analysis demonstrates an innovative approach to urban historiography.

Revealing some of the earliest tendencies of postmodern expression in Hollywood cinema, this book will be of great relevance to students and researchers working in the fields of film, literature, cultural, and urban studies. It will also be of interest to scholars researching histories of Los Angeles and the American noir imagination.

Sean W. Maher is Senior Lecturer in the Creative Industries Faculty at the Queensland University of Technology (QUT) in Brisbane, Australia. He has been a been Visiting Scholar at UCLA Film and Television Archives. He is an Australian representative on the Steering Committee for the Filmmakers Research Network (FRN), funded by a British Arts and Humanities Research Council (AHRC) grant investigating filmmaking-based research. As a writer and director, he has produced essays and films on Los Angeles and film noir as part of investigating creative practice-based research "Noirscapes: Using the Screen to Write Los Angeles Noir as Urban Historiography" written with S. Kerrigan).

Routledge Advances in Film Studies

Melancholy in Contemporary Cinema
A Spinozian Analysis of Film Experience
Francesco Sticchi

Found Footage Horror Films
A Cognitive Approach
Peter Turner

Affect and Embodied Meaning in Animation
Becoming-Animated
Sylvie Bissonnette

Classical Hollywood Film Cycles
Zoë Wallin

Re-reading the Monstrous-Feminine
Edited by Nicholas Chare, Jeanette Hoorn and Audrey Yue

Ethics of Cinematic Experience
Screens of Alterity
Orna Raviv

Why We Remake
The Politics, Economics and Emotions of Remaking
Lauren Rosewarne

Hollywood Remembrance and American War
Edited by Andrew Rayment and Paul Nadasdy

Film Noir and Los Angeles
Urban History and the Dark Imaginary
Sean W. Maher

For more information about this series, please visit: www.routledge.com

Film Noir and Los Angeles
Urban History and the Dark Imaginary

Sean W. Maher

Routledge
Taylor & Francis Group

NEW YORK AND LONDON

First published 2021
by Routledge
52 Vanderbilt Avenue, New York, NY 10017

and by Routledge
2 Park Square, Milton Park, Abingdon, Oxon, OX14 4RN

*Routledge is an imprint of the Taylor & Francis Group, an
informa business*

© 2021 Taylor & Francis

The right of Sean W. Maher to be identified as author of this
work has been asserted by him in accordance with sections 77
and 78 of the Copyright, Designs and Patents Act 1988.

Library of Congress Cataloging-in-Publication Data
A catalog record for this book has been requested

ISBN: 978-1-138-30456-7 (hbk)
ISBN: 978-0-367-54799-8 (pbk)
ISBN: 978-0-203-73003-4 (ebk)

Typeset in Sabon
by Apex CoVantage, LLC

Contents

Acknowledgements vi

Los Angeles Noirscapes 1

PART I
Approaching the Metropolis 11

1 From Modern Metropolis to Postmodern Urbanism 13
2 Hard-Boiled Boulevards 46

PART II
Los Angeles – Between the Screen and the Streets 71

3 City of Silhouettes 73
4 Noirscapes of Motion 102
5 Neo Noirscape of Nostalgia 126
6 Through a Glass Darkly: Global Los Angeles and
 Postmodern Noirscapes at the End of the Twentieth
 Century 158

 Conclusion 202

 Appendix I: Classic Film Noirs (1940–1960)
 Featuring Bunker Hill in Location Cinematography 205

Index 208

Acknowledgements

This book is the culmination of many years of research, discussions, and teaching. I would like to thank the many people who have generously assisted me throughout the writing process. The research I conducted has been supported by my institution, the Queensland University of Technology and the School of Creative Practice in the Creative Industries Faculty. I thank all of my colleagues for their support and advice over the years with special mention for Ellen Thompson, Associate Professor Kari Gislason and Professor Mandy Thomas.

Essential research was made possible by the incredible generosity of Associate Dean, Professor Barbara Boyle, and her colleagues in the School of Theatre, Film and Television at UCLA. I am very grateful to many parties at UCLA who provided assistance while I was a Visiting Scholar, especially Dr Jan-Christopher Horak, Director of the UCLA Film and Television Archives.

I have also been the beneficiary of encouragement and support from Helen Yeates, Professor Jane Roscoe, and Dr Tim Milfull, who have each provided invaluable input and guided the ideas at key moments during the writing.

Finally, as always, nothing would have been possible without the unwavering support from my family, so I dedicate the book to Emma, Charlotte, and Isabelle.

Los Angeles Noirscapes

Introduction

> Los Angeles gives one the feeling of the future more strongly than any
> city I know of. A bad future, too, like something out of Fritz Lang's feeble
> imagination.
>
> – *The Air Conditioned Nightmare* (1945), Henry Miller

Epigraph quoted from Miller 1971, p. 257

For over 80 years, Los Angeles has been at the center of an indelible
intersection between cinema and hard-boiled detective fiction situating
film noir as the city's imaginary alter ego. Yet when it comes to accounts
of the City of Los Angeles, Hollywood, film noir, and crime writing, each
history has remained relatively bifurcated. Overcoming these distinctions
means approaching an urban history of Los Angeles through the primacy
of fictional lenses variously derived from crime fiction, film noir, and its
inheritor, neo noir. Together, these fictional forms converge through a
spatial approach apprehending ways in which *noir* has underwritten an
urban phenomenology of Los Angeles.

If any city is to be historicized according to its multiple cinematic rep-
resentations, is there any better candidate than Los Angeles, the city that
plays host to Hollywood and home to the foremost global image factory?
According to Alain Silver and James Ursini, '[a]s the city that contains
Hollywood, the suburb it annexed in 1910, Los Angeles has a unique
position in film history' (Silver, Ursini, & Ward, 2005, p. 12). But per-
haps even more poignantly, the reverse may be true, as it is history itself
and the processes of historiography that become uniquely configured,
opened up, and expanded when Los Angeles is viewed through the urban
imaginary of film noir and hard-boiled detective fiction.

As the uninterrupted center of global filmmaking, for over a century
Los Angeles has been synonymous with 'Hollywood,' which has all too
often seen the actual city eclipsed by this ultimate signifier of 'the mov-
ies.' Employing film noir and Hollywood as the central optics upon
which a historiography of the actual city of Los Angeles is approached

has meant embracing the dialectics between the real Los Angeles and its cinematic imaginary and embarking on a historical inquiry that poses as many theoretical challenges as it does transdisciplinary opportunities. In the first instance, it is not about collapsing inseparable or unmistakable distinctions between the city's rich film history and complex urban history. Rather, it is about understanding how the city's physical spaces have informed its myriad representational spaces and vice versa. As a historiographical exercise, the aim is to map vital points of connection across a Los Angeles that resides as much in the real as in the imaginary by tracing the ways in which each has informed the other in enduring and significant ways.

As distinct sets of onscreen iterations that are emblematic of the city, film noir and neo noir have functioned as sustained expressions of Los Angeles that, like a dark mirror, have also reflected its preeminent industry – Hollywood. Although the corpus of classical film noir spans American urbanism and captured the oppressive modernity of cities from New York to Kansas City, in the case of Los Angeles the scathing critique from film noir formed one of the most sustained and quintessentially, local representation of the 'home of Hollywood.' In an uninterrupted lineage spanning hard-boiled fiction, film noir, and neo noir, Los Angeles has been continuously rendered by various iterations of noir since the 1930s. As neo noir builds on traditions inherited from film noir, and writers such as Michael Connelly and James Ellroy advance hard-boiled detective fiction centered on Los Angeles, 'Los Angeles noir' continues to grow and be consolidated.

By contextualizing the historical and representational dimensions of Los Angeles as they appear in crime writing and cinematic noir, the aim is to understand how the actual city and its noir imaginary constitute layers in what I term the *noirscapes* of Los Angeles. As *genius loci* in crime writing and the *ur*-city of film noir and neo noir, Los Angeles has produced a multitude of such *noirscapes*. By configuring key aspects of Los Angeles and noir in the twentieth century, noirscapes provide expression to some of the city's unique lived and imaginary dimensions. Mapping the constituent parts of the city's noirscapes means identifying how various iterations of *noir* have been deposited like textual layers across the city. Like a steady process of sedimentation, all things noir have been infusing meaning and associations across quadrants of Los Angeles from Hollywood and Downtown to the city's coastal and desert regions, industrial precincts, and freeway-clogged suburbia.

The foundational layer to these noirscapes commenced in the 1930s, emerging out of the pulp pages of hard-boiled detective fiction and most significantly through the writing of Raymond Chandler. Celluloid contributions soon followed, with cinematic layers deposited by the Poverty Row origins of film noir that ramped up under the B-movie system of the major studios during the classical era of Hollywood. Color innovations

in proto-neo noir arrived with the New Hollywood of the 1960s and 1970s, culminating in the fully fledged neo noirs of the 1980s and 1990s. Today, the process continues with long-form television noirs such as *True Detective* Season 2 and *Bosch* joining the steady procession of neo noir feature films that continue to contour the noirscapes of Los Angeles into the new millennium.

In contrast to previous imaginings of the city propagated for the promotional purposes behind the city's infamous boosterism, the Los Angeles noirscape that commenced with the pulps and hard-boiled detective fiction ensured that Los Angeles began to assume place value in the popular American, and subsequently international, imagination. The arrival of noir Los Angeles converted images of sunshine and orange groves into a city steeped in chiaroscuro with 'streets that were dark with something more than night' (Chandler, 1973). Over the course of some 60 years, film noir has gone on to produce a spatial dimension to the city that radically inflects the city's association with the Dream Factory of Hollywood. Indeed, Los Angeles and noir have come together to expose the nightmare beneath the desires lurking beneath the American Dream and the contradictions of twentieth-century capitalism.

Film noir also occupies a cultural site that evokes the sense of a lost past in relation to midcentury America, rendering its built environment and spatial modalities that have long vanished through periods of rapid and tumultuous development. One of the central ironies of Los Angeles and its reputation as the *ur*-city of film noir is how this quintessentially urban form of filmmaking became so closely associated with a city always considered so lacking as a metropolis. Dismissed as a suburban agglomeration, it was not until the 1930s that Los Angeles finally began to challenge its reputation as a suburban outlier eclipsed by other twentieth-century metropolises such as New York, Chicago, Philadelphia, and San Francisco. Therefore, one of the historical contradictions that this analysis takes into fuller account is how the suburban flatlands of Los Angeles were able to become prototypical for the mean streets of noir and its urban milieu.

The concept of Los Angeles noirscapes acknowledges the spatial dimensions of the city's representations in film noir and crime writing. Capturing and recording sites bound up in the city's filmmaking history and representational history, noir is examined in terms of a potent form occupying a liminal status between social history and shared memory. The space where a social and individual imaginary come together, hard-boiled detective fiction, film noir, and neo noir apprises fans, crime writers, filmmakers, and legions of foreign and local experiential tourists of a lived phenomenon in Los Angeles that is repeatedly described in terms of how the city, and Southern California more generally, exudes a 'temporal-spatial aura of the hard-boiled myth' (Calwetti, 2012, p. 280). Urban phenomena resonating in these rich and enticing ways capable of

informing personal lived experience in a city, and shared among visitors and residents alike, constitute kinds of affect understood as psychoge-ography. Registering deeply personal and meaningful connections with place, there are myriads ways psychogeographical meanings can manifest through textual relationships between individuals and specific places. As a form of urban experience, psychogeography acknowledges how the physical settings and locations of creative and textual works can result in individuals forming highly personal connections with place that rely on individual cognitive mapping processes that may disavow mainstream histories and interpretations.

Predicated on the city's imagined past, manifestations of noir remain imprinted across the actual built environment of Los Angeles that func-tion as psychogeographical traces informing key aspects of the city's spatial dimensions. The creative affordances issuing from Los Angeles' psychogeography ensure that contemporary crime fiction and filmmak-ing regularly mine the city's noir heritage in the service of articulating present-day life in the city and its speculative futures. In the same way lit-erary London is imbued with Charles Dickens and literary Paris resonates through the writings of Victor Hugo, noir-laden Los Angeles pulsates to the stories, tone, and famous similes of Raymond Chandler. Providing the foundation for all subsequent noirscapes, Chandler assumes a privileged space in the representation of Los Angeles. His actual life and biography, together with his extensive oeuvre of Los Angeles–based crime writing, has led to the notion of *Chandleresque* Los Angeles.

Innovating a critical approach to Los Angeles history through fic-tional films and texts acknowledges Los Angeles preeminent position in the burgeoning field of city and cinema scholarship and discourse. Criticism focusing on cities and the screen has been developing in a judi-cious manner for more than 20 years out of rich analyses stemming from urban studies, film studies, and cultural studies. City/cinema criticism asks questions that explore the diverse ways in which cinema enriches urban experience, and in turn, how urban space impacts cinematic rep-resentation and its role in shaping wider socio-temporal experience. Like a double helix, the fusion of cities and cinema has underpinned the preeminent experiences of modernity, but it is in, 'Los Angeles – the home of Hollywood,' where this relationship contorts into an unrivaled interdependence.

So where among the expansive and transdisciplinary nature of this vast intertwining between cities and cinema does the historicization of such a relationship commence? Despite the many disciplinary challenges of critically approaching the city when it is imbricated within film, a grow-ing body of scholarship has been steadily mapping how cities have been interacting with cinema and effectively forging a dialogue between urban theory and film history. As a growing field of inquiry, city and cinema discourse seeks to overcome the qualitatively and quantitatively different

ways critical perspectives emanate from film and cinema studies to that of traditional urban studies and urban theory. Uniting city and cinema discourse is interest in how real cities and cinematic cities can become mutually constitutive by reinforcing some of the most vital aspects of each other.

Unsurprisingly, the representation of the city onscreen is dominated by film theory and film history perspectives with critical efforts often centered on the film side of the cinema–city equation. Writers such as Nezar AlSayyad, Will Brooker, Edward Dimendberg, James Donald, Tony Fitzmaurice, Barbara Mennel, and Mark Shiel have been instrumental in developing critical perspectives on how cities interact with their onscreen counterparts. While the emphasis in city–cinema discourse has been from film theory and film history quarters, there are corresponding interests from sociology, urban theory, and geography quarters. The first significant sociological study of Hollywood commenced in the 1940s with Hortense Powdermaker's landmark 1950 study, *1950 Hollywood, the Dream Factory: An Anthropologist Looks at the Movie-Makers*. More recent sociological analysis of the role of popular culture and impact from pulp forms on American modernity has come from Paula Rabinowitz. Meanwhile, analysis of American cities under the onslaught of relentless image-making from urban planning and urban theory perspectives has come from sociologist Sharon Zukin and urban geographers – Edward Soja, Mike Davis, and Michael Dear among others – associated with the Los Angeles School of Urbanism. Soja in particular, has advocated for critical approaches to Los Angeles that can take account of its peculiar form of urbanism that challenges conventional urban analysis, '[i]ncreasingly unconventional modes of exploring Los Angeles are needed to make practical and theoretical sense of contemporary urban realities – and hyper-realities' (Soja, 1996, p. 17).

The interdisciplinary approach pursued in this study joins the efforts of these writers to elucidate on the broader matters affecting the relationship between cinema, cities, and their representation on screen. It is also responding to calls for interdisciplinary-based interpretative analysis from Norman Denzin and John Sherry who advocate renewing methods of inquiry in an effort to overcome the sense of dislocation arising from our 'crisis'-laden era.

> With John Sherry . . . I am convinced that critical interpretive research has a vital moral and political role to play in the new millennium. I too am concerned with how our patterns, practices, and philosophies of consumption estrange us from and threaten our place in the "natural" world. And with Sherry, I believe we need to craft new humanistic "interdisciplinary methods of inquiry and inscription."
> (Flaherty, Denzin, Manning, & Snow, 2002, p. 488)

Grasping the effects generated in the intersection between cities and screens requires supplementing film theory and textual analysis with insights drawn from the spatial disciplines of urban geography, urban planning, and architecture, as well as traditional and counterhistories drawn from conventional historical analyses. By identifying sites of common interdisciplinary ground, the broader aim of this investigation is to identify critical approaches that contribute to understanding how films and image-making inform lived experience in our cities.

The six chapters are arranged into two parts, with each chapter demarcating the discussion along a generally chronological time line that outlines the development of Los Angeles in the twentieth century. Part I establishes the methodological basis for employing the imaginary alongside historical events and factual data as the means for conducting a historical inquiry. Part II focuses on the representation of Los Angeles in film noir and neo noir. Together, both sections provide the framework underpinning the conceptual model of noirscapes, a spatial approach to cinematic urbanism that relies upon interdisciplinary analysis spanning urban theory, film theory and the history of Los Angeles.

Chapter 1 outlines foundational inquiries into urbanism that have incorporated the cinematic city as the means for countervailing the overwhelming rationality imposed by the modern metropolis. Images and films from the early twentieth century that captured modern cities in both fiction and nonfiction filmmaking served as some of the key means for enquiry into the social, cultural, and economic transformations unleashed by modernity. Approaching the modern city through the primacy of cultural texts and cultural experience were the formative writings of Walter Benjamin, Georg Simmel, and Siegfried Kracauer. Each contributed to a renowned survey of early twentieth-century urbanism by documenting metropolitan modernity through the nexus of cultural and sociological experience. In addition, Benjamin, Kracauer, and Simmel each investigated the role cinema played in capturing and recording the modern metropolis, and significantly, also postulated ways in which films helped to reconfigure the experience of the modern city.

In Chapter 2, critical perspectives on the representation of Los Angeles are drawn from the spatial ideas that Henri Lefebvre developed under the concept, the social production of space. Lefebvre's concepts are specifically applied in an examination of the relationship between Raymond Chandler and Los Angeles. As the ultimate chronicler of midcentury Los Angeles, Chandler and his writing occupy a distinctive place in the literary and cinematic imaginary of his adopted city as well as Hollywood. Through the seven completed novels, Los Angeles assumes far more than a simple backdrop or setting. Capturing the city during some of its most tumultuous periods, Chandler's fiction is a key supplement to traditional histories of midcentury Los Angeles that renders in minute detail the period's 'social interiority' – a phenomenon the renowned cultural historian

Raymond Williams describes as a 'structure of feeling,' particularly accessible to fiction, which is conveyed through Chandler's writing. In particular, Raymond Chandler's first novel, *The Big Sleep*, produced during one of the city's most formative decades, the 1930s, documents the quotidian rhythms of midcentury Los Angeles urbanism as have few other sources. As an author who also went on to co-write one of the definitive film noir screenplays, *Double Indemnity* (Wilder, 1944), Chandler's actual life and work are approached in terms of providing an essential substratum to Los Angeles' pulp fiction noirscape.

In Part II, a spatial history of Los Angeles is charted through representation of the city in 1940s and 1950s film noir, followed by neo noir across the 1960s to 1990s. Four chapters span a 60-year period, commencing in the 1930s as they map the imbrication of film noir and neo noir across the physical and imaginary topography of Los Angeles. Chapter 3 focuses on the classical era of film noir and the city's relationship with Hollywood through physical production spaces and the studio system as well as Poverty Row studios.

Chapter 4 examines the relationship between film noir at the height of modernity and the emergence of a car and freeway culture pioneered in Los Angeles from the 1940s. Film noir is argued to have been instrumental in shaping a space of representation for the newfound culture of mobility celebrated by southern California's extensive freeway system, registering what Henri Lefebvre describes in terms of spaces of representation that contribute to forms of spatial practice.

Chapter 5 examines the development of neo noir as a genre against the rise of New Hollywood in the 1960s and 1970s. Neo noir is seen in response to the spatial dislocations emerging from centrifugal urbanism and reflects its impact on Los Angeles. The consolidation of neo noir in this context is examined by revisiting *The Long Goodbye* (Altman, 1973), *Chinatown* (Polanski, 1974), and *Blade Runner* (Scott, 1982). Each film represents a milestone in the development of neo noir and the representation of Los Angeles by negotiating the nostalgia from the classical cycle of film noir.

Chapter 6 traces neo noir against the altered spatial logics of Los Angeles as the city became paradigmatic of postmodernity. As distinctions between a 'real' and 'reel' Los Angeles became increasingly blurred in the media distortions accompanying postmodernism and the dynamics of the Los Angeles noirscape reversed. Noir-styled nostalgia exacerbated how the real was in retreat from the extreme events surrounding the 1992 LA Riots and impacts from globalization on the local economy of Greater Los Angeles. While in a countermovement, neo noirs like *Heat* (Mann, 1995) and the under-appreciated, *To Live and Die in L.A.* (Friedkin, 1985), sought out new spaces across the city's postindustrial landscape in a 'return to the real'.

Los Angeles and noir provide some of the most compelling evidence to substantiate the theoretical prototype of a noirscape that has been

arrived at through employing a series of interdisciplinary lenses. Conceptualization of noirscapes has been undertaken with the hope of shedding new light on cinema as a space of representation and the relationship between cinematic cities with their actual counterparts. The effect of spaces of representation on real cities and actual urban space will always be open for interpretation. By advancing the spatial phenomenon of Los Angeles noirscapes in the twentieth century, the intention is to map how the representation of Los Angeles through all things noir adumbrates speculative, historical, as well as the lived dimensions of urban life in this filmmaking capital of the world.

Concluding at the end of twentieth century, the study resists venturing into the noirscape of Los Angeles in the twenty-first century. Although we are two decades into the new millennium, prescribing noirscapes onto the current, digital-laden environment of Los Angeles in the midst of the ongoing upheavals of the digital economy is beyond being circumscribed to additional chapters. The scale and pace of transformations in the twenty-first century constitute a separate and appropriately tailored future study.

The vitality of contemporary Los Angeles continues as both an urban megalopolis and global center of filmmaking and screen content creation. The city's actual history alongside its rich film noir and cinematic heritage ensures all things noir will continue to play a role in shaping the city's dark imaginary. Arriving at new understandings of the relationship between Los Angeles and film noir involves deploying its representations as a cinematic city as the means for innovating historiographical approaches without necessarily dispensing with older ones. Rather, as major contributions like, Edward Dimendberg's, *Film Noir and the Spaces of Modernity* (2004), and Mark Shiel's, *Hollywood Cinema and the Real Los Angeles* (2012) have demonstrated, it is more matter of how indelible intersections between the actual and cinematic city can supplement traditional historical knowledge. Whether it is through new or traditional approaches to history, the aim is to expand understandings of Los Angeles' pioneering form of urbanism, and in this instance, to take fuller account of its relationship to Hollywood. Only through the expansion of historical perspectives, enabled in this instance by the prism afforded by film noir, can fragments from a previously unknowable past be converted into knowable forms of 'history.'

References

Altman, R. (Director). (1973). *The Long Goodbye*. United Artists.
Calwetti, J. G. (2012). Chinatown and generic transformation in recent American films. In B.K. Grant (Ed.), *Film genre reader IV* (4th ed., pp. 279–297). Austin, TX: University of Texas Press.

Chandler, R. (1973). Introduction [1950]. In *Pearls are a nuisance*. Penguin Books: Harmondsworth.

Denzin, N. (2002). Confronting ethnography's crisis of representation. In M. Flaherty, N. Denzin, P. Manning, & D. Snow (Eds.), Review symposium: Crisis in representation. *Journal of Contemporary Ethnography, 31*(4), 478–516.

Dimendberg, E. (2014). *Film Noir and the Spaces of Modernity* (2004). Cambridge, Mass.; London: Harvard University Press.

Miller, H. (1971). *The air-conditioned nightmare*. New York: New Directions.

Polanski, R. (Director). (1974). *Chinatown*. Paramount.

Powdermaker, H. (1950). *Hollywood, the dream factory: An anthropologist looks at the movie-makers*. Boston: Little, Brown.

Scott, R. (Director). (1982). *Blade Runner*. Warner Bros.

Shiel, M. (2012). *Hollywood Cinema and the Real Los Angeles*. London: Reaktion Books.

Silver, A., Ursini, J., & Ward, E. (2005). *L.A. Noir: The city as character*. Santa Monica: Santa Monica Press.

Soja, E. (1996). *Thirdspace: Journeys to Los Angeles and other real-and-imagined places*. Cambridge, MA: Blackwell.

Wilder, B. (Director). (1944). *Double Indemnity*. Paramount.

Part I

Approaching the Metropolis

1 From Modern Metropolis to Postmodern Urbanism

Introduction

The seemingly simple descriptor, *Los Angeles urbanism*, belies a complex and contested object in urban studies. Historically positioned as the great exception to the modern metropolis of the twentieth century, Los Angeles has been defined more by its deviations rather than adherence to the conventional urban characteristics of other American cities such as New York, Chicago, Boston, San Francisco, Detroit, and Philadelphia. The pattern of twentieth-century urban development typically featured a downtown business district surrounded by diminishing spheres of commercial, industrial, and residential zones. Urban development that corresponds with concentric ring theory may have once applied to most American cities but was always antithetical to Los Angeles.

The problematics surrounding urban understandings of Los Angeles reveal shifts in how cities and urbanism have been approached over the course of the twentieth century. Beginning in the 1920s, the Chicago School dominated ideas in urban studies, with perspectives developed in direct response to its host city. These ideas were often ill-equipped to approach Los Angeles on its own terms. For example, the Greater Los Angeles metropolitan region spans 4,850 square miles and constitutes five counties: Los Angeles, Ventura, San Bernadino, Riverside, and Orange. The extraordinary growth of the region across the twentieth century with its expansive urban sprawl confounded many urban planners. A pejorative view of Los Angeles extended to popular discourse, where it was routinely disparaged as, '*Los Angeles – suburbs in search of city.*' Los Angeles County alone hosts 88 city municipalities, many with commercial districts. Surrounded by competing retail and business downtowns, they contributed to the sense that Los Angeles was centerless and somehow less of a city than other American metropolitan centers.

Flat, dispersed, and highly decentralized, sprawl in Greater Los Angeles has also been amplified by the region's topographical basin, which has been inscribing lateral dispersal ever since the Tongva (Gabrielino) settlements were sighted by a small Spanish armada sailing up the California

coast on an expeditionary mission in 1542. By the middle of the twenti-
eth century, cheap available land, suburban subdivision, and tract hous-
ing meant the economic impacts from World War II fueled unprecedented
growth in Los Angeles. Vast and highly decentered, the rise of car owner-
ship and freeway development further compounded the region's atypi-
cal urban form that saw Greater Los Angeles become synonymous with
sprawl. Defined by the urban planner Oliver Gillham, urban sprawl is,
'a form of urbanization distinguished by leapfrog patterns of develop-
ment, commercial strips, low density, separated land uses, automobile
dominance, and a minimum of open public space' (Gillham, 2002, p. 8).
The pace and scale on which Los Angeles developed in the first half of the
twentieth century meant it resisted conventional interpretation, which in
effect translated into a city that was *difficult to read*. Essentially, critical
analysis and urban planning approaches have had to catch up with Los
Angeles style urbanism.

Mapped against four cycles of urban thought, conceptual approaches
to urban living reveal how the metropolis of modernity has given way to
the decentered urbanism of postmodernity characteristic of Los Angeles.
Out of the four cycles of urban thought, three emphasize the role played
by the 'everyday' in urban life. By examining how the modern metropo-
lis has given way to postmodern urbanism, this chapter traces spatial
dynamics against considerations of the everyday and the role played by
the imaginary under the onslaught of modernity and postmodernity.

Addressing the modern European metropolis at the turn of the twen-
tieth century, Georg Simmel, Walter Benjamin, and Siegfried Kracauer
approached a city such as Paris or Berlin as an object of philosophical
contemplation that revealed some of the essential qualities of moder-
nity. In the 1920s, following a geographical shift to the United States,
the second paradigm of urban thought sees the consolidation of social
science–based approaches to the city and the emergence of the Chicago
School. Philosophical contemplation of the metropolis was subsumed by
the rationalized pragmatism of the Chicago School, which came to domi-
nate American intellectual engagement of the modern city. During this
cycle, considerations of the everyday and the imaginary were sidelined
by urban planning logics and the doctrines of progress. By the 1960s,
rational perspectives on the city were being challenged by a third cycle of
urban thinking from reactionary movements that assuaged the hegemony
of urban planning logics and the instrumentalization of the modernist
project. Commencing as radical and styled as 'community-first' move-
ments, these reactionary alternatives have inexorably progressed from
the margins to the center of urban thinking and practices. As activist
style incursions, they reinstated the importance of the everyday through
principles derived from livable cities augmented by human-scale design
movements and critical urban theory discourse. Finally, the fourth cycle
of ideas impacting approaches to cities and space that is concomitant with

postmodernity is commonly referred to as the 'spatial turn.' Functioning as an ontology of space, the spatial turn has influenced critical, historical, and cultural analysis since the 1970s and is largely attributed to the intellectual oeuvre of Henri Lefebvre. Discussed in the context of the paradigmatic shift from modernity to postmodernity, the spatial turn coincides with Los Angeles displacing Chicago as emblematic of late twentieth-century urbanism. The corresponding rise of the Los Angeles School of Urbanism in the 1980s completed the shift from the traditional view that Los Angeles was an urban anomaly to understanding it as a forerunner to postmodern urbanism.

The four cycles of discourse on the metropolis across the twentieth century reveal how, in their efforts to observe and recount the complexities of urban lived experience, critical interpretations regularly drew upon some of the most potent imaginings of cities. When the physical impacts of modernity were first expressed in the dramatic reconfiguration of space and accelerated tempo of life in the nineteenth century, the metropolitan capitals of Paris, Berlin, London, and New York were the central coordinates of modern existence. Insights from film and cinema were employed to comprehend the forces of modernity in these metropolitan centers. As Scott McQuire observes: 'Cinema provided a means by which multiplicity and movement could be negotiated, offering the potential for mapping processes. . . . [m]ontage constituted cinema's formal equivalent to the shock effect of the big city' (McQuire, 2008, p. 75). Calibrating formal expression to the new ways of living presented by these modern metropolises, the essential elements of cinema – editing and montage, provided ways of articulating as well as reflecting metropolitan life.

Ever since the end of the nineteenth century, the metropolis and the cinema have been resolutely imbricated, and contemporary films continue to illuminate the spatial, perceptual, and lived dimensions of cities and urban space. Actual cities bristling with the multiplicity contained within their diverse populations continue to provide the basis for the superabundance offered up to cinematic imagery and narratives. And as modernity has given way to postmodernity, mutually constitutive relationships between the real and representation entwine cities and cinema more than ever.

Tracing the four cycles of urban thinking on the city reveals associated urban practices that form competing perspectives on the modern metropolis and urbanism across the twentieth century. As the centered metropolis of modernity has given way to the decentered processes of postmodern urbanization, each cycle of urban theory with their concomitant values and approaches testify to deeply etched thought contours that have shaped modern cities. As ideas and attitudes, these often contested approaches form some of the most sustained engagements of urban life. They represent efforts to keep pace with the ever-changing dynamics of

city-space and the challenges surrounding its sociohistorical relations and lived reality.

As well as historical context, this critical urbanism also provides a framework for how the relationship between Los Angeles and all things noir can be conceptualized in the proceeding chapters in terms of a *Noirscape*: a spatial approach embedded in urban history, popular culture, and social memory, binding everyday lived experience to a dark imaginary distinctive to the *'home of Hollywood.'*

The Metropolis of the Mind

In the nineteenth century, the dramatic upheavals in sociopolitical, cultural, and economic life under modernity were synonymous with the impacts unleashed by life in the modern metropolis. Paris, Berlin, London, and New York demarcated the central coordinates of urban modernity and where the new experience of metropolitanism was most dramatically visible. Electric lighting saw one of the last vestiges of nature banished from the city, and with its teeming population the modern metropolis represented nonstop spectacle. As the modern city wrought changes to all facets of social and economic life, it also redefined the relations between class, work, and family, across both urban and rural populations. In the wake of the industrial revolution, life in the modern metropolis ushered in levels of consumption spanning everything from leisure, travel, and fashion, to art, design, and architecture, representing new and unprecedented ways of living in the world. As the social historian of modernity, Peter Conrad reminds us, 'modernity is about the acceleration of time, and also the dispersal of places' (Conrad, 1998, p. 9). As cities transformed temporal-spatial experience through high-rise living, crowded boulevards, trolleys, cars, motorways, and telecommunications, the metropolis was seen to be fostering nothing less than new forms of human consciousness.

By the twentieth century, key thinking on the modern metropolis was being conducted by Georg Simmel (1858–1918), Walter Benjamin (1892–1940), and Siegfried Kracauer (1889–1966). Each writer contributed enduring, poetic, and searing commentaries on modern life and the modern metropolis. A physical entity generating the irrepressible Promethean energies of Modernity itself, the modern metropolis was interpreted by Simmel, Benjamin, and Kracauer to be a form of mental energy just as much as material energy. In the same way as materialist capitalism was erecting the exoskeleton of modern life through the soaring towers of cities with endless confabulations of asphalt, steel, concrete, and glass, it was also reshaping the soft tissue of its human inhabitants. The observations on metropolitan life by Simmel, Benjamin, and Kracauer offer first-hand insights into urban modernity as it transitioned from the

nineteenth century into the twentieth century. As Paris and Berlin became synonymous with avant-garde modernism, these writers observed how metropolitan life was transforming everyday life in actual city streets along with literary and aesthetic expression. From the works of Charles Baudelaire, Guy de Maupassant, Marcel Proust, and Victor Hugo, to the avant-garde design and art movements of Cubism, Surrealism, Dada, DeStijl, and Bauhaus, the modern metropolis had become omnipresent.

For Simmel, Benjamin, and Kracauer, urban modernity at the dawn of the twentieth century not only represented dramatic reconfigurations of external social space, but carried over into sensory experiences that exerted transformative effects on the inner lives of its millions of inhabitants and creative artists. Like mental cartographers, Simmel, Benjamin, and Kracauer mapped the psychic impacts of the metropolis. By paying close attention to how metropolitan life was the corollary of the *experience* of the modern city and how it manifested in the behaviors of its population and artifacts of modern artists, they saw the human psyche as the real frontier of metropolitan modernity. It was here in the minds of city dwellers where the most dramatic reconfiguration of human history was occurring.

Of course, in the nineteenth century, Freud was also embarking on a scientific journey of discovery into the mind, developing psychoanalysis to chart untapped dimensions of human psychology. The contribution made by the urban life of Vienna, the capital of the waning Austro-Hungarian Empire, factors into historical considerations of Freud's breakthroughs, not least in part for the role it played as the external environment amplifying what he identified as the internal neuroses of his patients. In a similar vein to Freud, Simmel interpreted the broader sociological effects of the metropolis as having a direct impact on the nervous systems of its inhabitants, but in his most influential essay, *The Metropolis and Mental Life* (1903), Simmel describes it in terms of a collective experience evocative of cinematic montage.

> The psychological basis of the metropolitan type of individuality consists in the *intensification of nervous stimulation* [sic] which results from the swift and uninterrupted change of outer and inner stimuli. . . . Lasting impressions, impressions which differ only slightly from one another, impressions which take a regular and habitual course and show regular and habitual contrasts – all these use up . . . less consciousness than does the rapid crowding of changing images, the sharp discontinuity in the grasp of a single glance, and the unexpectedness of onrushing impressions. These are the psychological impressions which the metropolis creates.
>
> (Georg Simmel, *Simmel on Culture: Selected writings.*
> Simmel, Frisby, & Featherstone, 1997, p. 175)

In this account, Simmel could just as easily be describing the processes of film editing as the cognitive and psychological effects activated by daily life in the modern city. Sharp cuts, close-ups, and the juxtaposition inherent in montage provide Simmel with the language for describing mental processes assaulted by life in the metropolis that end up requiring *more* consciousness than those stemming from rural impressions. Cinematic form parallels Simmel's observations on the effects generated by the 'discontinuity' and 'onrushing impressions' from the metropolis and its impact on human consciousness. Simmel's reflections reveal how as a formal device, cinematic montage emerged as a finely calibrated language that not only represents the kinetics of daily urban life but also seems to have arisen out of it.

> The psychological foundation, upon which the metropolitan individuality is erected, is the intensification of emotional life due to the swift and continuous shift of external and internal stimuli. . . . To the extent that the metropolis creates these psychological conditions – with every crossing of the street, with the tempo and multiplicity of economic, occupational and social life – it creates in the sensory foundations of mental life . . . a deep contrast with the slower, more habitual, more smoothly flowing rhythm of the sensory-mental phase of small town and rural existence.
>
> (Longhofer, & Winchester, [Eds.], 2016, pp. 470–477)

For Simmel, urban cosmopolitanism relies on the metropolitan inhabitant repressing reactions to the onslaught of stimuli constantly generated by city life. As a distinct form of city behavior, it results in what Simmel describes as the cosmopolitan's blasé attitude that also counterpoints habits of 'being noticed.' As opposite conditions, they reveal the tension between the bombardment of shock and stimuli provoked by the modern metropolis that requires a level of perceptual numbness, against the way city inhabitants pursue cosmopolitan-style individuality in an effort to stand out from the urban masses. 'This leads ultimately to the strangest eccentricities to specifically metropolitan extravagances of self-distanciation, of caprice, of fastidiousness, the meaning of which is no longer to be found in the content of such activity itself but rather in its being a form of "being different" – of making oneself noticeable' (Longhofer & Winchester, 2016, p. 476). Simmel identifies how cosmopolitan inhabitants of the metropolis intuited the value of constructing heightened individualism through modes of fashion, behavior, and scandal. As various stances, they are recognizable as precursors to what is now understood as celebrity and brand-style identity, which Simmel perceives as grounded in a resistance to the crushing anonymity of modern life in the metropolis.

Cosmopolitanism for Simmel is a reactionary stance to '[t]he development of modern culture . . . characterised by the predominance of

what one can call the objective spirit over the subjective' (Longhofer & Winchester, 2016, p. 476). Diagnosing some of the classic symptoms of alienation synonymous with capitalist modernity, Simmel anticipates the position taken by Theodore Adorno, Max Horkheimer, and the Frankfurt School, and is wary of how individuals could be reduced to 'cogs' in the overwhelming cultural force epitomized by the metropolis. 'The operation of these forces results in the transformation . . . from a subjective form into one of purely objective existence. It need only be pointed out that the metropolis is the proper arena for this type of culture which has outgrown every personal element' (Longhofer & Winchester, 2016, p. 476). Yet in the face of these reservations, Simmel concludes *Metropolis and Mental Life* (1903) on the hope that the metropolis may ultimately end up serving as none other than an emancipatory site, where the sociocultural leftovers from the eighteenth century infringing upon personal freedoms in the nineteenth century could finally be reconciled. 'The eighteenth century found the individual in the grip of powerful bonds which had become meaningless – bonds of political, agrarian, guild and religious nature. . .' (Longhofer & Winchester, 2016, p. 477). The constraints imposed by rural society with its religious, class, and family based traditions saw 'trivialities and prejudices . . . bind the small town person' (Longhofer & Winchester, 2016, p. 474). In contrast, cosmopolitan-based individualism meant, 'in an intellectualised and refined sense the citizen of the metropolis is "free" . . . nourished by the quantitative relationships of the metropolis, i.e., individual independence and the elaboration of personal peculiarities. . . . [T]he metropolis attains an entirely new value and meaning in the world. . .'(Longhofer & Winchester, 2016, p. 477). These new values and sense of meaning could be derived from the transformative potentialities of life promoted in the metropolis and enable the lingering historical determinants on social identity from the eighteenth century to be finally extinguished.

Benjamin and Kracauer – The Redemptive Qualities of the Metropolis

Walter Benjamin's critical oeuvre on modernity famously explores issues of memory, the crisis of experience, and the redemptive possibilities inherent in the metropolis and mass culture. Benjamin's renowned essay, *The Work of Art in the Age of Mechanical Reproduction*, not only articulated the impact of technology on the experience of art, but also provided insights for film theory. His most ambitious work, the unfinished, *The Arcades Project* (also known as *Das Passagenwerk* and *Paris: Capital of the Nineteenth Century*) spanned writings between 1927–1940. As a poetic treatise on the experience of metropolitan capitalism, *The Arcades Project* modeled a new form of materialist historiography based on the phantasmagoria of Parisian modernity. Rather

than simply conducting traditional historical inquiry focused on the past, Benjamin constructed a series of temporal relations among a multitude of archival objects in an effort to reveal how modern temporality dehistoricizes experience.

For Benjamin, the crisis of experience unleashed by the arrival of modernity in the nineteenth century had become, in the twentieth century, a temporal crisis of memory. *The Arcades project* is partly an attempt to convey the impact modern life was having on individual and social memory that called for a new philosophy of historical time. Aiming to critique modernity through some imaginative form transcending keenly observed analysis, Benjamin's archival galleria demonstrates how the confabulation occurring between reality, images, and modern space generated by everyday metropolitan life becomes a kind of urban scenography beneath which history and memory were being radically reconfigured.

Like Simmel, Benjamin was also interested in the way the external characteristics of the metropolis manifested internally and psychologically as forces reshaping modern consciousness. A vital aspect of the metropolitan experience for Benjamin was the way in which it operated through a series of internal 'shocks' that mirrored the external kinetics of its social reality. In dedicating a large portion of *The Arcades Project* to the work of Baudelaire, Benjamin noted how the poet used shock to characterize movement in modern urban space: 'Moving through [metropolitan] traffic involves the individual in a series of shocks and collisions. At dangerous intersections, nervous impulses flow through him in rapid succession, like the energy from a battery' (Benjamin, 1997, p. 175). The shocks comprising metropolitan life were generated out of various forms of movement, both physical and psychological. Traffic, for example, signified all kinds of urban movement that describes various forms of metropolitan encounters and collisions. For Benjamin, operating at metaphoric and literal levels, traffic formalizes the multitude of urban experiences derived from juxtaposition that are compounded by forces of motion and shifts in perceptual orientations.

Benjamin regularly employed insights drawn from filmmaking and cinema as part of his intellectual armature for grappling with the magnitude of social change brought about by the city as the locus of modernity. He describes film as the means by which modern experience is intensified, while also functioning as the medium that enables the city dweller to comprehend the new forms of movement operating across the physical, perceptual, and conceptual levels of the metropolis. 'Only film commands optical approaches to the essence of the city, such as conducting the motorist into the new centre' (Benjamin, 1985, p. 298). For Benjamin, film contained an emancipatory potential for rediscovering our urban reality through its innate ability to transport audiences into an imagined spatiality. Film as a perceptual space was equipped with the

peculiar ability to catalyze all manner of mundane urban locales into vibrant cinematic geographies.

> Our taverns and our metropolitan streets, our offices and furnished rooms, our railroad stations and our factories appeared to have us locked up hopelessly. Then came the film and burst this prison-world asunder by the dynamite of the tenth of a second, so that now, in the midst of its far-flung ruins and debris, we calmly and adventurously go travelling.
>
> (Walter Benjamin. *Illuminations*, Benjamin & Arendt, 1987, p. 236)

Benjamin saw filmic techniques deepening our sensory apperception, that 'reveal[s] entirely new structural formations of the subject. . . . Evidently a different nature opens itself to the camera than opens to the naked eye – if only because an unconsciously penetrated space is substituted for a space consciously explored by man' (Benjamin & Arendt, 1987, p. 236). The camera mediates reality through techniques such as slow motion, time-lapse, close-ups and wide shots and exposes different qualities from our surrounding environment to that of the human eye. For Benjamin, film becomes about spatial and temporal, 'isolations,' 'extensions,' 'enlargements,' 'reductions,' and 'accelerations,' and '[t]he camera introduces us to unconscious optics as does psychoanalysis to unconscious impulses' (Benjamin & Arendt, 1987, p. 237). This famous comparison between film and Freud's unconscious sees the modern city as a site of latent meaning primed for the experience of cinema to expose its hidden nature.

Contemporary and personal friend of Benjamin, Siegfried Kracauer shared similar intellectual interests about modernity and assessed metropolitan life in the twentieth century from the professional vantage points: journalist, novelist, sociologist, cultural critic, and film theorist. Film, and more broadly, cinema, preoccupied Kracauer, whose earlier training as an architect meant he had a professionally honed instinct for assessing the spatial dynamics beneath metropolitan and cinematic experience.

Through his film reviews and journalism, Kracauer identified an insatiable thirst for cinema among the metropolitans of 1920s Berlin, which he diagnosed in terms of an addiction to cinema. Appetites for popular 'movies' and bourgeoise narrative cinema were generally seen by turn of the century intellectuals in terms of the desire for escapism, and in this view Kracauer was no exception. Nevertheless, like Benjamin, Kracauer was also drawn to the possibilities of film and its potential to ameliorate the deleterious effects of modern life. Despite the cinema's preoccupation with escapist and illusionistic narratives, Kracauer saw its ability to record and capture aspects of everyday life as its key redemptive quality. An authentic 'life world' was visible behind the artifice of cinema,

and it was this that he saw as central to its audience appeal. Kracauer identified film's cognitive mapping functions, which accounted for the reason why film was drawn to so many kinds of urban spaces, those 'hopelessly,' 'locked up' spaces that had previously been identified by Benjamin. Kracauer remained attuned to the way film sought out these particular spaces, which he continued to explore up until 1960 in *Theory of Film: The Redemption of Physical Reality*.

> The affinity of film for haphazard contingencies is most strikingly demonstrated by its unwavering susceptibility to the "street" – a term designed to cover not only the street, particularly the city street, in the literal sense, but also its various extensions, such as railway stations, dance and assembly halls, bars, hotel lobbies, airports, etc. If the medium's descent from, and kinship with, photography needed additional confirmation, this very specific preference, common to both of them, would supply it. Within the present context, the street, which has already been characterised as a center of fleeting impressions, is of interest as a region where the accidental prevails over the providential, and happenings in the nature of unexpected incidents are all but the rule. Startling as it may sound, since the days of Lumiere there have been only few cinematic films that would not include glimpses of the street, not to mention the many films in which some street figures among the protagonists.
>
> (Kracauer, 1960, [reprint 1978], p. 62)

Filmmakers' affinity for the street exposed cinema's preoccupation with capturing the everyday, and Kracauer never lost interest in how film conveyed the poetics of everyday life.

Under the perceptual onslaughts of modernity, Kracauer saw metropolitan life as having lost touch with the essential qualities of nature, and he envisioned film as the means by which some of the virtues of our premodern consciousness, erased by modern life, could be returned to us.

Maintaining positions on film often against widespread critical opposition, Kracauer nevertheless developed one of the most comprehensive approaches to a realist theory in the enduring publications, *From Caligari to Hitler: A Psychological History of German Film* (1947) and *Theory of Film: The Physical Redemption of Reality* (1960). In the latter publication he fully developed his central preoccupation and key thesis around film's ability to reveal reality through heightening our visual capabilities.

> Film may bear real-life complexes which the conventional figure-ground patterns usually conceal from view. Imagine a man in a room: accustomed as we are to visualize the human figure as a whole, it would take us an enormous effort to perceive instead of the whole man a pictorial unit consisting, say, of his right shoulder and arm,

fragments of furniture and a section of the wall. But this is exactly what photography and, more powerfully, film may make us see. The motion picture camera has a way of disintegrating familiar objects and bringing to the fore – often just in moving about – previously invisible interrelationships between parts of them. These newly arising complexes lurk behind the things known and cut across their easily identifiable contexts.

(Kracauer, 1960, [reprint 1978], p. 54)

For Kracauer, the most wonderous dimension of film is its ability to help us see the neglected everyday world all around us. 'Many objects remain unnoticed simply because it never occurs us to look their way. Most people turn their backs on garbage cans, the dirt underfoot, the waste they leave behind' (Kracauer, 1960, p. 54). The capacity of film to delimit without limiting what we encounter on a regular basis enables film to 'redeem physical reality' through the familiar and innocuous elements making up the everyday that otherwise recedes in our consciousness. Perceiving common experience phenomena such as the everyday spaces of 'rooms' and 'streets' to 'refuse,' eludes us, 'because we know them by heart we do not know them with the eye' (Kracauer, 1960, p. 55). Amid the barrage of stimuli unleashed by modernity, film, as well as being complicit, also offered the means of arresting the incessant flow of excitements that ended up numbing our perception.

For Simmel, Benjamin, and Kracauer, the metropolis defined key social and historical phenomena emerging from modernity, and the cinema was not only symptomatic of modernity – it was also expressly attenuated to the state of being it engendered. The properties uniting film with the experience of the modern city characterized by shock and its assault on our perception was mirrored in the processes of editing and montage. Countervailing effects from modernity on perception was the close-up and film's ability to render the everyday. Film could combat the excesses of modernity by redeeming what it seemed to be rapidly erasing – the natural world and our connection to it.

Writing at the time modern consciousness was erupting out of the metropolis, Simmel, Benjamin, and Kracauer each documented key aspects of the invention of modern life. Significantly, both Benjamin and Kracauer were drawn to the spatial properties in the relationship between the metropolis and cinema. As well as helping to rediscover the everyday, film seemed to embody new forms of spatiotemporal movement that could transport audiences and facilitate cognitive mapping processes of the metropolis. Under modernity, space and time were dramatically reconfigured, and the combination of the metropolis and the cinema were central to the phenomenology accompanying modern spatial experience. The role of cinema amid these transformations spanned the generative to the reflective, as each interpreted film as both antidote

and symptom of modernity. Together, the metropolis and the cinema had been key to forging modern consciousness, and Simmel, Kracauer, and Benjamin traced how the dimensions of a new mental, urban geography was situated somewhere between the lived and the imaginary, the real and the represented.

The Rational City and Its Discontents

At the turn of the twentieth century, the metropolis was the central prism through which modernity was seen to be manifesting, and Simmel, Benjamin, and Kracauer had been attuned to the interior life engendered by urban living. By the 1920s, interest in the 'mental metropolis' and its effects on forms of modern consciousness were superseded by the far more concrete and pragmatic concerns of regulating and exerting control over cities and urban processes. Social issues arising out of the provision of housing and transport needed to be addressed by perspectives informed by urban planning logics through quantifiable and applied means. Contemplative and qualitative perspectives on the modern metropolis were overtaken by disciplinary engagements through quantitative analyses of cities in an effort to keep pace with the physical needs accompanying rapid growth in urban populations.

As the city entered the domain of the social sciences, analyses focused on urban populations and city development patterns. In 1925, *The City: Suggestions for Investigations of Human Behaviour in the Urban Environment* by Robert Park and Ernest Burgess with contributions from Louis Wirth and Roderick McKenzie, became a landmark study in modern urban sociology. *The City* became a primer for the Chicago School, which framed analytical and conceptual approaches to the American metropolis for several decades. Subsequent sociological analyses of Chicago led to it becoming one of the most studied cities in history and an exemplar of high modernity.

Under the aegis of the Chicago School, urban studies was extended by the social sciences to assist in the planning, measurement, and regulation of the modern city. By the 1920s, urban planning had become the central means for exerting control over the social upheavals wrought by the proliferation of urban populations. The development of urban studies and the Chicago School demonstrates how urban discourse and practices under modernity advanced through the principles of rationalization, institutionalization, and discipline-bound knowledge. Maintaining traditions inherited from the Enlightenment, the logics of modernity are premised on reason and the doctrine of objective knowledge domains based on scientific empiricism. The Chicago School was synonymous with these fundamentals, developing an applied sociology within urban planning approaches designed to tackle the complexity of city life in the twentieth century and the challenges confronting urban

populations. The logic flowing out of the Chicago School informing modernist urban planning can be seen to have reached its apogee in 1960 with the construction of the Brazilian capital, Brasilia. The Le Corbusier protégé and principal architect, Oscar Niemeyer, in collaboration with urban planner, Lucio Costa, designed a city embodying the extreme rationalism of modernist style functionalism synonymous with the International Style.

Since the 1960s, however, reactionary movements have been pushing against the orthodoxies associated with the design principles of high modernism and the forms of urban planning associated the Chicago School. Like a fault line tugging at conventional attitudes to urbanism, these movements contributed to seismic changes in the approach to city life, as the momentum behind what could be paraphrased as the historical project of Modernity diminished. Since the values and aesthetics that advanced modernist ideals in Western cities were reevaluated, unbridled city development in the name of progress has given rise to new levels of scrutiny driven by urban preservation movements. For example, demolition in 1963 of Manhattan's Pennsylvania Railway Station, constructed in 1910 in the Beaux-Arts style, and subsequent threats to Grand Central Terminal, galvanized heritage movements in the citadel of progress, New York City. The rampant progress signaled by similar projects globally alerted many to the wholesale erasure of forms of social memory accompanying the loss of historical architecture and devastation of urban communities.

In her landmark publication, *The Death and Life of Great American Cities* (1961), Jane Jacobs challenged the aerial view of instrumental urban planning dictates by advocating for urban regeneration that stressed the importance of human scale development and the lived dynamics of cities. Taking a 'bottom up' view, Jacobs identified the street as the crucial site where urban experience plays out. Tight social bonds emerged in urban communities through shared public spaces and in local street life, sustaining the vitality that made city neighborhoods so distinctive. Jacobs subsequently led community campaigns in Manhattan that successfully defeated the proposals of New York's Planning Commissioner, Robert Moses. Through grassroots campaigning, Jacobs and her fellow community members prevented the extension of Fifth Avenue through Washington Square Park in Greenwich Village and averted construction of a Lower Manhattan Expressway bisecting Soho and Little Italy that would have decimated their local inner-city communities. As Marshall Berman has recounted, however, the Bronx was less fortunate during this same period. Similar neighborhood protests were overridden by the Cross Bronx Expressway completed in 1963, which carved a freeway canyon through its community displacing some 1,400 residents and forever altering the working- and middle-class fabric of the Bronx.[1]

Despite many setbacks, by the 1970s urban preservation movements were gathering momentum around the world as inner-city communities, heritage movements, and historical societies organized to halt the unrelenting pace of modern development occurring from London to Sydney and Mumbai to Lebanon. Rethinking conceptual approaches to cities and urban life since the 1960s, writers such as Kevin Lynch, Michel de Certeau, Guy Debord, and Reyner Banham have helped articulate restored values around the lived experience of city life, renewing both practical and philosophical approaches to urbanism. More reflective of the values of an emerging postmodernity, viewpoints from these thinkers and writers have been formalized into a reinvigorated urban theory. Contributions and challenges to planning orthodoxies have come from sociologists and urban geographers; Manuel Castells, David Harvey, Mike Davis, Michael Dear, and Edward Soja. The latter three are associated with the Los Angeles School of Urbanism, which is addressed in greater detail below.

The cumulative effect of renewed urban thinking has produced an irrevocable move away from the modernist doctrines of master urban planning as the emphasis has shifted to ground-level identification of the vitality of city-space. Acknowledging the underlying urban processes that occur locally means insisting on the maintenance of community vitality. The complex amalgam of urban life demands that modernist rationalities are no longer the overriding factor to solving the complex issues raised by cities and urban life. Urban planning solutions have had to respond to the multiple stakeholders participating in the life of our cities who routinely mobilize against the narrow agendas based on the pursuit of profits and efficiency.

Nevertheless, the rise of megacities in the twenty-first century and the age of global finance are also bringing about unprecedented challenges for urban life. As command and control centers of international trade and investment flows, new megacities such as Mumbai, Shanghai, and São Paulo have joined traditional centers such as London, Paris, Tokyo, and New York and can have more connections among themselves as global nodes of influence than to their immediate and local populations. In confronting some of the most tumultuous and disruptive processes of global urbanization, megacities are capable of shaping economic forces that can outweigh that of entire national economies. Responding to the challenges posed by global megacities in the age of finance capital may seem overwhelming for anyone interested in the fate of urban life as it unfolds in the twenty-first century. Yet the enormity of the task and the scale of the project are neither unprecedented nor that far removed from what was facing those inspirational pioneers of metropolitan thought – George Simmel, Walter Benjamin, Siegfried Kracauer – and the achievements of Jane Jacobs.

Paradigm of Postmodernity and the Los Angeles School of Urbanism

The concentric zone model is closely associated with conceptual thinking of the Chicago School. Accounting for land use and zoning policies to aid in the systematic approach to urban planning, the concentric zone model positions the downtown center of a city such as Chicago as the urban core. Copious commentary has highlighted the simplicity of the model despite the qualifications provided by Burgess in *The City*. As Robert Sampson in his foreword of the 2019 edition points out, 'The concentric zone is a perennial punching bag, for example, because it seems too simple and schematic. But Burgess himself said the concentric zone was but an ideal type that did not describe every city, noting that, "it hardly needs to be added that neither Chicago nor any other city fits perfectly into this ideal scheme" ' (Sampson in Park & Burgess, 2019, p. x).

Acknowledging its many limitations, Burgess's concentric zone model, drawn from the spatial characteristics of industrial Chicago, testifies to how the centered American city of modernity organized the surrounding regions and was interpreted in terms of its command and control functions. But as developments in telecommunications, combined with enhanced road and rail transportation networks, continued to alter the economic drivers of cities, the spatial impacts on the downtown was unmistakable.

Urban geographer Michael Dear has chronicled the shifts from modernist to postmodern practices of urban spatial formation in specific relation to both the actual cities of Chicago and Los Angeles and their respective schools of urban thought. Dear highlights how Louis Wirth identified the role that regions would play in reshaping urban formations, thereby ceding power and influence away from traditional downtowns and urban cores. Dear highlights how in the final chapter of *The City* (1925) Louis Wirth, 'in a remarkably prescient way' identified two fundamental features of the urban condition that would become dominant in the twenty-first century: satellite cities and modern communications. These two elements would alter the growth patterns of the modern city, reversing its role as a command node at the center of the concentric circles organizing the regional hinterland surrounding it. Satellites cities and regions would exert what Wirth labeled a, 'determining influence.' In conjunction with modern communications, Wirth foresees the globalized city and envisages how the world would turn into a 'single mechanism,' where the global and local would intersect continuously. According to Dear:

> Wirth anticipates the pivotal moments that characterize Chicago-style urbanism, those primitives that eventually will separate it from an L.A. style urbanism. He effectively foreshadowed *avant la lettre*,

the shift from what I term a "modernist" to a "postmodern" city, and in so doing, the necessity of the transition from the Chicago to the Los Angeles School.

(Lin, & Mele, 2005, p. 110)

Dear and other urban geographers such as Edward Soja and Allen Scott have identified how urban dynamics transformed cities across the twentieth century into the twenty-first century. Decentralization, global communications, and international trade and investment flows have meant, 'the twenty-first century's emerging world cities (including Los Angeles) are ground-zero loci in a communications-driven global political economy' (Dear, in Lin, J., & Mele, C. 2005, p. 110). The urban restructuring occurring at the end of the twentieth century shifts understandings of Los Angeles from the 'great exception' to the modern city, to something more much emblematic of the decentralizing forces of postmodern urbanism. Similar to the manner in which Chicago had functioned in relation to the modern city, Los Angeles has come to function paradigmatically in relation to postmodern urbanism. With urban dispersal a key force in these postmodern dynamics, urban agglomeration replaces urban concentration, urban regionalism replaces urban density, while processes of urban territorializing mean networks of influence are extended globally, linking cities as nodes through transnational trade and telecommunication networks. The combined effects from globally networked dispersal facilitates urban restructuring on an unprecedented scale. According to Edward Soja, twenty-first century urban processes that are now occurring on a global scale amounts to, 'planetary urbanisation,' and undeniably means, 'we must all be urbanists today.'[2]

With the 1986 publication of Edward Soja's critical tour of Los Angeles in the journal *Society and Space*, the Los Angeles School of Urbanism became associated with analyses of postmodern urbanism and a revitalized urban theory derived from Los Angeles. Since the 1980s, in addition to Michael Dear and Edward Soja, writers such as Mike Davis, Margaret FitzSimmons, Robert Gottlieb, Charles Jencks, Rebecca Morales, and Allen Scott, working out of architecture and urban planning departments in (UCLA) University of California Los Angeles), USC (University Southern California), and Loyola Marymount College, made concerted efforts to analyze the Los Angeles basin and its greater metropolitan region. Key publications associated with the Los Angeles School of Urbanism include: *Postmodern Geographies* (Soja, 1989), *Rethinking Los Angeles* (Dear, Schockman, & Hise, 1996), *The City: Los Angeles and Urban Theory at the End of the Twentieth Century* (Eds. Soja & Scott, 1996), and *Ethnic Los Angeles* (Eds. Waldinger & Bozorgmehr,1996). In addition, there has been the establishment of centers such as USC's Southern California Studies Center, UCLA's Lewis

Center for Regional Policy Studies, and Loyola Marymount University's Center for the Study of Los Angeles.

The approaches taken by each of these writers operating out of Los Angeles shared a fundamental orientation in their respective studies. Rather than assessing Los Angeles against a form of urbanism that was imposed from without, maintaining the view that the city's status was the 'great exception,' these writers focused on the urban attributes of Los Angeles that were actually present, unfolding locally and occurring across the greater metropolitan region of Southern California.

As a school of thought representing various critical approaches to urbanism, the Los Angeles School has had to negotiate ideals of discursive plurality against continuities with both the Frankfurt and Chicago Schools. Even the label of a 'School' of urban theory implies a hegemonic function that contradicts the fundamental orientation of many of the LA School's participants. The extent to which these authors and their writings constituted an actual School has been a contentious issue among both its members and detractors alike. Under the notion of a Los Angeles School of Urbanism, however, studies contributed to a body of work seeking to understand specific dynamics behind the local urban context of greater Los Angeles and its surrounding regions. In pursuit of some kind of consistent and systematic approaches to urban analyses, the Los Angeles School sustained valuable critical discourse centered on Los Angeles. Michael Dear and Steven Flusty summarize their position on the LA School as:

> First, the LA School exists as a body of literature. It exhibits an evolution through time, beginning with analysis of Los Angeles as an aberrant curiosity distinct from other forms of urbanism. The tone of that history has shifted gradually to the point that the city is now commonly represented as indicative of a new form of urbanism, supplanting the older forms against which Los Angeles was once judged deviant. Second, the LA School exists as a discursive strategy demarcating a space both for the exploration of new realities and for resistance to old hegemonies. It is proving to be far more successful than its detractors at explaining the form and function of the urban.
>
> (Lin, & Mele, 2005, p. 114)

Thirty plus years after Soja's publication in *Society and Space* in 1986, valuable contributions to urban theory and urban studies are attributable to the Los Angeles School. The studies associated with the Los Angeles School of Urbanism have a discursive orientation appropriate to the postmodern dimensions of sociopolitical, cultural, and economic transformations produced by globalization under late capitalism. Despite reservations with positioning Los Angeles in the way Paris was to modernity at the end of nineteenth century, and Chicago in relation to the high modernity of

the middle of the twentieth century, as the end of the twentieth century drew to a close the urbanism exemplified by Los Angeles was unmistakably paradigmatic of postmodernity.

Spatial Turn

The spatial turn represents the final cycle of intellectual thought that has irrevocably altered how cities and urban life are approached in historical, conceptual, and political terms. Acknowledging the role of space in the construction of social reality, the spatial turn continues to impact critical thought, historical interrogation, and understandings of lived urban experience. Writers such as Henri Lefebvre, Michel de Certeau, Michel Foucault, and Paul Virilio draw attention to the implicit power relations residing in the spatial dimensions of the social realm. Highlighting the differences among space and place, abstract space, and symbolic space reveals the impact space has on lived reality, society, and history. Similar to a positive feedback loop, urban space in particular is a highly charged and generative force in meaning-making when it comes to understanding historical and social reality. As summarized by Fainstein and Campbell,

> Urban Space gains its meanings as a consequence of the activities carried on within it, the characteristics of the people who occupy it, the form given to it by its physical structures, and the perceptions with which people regard it. Consequently, such space does not simply exist; it is instead a social creation.
>
> (Fainstein & Campbell, 1996, p. 10)

In place of the dualism that sees a dialectic between society and history, a spatial perspective ushers in reasoning based on what Edward Soja has argued is the 'trialectic' of society, history, and space. Soja's ouevre has built on the groundbreaking work conducted by Henri Lefebvre, whose writings have been central to inscribing space into political and historical analyses of social life. In *The Urban Revolution* (1970) and *The Production of Space* (1974), Lefebvre theorized a set of urban relations that were linked to a critique of Marxism, philosophy, and social theory. In an attempt to reinvigorate conceptual understandings of late capitalism, Lefebvre saw the twentieth century producing an urban revolution. According to Lefebvre, the social realm in the twentieth century was being shaped by a revolution of '[u]rban thought (not urbanism) that is reflective of urban society' Lefebvre, 2014, p. 37). The new field of the urban is, 'constituted by a renewed space-time, a typology that is distinct from agrarian (cyclic and juxtaposing local particularities) and industrial (tending towards homogeneity, towards a rational and planned unity of constraints) space-time' (Lefebvre, 2014, p. 37). For Lefebvre, in order to fully grasp the urban moment, it was essential not to confine

thinking under the conceptual constraints inherited from the eighteenth and nineteenth century. In the twentieth century, Lefebvre saw the urban revolution as the driving force shaping society and history in ways that superseded those from industrialization occurring since the eighteenth century. Ideas and approaches shaped and bound by the industrial revolution occurred under a different temporality premised on homogenization rather than the differentials of urban space-time.

In order to grasp the implications of Lefebvre's position, it is essential to highlight that space has traditionally been interpreted as remaining relatively inert amid political processes and the upheavals of society and history. Indeed, much analysis is still coming to terms with ways in which space is not only socially and historically constructed, but the specific ways in which it can be active and capable of generating forces that influence and flow back into society and shape history. With the perspective provided by Lefebvre, space, far from inert, is dynamically charged through what he outlines as processes identified as the 'production of space.' These processes are constituted by three elements: 1. spatial practice, 2. representations of space, and 3. representational spaces. Serving as the means for how we interpret space, each of these three processes correspond to the experiential dimensions of space in terms of: 1. the perceived, 2. the conceived, and, 3. the lived. According to Lefebvre, relations between spatiality, society, and history need to be understood and conceived in terms of this new spatiality, a process that de-abstracts all social relations, whether linked to class, family, community, market, or the state.

Despite objections raised by writers such as Manuel Castells and proponents of traditional Marxist perspectives on historical materialism maintained by David Harvey, the concept of an urban revolution continues to inform positions on postmodern urbanism. While Lefebvre's ideas remain problematic and have been variously interpreted in terms of their alignment to postmodern approaches, his critical reassessment of modernity is indicative of the reappraisals that gathered pace from the 1970s. Lefebvre's work continues to inform an urban theory premised on rhizomatic processes of urbanization that emphasizes how the social creation of space make explicit the meanings and functions of urban space as the site of social transformation.

As one the most vociferous advocates of Lefebvre's ideas, Edward Soja set out to apply and deepen understandings of the principles of Lefebvre's concepts of space in his three major works: *Postmodern Geographies: The Reassertion of Space in Critical Social Theory* (1989), *Thirdspace: Journeys to Los Angeles and Other Real and Imagined Places* (1996), and *Postmetropolis: Critical Studies of Cities and Regions* (2000). For Soja, Lefebvre's ideas on the production of space reveal how the

> urban problematic derives from the complex interaction between macro- and micro-geographical configurations of cityspace. When

viewed "from above," these developmental geographies describe the overall condition and conditioning of urban reality in general or global terms. Viewed "from below," they are more grounded in localized spatial practices and the particular experiences of everyday life. The tensions and contradictions that arise from these different *scales* of spatial specificity, as well as from the contrasting perspectives used to interpret them, are resolved – or at least unfold – in a third process, which Lefebvre described most comprehensively as the (social) production of (social) space.

(Soja, 2000, p. 10)

Acknowledging the spatial has meant understanding the generative capacities of space, which is helping to forge the basis of revised sociohistorical analysis. Space is approached as the repository of social and historical forces, which in turn sees it effecting the construction of social and cultural relations. For example, urban space has many competing social, political, and economic demands placed upon it, ensuring it is highly contested. In cities, commercial demands and the operation of space as the means for social control typically compete against community and environmental concerns. The constraints imposed by the intense competition over urban space means cities are where spatial tensions are most highly visible and where conflicts play out in the most explicit terms expressed through economic and political power relations.

What is often less obviously discernible, however, are the myriad ways in which space in its multiple forms exerts influence back onto social processes. Often functioning as normative sets of power relations, the dynamics of space are understood as being active in the shaping of logics driving social processes and the hegemonic structures imposed upon society and history. By urban space assuming degrees of natural presence, it can function as a form of determinism, enforcing certain logics that seem to be as fixed as the underlying, physical geography. Assuming any degree of natural order, however, masks the cultural logics that are relative and operating within that space. Cultural logics translate as sociohistorical forces that can create, destroy, or sustain those physical sites that have come to designate place amid various sets of social relations and meaning. But at the heart of these logics are layers of sociohistorical occurrences, decisions, actions, and relative values that have configured the space for specific purposes and serve the interest of specific groups at specific times in the name of sociocultural norms. Soja and Lefebvre's approaches help to conceive of space as active and generative, at once a container of received logics, but equally a transmitter of those very logics that have produced and sustain its current iteration. By reinforcing certain rationales back into social, cultural, and political decision-making domains, space comes to exert influence. Previous linear style cause and

effect spatial dynamics are shattered as the causal forces generated by space are revealed to occur in a far more complex triad.

For Edward Soja, the nineteenth century witnessed a great ontological distortion that has prevented us from giving due consideration to the spatial and generative powers of space, and cities and urban space in particular. In privileging temporality (history and time) over space, the social historicism of the nineteenth century only focused on two of the three most fundamental aspects of our lives. As human beings, we are all social, historical, and spatial beings, in other words, we are three-sided in our ontological being. Western social thought has been biased towards the social and historical, while the spatial has been pushed to the background, causing a narrow dialectic between the social and historical across Western thought, as well as critical thinking. For Soja, the spatial/geographical needs to be included and properly conjoined with the social and historical to form a more appropriate trialectic on which to base our approach to being in the world. The social, the historical, and the spatial are forces that translate into the tangibles of the everyday: people, time, and space. Each of these dynamics shape a single person's biography and are inescapable in terms of lived experience.

As urban agglomeration in the twenty-first century continues to gather pace, it remains to be fully understood the extent to which the social forces it unleashes are the products of human history as much as they are human geography. Urban spatial causality attempts to take account of, and reorientate, how we interpret the role and functions of urban space. Quantifying the phenomena of urban causality is Soja's clarion call for future empirical studies that can locate, measure, and identify the spatial forces of cities. Pursuing urban spatial causality for Soja is aimed at revitalizing forms of urban analysis and, 'putting cities first' by focusing on how cities contain, 'generative forces shaping creativity, innovation, development.'[3]

The work of Richard Florida, in particular, seems to have responded to aspects of Soja's quantitative call. By attempting to measure the extent to which cities cultivate particular dynamics, specifically creativity and innovation, Florida's work examines contemporary working conditions that continue to transform in the context of postindustrialization and postmodern culture. In, *The Rise of the Creative Class* (2003), *Cities and the Creative Class* (2004), and *Flight of the Creative Class* (2007), Florida focuses on cities as self-sustaining systems of resourcefulness and innovation, delivering enduring economic growth, provided they foster knowledge-intensive professions. Formulating the notion of a creative class sustained by vibrant urban ecologies, Florida interrogates similar urban dynamics that Jane Jacobs had identified in the 1960s. Significantly, however, Florida's work evaluates specific urban characteristics in terms of an urban quantum of creativity that aligns with Soja's insistence

on the reevaluation of urban space and its dynamics through empirical methods.

The Everyday and Urban Lived Experience

Theoretical perspectives on the city and urban ways of life have formed fundamental critical responses to modernity, contributing to the rediscovery of everyday life since the middle of the twentieth century. Lefebvre's *Critique of Everyday Life* (1947) and Michel de Certeau's *The Practice of Everyday Life* (1980) redefined everyday life as the ground upon which all other activities and perspectives need to be based upon. In contrast to traditional Marxist perspectives and discipline-bound specialist thinking, where the everyday was dismissed as banal or a domain of distraction that had to be overcome, the twentieth century saw it become the center of consideration. As Lefebvre identified, 'Everyday life, in a sense residual, defined by "what is left over after all distinct, superior, specialized, structured activities have been singled out by analysis," must be defined as a totality' (Lefebvre, 1991, p. 97). Outside of the locus of dominant activities, everyday life is nonetheless far from peripheral. Instead, it serves as the essential, connective tissue between discourse, institutional power, and discipline bound perspectives, mediating relationships between abstract and concrete reality; 'Everyday life is profoundly related to *all* activities, and encompasses them with all their differences and conflicts; it is their meeting place, their bond, their common ground' (Lefebvre, 1991, p. 97).

Lefebvre reinterpreted class-based alienation through the quotidian experience of postwar consumerism and effectively pioneered a form of cultural hermeneutics that subsequently developed into cultural studies. Informed, yet diverging from Lefebvre in key ways, Michel de Certeau is also associated with the rise of cultural studies. He reevaluated the everyday through his landmark work, *The Practice of Everyday Life*, published in 1980. Outlining the 'marginality of the majority,' he investigated how 'the showy products through which a productivist economy articulates itself' are co-opted as part of the 'tactics of consumption, the ingenious ways in which the weak make use of the strong, thus lend a political dimension to everyday practices' (de Certeau, 1984, p. xviii). At the center of the everyday is what de Certeau celebrates as the 'common hero, an ubiquitous character, walking in countless thousands on the streets' (de Certeau, 1984, p. v) and to whom *The Practice of Everyday Life* is dedicated. In Chapter 7, "Walking in the City,' de Certeau recounts impressions of Manhattan from the view on the 110th floor of the original World Trade Center. Seeing the city from such a great height abstracts Manhattan; he interprets the view in terms of perpetuating the illusion inherited from medieval and Renaissance painters who, 'represented the city as seen in a perspective that no eye had yet

enjoyed' (Ibid, p. 92). The panoptical, totalizing view from the World Trade Center 'continues to construct the fiction that creates readers, makes the complexity of the city readable, and immobilizes its opaque mobility in a transparent text' (Ibid, p. 92). De Certeau is as skeptical about actual vantage points, offering totalizing assessments as he is theoretical ones pursuing the macro perspectives of modernity premised on the mastery of knowledge. For de Certeau, the urban precedes the city as an atopia fact of urban agglomeration that since the sixteenth century has been transforming into the concept of the city.

As a concept, the city becomes a projection that relies on historical processes of representation and optical artifacts to inform a discourse centered on managing its growth. In other words, the emancipatory potential of urban space is lost amid the panoptics of planning perspectives. The seemingly 'transparent text' of the 'readable city' is 'the analogue of the facsimile produced, through a projection that is a way of keeping aloof, by the space planner, urbanist, city planner, or cartographer. The panorama-city is a 'theoretical' (that is, visual) simulacrum, in short a picture, whose condition of possibility is an oblivion and a misunderstanding of practices' (Ibid, pp. 92–93). Harking back to an orientation on urban practices that precedes the Chicago School, de Certeau returns to the speculative deliberations of Simmel, Benjamin, and Kracauer in pursuit of the elusive qualities of everyday urban life.

The arrival of the modern metropolis in the nineteenth century brought about one of the ultimate forms of the city as a concept and the tensions arising between human agglomeration and capital accumulation. What becomes essential in its wake is maintaining the emancipatory potential of the everyday, something that is as indefatigable as it is precious. Residing in plain sight, the everyday manifests out of ineluctable qualities of the urban, forms of interactions that prefigure the city as concept, accompanied by the panoptics that reduce the everyday to abstractions. 'The ordinary practitioners of the city live "down below," below the threshold at which visibility begins' (Ibid, p. 93). Like Simmel, Benjamin, and Kracauer, de Certeau strives to identify the form and essential characteristics of urban life, but is also wary of immobilizing its potency by reducing it to any clearly visible form of readable representation. 'Escaping the imaginary totalizations produced by the eye, the everyday has a certain strangeness that does not surface, or whose surface is only its upper limit, outlining itself against the visible' (Ibid, p. 93). It is this shadowy nature of the everyday that becomes de Certeau's project, wherein,

> I shall try to locate the practices that are foreign to "geometrical" or "geographical" space of visual, panoptic, or theoretical constructions. These practices of space refer to a specific form of operations ("ways of operating") to "another spatiality" (an "anthropological," poetic and mythic experience of space), and to an *opaque and blind*

mobility characteristic of the bustling city. A *migrational*, or meta-
phorical, city thus slips into the clear text of the planned and read-
able city.

(Ibid, p. 93)

Despite the impost of a utopian rationality that may have underscored
the concept of the modern city, the reassertion of everyday life acts as a
countervailing force to the logics imposed by its production of space in
the twentieth century. The model for how urban space contains agency
is owed to Lefebvre's social production of space, which foregrounds
the role that perceived and conceived space plays in urban lived experi-
ence. Following Lefebvre and de Certeau, key urbanists such as Bordieu,
de Bord, and Jacobs, have interceded in what de Certeau labels as the
'rationalization of the city [which] leads to its mythification in strategic
discourses' (Ibid, p. 95). Acknowledging the active role of space in cities
has meant wrestling control from the 'functionalist organisation' respon-
sible for 'privileging progress (i.e. time) [and for] – space itself – to be
forgotten; space thus becomes the blind spot in a scientific and political
technology' (Ibid, p. 95) that de Certeau refers to as the 'Concept-city':

> Today, whatever the avatars of this concept may have been, we have
> to acknowledge that if in discourse the city serves as a totalizing and
> almost mythical landmark for socioeconomic and political strategies,
> urban life increasingly permits the re-emergence of the element that
> the urbanistic project excluded. The language of power is in itself
> "urbanizing," but the city is left prey to contradictory movements
> that counterbalance and combine themselves outside the reach of
> panoptic power. The city becomes the dominant theme in political
> legends, but it is no longer a field of programmed and regulated oper-
> ations. Beneath the discourses that ideologize the city, the ruses and
> combinations of powers that have no readable identity proliferate;
> without points where one can take hold of them, without rational
> transparency, they are impossible to administer.
>
> (Michel de Certeau, *The Practice of Everyday Life*,
> de Certeau, 1984, p. 95)

As the modernist city of rationality has had come to terms with the spatial
dimensions accompanying everyday lived reality, both perspectives have
also had to negotiate the city as sign. As a contested space emerging out
of an abstract set of symbolic relations, the city as sign continues to pro-
pel aspects of postmodern urban thinking. As actual and imaginary cities
enter a period of dizzying conflation, the new coordinates of spatialized
reality under postmodernity reveal some of the fundamentals governing
urban life under late capitalism. Recognizing the role that cultural and

symbolic elements play in the hard economics shaping cities has shed light on the dramatic realignments of capital, labor, and resources in the globalizing context of the twenty-first century. As a result, urban discourse has been at the center of the critical reevaluations of social, cultural, and economic transformations accompanying postmodern life. Postmodern urbanism acknowledges how the material form of actual cities is increasingly dependent on the symbolic economy of the sign. The role of the symbolic economy challenges sets of assumptions predicated on the orthodox Marxist model of Superstructure and Base and the economic determinism flowing from capitalist accumulation of land, labor, and capital.

Traditional Marxist thought posits that if society is ever to be transformed, the control, ownership and redistribution of all base factors is central. The role of everyday life expressed as mass culture through the culture industry and confined to the Superstructure is seen as secondary. From Heidegger to Lukacs through to Adorno, Horkheimer, and the Frankfurt School, the expression of everyday life in mass culture has been dismissed as false consciousness. In contrast to these views, however, Benjamin maintained that within the cultural expressions of mass culture under modernity were social energies essential for the transition to a socialist society.

Recognizing a dialectic operating in the Superstructure similar to what Marx had identified in the base of capitalist economics, Benjamin's meditations on the role of culture anticipated Max Weber and Antonio Gramsci's reassessments of the fundamental dynamics between Superstructure and Base. For Benjamin, the productive forces of economics were not confined to Base and nor were production relations confined to the Superstructure. As Buck-Morss has detailed in her analysis of the *Arcades Project* (*Passagen-Werk*), 'The relationship between art and technology is a central theme in the *Passagen-Werk*. . . . It identifies a structural transformation in the relationship of consciousness to reality – specifically, fantasy to productive forces . . . capable of informing every sort of critical cultural practice' (Buck-Morss, 1989, 123–124). Benjamin saw the yearning for improved living under Modernity manifesting in unconscious states as much as conscious reality. Dream states, the unconscious and fantasy, all essential elements in comprising the Imaginary, suggest how cultural forms expressed through the technologies of modernity could form the basis of a new language central to transforming social reality.

> During long periods of history, the mode of human sense perception changes with humanity's entire mode of existence. The manner in which human sense perception is organised, the medium in which it is accomplished, is determined not only by nature but by historical circumstances as well.
>
> (Walter Benjamin, *Illuminations,* in (Benjamin, & Arendt, 1987, p. 222)

One of the features of modernity that Benjamin articulates is its potential to reverse what de Certeau later outlined as the dynamics of abstraction that result from making the city visible through representation. As de Certeau argues, the rational representation of cities contributes to the abstraction of urban processes, which urban planning relies upon as part of its conceptual imagery. Expanding the repertoire by which we approach the city is needed if we are come to terms with its multiplicity. As Siegel states, images of the city are required that can convey its prismatic lived realities. 'It would be erroneous to talk of the city as a singular, unified social reality. . . . More appropriate to the discussion are images of a city, a multi-faceted city that represents ideological concepts, economic forces, and social spaces that reflect a diversity of cultural, historical, and geographical markers' (Siegel, 2003, p. 143).

The spectacular rise of the modern city reshaped everyday urban life and provided the basis for cultural and aesthetic expression that articulated modern consciousness. Assuaging the city as an image, as abstraction, is the imagined city that has been pivotal in recording the historical progress of the modern metropolis and capturing its impact on everyday urban life. The collective, creative storehouse of paintings, photographs, novels, theater, music, and films throughout the twentieth century conveys the phenomenology of the modern metropolis. Yet, the extent to which aesthetic representation works to remediate the tensions between the abstract city of the image and the lived dimensions of its everyday reality remains to be grasped. But as literary, cinematic, biographical, photographic, and other symbolic and creative renderings of the city are included in urban analyses, the exchange in ideas and approaches to the city has expanded the armory that can be deployed to tackle comprehension of contemporary urban processes and their inherent superabundance.

The centered metropolis of modernity may have long been seen as instrumental in providing creative formal expression to the representation of modern life, but what is less understood is how symbolic and other forms of imaginings translate into the hard economics of capitalist relations of production. Pierre Bourdieu's notion of 'habitus' is one response to the symbolic economy and challenges conventional understandings of economic dynamics. According to Anne Jourdain, 'Bourdieu always decried what he called 'economism' and claimed that the social sciences should focus on the social foundations of economic phenomena' (Jourdain, 2018, pp. 356–357).

With the shift from metropolitan modernity to postmodern urbanism, it is clear that international capitals have become drivers of cultural and creative industries and function as mega forms of habitus shaping local and global economic transformations. As the economist, Edward Glaser states, 'The success of London and New York and Paris today reflects, in part, their strengths as consumer cities' (Glaeser, 2012, p. 259). But along with Amsterdam, Berlin, Milan, Moscow, Tokyo, Sydney, Singapore,

Mumbai, Hong Kong, Shanghai, Beijing, Mexico City, Sao Paulo, San Francisco, and Los Angeles, these cities are also economic powerhouses of symbolic production fueling innovations that are driving new global systems of production and consumption. Commerce in these cities is centered on service industries such as finance, retail, real estate, tech sectors, tourism, and entertainment. Manufacturing sectors in these global cities are dominated by the production of abstract and symbolic forms of the image through industries such as gaming and software engineering, marketing, advertising, and filmmaking. The production and distribution of these abstract commodities blurs former distinctions between economy and culture, consumption and production, characteristic of the symbolic economy of the sign.

Lefebvre's former assistant, Jean Baudrillard pursued the social implications of the symbolic economy as early as 1972. The critical oeuvre of Baudrillard is distinguished by his poststructuralist emphasis of the primacy of signs. The fusion of the sign and the object in a cultural analysis of mass society dominated by the circulation of signs constitutes Baudrillard's 'aesthetic mode of investigation' (Gane, 1991, p. 5). Building on the ideas he outlined in *Consumer Society: Myths and Structures* published in 1970, Baudrillard released a collection of essays in 1972 under the title *For a Critique of the Political Economy of the Sign*, which approached late capitalism as the ascent of the sign in urban culture. Attempting to develop what was essentially a new theory of symbolic cultures, Baudrillard's thinking had to break with some of the central tenets of Marxism. The cornerstone of Baudrillard's approach separating him from traditional Marxist economic thought is the conviction that consumption has replaced production as the main driver of economic activity in late capitalism.

Baudrillard's reconceptualization of the relations between culture and capital reflects the social and spatial reconfigurations symptomatic of postmodern urbanism. As cultural production continues to transform the economics of the world's largest cities, sociological perspectives from writers such as Sharon Zukin argue how the role of culture in cities has become 'a powerful means of controlling cities' (Zukin, 2013, p. 350). While the base economy of cities under modernity may have traditionally relied upon land, labor, and capital, increasingly these factors are driven by an 'aesthetic power' and what Zukin describes as the second and more abstract symbolic economy of cities, 'devised by "place entrepreneurs," officials and investors whose ability to deal in the aspirational symbols of desire and growth yields "real" results in real estate development, new businesses and jobs.' (Zukin, 2013, p. 351). As global media content, advertising, and promotional campaigns circulate through entertainment-style synergies, the representation of cities far exceeds the limits of any former physical boundaries. The symbolic dimensions of the postmodern city mean it continues to expand exponentially. No longer confined by

its physical borders or a cultural sphere of social relations, the city as text enters into the relations of production through the symbolic economy.

The significance of the symbolic economy, however, demonstrative of postmodern urbanism and the kinds of economic relations, traced by Zukin, Florida, and Bourdieu among others, has not gone unchallenged. In *The Condition of Postmodernity* (1989) through to *Spaces of Hope* (2000), David Harvey has questioned perspectives on culture and the altered economic roles afforded to the Superstructure through postmodern urbanism. Harvey's sustained critical output since the 1970s insists that, despite capitalism entering an information age and globalizing era that enables flexible capital accumulation and social mobility, the traditional economic drivers of Base hold sway. For Harvey, issues of class and labor relations maintain their dominance over and against the social, cultural, and spatial impacts associated with postmodern urbanism. Harvey advocates that Marxist-based economic conceptualizations remain capable of keeping pace with the postindustrial and urban processes arising out of late capitalism.

Meanwhile, for those who interpret the shift from industrial, production-based economies as symptomatic of new forms of urbanism driven by service and consumption 'systems,' Los Angeles provides an urban exemplar. Attempting to describe how a thorough reworking of capitalist relations in the twenty-first century has fundamentally altered social, cultural, and economic relations, for many critical, cultural, and urban theory writers, traditional Marxism can only offer a partial response. In addition, the emphasis in traditional Marxism on Base and the relations of production also has to be revisited. What amounts to postmodern perspectives on urbanism and the interpretation of economic dynamics exemplified by Los Angeles reinforce Benjamin's contention that it is the Superstructure and social relations that contain a key dialectic shaping history as much as the economics of Base and the relations of production.

> Marx lays bare the causal connection between economy and culture. For us, what matters is the thread of expression. It is not the economic origins of culture that will be presented, but the expression of the economy in its culture. At issue, in other words, is the attempt to grasp an economic process as perceptible *Ur* phenomenon, from out of which proceed all manifestations of life in the arcades (and, accordingly, in the nineteenth century).
>
> (Walter Benjamin, *Walter Benjamin and the Arcades*, in Hanssen, 2006, p. 460)

Writers such as Sharon Zukin, Edward Soja, Allen Scott, and Michael Dear represent a reinvigorated intellectual engagement of the rapidly changing formations in production, consumption, and exchange and the cultural relations underpinning postmodernity. Contemporary urban

research is now comprised out of a wide-ranging theoretical matrix consisting of critical cultural theory intersecting with urban geography discourse. Key dialectics in urban thought have arisen out the writings and ideas supplied by Jane Jacobs, Henri Lefebvre, Michel Foucault, and Manuel Castells through to David Harvey, Edward Soja, Michael Dear, and Richard Florida. Soja, in particular, has advanced positions outlined by Lefebvre and the primacy of space, by advocating for a radical shift in Western thinking, and interpreting causality as coming from urban space. The radical proposition reverses the previous determinism of social, political, cultural, and economic forces shaping space. Instead, Soja, following Lefebvre, sees human geographies shaping culture, class, economy, and politics, and at the very least urban space and social construction are mutually constitutive in a two-way dynamic. Postmodern urbanism as expressed through globalization and the rise of the symbolic economy and consumption, may be some of the starkest manifestations of late capitalism. But those very same processes also contain the conditions within which resides the possibility of social transformation.

Conclusion

Since the 1960s, theoretical approaches to urbanism have reconnected to the emancipatory ideals associated with the modern metropolis first explored by Benjamin, Kracauer, and Simmel. Since Lefebvre's *The Production of Space* (1974) inserted the spatial as the means for revising the construction of historical knowledge itself, urbanism has displaced industrialization as the *dispositif* of late capitalism.

Charting discourse on the modern city throughout the twentieth century reveals how urban research has spanned speculative contemplation to scientific measurement. Associated urban practices have drawn upon the inspirational metropolis embodying the energies of early modernity, to the discipline-bound functionalism of urban planning under high modernity. As interdisciplinary approaches to the city have been embraced, the hegemony of the social sciences and their claim on the city has been challenged alongside the sets of assumptions that underpinned the project of modernity.

In the 1960s, the city was reclaimed amid the reactionary crisis points driven by bodily and emotional intensities contesting the power differentials of urban lived reality. As time and space continued to collapse under the globalizing forces of late capitalism, spatial reconfigurations from the centrifugal drivers of telecommunications, suburbia, and the proliferation of media saw the rise of the global city transform everyday urban experience.

By the end of the twentieth century, economic transformations from the rise of the symbolic economy cemented the crystalline surfaces of postmodernity. Devising critical approaches that take account of the

rational as well as the imagined city saw urban research undergo the same restructuring occurring within its object of study. Previously in Chicago-style urban studies, the rational city was an object of study celebrated and promoted under modernity. Approached *quantitatively*, the social sciences constructed perspectives on cities based on the disciplines of anthropology, sociology, architecture, urban planning, urban history, and urban geography. Meanwhile, the richness, diversity, complexity, and contradictory quality of the modern city rendered by the 'imagined city' was consigned to the margins of critical analyses. Constructed as metaphor, symbol, and backdrop, the city could also perform in dramaturgic terms as design object or at the level of character in fictional narratives. But this imaginary city was dismissed along the same lines as fantasy and false consciousness, denigrated in the same vein as 'everyday life' by Marxist intellectuals.

By the 1980s, cross-disciplinary methodologies from the ascendancy of cultural studies were establishing new forms of urban theory that became synonymous with postmodernism. Meanwhile, across the social sciences themselves, methodological innovations saw critical and analytical approaches expanded to incorporate knowledge, ideas, and insights drawn from a wider array of sources and methods. Norman Denzin described these methodological innovations as representing a 'distinct turn of the social sciences toward more interpretative, postmodern, and criticalist practices and theorizing' (Denzin & Lincoln, 2005, p. 191). These methodological innovations in the social sciences were paralleling the expansion of historiography through feminist, race, gender, and sexuality-based orientations. By 2018, developments in qualitative research led Denzin and Lincoln to proclaim, '[w]e no longer just write culture. We perform culture . . . qualitative inquiry inspired by the sociological imagination can make the world a better place' (Denzin & Lincoln, 2018, p. xi).

In the 1980s, urban theory contributed to new understandings of Los Angeles and its urban form through the programs pursued under the Los Angeles School of Urbanism. What may have been initially received as the School's radical postmodern perspectives has now translated across into more sober historical analyses of Los Angeles and California. Focus on the region through an expanded historiography continues to reinvigorate understandings of Los Angeles' past within the wider context of Californian history and the American West. Collaborations between the University of Southern California Archival Research Center and organizations such as the Getty Research Institute, Autry National Center, UCLA Hammer Museum, and Los Angeles Public library, has ensured '[t]the history of Los Angeles has come out of the shadows' (Fireman, 2004). These concerted historical projects address the Native American, Spanish, Mexican, and American periods of settlement of the greater Los

Angeles region, renewing perspectives and complementing understandings of its urban development across the twentieth century.

Postmodern approaches and urban theory may have initially been conflated with the crisis in modernity, but they have gone on to reinvigorate forms of historical inquiry and critical analysis underpinning research into global cities and urban lived experience. As late capitalism continues to manifest as systems of exchange based on the production and reproduction of symbolic commodities, the social, cultural, and economic transformations from the inchoate information age have materialized into the digital economies of the twenty-first century. Most significantly, however, in the lead up to these transformations, and occurring since the middle of the twentieth century, has been a precipitous shift from the temporal to the spatial. Such a paradigmatic reconceptualization of history and society has required an expanded repertoire of data sets to which postmodern urban theory has been but one response.

Evaluating the role of spatial forces in the historical transformations occurring since the end of the twentieth century illuminates shifts from the industrial to the urban and the modern to the postmodern. The cultural and economic dynamics identified with late capitalism reveal how the social forces from cities have been reconfigured according to the much more far-reaching impacts from widespread processes of urbanization. As the stunted metropolis of the first half of the twentieth century, Los Angeles' rapid emergence in the middle of the century coincided with this transfigured urban geography. Distinct on many levels, Los Angeles remains as a key epistemological site from which to examine the forces of late capitalism that continues to transform the topology of social relations. By pursuing an archaeology of Los Angeles noir, the proceeding chapters commence the identification of a specific Los Angeles urban imaginary that serves as one of the concrete historical formations beneath its unique symbolic economy.

Notes

1. Retrieved February 2, 2019, from https://ejatlas.org/conflict/cross-bronx-highway
2. Edward Soja, Putting Cities First, February 28, 2007, 19:13. Retrieved October 21, 2019, from www.youtube.com/watch?v=0FCTIxZt4tE.
3. Soja, Syracuse University talk, April 12, 2013 YouTube – Putting Cityspace First. Retrieved March 12, 2019, from www.youtube.com/watch?v=KcYNdf4Bczw.

References

Baudrillard, J. (1981). *For a critique of the political economy of the sign*. St. Louis, MO: Telos Press.
Baudrillard, J. (1998). *The consumer society: Myths and structures*. London: SAGE Publications.

Benjamin, W. (1985). *One-way street and other writings*. London: Verso.

Benjamin, W. (1997). *Charles Baudelaire: A lyric poet in the era of high capitalism.* (Trans. H. Zohn). London: Verso.

Benjamin, W., & Arendt, H. (1987). *Illuminations.* New York: Schocken Books.

Buck-Morss, S. (1989). *The dialectics of seeing: Walter Benjamin and the Arcades project.* Cambridge, MA: MIT Press.

Conrad, P. (1998). *Modern times, modern places: Life and art in the 20th century.* London: Thames & Hudson.

Dear, M. (2005). Los Angeles and the Chicago school: Invitation to a debate. In J. Lin & C. Mele (Eds.), *The urban sociology reader* (pp. 106–116). London: Routledge.

Dear, M., Schockman, H.E., & Hise, G. (Eds.). (1996). *Rethinking Los Angeles.* Thousand Oaks: Sage Publications.

de Certeau, M., & Rendall, S. (1984). *The practice of everyday life.* Berkeley: University of California Press.

Denzin, N., & Lincoln, Y. (2005). *The Sage handbook of qualitative research* (3rd ed.). Thousand Oaks: Sage Publications.

Denzin, N., & Lincoln, Y. (2018). *The Sage handbook of qualitative research* (5th ed.). Los Angeles: Sage.

Fainstein, S., & Campbell, S. (1996). *Readings in planning theory.* Oxford, UK: Blackwell.

Fireman, J. (2004). Invisible no more: The place called Los Angeles. *Historian*, 66(3), 517–523. https://doi.org/10.1111/j.1540-6563.2004.00083.x

Florida, R. (2003). *The rise of the creative class: And how it's transforming work, leisure, community and everyday life.* Annandale, N.S.W: Pluto Press.

Florida, R. (2005a). *Cities and the creative class.* New York: Routledge.

Florida, R. (2005b). *The flight of the creative class: The new global competition for talent.* New York: HarperBusiness.

Gane, M. (1991). *Baudrillard: Critical and fatal theory.* New York and London: Routledge.

Gillham, O. (2002). *The limitless city: A primer on the urban sprawl debate.* Washington, DC: Island Press.

Glaeser, E. (2012). *Triumph of the city.* Basingstoke and Oxford: Pan Books.

Hanssen, B. (2006). *Walter Benjamin and the Arcades project.* London: Bloomsbury Publishing.

Harvey, D. (1989). *The condition of postmodernity: An enquiry into the origins of cultural change.* Cambridge, MA and Oxford, UK: Blackwell.

Harvey, D. (2000). *Spaces of hope.* Berkeley and Los Angeles: University of California Press.

Jacobs, J. (1961). *The death and life of great American cities* (Vintage Books ed.). New York: Vintage Books.

Jourdain, A. (2018). Analysing the symbolic economy with Pierre Bourdieu: The world of crafts. *Forum for Social Economics*, 47(3–4), 342–361. Retrieved February 20, 2019, from https://doi.org/10.1080/07360932.2015.1075895

Kracauer, S. (1947). *From Caligari to Hitler: A psychological history of the German film.* Princeton, NJ: Princeton University Press.

Kracauer, S. (1960, 1978). *Theory of film: The redemption of physical reality.* New York: Oxford University Press.

Lefebvre, H. (1991). *Critique of everyday life.* London: Verso.

Lefebvre, H. (2014). *The urban revolution.* Minneapolis: University of Minnesota Press.

Longhofer, W., & Winchester, D. (2016). *Social theory re-wired: New connections to classical and contemporary perspectives* (2nd ed.). New York: Routledge.

McQuire, S. (2008). *The media city: Media, architecture and urban space.* Los Angeles: Sage.

Park, R., Burgess, E., & Sampson, R. (2019). *The city.* Chicago: The University of Chicago Press.

Siegel, A. (2003). After the sixties: Changing paradigms in the representation of urban space. In M. Shiel & T. Fitzmaurice (Eds.), *Screening the city* (pp. 138–159). London and New York: Verso.

Simmel, G., Frisby, D., & Featherstone, M. (1997). *Simmel on culture: Selected writings.* London: Sage Publications.

Soja, E. (2000). *Postmetropolis: Critical studies of cities and regions.* Malden, MA: Blackwell Publishing.

Waldinger, R., & Bozorgmehr, M. (Eds.). (1996). *Ethnic Los Angeles.* New York: Russell Sage Foundation.

Zukin, S. (2013). Whose culture? Whose city? In J. Lin & C. Mele (Eds.), *The urban sociology reader* (2nd ed., pp. 349–357). Abingdon, Oxon: Routledge.

2 Hard-Boiled Boulevards

In a typological prefiguring, hard-boiled detective fiction precedes film noir through formal expressions of tone and style that convey essential characteristics of the post-Depression landscape of American crime writing. More than any other writer, Raymond Chandler ensnared Los Angeles in pulp fiction narratives that have become essential to the city's noir identity. An antidote to the boosterism afflicting Los Angeles, the hard-boiled fiction of Raymond Chandler has chronicled the city's urban syncopations in pulp form, mapping transgressive and repressed impacts from the Depression and interwar years, World War II, and beyond. Offering a dark scenic history of the urban development of Los Angeles in the twentieth century, Chandler's detective fiction augments historical understandings irrespective of its basis in fiction. Indeed, Chandler's work is routinely called upon precisely *because* of its basis in fiction demonstrating how fiction can mobilize an imaginary Los Angeles to forge experiential connections between an irretrievable past, the actual city, and its history.

In his short stories, novels, and screenplay collaborations, Chandler's writing brings a period of Los Angeles to life through highly detailed observations steeped in the values and perspectives from the middle of the twentieth century. His writing informs historical accounts of the city to such an extent that Chandler has become shorthand for an entire way of seeing and understanding Los Angeles between the 1930s and late 1950s. Chandler's oeuvre centered on Los Angeles is constructed across the seven novels: *The Big Sleep* (1939), *Farewell My Lovely* (1940), *The High Window* (1942), *Lady in the Lake* (1943), *The Little Sister* (1949), *The Long Goodbye* (1953), and *Playback* (1958). Combined with his screenwriting on *The Blue Dahlia* (Marshall, 1946) and *Double Indemnity* (Wilder, 1944) – co-written with Billy Wilder from the James M. Cain novel – Chandler's writing provides unique insights into the lived experience of the post-Depression generation inhabiting midcentury Los Angeles.

American cities such as New York, Chicago, Philadelphia, Kansas City, and San Francisco have all been featured in the work of other hard-boiled

and pulp fiction writers such as Dashiell Hammett, James M. Cain, and Mickey Spillane, who have also employed Los Angeles settings. But no other hard-boiled detective writer is as synonymous with Los Angeles as Raymond Chandler, whose work has gone on to inscribe the city's history, ambiences, and social inflections as *Chandleresque*. These potent layers of meaning reside in the imaginary of a 'Raymond Chandler Los Angeles' that binds cultural and historical meaning to urban lived experience intrinsic to the real city. The interplay between Chandler and Los Angeles vividly illustrates aspects of phenomenology, which alongside insights from Raymond Williams and Guy DeBord, demonstrate how the role of fiction contributes to Lefebvre's social production of space. Through Chandler, a fictional Los Angeles and the city's actual past combine into a potent urban imaginary that historicizes spatiotemporal relations and generates the city's foundational noirscape.

The Experience of the Past

As one of the most significant cultural and literary theorists of his time, Raymond Williams developed approaches to the writing of cultural history that could account for the ever elusive social and cultural specificity of the past. Through his concept, 'structure of feeling,' Williams sought to acknowledge how culture is comprised out of the multitudinous qualities of daily life inseparable from a specific generation that comprises the minutiae of the everyday. For Williams, these everyday details shape, 'a particular quality of social experience and relationship, historically distinct from other particular qualities, which gives the sense of a generation or a period' (Williams, 1977, p. 131) The 'structure of feeling' derives from patterns and instances of cultural nuances shaping lived experience, but can only be translated out of the past into the present through a series of 'approximations.' These approximations are delivered through the 'documentary culture' produced from the wide assortment of textual forms (literature, poems, architecture, fashion, etc.) that can evoke the 'everydayness' of their time (Williams & McGuigan, 2014). Williams's insights reveal how efforts to directly convey authentic versions of these patterns, instances, and nuances, ends up inevitably misrepresenting them. Accumulating out of a series of latent meanings, assumed knowledge, and unconscious values, direct reportage of these components of everyday life in the historiographical methods of history distort such nuanced patterns. Disrupting the modulating harmonics imposed by spatiotemporal forces on lived experience, traditional historical accounts seize and freeze the instances of everyday life. An authentic impression of the past eludes historical analysis when removed from the context of the nuances shaping the daily flow of social reality as it unfolds moment to moment. The key question then, is it possible to access the complexity and richness of the past that is beyond the reach of conventional history and its

direct methods that distort such nuanced patterns of life no matter how rigorously its methodologies may be constructed and applied? Williams seems convinced we can because of the 'indirect' nature of documentary culture that can convey the structure of feeling through an accidental and unintended capture of time, people, and places that ameliorates the missives of historical discourse. The word *feeling* in 'structure of feeling' is key here, highlighting the emotional dimensions over purely rational and intellectual processes. As with formal history, however, documentary culture remains limited by virtue of its own distortions inherent in all of its formal codes of representation, hence the qualification from Williams that even documentary culture can still only relay the past through his 'approximations.'

Williams's interest in structures of feeling as a way to gauge how an authentic sense of the past could be conveyed as it was passed down through the ages is complemented by Guy Debord's ideas on psychogeography. While Williams's focus was on relaying the authentic features of the past, Guy Debord was more attuned to what underpinned our immediate experience as it was occurring moment to moment in the present tense of lived reality. For Debord, subjective experience, particularly in urban space, was continuously shaped by intersections with texts, place, and history that fused into specific spatial interactions under the concept of psychogeography. Developed in his *Introduction to a Critique of Urban Geography* (1955), Debord saw psychogeography as, 'the study of the precise laws and specific effects of the geographical environment, consciously organized or not, on the emotions and behaviour of individuals.'[1] Despite its strong association with the Situationist movement circa-1950s Paris, psychogeography has antecedents back to Benjamin and Baudelaire, connecting to the figure of the flaneur in early modernity. Psychogeography articulates how experience in the modern city means traversing its real and imagined dimensions, and navigating the historical and fictional sources that inform the personal cognitive mapping processes beneath urban lived experience.

Since the 1990s, psychogeography has garnered renewed interest, and its applications have been more fully articulated and applied by assorted cultural studies theorists. Variously employed as a form of urban activism through creative and artistic interventions into city space, its critical dimensions have also been developing since the early 2000s. According to Phil Baker, contemporary psychogeography, 'is not interested in the "objective" panoptical mapping, but only in the private cognitive maps of our customized cities' (Baker, 2003, p. 324). Under the British influence, Baker has outlined how psychogeography has expanded along four central ideas: 'the emotional effects generated by environment; the behavioral effects generated by environment; the ambiences generated by particular locales; and the process of cognitive mapping, that is, the way individuals construct and assign particular meanings to specific places'

(Baker, 2003, p. 324). As a theoretical framework, psychogeography expands understandings on how we customize the experience of cities and urban space irrespective of whether we are residents, visitors, or simply consumers through its representations.

Together, psychogeography and structures of feeling articulate philosophical approaches to the nature of individual experience and consciousness as pursued by phenomenology developed by Edmund Husserl and Maurice Merleau-Ponty. The specific relationship between individual experience and aesthetic forms was subsequently explored by Mikel Dufrenne's influential contribution, *The Phenomenology of Aesthetic Experience* (1953). In a prescient anticipation of the critical shift to readership, Dufrenne emphasized the reception of objects and art rather than the intention of their producers. Expanding some of the fundamental concepts in phenomenology in order to focus on aesthetic experience, Dufrenne described art in terms of its ability to express the 'sensual' surfaces of the world. Following Merleau-Ponty, Dufrenne approaches art as a fundamental and intuitive way for understanding life, where art is a primary activity, not a secondary activity like any theory of art. Uniting the many branches of phenomenology is the view that reason and logic have a tendency to overwhelm the primary activities they interrogate. Dufrenne argues that art and the much more encompassing and general experience of aesthetics challenge logic and reason by providing visible forms to the otherwise concealed depths of reality. Art and aesthetics manifest in what Dufrenne describes in terms of 'the progressive thickening of a surface' that expresses the world (Dufrenne, 1973). Aesthetic experience extends beyond artistic objects and provides form to the real by engendering experience through formal representations and their perception.

> In all the arts, both temporal and spatial factors are present. Time and space become correlative and even continuous, so that the space of every aesthetic object is temporalized and its time spatialized. The direct consequence of this spatializing of time temporalizing of space is to turn the aesthetic object into a "quasi subject," that is, a being capable of harbouring internal spatiotemporal relationships within itself. These relationships constitute in turn the "world" of the aesthetic object – a world which is more like an atmosphere than an objective cosmos filled with discrete entities and events.
>
> (Dufrenne, 1953, 1973, p. xxvi)

Phenomenology, structure of feeling, and psychogeography provide complementary theoretical frameworks for interpreting the many levels on which Chandler's writing operates in relation to Los Angeles. Chandler's detective fiction comprises a highly distinct, visible form, something delivering on Dufrenne's 'thickened surface.' Drawn from everyday

life in midcentury Los Angeles, this form, as well as Chandler's detailed descriptions not only describe its external characteristics but also manage to convey the period's 'structure of feeling.'

Phenomenology and psychogeography are particularly concerned with consciousness as it unfolds through subjective experience. Central to Chandler's form of detective fiction of course, is the first-person perspective from Philip Marlowe. Bound up in Chandler's form is a mode of writing that directly communicates to readers through the impression-laden perspective of an intersubjective modality. Over the course of so many novels and narratives, the experience of reading Chandler is highly conducive to transporting readers into the present tense of midcentury Los Angeles bristling with its lived impressions of time and place. As it continues to recede into the confines of history, however, beyond the reach of living memory (which Williams identifies as one of the most significant thresholds as social memory becomes abstract history), Chandler's Los Angeles functions as a palimpsest of the past. It is hardly surprising then, that Chandler's fiction has come to resonate so profoundly according to the principles of psychogeography.

The Imaginary and the Inscribing of Feeling

Since the eighteenth century, the novel has served as one of the most elemental artifacts of 'documentary culture,' enabling us to grasp the past by providing indispensable historical insight into Western culture. Providing a valuable supplement to historical knowledge and data, the novel has been responding to the social circumstances surrounding the rise of the bourgeoisie and the disruptions emanating from the industrial revolution by recording intrinsic micro and macro components of Western consciousness. Literature on numerous scales has enabled carefully observed attention to be paid to the particularity and peculiarity of social mores from the nineteenth century. European society and culture with all of its richness and diversity, all of its contradictions and struggles, has been captured through the imagined form of the novel. The values and ways of life of generations reside in the pages of Tolstoy, Dostoyevsky, Dickens, the Brontës, Austen, Hugo, Proust, and others, while novels from Alcott, Emerson, Melville, James, Poe, and Thoreau are just as central to the American experience in the nineteenth century.

In the twentieth century, the tenor of American novels shifted decisively with the United States coming to terms with rapid urbanization. The industrial northeast was the heart of America's urban transformation and city life became the basis of novels by Baldwin, Fitzgerald, Hemingway, and literary movements such as the Harlem Renaissance. Meanwhile the South and its agrarian past captured in writing by Faulkner was a reminder of what was rapidly being lost. On the opposite side of the continent, the West gave way to the opportunity-laden 'Golden State' of

California. Physically the farthest point in American civilization from the strictures and traditions inherited from ancestral Europe, California has long been bound up with ideas of American manifest destiny and utopianism. By the 1920s, however, novels were already exploring how the promise of this new society and the potential of its way of life was being squandered through rampant greed and artifice.

California and what it had come to represent was critiqued by lesser-known American authors in *Angel's Flight* (Don Ryan, 1927), *Wild Orchard* (Dan Totheroh, 1927), *The Flutter of an Eyelid* (Myron Brinig, 1933), *Young Man with a Horn* (Dorothy Baker, 1938), and *Long Haul* (Bezzerides, 1938). Despite whatever may have been perceived as their literary shortcomings, these writers and novels repudiated the paradise posed by Southern California and its boosterism, often taking aim at the spiritual and cultish religiosity of an increasingly commercialized region.

By the 1930s in the wake of the Great Depression, the literary critique of California was becoming squarely centered on Los Angeles, as the city began to assume an entirely new dimension in the American cultural imaginary. In literary terms, the year 1939 was a watershed year, ushering in sobering depictions of Los Angeles from more well-known and established authors: John Steinbeck's *The Grapes of Wrath*, Nathanael West's *Day of the Locust*, and Aldous Huxley's *After Many a Summer Dies the Swan*. However, the publication of Raymond Chandler's *The Big Sleep*, inaugurated a relationship between his fiction and Los Angeles that has gone on to rival Victor Hugo's Paris and Charles Dickens's London.

Chandler's Los Angeles traverses across each of the pulp, literary, and cinematic forms of the short story, the novel, and feature screenplay. Chandler's oeuvre ensures his work stands as one of the foremost accounts of Los Angeles by chronicling the city from the 1930s until the end of the 1950s, providing an indelible rendering of the city during some of its most transformative years. Testament to the way in which Chandler's fiction maps the historical dimensions of Los Angeles is how regularly it is employed in the service of historical analyses of the city, prefiguring the way Roman Polanski's *Chinatown* (1974), would be similarly employed. For example, in urban geographer William Fulton's study *The Reluctant Metropolis: The Politics of Urban Growth in Los Angeles*, a quote from *Farewell My Lovely* is used to illustrate a very precise attitude and cultural disposition in the 1930s.

Perhaps the most vivid source of information about the consequences of the growth machine on Los Angeles is in the writing of mystery novelist Raymond Chandler, especially his novels *The Big Sleep*, *Farewell My Lovely* and *The Lady in the Lake*. Chandler had a great eye for detail of all kinds, and the details he provides us with about the Southern California landscape and its people are filled with

insight. In *Farewell My Lovely*, published in 1940, detective Philip Marlowe visits a neighbourhood busybody living in a transitional section of what we would now call South Central. Seeking to gain her confidence, he admires her carved sideboard and says: "I bet that side piece was the admiration of Sioux Falls." She answers: "Mason City. Yesser, we had a nice home there once, me and George. Best there was."

(Fulton, 2001, p. 366)

Fulton is drawn to this passage in *The Big Sleep* because: 'Just in that one exchange Chandler manages to convey volumes about the hopes and the realities of Midwestern migrants living in Los Angeles in the 1930s' (Fulton, 2001, p. 366). It is these elusive human attributes, like 'hope,' and the way in which they manifest in such specific forms at specific times in specific places that constitutes the intangibles that Raymond Williams sought to account for in his concept of 'structure of feeling.' Chandler's Los Angeles functions as a vast container of those intangibles preserved from the past. As a record of such intangibles, Chandler's fiction resembles history, but clearly as fiction it operates on entirely different terms. For Fulton, the insights he gleans from *Farewell My Lovely* function as a 'vivid source of information,' yet it is a noticeably different kind of information from the conventional data employed in urban studies. The vividness that Fulton attributes to Chandler's passage is derived from details that can deliver social and historical insights endowed with the minutiae of lived experience.

Chandler's fiction may only offer imagined details of mid-century Los Angeles, but it is also derived from his own lived experience during a period in the city that witnessed momentous change. As a literary artifact, his fiction continues to resonate in such rich and authentic ways, first because Chandler is drawing details from a period he inhabited and second, because his writing captures details that remain immersed in the flow of events unfolding in a narrative form judiciously crafted out of such specific tone and style. Residing in the temporal movement of narrative events, period details are inflected with Chandler's keen eye and unwavering stylistics. The details he captures of everyday life are able to communicate structures of feeling because they have not been removed or isolated in a test tube of historical discourse, but rather, are the embodiment of a past style generated from the actual period.

As biographies on Chandler have recounted, his life reflected the repeated rise and falls that coincided with World War I, the Great Depression and World War II. Upon the divorce of his American father and British mother, he became a transplanted American receiving a classical education at the British public school, Dulwich College. Aspiring to be a writer, Chandler obtained some experience working for various publications in London, but like countless tens of thousands in the early decades of the twentieth century, he journeyed to the United States seeking greater

opportunities. Returning to America was also a homecoming after being dislocated during his formative years, and he was separated again when he joined the war effort by enlisting in the Canadian RAF. As a World War I veteran, he was the only surviving member of a platoon company (MacShane, 1976, p. 29) and experienced first-hand the dislocation of a returning soldier confronted with adjusting to civilian life in peacetime Los Angeles.

Chandler's cultural separations from the Unites States had the effect of sharpening his perspective on what oscillated as both his native and adopted culture. Always an outsider, throughout his twenties he experienced the itinerant work many migrants encountered when they first moved to California. Chandler is quoted, "We are so rootless here. . . . I've lived half my life in California and made what use of it I could, but I could leave it forever without a pang" (MacShane, 1976, p. 26). It was not until Chandler was in his thirties, when he managed to build a career as an oil executive, that he achieved a level of domestic and financial security. Yet, despite enjoying a level of success as a corporate manager in the booming Los Angeles oil industry, he also famously battled alcoholism, which ultimately caused him to lose his corporate position. Aged forty-four, and feeling like he had few other prospects, he attempted to write full-time and eventually carved out a living writing mystery stories for the pulps, which led to his first novel in 1939, *The Big Sleep*. Chandler was fifty-one, and the novel's publication marked a significant turning point in his writing career, as well as financial situation. Until publication of *The Big Sleep* he was reputedly earning one-tenth of what he had been earning as an oil executive.

Chandler himself, as much as his writing, was the product of all the temporal sensibilities of a time and place that has now receded into a past beyond the reach of living memory. In terms of a temporal threshold, passing beyond living memory is significant because it limits access to a specific time through historiographical retrieval only. When all living memory of a period passes through the demise of a specific generation or population, Williams classifies the remaining traces of that past under second-order social artifacts. This 'documentary culture' of objects, texts, archival records of that past, render and lock the complexities of social and cultural lived experience into abstract formations. Locked into the object of history, no matter how contested that history may be, or eventually becomes, the minutiae of lived experience from that past is inevitably subsumed beneath official history. The dynamics produced between the seemingly hegemonic and dominant with the emergent, the contested, the relational, and the latent, all but disappear beneath processes of formal historicization. According to Williams, 'the most difficult thing to get hold of, in studying any past period, is this felt sense of the quality of life at a particular place and time: a sense of the ways in which the particular activities combined into a way of thinking and living' (Williams & McGuigan, 2014, p. 33).

For Williams, the dynamics of a certain period reside like a 'solution,' and come to define a certain 'style' that characterizes particular periods. It is ultimately something that is incalculable and irretrievable through historiographical processes.

Williams's concept of the 'structure of feeling' is not exactly a radical reappraisal of historical processes, but like Gramsci's perspective on hegemonic historical forces, it disrupts how we interpret dominant structural forces and their role in history. The concept of structure of feeling has been considered in terms of an early articulation of *affect* that offer perspectives complementing the analysis of social and material infrastructure in society and culture. This has led to Williams's concept being consigned to structuralist thinking; nevertheless, its influence on cultural studies persists, and it continues to be reappraised (see Sharma & Tygstrup, 2015). When employed alongside ideas of psychogeography, structure of feeling sheds light on why an urban geographer such as Fulton sought to employ insights drawn from Chandler's writing. *The Big Sleep* captures midcentury life in Los Angeles at the granular level, conveying the texture of attitudes informing the structure of feeling accompanying macro phenomena such as internal migration in the United States to Los Angeles and Southern California.

By insisting on the emotional and experiential dimensions of social life as it unfolds, Williams's conceptual ideas account for dominant, emergent, and residual social forces occurring among the complexity of social practices. By emphasizing 'feeling' in the naming of this concept, which Williams preferred over 'experience,' structure of feeling as a concept is a direct challenge to the preeminence always afforded to supposed rationality and logic-bound practices of history. By privileging the emotional over the rational, Williams was challenging historical interpretations of the past that are confined to abstract philosophical considerations more prone to avowing hegemonic ideological interpretations.

All manner of formal and informal commentators, from historians to urban geographers to readers and fans, are drawn to Chandler's fiction because it captures in so many intricate ways a highly particular time in Los Angeles. Nevertheless, Chandler's Los Angeles is far from any kind of factual version of the city; nor was it an attempt to mimetically render it in any way. Couched in the evolving pulp form of the American detective novel and crime genre, Los Angeles appears through splinters in the narrative among momentary sideways glances away from the central plot. Yet the city clearly functions in a much more complex manner than mere backdrop, and Chandler's plots were far less all-consuming of his literary talents than most of his contemporary crime writers. Indeed, with the exception of Dashiell Hammett, the literary aspirations of Chandler drove him to experiment with the formal conventions of the detective genre in a more systematic way than perhaps any other crime writer.

Chandler saw crime writing as having significant potential for something that could transcend the pulp pleasures surrounding neatly resolved whodunnits among violence-riddled plots:

> I want to develop an objective method – but slowly – to the point where I can carry an audience over into a genuine dramatic, even melodramatic, novel, written in a very vivid and pungent style, but not slangy or overly vernacular. I realise that this must be done cautiously and little by little, but I think it can be done. To acquire delicacy without losing power, that's the problem.
>
> (Day, 2015, p. 40)

Chandler's styled realism was achieved through his detailed descriptions of settings and objects amid the urban and natural contexts provided by Los Angeles. Striving for a semiliterary form, Chandler countenanced the sparse realism of hard-boiled detective fiction through precisely honed language features, developing his highly recognizable style that became a trope in the dialogue and narrative voice-overs employed in classical film noir.

As Chandler observed later in life, 'My whole career is based on the idea the formula doesn't matter, the thing that counts is what you do with the formula, that is to say, it is a matter of style' (MacShane, 1976, p. 63). Here the notion of style is worth elaborating on because it connects to Williams's 'structure of feeling.' Style performs as something much more significant when it is applied to a certain period or how a particular generation lived in the world. Style becomes something all-encompassing, suggestive of how a period exists in Williams's socio-temporal 'solution.' What style captures is the ineluctable absence outside of history that leaves no trace of itself. Style can be seen to function as the connective tissue, being at a particular place in a particular time, informing the meanings, inflections, and nuances that shape a sociohistorical moment into personal as well as shared lived experience. In this context, it is highly significant then, that American hard-boiled detective fiction of the mid-twentieth century is marked by a definitive writing style, and its inheritor, film noir, has been interpreted as a film style rather than a film genre. In distilling something so specific to midcentury American experience, the narrative forms of hard-boiled detective fiction and film noir provide rich access to the period's structure of feeling generated in the everyday of the aftermath from the Great Depression and World War II.

Amid the upheavals of the middle of the twentieth century, Chandler was striving to see the detective novel transcend its pulp status and articulate something specific to his time and generation. Blending highly detailed observations of Los Angeles and its inhabitants with his famous

similes, he was convinced mystery writing could deliver something highly attenuated to the time he was living in. In a letter from October 18, 1948 he commented:

> Murder novels . . . they have the elements of heroism without being heroic . . . border on tragedy and never quite become tragic. . . . [i]t is possible that the tensions in a novel of murder are the simplest and yet most complete pattern of the tensions in which we live in this generation.
>
> (Day, 2015, p. 219)

For feminist historian and literary critic Paula Rabinowitz, forms of popular mass culture in midcentury America from the pulps and film noir account for an entire sociological moment in American history and culture. In *Black & White Noir, America's pulp modernism* (2002), Rabinowitz argues film noir and other mass-produced pulp forms provide an alternative narrative that brings into focus marginalized elements of American society. Actual film noirs are not at the center of Rabinowitz's analysis, because her sociological approach 'is less about film noir as a subject of study than as a leitmotif running through mid-century American culture' (Rabinowitz, 2002, p. 14). As a counterpoint to the kind of analysis conducted by leading film noir scholar James Naremore and his study, *More Than Night: Film Noir in Its Contexts*, Rabinowitz effectively reverses Naremore's historical perspective on film noir. Rabinowitz contends, 'I view film noir *as* the context; its plot structure and visual iconography make sense of America's landscape and history' (Rabinowitz, 2002, p. 14). By interpreting American modernity in terms of 'pulp,' Rabinowitz inverts conventional perspectives on American sociological history. Approaching the mass reproduced forms of American culture that proliferated across the twentieth century, they are no longer positioned as minor subcurrents of history. Instead, they serve as pronounced cultural expressions responding to broad ranging social fears from the Great Depression, wartime anxiety, and social displacement. Through pulp modes that transformed mass consumption and communication, the pace at which modernity ushered in new ways of living in the world hollowed out the last vestiges of a premodern America, erasing ways of life that were previously conducted and informed by its rural heritage. For Rabinowitz, modernity and the twentieth century saw the American population confronted with:

> The terrifying size and emptiness of the American continent . . . tamed by incessant crossings of telephone wires, linked by a never-ending web of female operators routing calls through switchboards, highways traversed by lone roadsters driving through the night, and road houses where a satin sheathed chanteuse sits alone on her cigarette

break. Film noir shows how communication, transportation, and entertainment shade into pulp.

(Rabinowitz, 2002, p. 14)

For Rabinowitz, the sociology contained in the subterranean depths of pulp and noir conveys the troubling reaction to the scale of American modernity and how urbanism was inverting the sublime of nature into an existential dread of humankind. Chandler's *The High Window*, published in 1942, features a striking illustration of this social dread and the effects emanating out of the existential dimensions of modernity and its terrifyingly visceral sensations. The new anonymous terrors brought about by modernity and its communication technologies are precisely relayed when Marlowe, staying back late one night in his office, receives two messages courtesy of the modern technologies transforming mail distribution and communication systems. The first involves the Brasher Doubloon itself, the rare gold coin at the heart of the novel's mystery that serves as what Hitchcock famously described as the 'McGuffin'. The empty signifier propelling the plot elements of the narrative, but of little actual consequence in and of itself. The gold coin is delivered late at night to Marlowe in his office by the private courier business, the 'Green Feather Messenger Service,' which precipitates an unexpected plot twist. The unanticipated turn of events follows Marlowe's recent discovery of a dead body in a rooming house in the most quintessential of Los Angeles noir locations, Bunker Hill. The two events, the dead body and the unexpected delivery of the coin, perplexes Marlowe. He contemplates their meaning and consequences then decides to arm himself with his Colt .38 automatic. As he prepares to leave his office, the phone begins to ring.

The ringing bell had a sinister sound, for no reason of itself, but because of the ears to which it rang. I stood there braced and tense, lips tightly drawn back in a half grin. Beyond the closed window the neon lights glowed. The dead air didn't move. Outside the corridor was still. The bell rang in the darkness, steady and strong. I went back and leaned on the desk and answered. There was a click and a droning sound on the wire and beyond that nothing. I depressed the connexion and stood there in the dark, leaning over, holding the phone with one hand and holding the flat riser on the pedestal down with the other. I didn't know what I was waiting for. The phone rang again, I made a sound in my throat and put it to my ear again, not saying anything at all. So we were there silent, both of us, miles apart maybe, each one holding a telephone and breathing and listening and hearing nothing, not even the breathing. Then after what seemed like a very long time there was the quiet remote whisper of a voice saying dimly, without any tone: 'Too bad for you, Marlowe.'

(Chandler, 1977, p. 181)

Modern communications technology has collapsed all spatial distance in this portentous moment. Inexplicable and eerie, the anonymous disembodied voice is a stark reminder that the interconnections brought about by the modern world make it feel like anyone can be 'got to' at any time and any place. The pervading sense of unease that accompanies this realization with its ominous overtones threatens to destabilize some of the core American belief systems around freedom, privacy, and liberty. The sense of exposure under this reach of technology may account for leitmotifs in hard-boiled fiction and film noir centered on hidden and false identities as one means of combatting this newfound vulnerability.

Detecting the City

Despite the fact that Chandler's writing was admired by British literary establishment figures like W.H. Auden and Evelyn Waugh, the pulp fiction status of detective and mystery writing meant he was consigned to low-brow critical reception. Even for renowned literary critic Fredric Jameson, who has conducted some of the most carefully delineated analysis of Chandler's work, he describes Chandler as a writer who was, 'not a builder of those large-scale models of the American experience which great literature offers, but rather in fragmentary pictures settings and place, fragmentary perceptions which are by some formal paradox somehow inaccessible to serious literature' (Jameson, 2016, p. 3). Over the course of seven novels, Chandler's Los Angeles was built up from these 'fragments' like the residue of a broader American modernity: seedy motels, diners, squalid apartments, and often the uncanny spaces of foyers and offices. Chandler's style was to describe these environments and their features through a surfeit of detail beyond any scale required for conventional detective stories. Reflecting the fragments of a generalized American modernity, they nevertheless derived from the particular spatiotemporal landscape of midcentury Los Angeles.

The languid poetics of Chandler's tone and style combine with the detached perspective of Marlowe to provide a running commentary on Los Angeles and its particular urbanism in the middle decades of the twentieth century. The city becomes omnipresent through details of locale that permeate the narrative as Marlowe journeys across its vast spaces that convey an existential emptiness. As a product of the twentieth century, Marlowe supplies a mobile optic for interpreting the new urbanism of Los Angeles. Comparisons between the nineteenth century detective and twentieth century detective have emphasized how the latter is an everyman, attenuated to the mobility demanded by the modern metropolis, while often overwhelmed by the scale of its corruption.

As a nineteenth-century private detective, Sherlock Holmes embodies the scientific rationalism inherited from the Enlightenment, a supreme manifestation of calculated deduction and logic-based reasoning first

developed in Edgar Allan Poe's detective, Auguste Dupin, and who was governed by a 'super rationality' (Porter, 1981). Dupin and Holmes embody nineteenth century detection methods that were predictive of modern forensics with evidence-based methodologies that exposed clues down to a microscopic scale, processes that have culminated in contemporary DNA exactitudes. In contrast, Philip Marlowe personifies forms of bodily action over intellect, as well as remaining independent from the State and the organs of its official apparatus to which he is often in violent opposition. Marlowe represents a half-educated average citizen, someone who is governed by 'hunches,' intuition, and observing human nature, rather than employing any kind of scientific deduction. As a figure of midcentury modernity associated with city streets, he evokes de Certeau's everyman, the 'common hero, a ubiquitous character, walking in countless thousands on the streets' (de Certeau & Rendall, 1984, p. v). In this sense, Marlowe's cynicism belies a level of exhaustion and fatigue personifying the displaced energies left over from the relentless march of progress under midcentury modernity and its sundry deficits.

As a Los Angeles private detective, Marlowe's mobility is key. The capacity to traverse the physical terrain of the city underscores his ability to gain access to the competing social hierarchies of the city. From the public space of the street to the restricted mansions of the city's ruling class, a mainstay behind the popular appeal of the detective story is enabling readers to journey in and around the spatial dimensions of the modern city. The constant traveling complements the essential first-person narration that ensures Marlowe's perspective firmly delimits the readers' awareness and knowledge of unfolding events. Narrative progression is propelled through a series of external physical journeys that exposes characters to Marlowe and whose inner conflicts must be deciphered before he can reveal the causal forces beneath the mystery he is investigating.

Prefiguring the detective in relationship to the modern city was the flaneur, that essentially urban character adapted to late nineteenth-century and early twentieth-century metropolitan space theorized by Benjamin et al. An ideal of the flaneur was to remain detached from the urban environment orchestrated as an endless spectacle catering to the male gaze. In the twentieth century, in contrast to the flaneur, the detective is a figure who has become immersed in their urban environment and whose gaze has to compete amid the altered spatial relations of high modernity. While they strive to maintain a level of objectivity, pursuing their subjects through various modes of surveillance, their proximity means they end up engaging in physical interactions that can span from forceful and violent to sexual. Inevitably, the detective's propinquity to their clients and the cast of characters involved in their cases leads to all manner of compromises and conflicts. Detectives can effectively be seen to traverse the spectrum of urban engagement outlined by Simmel, as they maneuver

between states premised on urban induced, metropolitan blasé-ness to the more personalized modes of contact evocative of small-town exchanges. These interactions are born of intuition and feelings through their familiarity and immersion in criminal milieus and the corruption surrounding law enforcement fostered by the modern city.

Marlowe's physical journeys enable Chandler to capture and describe locales in a taxonomy of the city's private and public domains, along with its intermediary spaces. Through direct and indirect observations, Los Angeles the city assumes a level of omnipresence through Chandler's carefully observed details of quotidian life that render the city in multiple contexts. More than simply a physical container or backdrop for the plot and narrative, Los Angeles operates dramaturgically in Chandler. From its climate to its lighting, Los Angeles bathes Chandler's characters in its simulated environment, helping to construct them in ambiguous and untrustworthy terms. When Dolores Gonzales gets inside Marlowe's car in *The Little Sister*: 'The light from the drugstore caught her face. She had changed her clothes again, but it was still all black, save for a flame colored shirt. Slacks and a kind of loose coat like a man's leisure jacket.' The mixed gendering and ambiguous signals emitted by her wardrobe are compounded by the artificial light catching her face. In *The High Window*, space itself is obliterated by signs and lighting when Marlowe journeys to the Idle Valley Club:

> It had a roofed porch and a floodlighted sign on it read: *Idle Valley Patrol*. Open gates were folded back on the shoulders of the road, in the middle of which a square white sign standing on its point said STOP in letters sprinkled with reflector buttons. Another floodlight blistered the space of road in front of the sign.
>
> (Chandler, 1977, p. 196)

Chandler conveys how the profligate signs and artificial lighting heighten the sense of absence in Los Angeles' built environment. From the iconic 'Hollywood' sign to endless vistas of neon advertising, signs and simulations emphasize the city as having been displaced by the image. James Ellroy has followed this theme of an urbanism characterized by absence in the title of one of his L.A. Quartet novels set between the 1940s and 1950s – *The Big Nowhere*. As the site of potently imagined dimensions, Los Angeles provides Chandler with a meta-language for something barely discernible emerging out of modernity. A liminal space of the urban as unbridled system, that which remains immaterial, a hazy outline pulsating through the flow of symbolic imagery.

Sprawling Slumber

Los Angeles as the site of erasure with nature and its built environment continuously laid over in the manner of a palimpsest, is captured in

Chandler's 1939 novel, *The Big Sleep*. Conveying the historical contradictions of modernity as it transformed Los Angeles into a boom city, the distinctive urbanism of Los Angeles suffuses Chandler's debut novel. In *The Big Sleep*, remnants of the city's natural idyll are in retreat against an encroaching modernity, with crime and corruption flourishing unchallenged across the growing city. Chandler depicts the rapidly expanding built environment and the remaining natural spaces that at the time of his writing still punctuated the city's diverse topography. From the Hollywood Hills to the canyons of the Valley and out to the coastal region of Santa Monica, dubbed Bay City, Chandler catalogues the city's spatial organization through layers of class and a steady arrival of neighborhoods against an ever-receding nature.

When Marlowe is leaving the manicured grounds of the Sternwood manor, the vestiges of elemental nature is only visible through looming weather, 'Thunder was crackling in the foothills now and the sky above them was purple-black. It was going to rain hard.' Beneath the foreboding sky, Marlowe's observes how the landscape surrounding the mansion bears the distant physical and temporal reminders of what literally lies beneath the Sternwood's wealth.

> Beyond the fence the hill sloped for several miles. On this lower level faint and far off I could just barely see some of the old wooden derricks of the oilfield from which the Sternwoods had made their money. Most of the field was public park now, cleaned up and donated to the city by General Sternwood. But a little of it was still producing in groups of wells pumping five or six barrels a day.
>
> (Chandler, 1977, p. 22)

General Sternwood's donated public land and private cultivated space testify to the city's rapid development over the space of just a few decades. In contrast, the oil beneath the surface is the product of millions of years of geological time. The natural processes resulting in oil produced over an inconceivable temporal expanse have, within a single generation under modernity, been transformed into the central commodity driving boomtown Los Angeles and the industry that literally fuels the modern age. In rapid succession, the primary basis of the oil industry has vanished in the Sternwood Estate, concealed beneath the respectable surfaces of a bourgeoisie garden. Fading into the distance, however, Marlowe can just discern the residual trace of the city's industrial past in the form of a small group of wooden oil derricks. In this respectable corner of the city, Chandler illustrates how land has gone from nature and a primary resource, to commodity extraction through secondary industry, and finally into the tertiary simulacra of landed gentry. Chandler's description of the Sternwood estate presents the reader with a spatial vista, but like a cinematic time lapse, it also records the pace of change irrevocably transforming twentieth-century Los Angeles.

A similar lens is applied to reveal the past, present, and future of Los Angeles when Marlowe makes his way to Eddie Mars's gambling establishment on the city's coastal fringe. Under a shrinking moon, beach fog and twisted trees envelop the decaying gothic structure that houses an illegal casino. As a structure, it has gone from private mansion summer house to commercial hotel, descending into illicit gambling den over the course of just a few decades. In addition to having been ravaged by processes of nature, various social markers have recorded its dwindling status as it spiralled downwards through an architectural class structure with its final resting place in the criminal netherworld.

> I got down there about nine, under a hard high October moon that lost itself in the top layers of a beach fog. The Cypress Club was at the far end of the town, a rambling frame mansion that had once been the summer residence of a rich man named De Cazens, and later had been a hotel. It was now a big dark outwardly shabby place in a thick grove of wind-twisted Monterey cypresses, which gave it its name. It had enormous scrolled porches, turrets all over the place, stained-glass trims around the big windows, big empty stables at the back, a general air of nostalgic decay. Eddie Mars had left the outside much as he had found it, instead of making it over to look like an MGM set.
>
> (*Chandler*, 1977, p. 78)

Eddie Mars's gambling house is located in the fictional locale of Los Olindas, suggestive of Venice or Manhattan Beach, areas that were once conducive to Victorian architectural folly. Nineteenth century remains are frozen in the old building's 'scrolled porches,' 'turrets,' 'stained-glass trims,' 'big windows,' and 'big empty stables at the back.' Brooding with a 'general air of nostalgic decay,' it resonates like an architectural equivalent to Miss Havisham in *Great Expectations*. The decaying structure underscores the residual Victorian values in General Sternwood's opening comment to Marlowe, 'If I sound a little sinister as a parent, Mr. Marlowe, it is because my hold on life is too slight to include any Victorian hypocrisy' (Chandler, 1977, p. 18). The ravages of time on the seaside gambling house reveal how cultural leftovers from the nineteenth century permeate twentieth-century Los Angeles despite the ferocity and pace of the city's development. The house in its contemporary setting, although repurposed several times over, is an incongruous rubble of Victoriana resisting final evisceration though a makeover to 'look like an MGM set.' Delayed in its final liquidation in the wake of the Depression, premodern architecture in this part of Los Angeles sits in limbo. Beyond any notion of heritage, its fate is to suffer continued incursions from nature, or subsumed by what Chandler presciently anticipated as Hollywood-style simulacra.

The temporal ravages occurring throughout *The Big Sleep* reveal the distinctive qualities of historical change in Los Angeles under modernity. Chandler provides formal representation to the historical qualities highlighted by Georg Simmel and the modern metropolis functioning as a site of possibility for reconciling the residual social tensions left over from the nineteenth century. Like Simmel, the philosopher, Ernst Bloch interpreted the temporal relations of the present caught up in the tensions produced by the past and its unrealized emancipatory potential. He described the dialectics produced by the latency of the past against the tendencies of the present as 'non-synchronous' historical currents. The forces of change, whether nonsynchronous, emergent, latent, or dominant, leave traces across cultural artifacts from specific historical periods. Simmel, in particular, understood the modern metropolis as the key site where these sociohistorical tensions would play out. Chandler's account of Los Angeles conveys how competing phenomena from rapid change manifested in the city's architecture, suburbs, and boulevards in the middle of the twentieth century. Chandler's writing records urban processes so profligate in the built environment of Los Angeles that by the time he wrote his fifth novel, *The Little Sister* in 1949, the city he had described in *The Big Sleep*, just ten years prior in 1939, was also vanishing. As Marlowe reminisces in *The Little Sister*,

> I used to like this town. A long time ago, there were trees along Wilshire Boulevard. Beverly Hills was a country town. Westwood was bare hills and lots offering at eleven hundred dollars and no takers. Hollywood was a bunch of frame houses on the inter-urban line. Los Angeles was just a big dry sunny place with ugly homes and no style, but goodhearted and peaceful. . . . Little groups who thought they were intellectual used to call it the Athens of America. It wasn't that, but it wasn't a neon-lighted slum either.
> (Chandler, 1949, p. 150)

In *The Little Sister*, the impacts on Los Angeles from Hollywood and the city's profligate neon lighting are indicative of how the substance of the city continues to be overridden by its simulations. Through Marlowe's sensory impressions, Chandler presents Los Angeles as a place reduced to sights and smells that create the feeling of being enclosed, deceived, and seduced.

> I smelled Los Angeles before I got to it. It smelled stale and old like a living room that had been closed too long. But the colored lights fooled you. The lights were wonderful. There ought to be a monument to the man who invented neon lights. Fifteen stories high, solid marble. There's a boy who really made something out of nothing.
> (Chandler, 1949, p. 68)

For Chandler, a unique conundrum was posed by Los Angeles' hosting of Hollywood, which he portrays in *The Little Sister* as the means for hollowing out the city, and served as a poor substitute for the substance of other American cities. 'Real cities have something else, some individual bony structure under the muck. Los Angeles has Hollywood and hates it. It ought to consider itself damn lucky. Without Hollywood it would be a mail-order city. Everything in the catalogue you could better somewhere else' (Chandler, 1949, p. 26). A double-edged sword, Chandler articulated the sense that Hollywood and its celluloid cities were overshadowing the real Los Angeles, something that persisted until film noir discovered the actual city lurking behind the studio backlots.

Noir Recuperation: History and a Dark Heritage

Raymond Chandler, and the wider corpus of hard-boiled detective fiction, provide ways of reading and experiencing Los Angeles that transcend the constraints imposed by conventional history. Detective fiction has recorded the city's vanished sites and forgotten places, and Chandler's writing, in particular, communicates a phenomenological sense of the era through relaying the period's structure of feeling. Chandler's unique literary style and tone combines with the intricately observed spatial characteristics of midcentury Los Angeles while the first-person perspective enhances the sense of subjective, lived experience.

As outlined above, psychogeography offers valuable insights on how certain texts become embedded in certain places that can then go on to imbue those places in very tangible and experiential ways. These imaginary blendings combine into highly personalized urban associations that Debord sought to understand in terms of psychogeographical encounters: imaginary collisions with actual cities and their textual histories that exert rich and enduring meanings that also confront us with the potency of Lefebvre's representational cityspace. As urban history and place become personalized through psychogeographical encounters, the imaginary city and actual urban space intersect as customized quotidian urban experience. Catalyzed by imaginary texts, urban space thus begins to assume forms of personal heritage.

Hard-boiled detective fiction is integral to the psychogeography of Los Angeles and continues to be instrumental in the historicization of the city, as evidenced by the veritable industry that has developed around Chandler and pulp fiction: from heritage trails designating plaques on buildings that identify the location of fictional events and offices of Philip Marlowe, to fan publications, blogs, and tours of entire districts across Los Angeles. Endowed with a unique heritage premised on the hard-boiled imaginary, Raymond Chandler is afforded a privileged position in the evocation of Los Angeles' lost past. Amplified by cinema and classical film noir, the psychogeographical affect from his writing on the

city is customarily described as *Chandleresque*, and it continues to resonate across the real and imaginary surfaces of Los Angeles and its built environment. Chandler provides the foundations of what has become widely known as Los Angeles noir. As James Narmore observes in his appropriately titled analysis, *Film Noir in Its Contexts*, 'To the informed tourist . . . real places in Los Angeles . . . seem bathed in the aura of noir, the Alto Nido residence hotel at Franklin and Ivar, just up the street from where Nathaniel West wrote *Day of the Locust*; the Bradbury Building . . . most of all, the Glendale train station at night.' (Naremore, 1998, p. 2). Similarly, John Calwetti in discussing *Chinatown*, describes film noir as infusing Southern California with a certain 'aura' (Calwetti, 2012, p. 280).

In the 1970s, and again in the 1990s, psychogeography was revived among urban theorists as the means for describing these kinds of alternative urban histories, narratives, and sites of meaning that can produce affect among informed individual urban dwellers and visitors. In European cities that have a heritage derived from the gradual accretion of history and culture, the urban psychogeography and cultural identity of cities predominantly revolves around literature, poetry, painting, sculpture, and classical forms of architecture – forms of representation that predate the twentieth century that have recorded the many periods and transformations experienced by the European capitals. American cities on the other hand and Los Angeles in particular attained the level of metropolis in the twentieth century. Coinciding with cinema and the mass circulation of popular culture, their psychogeography means a bedrock and substrata of their urban identity is comprised from: cinema, images, and media composed from popular culture and its many pulp genres.

If noir and hard-boiled fiction instills Los Angeles with some kind of tangible noir aura, then it seems clear this is the result of the kind of affect that is better described by the processes of psychogeography. Beginning with the central role played by Raymond Chandler and his writing, textual histories and associations bind hard-boiled detective fiction and film noir to Los Angeles in ways that are highly affect-laden and derive from its noir heritage. Expanding on Los Angeles' past through the city's noir heritage reveals noir's recuperation of its urban history. Through online true crime sites, revival film festivals, and traditional print publishing, Los Angeles and noir is the constant subject of populist social histories exemplified by publications such as Jim Heimann's *Dark City: The Real Los Angeles Noir* (2018) and *Sins of the City: The Real Los Angeles Noir* (1999), and Sean Tejaratchi's *Death Scenes: A Homicide Detective's Scrapbook* (1996). Additionally, in the online era, countless websites recount details and locations of true crime cases across Los Angeles, often adopting a tone and perspective inherited from hard-boiled detective fiction and film noir. Pulp detective fiction and film noir protrudes from the city's built environment in ways that are highly discernible to noir

fans, aficionados, enthusiasts, and scholars alike. A noir psychogeography continues to offer noninstitutional ways of reading Los Angeles that not only augment official histories of Los Angeles, but also cross over and extend it.

In much the same way Dickens is a cornerstone to certain literary genres and histories that combine to provide the cultural contours of London, Chandler's writing has long formed a core sedimentary layer in the noirscape of Los Angeles. Chandler's Los Angeles derives from the third and fourth functions of psychogeography: 'the ambiences generated by particular locales' and the 'process of cognitive mapping,' and how individuals construct and assign particular meanings to specific places (Baker, 2013).

Produced fifteen years after Chandler's death, the inspiration behind Polanski's *Chinatown* (1974) stands as testament to how the urban ambiences and processes of cognitive mapping affect both producers and consumers of creative content. Screenwriter Robert Towne, has explained how he conceived the screenplay for *Chinatown* against a backdrop of tumultuous change and rapid development across Los Angeles in the 1970s. In other accounts, Towne also reveals how a key motivation behind his screenplay can be traced to a chance encounter with a *Los Angeles Times* article he describes as, 'Raymond Chandler's Los Angeles' (Towne interview in DVD extras, Evans, Polanski, & Towne, *Chinatown*, 2007). The *Los Angeles Times* article was accompanied by circa-1970s photographs of the places and settings featured in Chandler's stories. For Towne, the Chandler article highlighted how, 'it would still be possible to create the Los Angeles of that period.' But the opportunity to cinematically reconstruct this vital era in the city's history was, in Towne's opinion, only available for a limited time before the city's rapid expansion and development would erase its quintessential noir locales (Towne, *Chinatown*, 2007). Towne's account of how he conceived *Chinatown* highlights a very distinct kind of residual presence left over from film noir and the structure of feeling conveyed in the work of Raymond Chandler. The screenplay of *Chinatown* creatively engages the residual traces that no doubt motivated the original authors of the newspaper article to retrace the historical Los Angeles of Raymond Chandler – resonances pulsating across the city in the 1970s that alerted Towne to the psychogeographical dimensions of the city.

In the wake of *Chinatown* and 34 years after Towne encountered the Chandler article, a veritable industry has grown up reconstructing Chandler's Los Angeles, providing the basis of various forms of experiential tourism in which *Chinatown* itself now plays a central role. As well as standing in for official Los Angeles history on a recurring basis, *Chinatown* elicits all four functions of psychogeography: the emotional effects generated by environment; the behavioral effects generated by environment; the ambiences generated by particular locales; and processes of

cognitive mapping. As an IMDb user review reveals, the cognitive mapping individuals can perform across the city in response to *Chinatown* and the affect it can produce can be considerable.

> I saw this movie first in Chicago and heck, back then I knew nothing about LA, though I've since moved to and lived in the area for years. Once relocated, I quickly discovered the historically interesting side to the story and then appreciated the movie from yet another compelling angle. . . . Geez, I'll never forget that first confrontational scene at the Albacore Club! The study in absolute raw and evil power as masterly portrayed by John Huston. In the very same scene Jack Nicholson skilfully [sic] paints the subtleties of his cautious, cynical, small-time hustler character. The air crackles! I must have played this scene in my mind a thousand times. When I visited Catalina Island for the first time in about 1985, not knowing its significance to the movie, I walked by the Albacore Club (The Tuna Club in real life) and froze transfixed. I recognized it instantly of course, and I must have stood there gawking for 20 minutes not saying a word. I could literally HEAR the *Chinatown* theme – the memories were that clear and fresh!
>
> (Author: <u>attitudeadjustment</u> from Orange County, California)[2]

The IMDb user review clearly demonstrates the impact generated by the third and fourth functions of psychogeography, one that extends into memory, sensation and affect, revealing a phenomenological interpretation of place and history. Alongside Towne's account of how *Chinatown* was conceived, the bloggers account testifies to how psychogeographical dimensions of a place informs consumers of texts as much as their creators. Psychogeographical understandings of place reveal how texts can be understood as the means to forge highly individual relationships between place and history, amounting to something that transcends generalized tourist consumption. Through psychogeography, the interpretation and experience of place takes on highly personal and idiosyncratic dimensions, experiences that can run counter to formal and abstract histories as well as tourist cliché. As Baker outlines,

> It is also more fully psychogeographical if there is a sense that history affects ambience, and that the character of a place inheres and affects feelings and behaviour, or if it challenges the mainstream contemporary reading of a place. In that sense it can be an alienated and recalcitrant form of history, and one that resists being recuperated into 'heritage.'
>
> (Kerr, J., & Gibson, A., 2013, p. 280)

The notion of *Chandleresque Los Angeles* and the city's noir 'aura' signifies how official and unofficial histories of the city have been informed by

hard-boiled fiction and film noir. As they jostle alongside official history, the heritage from noir assigns meaning to locales across Los Angeles, contributing to what Rabinowitz has described as the 'pulp narratives,' of modernity. Forming layers of meaning across the physical as well as cultural topography of the Los Angeles basin, these pulp narratives provide the 'recalcitrant history' of psychogeography. Detective fiction, and subsequently film noir, provide Los Angeles with a form of psychogeography that communicates a sense of the city's quintessential 'pastness,' an experiential form of history resonating more along the lines of subjective memory than the abstract approximations of formal historicization. Chandler assumes a privileged position among the alternative historical discourses elicited by psychogeography because his fiction is able to convey the arresting power contained in Williams's structures of feeling. Chandler's hard-boiled style is instrumental in this sense, dispensing the tone of the period and nuances from its everyday through the 'solution' distilled in his fiction. Highly vivid descriptions of Los Angeles combine with Chandler's style and tone to produce a precise harmonic of form and content that enables his fiction to deliver one of the most authentic representations of Los Angeles summoned from its immutable past.

Conclusion

Chandler's work has documented the spatial features of midcentury Los Angeles, and now his writings contribute their own spatializing functions. The phenomenology of midcentury Los Angeles can be grasped through Chandler as our sense-based experience of the world is opened by the tonal aesthetics of his writing. Relaying structures of feeling preserved from a generation occupying the specific time and place of midcentury Los Angeles, the psychogeography from Chandler constitutes spatial layers of the city that now extend from the imaginary into the city's physical locales. Chandler, through his written oeuvre as well as the author – the history-bound human being – embodies a period of Los Angeles that serves as a key interlocutor between its imagined past and historical everyday.

The depictions of midcentury Los Angeles in Chandler configure key spatial dimensions of the city that went on to underwrite the essential tonal and stylistic qualities of film noir. Affecting history, memory and lived experience, Chandler's oeuvre operates as a core sediment in the pulp fiction noirscape of Los Angeles, and his work continues to contribute to assorted cultural expansions of Los Angeles through the city's true crime history. In psychogeographical terms, Los Angeles' irretrievable past resonates through Chandler's fiction and provides the essential foundations upon which the noirscapes from film noir would subsequently accumulate.

Notes

1. Retrieved October 2017, from http://library.nothingness.org, Debord, Les Levres, Nues, #6, 1955.
2. http://us.imdb.com/title/tt0071315/ IMDb website 4/29/2008. Retrieved August 19, 2018, www.imdb.com/user/ur3628812/reviews?ref_=tt_urv.

References

Baker, P. (2003, 2013). Secret city: Psychogeography and the end of London. In J. Kerr & A. Gibson (Eds.). (2013), *London from Punk to Blair* (Rev. 2nd ed., pp. 277–291). London: Reaktion Books.

Calwetti, J.G. (2012). Chinatown and generic transformation in American cinema. In B. Grant (Ed.), *Film genre reader IV* (pp. 279–297). Austin, TX: University of Texas Press.

Chandler, R. (1949). *The little sister.* Boston, MA: Houghton Mifflin Harcourt.

Chandler, R. (1977). *Raymond Chandler complete and unabridged: The big sleep, the high window, the lady in the lake, the long goodbye, playback, farewell my lovely.* London: Heinemann/Octopus.

Day, B. (2015). *The world of Raymond Chandler: In his own words.* New York: Vintage Books.

de Certeau, M., & Rendall, S. (1984). *The practice of everyday life.* Berkeley: University of California Press.

Dufrenne, M. (1953, 1973). *The phenomenology of aesthetic experience.* Evanston, IL: Northwestern University Press.

Fulton, W. (2001). *The reluctant metropolis: The politics of urban growth in Los Angeles.* Baltimore: John Hopkins University Press.

Heimann, J. (2018). *Dark city: The real Los Angeles noir.* Cologne: Taschen.

Jameson, F. (2016). *Raymond Chandler: The detections of totality.* London and New York: Verso.

MacShane, F. (1976). *The life of Raymond Chandler.* New York: E.P. Dutton & Co.

Naremore, J. (1998). *More than night: Film noir in its contexts.* Berkeley: University of California Press.

Porter, D. (1981). *The pursuit of crime: Art and ideology in detective fiction.* New Haven: Yale University Press.

Rabinowitz, P. (2002). *Black & white & noir: America's pulp modernism.* New York: Columbia University Press.

Sharma, D., & Tygstrup, F. (2015). *Structures of feeling affectivity and the study of culture.* Berlin and Boston: De Gruyter.

Tejaratchi S. (Ed.). (1996). *Death scenes: A homicide detective's scrapbook.* Portland: Feral House.

Williams, R. (1977). *Marxism and literature.* Oxford: Oxford University Press.

Williams, R., & McGuigan, J. (2014). *Raymond Williams on culture and society: Essential writings.* Los Angeles: Sage.

Part II

Los Angeles – Between the Screen and the Streets

3 City of Silhouettes

You can live a long time in Hollywood and never see the part they use in pictures.

– The Little Sister (1949), Raymond Chandler

Epigraph quoted from Day, 2014, p. 126

Los Angeles and cinema have been bound together during the twentieth century through the physical infrastructure of filmmaking and the city's association with the chimera of all things 'Hollywood.' Despite this close association, as the *'home of Hollywood'* Los Angeles was ironically overshadowed by the celluloid cities manufactured on its studio backlots and soundstages. The representation of Los Angeles onscreen paled in comparison with other cities, especially cinematic iterations of New York, which was the definitive urban setting despite, for the most part, its construction a continent away in Hollywood.

It was not until the 1940s and the advent of film noir that a cinematic form fused with the representation of Los Angeles and its built environment, allowing the city behind the studio backlots to emerge onscreen. In film noir, Los Angeles began appearing regularly in narratives actually set in the city. Aided by the location cinematography essential to film noir, Los Angles was no longer just an anonymous stand-in for other American cities. Like the Superstructure arriving on its industrial base, Los Angeles increasingly provided the urban physiognomy to film noir as its onscreen presence finally materialized.

As the site of uniquely American, industrial-scaled filmmaking, Los Angeles as a physical city, and Hollywood as a production environment, are key historical contexts for the classical cycle of film noir. For more than two decades, film noir captured midcentury Los Angeles like no other comparable form of representation. As hard-boiled detective fiction transferred to cinema through film noir the sociopolitical and economic circumstances shaping Los Angeles informed these cinematic narratives. As the repository of impacts from both textual, industrial, and historical influences, the classical cycle of film noir now provides for a spatiotemporal

mapping of Los Angeles from the 1930s, spanning the Great Depression, through to World War II and the postwar boom.

The representation of Los Angeles during the classical period of film noir stands in stark contrast to the traditional imagery promulgated by booster Los Angeles. Film noir can be traced in terms of providing a counterhistory to those shallow depictions centered on the city's lifestyle that so often saw Los Angeles reduced to emblematic orange groves, palm trees, and beaches. Drawing on the established histories documenting Los Angeles as a nonplace and then 'greedily' constructed as a place of opportunity, the classical cycle of film noir coincides with Los Angeles attaining the scale and size of a metropolis. By the 1930s, Los Angeles had attracted a population exceeding one million and film noir exposed the discrepancies between the dominant image of Los Angeles and the burgeoning realities posed by the Great Depression.

The classical era of film noir captures transformations in Los Angeles' physical environment as it expanded, initially like a centered metropolis and then along patterns of development that anticipated new forms of late twentieth century urbanism. In turn, Los Angeles and its inimitable urban milieu supplied film noir with key tropes and motifs extending the traditions inherited from hard-boiled detective fiction. As a sustained expression of Los Angeles' burgeoning urban form that commenced in the 1930s and lasted more than 20 years, the classical era of film noir redefined Los Angeles through its chiaroscuro representations, forever altering its place in the American and global popular imaginary.

By mining Los Angeles' locations in the service of narrative possibility, the classical cycle of film noir has chronicled key aspects of the city's spatial dimensions, producing a noirscape with distinctly Hollywood components. As the inheritor of hard-boiled and pulp fiction traditions, classical film noir marks the dramatic arrival of Los Angeles onscreen. Exploring the relationship between film noir and Los Angeles by combining textual with traditional historical perspectives, an understanding of the city emerges that takes full account of the role played by film noir in the cinematic urbanism of Los Angeles – specifically, how the cityscape came to endow narrative meaning to fictional situations and settings and how regular representation through its most prominent industry inscribed formless Los Angeles with an enhanced sense of place.

As one of the defining characteristics of film noir, location cinematography recorded the physical characteristics of the modern built environment of many American cities. As a result, more than any other type of filmmaking, film noir has inadvertently provided one of the most valuable archives of urban and interurban spaces of midcentury America. As a metaframe for Los Angeles, Hollywood and filmmaking augment the city with a unique historical narrative. The history of Hollywood and the history of the city's urban development overlap in the city's noir

heritage. By constructing a historiography of Los Angeles through one of its dominant industries – filmmaking, and one of its most sustained optics – film noir, the fandom based notion of *LA Noir*, can be expanded upon and formally configured into the city's historical as well as spatial dimensions. Acknowledging the role of space, means drawing upon Lefebvre's profound insights on spatial experience, which strove to take account of the role that representation, history, temporality, and physical space play in the experience of urban life. Adopting a spatial approach to classical film noir by expanding upon the popular notion of *LA Noir* reveals how cinematic and traditional histories converge to deliver the city's most essential *Noirscape*.

The Eternal Sunshine of the Spotless City

The few urban planning studies conducted on Los Angeles in the first half of the twentieth detailed how it was a city full of contradictions, absences, and deviations from conventional development patterns. In comparison to most other American cities at the turn of the twentieth century, Los Angeles lacked many of the necessary ingredients for sustained urban development. As a city, Los Angeles was traditionally maligned as the *sub* urban *other* to the great nineteen and twentieth century American industrial metropolises of the Northeast and the Eastern seaboard: New York, Chicago, Philadelphia, Cleveland, and Pittsburgh. Los Angeles stood apart from these other cities, mostly because it emerged from a unique set of geographical, political, cultural, and economic tensions that made it, according to the title of Carey McWilliams's milestone study, 'the great exception' (McWilliams, 1949).

In 1900, the City of Los Angeles had a population of just 102,000, but by 1930 this had swelled to 1.2 million, making it the fifth largest city in the United States. The larger County of Los Angeles had a population almost double that of the City of Los Angeles, with 2.2 million, which in 1930 represented close to 39 percent of the total population of California.[1] As American capitalism advanced westward, many of the development conditions affecting Los Angeles at the turn of the twentieth century were the result of a regional dynamics operating more broadly across California. But in 1848, when California was ceded from Mexico to the United States, the ensuing socioeconomic upheavals meant it was in Los Angeles where many of the challenges of frontier expansion were most keenly felt. From 1850 to 1920, the development of Los Angeles was controlled by a cabal of elite business interests, or as Fulton describes it, a 'growth machine,' (Fulton, 2001, p. 8) that orchestrated concerted growth across Los Angeles and Southern California. This influential group of business leaders fervently pursued the progress of Los Angeles following the land boom that occurred when the Southern Pacific rail line joined the Santa Fe rail line in 1886.

Unlike San Francisco, no Gold Rush ever occurred in Southern California, and Los Angeles had to actively promote itself as a city primed for future development. The relentless promotion of Los Angeles, known as boosterism, was fueled by advancements in modern printing, advertising, and marketing processes. This generated abundant publicity designed to attract Midwesterners to Southern California by selling its virtues as a temperate, agricultural Eden. Part of the uniqueness beneath the metropolitan growth of Los Angeles came from an unprecedented form of suburban migration occurring across Southern California. This migratory phenomenon was led by lifestyle, rather than the traditional attractors of industry, employment, or a resource boom. By the twentieth century, these traditional economic drivers would eventually propel Los Angeles' growth, as nascent industries such as aviation and filmmaking were joined by the oil boom that followed Edward Doheny's famous discovery in 1892. But initially, the drawing card to Southern California was premised on acquiring a suburban lifestyle that promised the best of urban and rural living. This image of a relaxed lifestyle in a comfortable, temperate climate had to be sold to Midwesterners, which reduced Los Angeles to sunny beaches, orange groves, and palm trees.

For boosters such as Harrison Gray Otis (editor) and Harry Chandler (owner/publisher) of the *Los Angeles Times*, attracting East Coast capital as well as Midwest migrants was a key priority. Powerful business interests were centered around the Los Angeles Chamber of Commerce, who were committed to their city surpassing San Francisco as the center of East Coast investment. A widespread policy of deregulation across labor, planning, and zoning laws was pursued by the growth barons that Fulton describes as a, 'small group of visionary (and greedy) business leaders'(Fulton, 2001, p. 7). Indeed, no challenge in the task of city-building seemed beyond them, '[l]acking an economy, they invented one' (Fulton, 2001, p. 7). The invented economy was partial to land speculation deals driven by haphazard financing schemes that saw the economic development of Los Angeles, '[emerge] through riotous bouts of speculative excess' (Dymski & Veitch, 1996, p. 35). Over more than forty years, spanning the 1880s to the 1920s, the boosterism rhetoric of the growth barons tirelessly promoted Los Angeles as the 'next big thing' in the narrative of American Manifest Destiny. A 1913 promotional poster for the Los Angeles department store, Arthur Letts, illustrates how pervasive booster rhetoric was in the mercantile fabric of the city.

> Opportunity – thy other name – Los Angeles. . . . With the thousands of acres of available land, adjacent to Los Angeles, yet to be tilled and developed; land, the productiveness of which California alone can boast, providing a livelihood for the thousands of immigrants to come . . . with the increasing investments of the thousands of dollars of

Eastern and foreign capital . . . WHO SHALL GAINSAY THE FACT
THAT LOS ANGELES IS THE VERY WORD OPPORTUNITY!
(Longstreth, 1998, p. 30)

The paradox belying Los Angeles boosterism at the turn of the twentieth
century and masking its proclamations of abundance and opportunity
were the city's many absences. The most visible absence was Los Angeles'
lack of conventional urban density. The sprawling suburbs famous catch
phrase was '*Los Angeles – 72 suburbs in search of a city.*' But it was the
lack of industry, population, and water that compounded fears around the
cessation of Eastern capital flowing into the city and across Southern Cal-
ifornia. As the place where American triumphalism and Westward expan-
sion met its geographical limit, the booster rhetoric of the growth barons
made sure Los Angeles did have one thing in abundance – abstractions.
The abstractions of 'opportunity,' 'promise,' and 'the future' were all
central ingredients in that ultimate abstraction underlining the booster's
claims about Los Angeles and its ability to deliver, 'the American Dream.'
Nowhere were these abstractions more forcibly contained than inside
Los Angeles' burgeoning filmmaking industry – the Dream Factory.

In the Shade of HOLLYWOODLAND

Occupying one of the most prominent sites of an American and global
imaginary, filmmaking and Hollywood are inseparable from Los Angeles –
'*the home of Hollywood.*' The filmmaking capital for most of the twen-
tieth century, Hollywood not only signifies everything to do with 'the
movies' but it functions as a utopian Dream Factory. As a place of excess,
Hollywood is the source of a distinctly American-style mythology capa-
ble of delivering 'overnight' celebrity, wealth, and success. Histories of
Hollywood now abound on how Los Angeles came to house the fledging
movie business in response to the restrictive Edison Trust and Motion
Picture Patents Company (MPCC) based in New York. Film businesses
run by Zukor, Fox, Goldwyn, Lasky, Laemmle, and Mayer, were forced
West not because California had varied landscapes like beaches, deserts,
and snow-capped mountains, but to avoid the monopolistic practices of
the Trust.

Situated on the opposite end of the American continent within proxim-
ity to Mexico, California provided irrefutable benefits for fledgling film
enterprises. The confluence of economic and environmental factors in
the first decade of the twentieth century meant it was not a conventional
industry that arrived in Los Angeles but the beginnings of a new, industri-
ally scaled form of entertainment. In 1903, when the suburb Hollywood
was incorporated as a municipal city, it was home to just 700 residents.
By 1910, as the filmmaking industry continued to grow, the population of
Hollywood soared to 10,000. Requiring access to adequate water supplies

and an established sewer system, Hollywood voted to merge with the City of Los Angeles. Yet filmmaking as an industry was initially perceived as something as insubstantial as Los Angeles itself. Hollywood may not have exactly been what the city's boosters and business elite had been seeking, but whatever it lacked in size and scale was made up for in ambition.

Businesses engaged in cinema entertainment rapidly progressed from fledgling operations into vertically integrated firms controlling production, distribution, and exhibition of films. By the 1920s, from scattered and disreputable beginnings, the movie industry had grown on a scale that exceeded all expectations. In *Celluloid Skyline* (2003), architect and historian James Sanders has recounted the impact that Los Angeles and California had on the established businesses pursuing film production in New York. 'The West Coast's film industry grew explosively in the space of a single decade; no more than a tiny rival to New York in 1911, it accounted for four-fifths of all American production by 1920' (Sanders, 2003, p. 36). As the emerging studios continued to grow, their spatial needs were immense, and the physical footprint of the studios literally filled the vacuum that characterized swathes of Los Angeles in the second decade of the twentieth century.

Despite being referred to as 'Hollywood,' the film studios and industry extended far beyond the actual Los Angeles suburb. Requiring immense infrastructure, film studios were set up across Los Angeles, from Edendale and Glendale to Culver City, and when Warner Bros. moved its operations to Burbank, it stretched into the San Fernando Valley. Each studio required diverse settings from ranches to downtown districts that could be modified easily and constantly reused and repurposed. As Sanders describes them, 'the studios were in fact veritable kingdoms, a hundred acres big or more, entirely self-sufficient and literally walled off from the outside world' (Sanders, 2003, p. 51). The studio complexes went on to comprise an essential part of the city's built environment, and amplified the city's horizontal signature in contrast to the verticality of American cities like New York and Chicago.

Film studios with their sets and backlots are a defining feature of Los Angeles. In the urban planning study, *The Emergence of Los Angeles*, author B. Marchand opens his analysis with a 1926 aerial photograph of the Pickford-Fairbanks Studio on Santa Monica Boulevard, featuring sets for *Ali Baba and the Forty Thieves*. The indistinct separation between the city streets and backlot prompted the urban planner to remark, 'Where is the limit between stage and city?' (Marchand, 1986, p. iv). As a home-grown Los Angeles industry, in his 1949 novel *The Little Sister*, Raymond Chandler observed how Hollywood provided Los Angeles with a unique but underappreciated infrastructure.

Real Cities have something else, some individual bony structure under the muck. Los Angeles has Hollywood – and hates it. It ought

to consider itself damn lucky. Without Hollywood it would be a mail-order city. Everything in the catalogue you could get better somewhere else.

(Chandler, 1949, p. 151)

Chandler's observation reinforces that despite providing Los Angeles with one of its largest sources of employment, the film industry was perceived as either deficient, or from the perspective of the Downtown business establishment, problematic.

From its earliest days, the film industry fueled a mercantile rivalry that had developed between the Hollywood Chamber of Commerce and the Los Angeles City Chamber of Commerce downtown. The promotional capabilities of the growing studios provided the Hollywood Chamber with its biggest weapon in the battle for development and investment against downtown Los Angeles. According to Richard Longstreth and his expansive study on the retail history of Los Angeles, 'Hollywood functioned much like a metropolitan centre in miniature, with an array of mutually reinforcing commercial activities' (Longstreth, 1998, p. 94). In 1927, a three-day publicity event organized by the Hollywood Chamber of Commerce united the film industry with Hollywood's retail trades for the Christmas season. Inaugurating the event was Paramount Studios star, Mary Pickford, who with the flick of a master switch, illuminated the shops on Hollywood Boulevard, declaring:

Much of the outside world is more prone to order things from Hollywood than the average resident of the town. We have . . . the means of setting fashions throughout the world. Many of the best people here realize this.

(Longstreth, 1998, p. 95)

The disparities between the Hollywood Dream Factory and the banal background of Los Angeles were epitomized by the actual studios and their backlots. As the rivalry between the Hollywood and Los Angeles Chambers of Commerce suggest, up until the 1930s it was all things Hollywood that had captured the American and global imagination, rather than Los Angeles itself. As image factories, the studio backlots and facades specialized in the constant manufacturing of other *real* cities from as far afield as Casablanca to New York. The largest and ultimate American metropolis, New York, contained what the Hollywood Studios considered to be the essential ingredients for urban narratives. The drama borne out of New York's teeming masses was denoted by its iconic skyline of soaring skyscrapers that signified density and urban sophistication. Despite the fact that celluloid New York was mostly built on the backlots and soundstages of Los Angeles, New York onscreen portrayed the ultimate, cosmopolitan metropolis.

Since the days of silent cinema, early films shot in Los Angeles were characterized by anonymous settings that could stand in for 'anywhere USA, while New York always represented a highly distinct and exceptional American setting.' In Charlie Chaplin's, *The Immigrant* (1917), when the Tramp satirizes American customs officials, the iconography supplied by Ellis Island and the Statue of Liberty in the mise-en-scène anchors these narratives in the symbolism of New York as much as the physical city itself. In Chaplin's film, the New World *is* New York, the place that confronted migrants with their greatest hopes and darkest fears. A Promethean city of soaring verticality, it was unlike anything these new arrivals had ever seen before. New York as the New World was also more than a physical place, when it came to cinema, it was also the future. According to the apocryphal story of the origins of *Metropolis* (Lang, 1927), when Fritz Lang caught sight of the New York skyline from the deck of a ship he was able to instantaneously envisage his German Expressionist nightmare.

With the advent of sound cinema, most Hollywood studio writers had been lured from New York. Employed for the dialogue-writing abilities they had crafted during their previous careers on Broadway, writers were transplanted to Los Angeles and forever looked longingly back East towards the 'real' city of New York. Fashioning scripts out of an idealized New York, Sanders (2003) credits these artists and writers with creating celluloid New York, a fantasy Manhattan brimming with urban sophistication and a place against which Los Angeles could never compete. Equipping the number of films set in this 'real metropolis' required every major studio in Los Angeles to maintain a permanent New York street set on its backlot, and Hollywood soundstages were regularly devoted to recreating the interior spaces of New York apartments featured in every genre from musicals and dramas to screwball comedies and detective thrillers (Schleier, 2009).

Until the 1930s, the representation of Los Angeles onscreen was overshadowed by Hollywood's imagined cities like celluloid New York. Eclipsed by its own filmmaking industry, Pauline Kael noted, 'Los Angeles itself has never recovered from the inferiority complex that its movies nourished' (Sanders, 2003, p. 59). According to German geographer Anton Wagner, the built environment of Los Angeles actually appeared to take its cue from the imagined architecture of Hollywood. Walking the actual streets of Los Angeles between August 1932 and February 1933, Wagner compiled an extensive photographic record of the city for his PhD thesis, *Los Angeles: The Development, Life and Form of the Southern Californian Metropolis*. Wagner argued the principles of movie set design had been transplanted into the 'façade landscapes' of Los Angeles. The notion of facades, as opposed to a built environment accreted through historical periods, echoes the parade of commentators who have regularly dismissed the suburban form of Los Angeles. The pejorative view with which these

assessments and observations are regularly cast against Los Angeles is indicative of how its built environment and sense of itself as a city was hampered by its preeminent industry.

By hosting Hollywood and providing acreage to vast studio complexes and their backlots, the development of Los Angeles coincided with it becoming cinema's ultimate staging ground. If real cities have 'bones,' then Los Angeles has signs. The city's global icon is the literal and material sign perched high above the city on Mount Lee in the Santa Monica Mountains. Constructed in 1923 the sign, HOLLYWOODLAND was built to promote a real estate subdivision in the Hollywood Hills. Falling into disrepair, it was reduced to HOLLYWOOD in 1949 when responsibility for its upkeep was taken up by the City of Los Angeles. Suspended above the growing city, it was not long before it ceased denoting a single locale and instead came to connote the entire American film industry. Able to construct elaborate settings that could stand in for those other real metropolises from New York, London, Paris, and Berlin to the exotica of Casablanca or Rio de Janeiro, Hollywood positioned Los Angeles as its blank screen, as a place that reified other 'real' cities for cinema audiences around the world, that is, any place except itself. Until the 1930s, through the preeminence of its filmmaking industry, Los Angeles was functioning as cinema's lumpen Base and barely visible beneath the shimmering Superstructure of Hollywood.

Blistering Shadows

Boosterism may have presented Los Angeles as the next big thing in American exceptionalism, but the hype of the growth machine surrounding Los Angeles and Southern California could do little to stave off the effects from the global depressions of the 1890s and 1930s. The lack of a manufacturing base in the local economy of Los Angeles made it vulnerable to external shocks and economic downturns. The situation persisted until 1931 when, despite becoming the fifth largest city in the United States, Los Angeles ranked only thirteenth in terms of the percentage of population employed in manufacturing. With a large proportion of its fledgling economy built on service industries, consumption, and speculative business such as real estate, the risky nature of its economy meant Los Angeles produced the nation's highest rate of bankruptcy from 1931 to 1933, with fraud during this period totaling $200 million (Clark, 1981, p. 24). The speculative basis of so much of the Los Angeles economy saw the privations of the 1930s reverberate throughout the city's growing population, exacting a toll on recent arrivals and established residents alike. According to historian, Kevin Starr,

> [D]owntown Los Angeles was where the Depression became most visible and where relief efforts were concentrated. In contrast to San

Francisco, Los Angeles was hit harder and more openly by the bad times. . . . The unemployment problem came up as an agenda item before the Los Angeles City Council on 297 separate occasions in 1931. By 1933 Los Angeles had become one of the most depressed cities in the country. Downtown teemed with shabby men selling pencils and apples, panhandling, or washing automobile windshields at stoplights, hoping for tips. In the mid-1930s the relief load in Los Angeles County was multiplied by ten in three years, a combination of locals going broke and the influx of impoverished transients.

(Starr, 1997, p. 165)

In the lead-up to the Wall Street crash of 1929 and the Great Depression that followed, Los Angeles experienced a perfect storm from social and economic problems. Rising unemployment, crime and corruption, and a growing homeless population exposed the city to the harsh realities accompanying the national economic slowdown. From 1927 to 1928, the LAPD made over 12,000 arrests under the charge, 'Vagabond-Idle.' As the journalist, Ernest Hopkins described it, 'being out of work, in that favoured city, is against the law' (Hopkins, 1931, p. 84). By 1931 the Municipal Service for Homeless Men processed forty thousand transients. Strict vagrancy laws were enforced behind its provision of one week's accommodation that was supplied with meals, a cash grant, and ticket to leave town (Starr, 1997, p. 166). By 1936, these measures were further escalated in order to stem the tide of the internal migration compounded by the infamous Dust Bowl. The plight of 'Okies' as they became known, and migrant agricultural workers more generally, was famously chronicled by writer and Californian native John Steinbeck's *Of Mice and Men* (1937) and *The Grapes of Wrath* (1939). In response to this wave of internal migration, Los Angeles and jurisdictions throughout Southern California implemented what became known as the 'bum blockade.' Deployed at various border roads, Los Angeles police turned back the families fleeing drought, bankruptcy, and poverty to seek a new life in California.

In contrast to the promises it had previously dangled, by the 1930s, Los Angeles was reeling from the effects of the Depression. As Starr recounts, the Depression had transformed parts of downtown Los Angeles into, 'a Hogarthian scene of human misery' (Starr, 1997, p. 166). These scenes were a dramatic departure from the ubiquitous postcard images of Los Angeles as the land of plenty. Pedaled by the city's boosters, these images persisted in promoting Californian tourism and encouraged the escapism produced and symbolized by Hollywood. Nevertheless, the irrefutable economic realities of the Depression were filtering through into political change. At the State level, in the 1934 California gubernatorial election, Democrat and avowed socialist Upton Sinclair, ran for office on a campaign platform titled, EPIC (End Poverty in California). Although

Sinclair ended up losing to Republican Frank Merriam, the policies outlined by EPIC carried over to federal policymaking by influencing the national New Deal program presided over by President Franklin D. Roosevelt. Sinclair's clarion call addressing poverty could not have been more discordant with the utopian image of Los Angeles as the land of opportunity.

EPIC was an uncharacteristically sober reality check on the hyperbole of opportunity associated with the Golden State. Further political disruptions from the Depression occurred in 1933 when the Republican Mayor of Los Angeles, John Porter, was defeated in his bid for a second term by former County Supervisor and Democrat, Frank Shaw. Ironically, Porter's defeat only fueled the level of corruption in Los Angeles, which had been growing since the beginning of Prohibition. Although revelations of civic dishonesty were commonplace since 1909 when Mayor Arthur C. Harper was forced to resign, the 1930s witnessed an unprecedented level of systemic malfeasance and violence in Los Angeles. Under Mayor Frank Shaw's watch, civic and private fraud grew as corruption flourished unchecked across public officials and the police. Famously, Raymond Chandler quipped that municipal government in Los Angeles was so corrupt that, 'it could be bought by the hour' (Siegel, 1997, p. 125).

The scale of corruption across Los Angeles was revealed when prominent cafeteria businessman, Clifford Clinton undertook a high profile anticorruption campaign. Clinton's mission uncovered the seamy underbelly of Los Angeles, rife with gambling dens, clip joints, and prostitution, all operating under the protection of city police on the take. As historian Kevin Starr recounts, organized crime syndicates were run by Guy McAfee, one-time head of the LAPD Vice Squad, and Bob Gans, the chief concessionaire of slot machines across the city.

> Obviously, a number of police were on the take for so many operations – an estimated six hundred brothels, three hundred gambling houses, eighteen hundred bookie joints, twenty-three thousand slot machines – to be flourishing.
>
> (Starr, 1997, p. 168)

Illegal gambling activities in Los Angeles featured pastimes like Tango, a betting game played with beans that was popular in Venice Beach amusement arcades, while lottery games, pinball, and slot machines were easily located in Chinatown. Casino gambling was concentrated along the County Strip, a part of West Hollywood not incorporated into the City of Los Angeles and therefore under the jurisdiction of county Sheriff Eugene Biscailuz. His lax enforcement of gambling and vice laws led to a concentration of casinos and prostitution along a patch of Sunset Boulevard between the City of Los Angeles and City of Beverly Hills. Clubs and casinos were controlled by organized crime, which implemented a system

of payoffs to corrupt police and officials. The Strip served as the precursor to the kind of practices that would later dominate Las Vegas. Lasting well into the 1950s, the Strip in Los Angeles was where organized crime, gambling, and prostitution first combined into a heady business model that fueled vice and corruption under cover from the glitz and glamour provided by the business of entertainment.

Los Angeles' Dark Mirror

Hollywood may have constructed other dark cities, but it was Los Angeles, that real and even stranger place lurking in the shadows, that became the place uniquely equipped to enable countless realizations of the noir city. Overlooked for decades by Hollywood while it was busy manufacturing New York and other exotic locales, it was not until the advent of film noir that a cinematic form could articulate the tensions and contradictory aspects of the real Los Angeles.

Enshrined in the canon of popular American cinema, the corpus of films comprising the classical period of film noir (1938–1958) has been deeply interrogated by film scholarship. Despite their relatively marginal status within the Hollywood studio production environment, film noir joined the Western, the Musical, the Screwball Comedy, the Melodrama, and the Gangster film as a midcentury staple of Hollywood. The seeds of film noir, sown during the Depression, are particularly associated with the American cinema of the 1940s due to their portentous association with World War II.

Film noir remains distinct from other popular filmmaking by not conforming to the strict conventions of genre and instead operating as a *filmic style*. By applying visuals and thematic concerns in the service of generating mood, tone, and atmosphere, film noir can also manifest transgenerically in other established genres. The appearance of films such as Fritz Lang's *You Only Live Once* (1937) and Boris Ingster's *Stranger on the Third Floor* (1940) signaled a thematic and stylistic shift, reshaping crime and thriller narratives that marked a new addition to American filmmaking. Noir inflections were soon evident in the gothic romance, (*Rebecca*, Hitchcock, 1940), the women's film, (*Mildred Pierce*, Curtiz, 1945)), the Melodrama (*The Strange Love of Martha Ivers*, Milestone, 1946), police procedurals (*Crossfire*, Dmytryk, 1947), and Westerns (*Johnny Guitar*, Ray, 1954). Often described as its epitaph, the classical era of film noir is seen to have concluded with Orson Welles's *Touch of Evil* in 1958.

Film noir represents a significant corpus of filmmaking reflecting midcentury American society. Contentious as the exercise may be, by cross-referencing titles from Internet Movie Database (IMDb) with the many encyclopedias on film noir, the classical era of American film noir appears to encompass approximately 600–650 films. The amount of productions divides roughly equally across 1940 to 1950 with three hundred titles,

followed by another three hundred titles produced from 1950 to 1960. Coinciding with the peak years of the Hollywood studio system before its demise, the number of productions under classical film noir far outstrips the number of neo noir productions that followed in the subsequent two decades, 1960 to 1980.

Pioneering theorists of film noir, Raymond Borde and Etienne Chaumeton, identified how the style arose within a very specific contextual relationship to Hollywood. As James Naremore has pointed out, Borde and Chaumeton saw, 'Somewhat surprisingly, that European cinema was a "feeble" influence on film noir and that American noir should be understood chiefly within the "Hollywood professional context"' (Naremore, 1998, p. 40). That professional context was the studio system and the way it was structured and operating at the end of 1930s into the 1940s and '50s. Maturing in the 1930s, Hollywood consisted of the big five studios: MGM, Paramount, Warner Bros., Twentieth Century Fox, RKO; and the little three: Universal, Columbia, and United Artists. Combined, these studios controlled the largest proportion of the American film market covering production, distribution, and exhibition. Film noir commenced in the smallest of the big five, RKO, and other minor studios such as Republic and Monogram. Eventually, as a result of the B-film structure, noirs would also be produced by some of the major studios and occasionally, as with *Double Indemnity* (Wilder, 1944) and *Sunset Boulevard* (Wilder, 1950), released as an A-movie from a major studio like Paramount.

Film noir is closely associated with the B-movie structure run by the major studios, and the low-budget films that were produced in response to exhibitor requests for double bills to meet the demand from growing cinema audiences. In the 1930s, the B-movie system saw secondary, low budget B-movies filling out the production schedules, and Taves estimates that 'roughly 75 percent of the pictures made during the 1930s, well over four thousand films, fall under the B rubric' (Taves, 1993, p. 313.).

Throughout the 1930s, outside of the eight major studios, approximately three hundred films were produced annually by smaller, independent or 'B-studios' geographically situated in Hollywood's Poverty Row. A distinct part of the filmmaking ecology actually located in the suburb of Hollywood but rarely celebrated, Poverty Row studios were made up of fledgling operators that pursued low-budget filmmaking. Rather than vertically integrated studios, Poverty Row was actually a cluster of production companies, and it also demarcated a physical site in Los Angeles at the intersection of Sunset Boulevard and Gower Street. The area also became known as 'the Gower Gulch' in response to the number of cowboys congregating at Poverty Row studios such as Christie, Republic, and CBC Productions (which eventually become Columbia), seeking acting work in low-budget Westerns churned out by these smaller studios between 1920 and 1950.

Adding production value while reducing costs, the location cinematography of film noir reflected the constraints of B-movie budgets and Poverty Row filmmaking. Innovations stemming from low-budgets such as location cinematography demonstrated what was creatively possible when it came to low-budget productions. A 1934 Saturday Evening Post story by reporter Frank Condon, observed how Los Angeles could provide ample low-cost production values:

> Suppose you require the illusion of a freight train in rapid motion, and are thinking of nothing but the costs. You cannot hire a regular freight train so what do you do? You load cameras on a motor truck and trundle over to Slauson Avenue, Los Angeles City where there is a freight track parallel with the street and plenty of motionless cars filled with furniture and motor-car parts. Passing along beside the inert box cars your cameraman grinds slowly which produces high speed on the screen, and give you a train roaring through the night at sixty miles an hour, with the hero escaping over the roofs and persons leaping into a ditch. You thus acquire a costly train scene for nothing, without real injury to anyone.
>
> (Condon, 1934, Aug 25)

Film noir cinematographers such as George Barnes (*Rebecca* [1940], *Spellbound* [1945], *Force of Evil* [1948]); Hal Mohr (*Woman on the Run* [1950], *Underworld U.S.A.* [1961]); Nicholas Musuraca (*Out of the Past* [1947], *Where Danger Lives*, [1950)]; and John Seitz (*Double Indemnity* [1944], *Sunset Boulevard* [1950]), had developed their skills and careers in the silent film era, employing the approach to filmmaking that Condon outlined. Although filmmakers were accustomed to location photography around Los Angeles in the silent era, early efforts at sound recording then problematized widespread location shooting, with sound requiring the controlled settings supplied by studios and indoor soundstages. By the 1940s, however, with advances in lightweight cameras, portable sound recording and influenced by newsreels and documentaries with realist aesthetics, the return to location shooting began to gather pace. The cost-cutting offered through location photography meant it was embraced by Poverty Row studios, whose lean production methods influenced the Major's B-movie divisions and its producers.

Hollywood's B-movie structure and Poverty Row studios formed an essential part of the film industry's unique filmmaking ecology in Los Angeles. Major studios (MGM, Paramount, Warner Bros., Twentieth Century Fox, RKO), and secondary studios (Universal, Columbia, United Artists) along with Poverty Row studios (Ambassador-Conn, Chesterfield, Grand National, Invincible, Liberty, Mascot, Monogram, Sono Art, Tiffany, World Wide), were all engaged in B-movie production. The most famous Poverty Row film noir remains Edward Ulmer's

Detour (1945) produced by the Producers Releasing Corporation (PRC). Operating from 1939 to 1946, PRC was behind more than 179 features and was one of the more substantial Poverty Row studios with diversified business interests spanning production and distribution.

The physical context of the studios highlights the site-specific aspects to film noir production and accompanying business practices that determined key components of Los Angeles' 1930s and 1940s production noirscapes. Recognizing how the physical production environment translates into innovations in production and financing points to what in contemporary terms is understood as the cluster effect generated among competing, but also complementary, creative enterprises. Clusters of creative businesses enable knowledge transfers and innovation across their respective operations. The low-budget and location-based filmmaking that contributed to the noir aesthetic is typical of the kind of innovation that smaller players had to pursue as they tried to compete against their more powerful competitors. The B-movie system not only provided an essential niche in which the Poverty Row and smaller studios could operate, but enabled the Majors to experiment with noir as a low-cost form of filmmaking.

Just as real Los Angeles locales began to appear more regularly on screen through location cinematography in film noir, the impact of the United States' involvement in World War II began to affect Los Angeles as a physical site of production. Between 1941 and 1945, wartime Los Angeles was reflected in the logistics and the production conditions surrounding Hollywood filmmaking. Announced in *Variety*, on December 16, 1942 the War Production Board imposed a $5,000 limit on the construction of film sets, down from the previous year's average for A-films ($50,000) and B-movies ($17,000) (Variety, May 13, 1942). As the City of Los Angeles was subjected to constant blackouts and resource rationing, the technical, logistical, as well as aesthetic components of film noir were impacted. As documented by Biesen, on December 11, 1941, four days after the Japanese attack on Pearl Harbor, an immense blackout extending from Bakersfield to San Diego shrouded the region in darkness upon army reports of unidentified aircraft. The front page of the *Los Angeles Times* featuring a 'nearly pitch-black photo . . . could easily be an image from a classic 1940s Hollywood film noir' (Biesen, 2005, p. 61).

World War II affected both the major and minor studios through the austerity measures that saw shrinking production budgets and forced technical constraints limiting formal and aesthetic choices across all filmmaking. Affordability and scarce resource provision may have limited the options available to creative decision-making in general film productions, but constraints from restricted budgets had always characterized film noir and fostered many of the innovations that led to its wide appeal. The use of low-light visuals contrasted with stark key lighting led to the shadowy motifs that positively contributed to the style of film noir,

combining expressionism with realism. While financial factors always determined aspects of noir aesthetics, some of the influences on film noir form lay further beyond the control of filmmakers than has traditionally been thought. The environmental conditions surrounding production in Los Angeles in the 1940s point to how the hermetics of Hollywood production and location shooting across the city bind the specific physical context of Los Angeles to noir representation. Even when it came to an A-budget film noir such as Paramount's *Double Indemnity* (Wilder, 1944), location shooting in Los Angeles meant working under restrictions imposed by the city's specific and very local wartime conditions. These production settings directly translated to what audiences were presented with onscreen. For example, in *Double Indemnity*, when filming a scene featuring the Glendale train station, its exterior lighting had to be blacked out in compliance with the city's wartime lighting restrictions (Naremore, 1998, p. 2). This production detail reveals how a key part of the chiaroscuro in the mise-en-scène is neither a choice of director Billy Wilder nor cinematographer John Seitz, and instead represents a pictorial recording of wartime Los Angeles at night.

Clearly, wartime conditions and other physical constraints remain minor influences compared to an overall aesthetic that was controlled and generally determined by the filmmakers. But through these kinds of impositions, traces of the real have nevertheless been captured amid the controlled fictional elements of hundreds of film noir productions. As a legacy from the location cinematography employed in film noir, these documentary-like elements record specific moments and particular places in Los Angeles that have been inadvertently rendered onscreen despite their basis in fiction. Although they may only constitute 'edge of frame' details, they underscore Kracauer's emphasis on the materialist aesthetics of film. In *Theory of Film*, Kracauer argued how film is a medium with 'a marked affinity for the visible world around us' (Kracauer, 1960, p. ix), enabling film to reveal the everyday and its rediscovery, and which Kracauer saw as its essential value.

> Now this reality includes the many phenomena which would hardly be perceived were it not for the motion picture camera's ability to catch them on the wing. And since any medium is partial to the things it is uniquely equipped to render, the cinema is conceivably animated by a desire to picture transient material life, life at its most ephemeral. Street crowds, involuntary gestures, and other fleeting impressions are its very meat. Significantly, the contemporaries of Lumiere praised his films – the first ever to be made – for showing "the ripple of the leaves stirred by the wind". I assume, then, that films are true to the medium to the extent that they penetrate the world before our eyes.
>
> (Kracauer, 1960, p. ix)

The ability of film to redeem our physical reality by capturing those most subtle of details is a poignant reminder that film texts, no matter how fictional in nature, are always produced in the workaday world of a particular time and a particular place. This means all films, irrespective of their basis in fiction or documentary, unintentionally record big and small details specific to the time and place of their production. This phenomenon is heightened by location cinematography, wherein the controlled sounds and images of fictional films are composited alongside the real in a porous process where slivers of documentary provide carriage for authentic fragments from history. Similar fragments from the everyday are the basis of prized finds in archaeology that seizes upon mundane objects like cups, crockery, and utensils. The more ordinary these objects, the better, since these innocuous traces provide the most fertile insight into the everyday life of civilizations long past, as opposed to grandiose monuments that usually only signify an era's hubris.

Bunker Hill – Fragments in a Shattered Mirror

Employing location photography, classical era film noirs utilized real Los Angeles locations to provide the mood and physical texture for these new thrillers. Across Los Angeles, nowhere supplied locations for film noir productions more often than the downtown district of Bunker Hill. According to Mike Davis, 'the epic dereliction of downtown's Bunker Hill . . . symbolized the rot in the expanding metropolis' (Davis, 1992, p. 20). Despite being one of the most historic districts of Los Angeles, by the 1960s Bunker Hill experienced what can only be described as a wholesale erasure of place from modernist redevelopment logics. If not for the location cinematography of film noir, this renowned downtown district with its hilly streets and rundown Victorian architecture may have been relegated to little more than still photography images when Bunker Hill joined the many other inner-city districts that vanished under the wrecking ball of progress. Instead, forever preserved inside the celluloid impressions of film noir, qualities like the quotidian interiority of Bunker Hill remain accessible amid the fictional settings.

Functioning as a form of social memory in the absence of a formal archive of the district, film noir provides a vital connection to Bunker Hill's unique past. Extending back to 1867, prominent businessman and former Mayor of Los Angeles Prudent Beaudry bought up large parcels of land that formed a promontory adjacent to downtown Los Angeles. With elevated hilltop views spanning Pasadena to the Pacific Ocean, Beaudry subdivided the perch of land converting it into a residential district, correctly assuming the views from the promontory would make for an appealing enclave for the city's wealthy elite. The vacant lots were soon filled with Victorian mansions inspired by the Eastlake Movement built by the business leaders of Los Angeles. By

the 1880s, the natural promontory of Bunker Hill was filled with the architectural splendor of Queen Anne–style houses, reminiscent of Nob Hill in San Francisco.

Key to the appeal of Bunker Hill was its propinquity to downtown Los Angeles, just a short stroll away. While the scale of downtown Los Angeles and its density has never rivalled New York or Chicago, the municipal concentration of a commerce and retail sector serviced by public transportation systems were characteristic of the centripetal forces shaping American cities in the nineteenth century. In 1886, 1-year prior to the development of Bunker Hill, Los Angeles Town Square in Downtown formed the centerpiece of open civic space, later renamed Pershing Square. Since 1885, downtown had served as Los Angeles' central public transport hub through the development of competing cable railway services. The Second Street Cable Railway, the city's first mechanical railway, was built and financed by the Los Angeles Improvement Company and was designed to promote its Crown Hill subdivision bounded by Second, Fourth, Beaudry, and Lucas Streets. Within the year, 1,400 lots along the line had been sold, contributing to the creation of Wilshire Boulevard. In 1886, Beaudry formed his own company to build the Temple Street Cable Railway between Spring Street and Belmont Avenue, terminating in the next suburban subdivision he was developing: Angelino Heights. By 1889, a third cable car service, The Los Angeles Cable Railway had commenced with services running every five minutes. In 1901, the most iconic mini-railway was built in Bunker Hill, the Angels Flight funicular. Built by Col. J. W. Eddy to connect the steep incline going up from Hill Street to Olive Street, the original Angels Flight opened in 1901 and ran continuously for over 60 years. [NB: following its relocation half a block south and after several failed attempts to reinstate it following mechanical breakdowns and accidents, the fully restored Angels Flight funicular returned to regular service in January 2017.] Together, downtown and Bunker Hill formed the core of Los Angeles in the tradition of metropolitan urban formation.

The exponential growth experienced by Los Angeles from the turn of the twentieth century meant new suburbs were opening up beyond the Downtown. They were dependent on cable and electric railway transport options that predate the mass production of automobiles and affordable private car ownership. These new housing developments, serviced by public transport options from competing cable railways and bus routes, were tied to these new subdivisions. Linked to Downtown by these public transport services, exclusive areas like Westlake and Beverly Hills were suddenly attracting the city's wealthy. By 1910, Bunker Hill had changed from an elite neighborhood to a white collar area, into a predominantly working-class neighborhood, when the former grand Victorian mansions were subdivided into rental properties and boarding houses. By the 1920s, surrounded by short-stay hotels and cramped apartments, Bunker

Hill was considered little more than an inner-city slum catering to the impoverished and destitute.

Bunker Hill is inscribed as a recurring motif in film noir, with its deteriorating built environment a stark reminder of the city's midcentury woes. Filmmakers had started using Bunker Hill as a location as early as 1914, when it featured in director Henry Lehrman's short, *Making a Living*, which marked the screen debut of Charlie Chaplin in a pre-Tramp role. Bunker Hill had also appeared in novels, for example, Don Ryan's *Angel Flight* (1927) and John Fante's semiautobiographical *Ask the Dust* (1939), gaining the reputation as Los Angeles' urban bohemia in the vein of New York's Greenwich Village and San Francisco's North Beach. The most iconic former resident of Bunker Hill was Raymond Chandler, who resided at 311 Loma Drive in 1916, when his mother, Florence Thornton, arrived from England to join him in Los Angeles. Years later, Bunker Hill would feature in Chandler's writing, most prominently in his 1942 novel, *The High Window*:

> Bunker Hill is old town, lost town, shabby town, crook town. Once, very long ago, it was the choice residential district of the city, and there are still standing a few of the jigsaw Gothic mansions with wide porches and walls covered with round-end shingles and full corner bay windows with spindle turrets. They are all rooming houses now, their parquetry floors are scratched and worn through the once glossy finish and the wide sweeping staircases are dark with time and with cheap varnish laid on over generations of dirt. In the tall rooms haggard landladies bicker with shifty tenants. On the wide cool front porches, reaching their cracked shoes into the sun, and staring at nothing, sit the old men with faces like lost battles.
>
> (Chandler, 1977, p. 167)

The original Bunker Hill of Los Angeles that commenced with Beaudry's subdivision in the 1860s exists more prominently in the memory of film noir than anywhere else. Serving as the epicenter of a downtrodden Los Angeles, and where the visible effects of the Great Depression continued to linger, Bunker Hill has been fortuitously memorialized as an indirect consequence of the classical era of film noir. A recurring feature in film noirs using Bunker Hill as a location is the residual Victorian era architecture that persisted in the area's built environment. The district has been captured exhibiting the pedestrian-based modes of movement and interactions typical of centripetal space. Examples include the productions *The Brasher Doubloon* (Brahm, 1947), *The Unfaithful* (Sherman, 1947), *Night Has a Thousand Eyes* (Farrow, 1948), *Act of Violence* (Zinneman, 1949), and *Criss Cross* (Siodmak, 1947), which show the fading Victorianism of Bunker Hill represented in terms dictated by urban density: nosy parkers, watchful neighbors, disapproving building superintendents, and

landladies. Despite the negative inflections film noir narratives supply to the proximities of Bunker Hill's dense living arrangements, they are nevertheless replete with the kind of interactions that Jane Jacobs stressed formed part of the vitality issuing from urban density. While film noir generally cast aspersions on the residents of 'seedy' Bunker Hill, it nonetheless recorded a community and one that ended up valiantly resisting wholesale relocation from downtown when its corporate redevelopment eventually banished it.

By the 1950s, Bunker Hill was indicative of an entire urban form containing ways of life that were rapidly vanishing and indicative of how by the 1950s aspects of centripetal urban space were appearing 'excessively archaic' (Dimendberg, 2004, p. 255). Amid the forces unleashed by centrifugal urbanism that were propelling Los Angeles into the future, film noir itself, the form of which had been so dependent on centripetal modern spaces, was also rapidly waning. In film noir titles like *Cry Danger* (Parrish, 1951), *The Turning Point* (Dieterle, 1952), *Cry of the Hunted* (Lewis, 1953), *Kiss Me Deadly* (Aldrich, 1955), *The Killing* (Kubrick, 1956), and *My Gun Is Quick* (Saville & White, 1957), Bunker Hill no longer simply represented denizens of a rotting Downtown. The mannerist style informed by the visual content supplied by Bunker Hill settings meant both film noir and this part of Los Angeles appeared as relics from a rapidly vanishing past.

While film noir would be rehabilitated by neo noir in the 1960s, Bunker Hill's precipitous slide was unstoppable. Repeated proposals for its complete razing had been occurring since 1928, when Bunker Hill was seen to be impeding the commercial westward expansion of Downtown. But it took another 30 years before the legislative means to erase Bunker Hill was fully in place, through the trifecta of federal, state and city government edicts. Slum clearance had been mandated through federal urban renewal programs under the Federal Housing Acts of 1946 and 1949, while the California Community Redevelopment Law of 1945 facilitated the creation of the Community Redevelopment Agency in 1948, which in turn, led to the Bunker Hill Urban Renewal Project in 1959.

Establishment of these urban renewal agencies reflects the exigencies of modernist master planning, which finally realized Bunker Hill's redevelopment. The scale of the urban master planning imposed on the infamous downtown district resulted in the wholesale erasure of Bunker Hill's community, built environment, and natural topography. Until 1961, Bunker Hill had been home to approximately ten thousand residents. By 1969, the last of the Victorian mansions had been removed, and the remaining population of Bunker Hill was dispossessed through demolition, razing, and regrading. After 30 feet of soil was removed from its natural topography, Bunker Hill was reduced to 'twenty-seven virgin superblocks' in preparation for the modern, high-rise development of the

soaring office towers: Arco Tower, Bank of America, IBM Tower, Union Bank, and Wells Fargo.

Bunker Hill as chronicled through the archive supplied by film noir, perhaps more than any other district in Los Angeles, reveals how modern urban space, transforming under centripetal and centrifugal forces, operates in terms of what has been described by Crang and others as 'poly-rhythmic temporality': the notion that, in the twentieth century, urban space unfolded 'not as a single abstract temporality but as the site where multiple temporalities collide' (Crang, 2001, p. 189). To experience such phenomena means witnessing how the past, present, and future can exist as a sequence of liminal surfaces. Assailed by the pace of modern development and hasty accommodations of the future, the logics of modernity have the effect of erasing the past in American cities. Eradicating swathes of the built environment in cities severs vital connections to both history and place. In the case of Bunker Hill, however, film noir has provided a veritable archive of its streets, Victorian architecture, shabby boarding houses, and physical topography that has enabled a heritage-style recuperation of its spatial day-to-day. Bunker Hill in film noir vividly demonstrates how a form of pulp heritage can be the basis of a history comprised from Hollywood's fictional galleria of image-making. Bunker Hill has in effect been memorialized in film noir where it resides as a trove, emphasizing how forms of social memory persist by whatever means are at its disposal.

Initially, as a result of such film noirs as *Double indemnity* (Wilder, 1944), *Murder, My Sweet* (Dmytryk, 1944), *Blue Dahlia* (Marshall, 1946), *The Postman Always Rings Twice* (Garnett, 1946), *The Killers* (Siodmak, 1946), *The Big Sleep* (Hawks, 1946), *He Walked by Night* (Werker & Mann, 1948), film noir took to Los Angeles' streets and represented its midcentury urban form like no other form of filmmaking. The dark imaginary of 1940s film noir inserted Los Angeles for the first time as a space of representation alongside other American metropolises. The combination of film noir and Los Angeles captured the vestiges of the city's centripetal urbanism and spatial modes that were rapidly receding from prominence alongside the city's few dense districts such as Bunker Hill and downtown. By the 1950s, despite the steady loss of film noir's cultural currency, productions that still used Los Angeles register the shift to centrifugal space and the spatial impacts from mobility reflecting the emerging urbanism posed by automobiles, freeways, and suburbia.

Casting LA

Through film noir, Los Angeles could be configured to the specific dictates of various narratives and scenarios but always resonated something of the uncanny. Describing *Double Indemnity* (Wilder, 1944), *D.O.A.* (Maté, 1950), and *Sunset Boulevard* (Wilder, 1950), Christopher states,

"All three are set in Los Angeles. . . . But it is a Los Angeles that is different in each of them – respectively bizarre, seedy, and fantastical" (Christopher, 2006, p. 10). Wilder's *Sunset Boulevard* lies at the intersection between memories of silent Hollywood and the future of Los Angeles. The 1950s ushered in the new modalities accompanying centrifugal space, a space synonymous with cars and road networks facilitating the kind of individual mobility that would come to dominate America. In *Sunset Boulevard*, the word *Sunset* deliberately invokes the film's theme addressing the end of Hollywood's silent era and the forgotten souls who once populated it. But by also denoting a physical space, *Sunset Boulevard* relied on associations that were now an iconic part of Los Angeles.

Sunset Boulevard was considered so scathing of Hollywood that many in the film industry accused Billy Wilder of, 'biting the hand that feeds him' (Sikov, 1998). The chiaroscuro of film noir becomes baroque in *Sunset Boulevard*, transforming Los Angeles' characteristic Spanish Mission architecture into gothic ruins that conceal the vice and nightmares of life inside the Dream Factory. The spectral presence of silent Hollywood hanging in pockets of the city into the final days of the studio system, reveals the nonsynchronous qualities infiltrating from the simulacrum of Hollywood history. The acerbic, self-reflexive narrative of *Sunset Boulevard* provides a remarkable account of its own production environment. Paramount's soundstages and backlot serve as literalized scenography alongside the actual Hollywood locations of Schwab's Pharmacy at 8024 Sunset Boulevard and Chateau Alto Nido Apartments at 1851 North Ivar Street, Hollywood. Schwab's was a renowned place for networking among production crew, while the Alto Nido apartments were a popular rental residence for actors. As well as convenient locales used for the narrative purposes of *Sunset Boulevard*, these locations were derived from the actual working conditions of Hollywood professionals. Far from simple settings or backgrounds, they resonate like a documentary on the lived circumstances surrounding real people, and how they occupied real Los Angeles among the real filmmaking milieu of 1950s Hollywood.

From the Hollywood Hills in *Double Indemnity* (1944), to the city's industrial districts, piers, boulevards, and bungalows, 1950s Los Angeles locations had become iconic enough to headline film noir titles. Alongside *Sunset Boulevard* (Wilder, 1950), were *711 Ocean Drive* (Newman, 1950), *Union Station* (Maté, 1950); and *The Strip* (Kardos, 1951). The embedding of Los Angeles locales within film titles continued with neo noir: *Chinatown* (Polanski, 1974), *To Live and Die in L.A.* (Friedkin, 1985), *Miracle Mile* (De Jarnatt, 1988), *Mulholland Falls* (Tamahori, 1996), *2 Days in the Valley* (Herzfeld, 1996), *L.A. Confidential* (Hanson, 1997), and *Mulholland Drive* (Lynch, 2001).

Despite film noir being one of the most urban of film forms, suburban Los Angeles came to dominate noir as a space of representation.

Providing the canvas for American urban experience, the Los Angeles of film noir registers in the imaginary through the vernacular terms of LA Noir and Dark City. Associations rivalling New York's alter ego of Gotham City and signalling how Los Angeles was acquiring expanded dimensions in the American cultural collective.

Until the end of the 1920s, American modernity pulsed to the vertical kinetics of New York and improvisational jazz. The staccato energies of early modern culture manifested in cinema through the rapid-fire dialogue of screwball comedies, machine guns, the screeching tires of Chicago gangsters, and the dizzying choreography of Busby Berkeley musicals. None of these formal elements of cinema could easily be grafted onto sparsely populated Los Angeles or provide expression to the sunbaked provincial lifestyle that resided within its horizontal urban form. Instead, Los Angeles remained a soundstage city, a blank screen for the reification of other cities under the dizzying energies of Modernity.

Following the Depression and leading into the uncertainties of the 1940s, the schism in cultural modernism is reflected in the disparity between the contemporaneous paintings *Broadway Boogie-Woogie* (1942–43) by Piet Mondrian and Edward Hopper's *Nighthawks* (1942). The discrepancy in mood from these iconic paintings points to the conflicting attitudes accompanying midcentury modernity. With its jazz-inspired, buzzing geometry, *Broadway Boogie-Woogie* signals the final exuberance of an urban modernity firmly entrenched in a New York vocabulary of grids, skyscraper perpendiculars, and stylized metropolitan bustle. In contrast, *Nighthawks* features alienated figures isolated and entrapped in an all-night diner signified by its doorless fishbowl design. As a harbinger of things to come, *Nighthawks* – and the oeuvre of Edward Hopper more generally – heralds the steady creep of a noir-world, casting its shadows across the United States. Advancing under the Great Depression, these ominous portents were realized by World War II and prolonged by the anxiety accompanying the Cold War. Noir as a thematic strand manifesting through novels, paintings, and film, supports cultural historian Paula Rabinowitz's perspective on noir and its function as a leitmotif for an entire way of life in the middle of the twentieth century.

In a potent combination, Los Angeles and film noir exposed the dark undercurrents shaping American society, and the ruthlessness driving its automated opportunism in the middle of the twentieth century. According to Naremore, ever since *Double Indemnity* in 1944, Los Angeles relayed a particularly caustic perspective on America.

> Los Angeles. . . [u]nder Wilder's supervision. . . (was) more like a dangerously seductive Eldorado – a centre of advanced capitalism, instrumental reason, and death.
>
> (Naremore, 1998, pp. 82–83)

The transformation of Los Angeles into the terminus of a ruthless American capitalism could not be further from the sunny image portrayed by the boosters 50 years earlier that proclaimed Los Angeles as *The Wonder City of the West*. Depicting the city as the place that turned sunshine into chiaroscuro and hope into despair, film noir articulates a peculiarly Los Angeles–styled American existentialism – a form of urban alienation produced by a city located at the endpoint of Manifest Destiny where a constantly buoyed Westward expansion folds back on itself. In Reyner Banham's classic study, *Los Angeles: The Architecture of Four Ecologies*, the architectural historian described this highly neglected, uncharacteristically pessimistic subtext, which accounts for the despair beneath Los Angeles noir.

> Los Angeles looks naturally to the Sunset . . . and named one of its great boulevards after that favourite evening view. But if the eye follows the sun, westward migration cannot. The Pacific beaches are where young men stop going West, where the great waves of agrarian migration from Europe and the Middle West broke in a surf of unfulfilled and frustrated hopes.
>
> (Banham, 2000, p. 6)

Like an undercurrent countering Los Angeles' association with the hyperbole of American triumphalism and Manifest Destiny, the sense of defeat and pessimism dismantles the central myth of the Golden West – a land where freedom meets boundless opportunity. With doomed characters in narratives that dared to contravene Hollywood happy endings, film noirs are riddled with the sense of failure punctuated by, 'unfulfilled and frustrated hopes.'

A cinematic image that literally depicts the Pacific as a barrier ending westward migration and further expansion appeared most strikingly in the 1980s. Employing a nostalgia-filled chiaroscuro through black-and-white cinematography, Francis Ford Coppola's *Rumble Fish* (1983) created a silhouette that visualizes Banham's observation. In the final scene, following the death of his fabled brother, Motorcycle Boy (Mickey Rourke), Rusty James (Matt Dillon) flees the small industrial town where they were both raised. Hoping to escape the Midwest, he also wants to realize his brother's unfulfilled dream of seeing the Pacific Ocean to experience its mythic sense of freedom and limitless possibility. Through the noir visuals supplied by silhouette and monochrome cinematography, the final image of the film forges a visual metaphor denoting hopelessness and despair. Rather than depicting the Pacific in the conventional visual terms of an endless expanse of sky and water, the mise-en-scène is composed using shallow depth-of-field, obliterating the sky, and confronting Rusty James with a watery wall of tumbling silver waves consuming the entire frame. In sharp contradiction to the mythic

West, this final image in *Rumble Fish* depicts the Pacific Ocean contravening any sense of a horizontal vista. Far from symbolizing freedom or a hopeful future, the steely cold ocean serves as a vertical, metallic-like wall that entraps Rusty inside America's continental landmass and his grief-stricken past.

Banham's Los Angeles as a deflated end point to Manifest Destiny is a reminder of an American spatial perspective that is forced back on itself once the furthest point of its civilization has been reached. This forced perspective represents an inward and introspective turn, informing the immutable sense of the finite and the bounded that constrains all human lived experience. Situated at the terminus of American Manifest Destiny and hosting the nation's Dream Factory, the implicit and explicit elements of Los Angeles settings provide additional layers that contribute to the existential apprehensions of classical film noir. These extend beyond the standard notions of pre- and postwar anxiety that film noir is often reduced to. Instead, when considering Los Angeles and its complex relationship to film noir, we are provided with unique windows into a time from a place that is far more evocative of the actual past than formal history itself. The emotive elements of film noir reside in the residue of the 1930s and its privations from the Great Depression as much as they do in the tensions leading up to, during, and beyond, wartime America. Through Los Angeles's mythic association with the West, freedom, and the excesses of Hollywood, classical film noir has rendered some of the most effusive qualities of the sociology beneath midcentury American experience. The unspoken, intuitive, and barely perceptible elements of the everyday that infuse the ways of life informing the attitudes and experiences of a generation are what Raymond Williams sought to account for in his concept, structure of feeling. Conveying the particularities of daily life faintly embedded in a specific time and place like midcentury Los Angeles, classical film noir conveys these structures of feeling through its representation of Los Angeles and the spatial dimensions shaping the experience of American urbanism.

Permeating representations of urban America, noir embodies the cultural dynamics Williams outlined that function in terms of dominant, residual, and emergent forces shaping culture. As cultural forms jostle alongside each other, nonsynchronous and residual elements from the past are contemporaneous with dominant and emergent forms, characterizing processes of dynamic cultural change. Noir appears to have provided carriage for the residual by connecting to the gangster narratives from the Prohibition era, while reshaping crime narratives in response to the emergent influences of the Depression. Calling attention to the contradictions from desire, gender, and social mobility under capitalist accumulation, noir functions in dialectical opposition to dominant socioeconomic forces. Emerging from the margins of Hollywood, the Poverty Row studios, and B-movie structure of the major studios, film noir not

only provided cultural expression, but also feasted on the repressed of midcentury American society.

The classical cycle of film noir supplies Los Angeles with a de facto discourse on its history of systemic crime and corruption, articulated through the imaginary of Hollywood. In an unparalleled dialectic, film noir pitted the booster image of Los Angeles and its carefree lifestyle against the city's entrenched levels of civic malfeasance and the stark realities of the Depression and wartime conditions. Meanwhile, the physical, industrial, and urban characteristics of Los Angeles afforded crucial elements to film noir that helped define and elevate them as low-budget thrillers churned out by Hollywood. As a city, Los Angeles not only supplied film noir with urban settings like other American cities, but also the filmmaking industry and production logistics dictated by its physical environment and structural organization that helped determine its key formal elements.

Conclusion

Imbricated into the emerging fabric of the city, classical film noir constitutes far more than a corpus of films in relation to Los Angeles. Comprising an essential, homegrown, urban metanarrative, when classical film noirs employed Los Angeles as a location, they countered booster Los Angeles and the soundstage predilections of Hollywood A-movies that had obscured representation of the city. Moreover, film noirs that used real Los Angeles settings through location cinematography ultimately catalogued the city's spatial dynamics. By capturing residual aspects of Los Angeles urbanism that exhibited qualities common to the centripetal metropolis of early modernity, film noir confirms how Los Angeles was briefly organized along lines of pedestrian movement and the street-scale proximities of density.

Film noir refracts Los Angeles' turbulent syncopations against a transforming modernity that, in the middle of the twentieth century, heralded the expiration of the modern metropolis. Through film noir, the spatial dynamics of Los Angeles districts such as Bunker Hill and downtown have been preserved through a form of cinematic heritage deposited over the pulp fiction noirscape. Conveying aspects of the city's everyday life, which was rapidly vanishing, film noir both recorded and was symptomatic, of the demise of the centripetal city of modernity. By the 1950s, with its low-lying suburbs and space-shattering freeways, Los Angeles projected the template for a new kind of American urbanism poised to manifest across the United States. The last gasps of classical film noir continued to render these transformations prior to neo noir's resuscitation and its corresponding representation of Los Angeles.

The advent of film noir in the 1940s saw Hollywood discover Los Angeles, and it has since comprised a vital component of the city's

screen-generated heritage. Through film noir, Hollywood finally began noticing its own backyard and the unique urban qualities of the city that hosted it. Behind the studios and the backlots dominated by New York street sets and 50-foot high flats featuring the painted skylines of other metropolises was a real city, the growing City of Los Angeles. The actual City of Los Angeles ultimately furnished film noir with one of its definitive urban settings. As a result of the imaginary Dark City of noir, centripetal Los Angeles has been preserved in cinematic chiaroscuro and defines midcentury Los Angeles in the same way older cities can be defined by periods in architecture.

Film noir affected Los Angeles unlike any other American city. It signaled Los Angeles as a location city in its own right, not just the home of Hollywood and positioned Los Angeles as 'a place,' capable of endowing films with settings that could sustain cinematic narratives. Identified and treated as a complex urban locale, film noir erased Los Angeles' one-dimensional identity as an orange-grove lifestyle destination, an identity narrowly constructed to serve the self-interests of the city's boosters. Providing a context for Los Angeles' unique urbanism, film noir finally gave form, texture, and meaning to those suburbs in search of a city. Film noir performed a heuristic, self-styled, and very local means through which Los Angeles came to *know* itself. Forging an indelible association as *the* city of film noir, the combination paved the way for Los Angeles to occupy an acute place in the popular American imaginary. As the Dark City of film noir, Los Angeles and Hollywood managed, quite unexpectedly, to provide one of the most searing commentaries on urban life, capitalism, and midcentury America.

Note

1. Los Angeles Almanac. Retrieved from www.laalmanac.com/population/po02.php.

References

Aldrich. R. (Director). (1955). *Kiss Me Deadly.* United Artists.
Banham, R. (2000). *Los Angeles: The architecture of four ecologies.* Berkeley, CA: University of California Press.
Biesen, S. (2005). *Blackout World War II and the origins of film noir.* Baltimore: Johns Hopkins University Press.
Brahm, J. (Director). (1947). *The Brasher Doubloom.* Twentieth Century Fox.
Chandler, R. (1949). *The little sister.* Boston, MA: Houghton Mifflin Harcourt.
Chandler, R. (1977). *Raymond Chandler complete and unabridged: The big sleep, the high window, the lady in the lake, the long goodbye, playback, farewell my lovely.* London: Heinemann/Octopus.
Christopher, N. (2006). *Somewhere in the night. Film noir and the American city.* Emeryville. CA: Shoemaker & Hoard.

Clark, D. (1981). *Los Angeles a city apart: An illustrated history*. Woodland Hills, CA: Windsor Publications.

Condon, F. (1934, August 25). Poverty Row. *Saturday Evening Post*, pp. 30–93.

Coppola, F. (Director). (1983). *Rumble Fish*. Universal.

Crang, M. (2001). Rhythms of the city: Temporalized space and motion. In J. May and N. Thrift (Eds.), *Timespace: Geographies of temporality*. New York and London: Routledge.

Curtiz, M. (Director). (1945). *Mildred Pierce*. Warner Bros.

Davis, M. (1992). *City of Quartz: Excavating the future in Los Angeles*. New York: Vintage Books.

De Jarnatt, S. (Director). (1988). *Miracle Mile*. Columbia Pictures & Hemdale Film Corporation.

Dieterle, W. (Director). (1952). *The Turning Point*. Paramount.

Dimendberg, E. (2004). *Film noir and the spaces of modernity*. Cambridge, MA and London: Harvard University Press.

Dymski, G.A., & Veitch, J.M. (1996). Financing the future in Los Angeles: From Depression to 21st Century. In M. Dear, H. E. Schockman & G. Hise(Eds.), *Re-thinking Los Angeles* (pp. 35–55). Thousand Oaks, CA: SAGE.

Dmytryk, E. (Director). (1944). *Murder My Sweet*. RKO.

Dmytryk, E. (Director). (1947). *Crossfire*. RKO.

Farrow, J. (Director). (1948). *Night Has a Thousand Eyes*. Paramount.

Friedkin, W. (Director). (1985). *To Live and Die in L.A.* Metro Goldwyn Mayer.

Fulton, W. (2001). *The reluctant metropolis: The politics of urban growth in Los Angeles*. Baltimore: John Hopkins University Press.

Garnett, T. (Director). (1946). *Postman Always Rings Twice*. Metro Goldwyn Mayer.

Hanson, C. (Director). (1997). *L.A. Confidential*. Warner Bros.

Hawks, H. (Director). (1946). *The Big Sleep*. Warner Bros.

Heimann, J. (1997). *Sins of the city*. San Francisco: Chronicle Books.

Heimann, J. (2017). *Dark city: The real Los Angeles noir*. Cologne: Taschen.

Herzfeld, J. (Director). (1996). *2 Days in the Valley*. Metro Goldwyn Mayer.

Hitchcock, A. (Director). (1940). *Rebecca*. United Artists.

Hopkins, E. (1931). *Our lawless police*. New York: Viking Press. (Reprinted with permission by Da Capo Press Inc. New York, 1972).

Kardos, R. (Director). (1951). *The Strip*. Metro Goldwyn Mayer.

Kracauer, S. (1960, 1978). *Theory of film: The redemption of physical reality*. New York: Oxford University Press.

Kubrick, S. (Director). (1956). *The Killing*. United Artists.

Lang, F. (Director). (1927). *Metropolis*. UFA.

Lewis, J.H. (Director). (1953). *Cry of the Hunted*. Metro Goldwyn Mayer.

Longstreth, R. (1998). *City centre to regional mall: Architecture, the automobile, and retailing in Los Angeles, 1920–1950*. Cambridge, MA and London: MIT Press.

Marchand, B. (1986). *The emergence of Los Angeles: Population and housing in the city of dreams, 1940–1970*. London: Pion.

Lynch, D. (Director). (2001). *Mulholland Drive*. Universal.

Marshall, G. (Director). (1946). *Blue Dahlia*. Paramount.

Mate, R. (Director). (1949). *D.O.A.* United Artists.

Maté, R. (Director). (1950). *Union Station*. Paramount.

McWilliams, C. (1949). *California: The great exception.* New York: Current Books.

Milestone, L. (Director). (1946). *The Strange Love of Martha Ivers.* Paramount.

Naremore, J. (1998). *More than night: Film noir in its contexts.* Berkeley: University of California Press.

Newman, J. (Director). (1950). *711 Ocean Drive.* Columbia Pictures.

Parrish, R. (Director). (1951). *Cry Danger.* RKO.

Polanski, R. (Director). (1974). *Chinatown.* Paramount.

Ray, N. (Director). (1954). *Johnny Guitar.* Republic.

Sanders, J. (2003). *Celluloid skyline: New York and the movies.* London: Bloomsbury.

Saville, V. (Director) & White, G. (Director). (1957). *My Gun Is Quick.* United Artists.

Schleier, M. (2009). *Skyscraper cinema: Architecture and gender in American film.* Minneapolis: University of Minnesota Press.

Sherman, V. (Director). (1947). *The Unfaithful.* Warner Bros.

Siegel, F. (1997). *The future once happened here: New York, D.C., L.A., and the fate of America's big cities.* New York: The Free Press.

Sikov, E. (1998). *On Sunset Boulevard: The life and times of Billy Wilder.* New York: Hyperion.

Siodmak, R. (Director). (1946). *The Killers.* Universal.

Siodmak, R. (Director). (1947). *Criss Cross.* Universal.

Starr, K. (1997). *The dream endures: California enters the 1940s.* Oxford and New York: Oxford University Press.

Tamahori, L. (Director). (1996). *Mulholland Falls.* Metro Goldwyn Mayer.

Taves, B. (1993). The B Film: Hollywood's other half. In T. Balio & Gale Group (Eds.), *Grand design Hollywood as a modern business enterprise, 1930–1939* (pp. 313–350). New York: Charles Scribner's Sons.

Werker, A. (Director) & Mann, A. (Director). (1948). *He Walked By Night.* Eagle Lion Films.

Wilder, B. (Director). (1944). *Double Indemnity.* Paramount.

Wilder, B. (Director). (1950). *Sunset Boulevard.* Paramount.

Variety, unsuspected $5000 ceiling on construction cues producers how priorities can hit them harder (1942, May 13). *Variety, 146,* 5. Retrieved from https://archive.org/details/variety146-1942-05/page/n59

Wagner, A. (1935). *Los Angeles: Werden, Leben, und Gestalt der Zweimillionenstadt in Sudenkalifornien.* Leipzig: Bibliographisches Institute AG.

Zinneman, F. (Director). (1949). *Act of Violence.* Metro Goldwyn Mayer.

4 Noirscapes of Motion

Since the 1930s, cars and a culture premised on mobility were prevalent across California. Tourism incorporating driving holidays had become a staple Californian pastime, giving rise to the motel and caravan trailer. As daily life in Los Angeles was rearranged by the private automobile, the city pioneered developments such as the world's first drive-in restaurants and housing such as the bungalow court situating the car at the center of design amenity. Emerging from the postwar era and ending years of privations from the effects of the Depression and wartime austerity, the new American lifestyle dominated by personal mobility was transforming life in Los Angeles and its built environment.

Histories of American cinema recount how the cultural currency of film noir was waning by the 1950s, and the classical cycle is considered to have petered out with Orson Welles's *Touch of Evil* in 1958. By the 1960s, self-conscious noir stylistics point to the emergence of neo noir, which represents the shift from noir as a filmic style to its development along the lines of genre. In the final years of the classical cycle of film noir, however, productions recorded centrifugal Los Angeles and articulate life lived in motion. *Armored Car Robbery* (Fleischer, 1950), *In a Lonely Place* (Ray, 1950), *Crime Wave* (De Toth, 1953), *Kiss Me Deadly* (Aldrich, 1955) and *Plunder Road* (Cornfield, 1957) supply spaces of representation for Los Angeles' burgeoning freeway culture and an increasingly car centered lifestyle. The final years of classical film noir not only recorded phenomena such as centrifugal urbanism that would ultimately reshape urban America, they also contributed to the new optics generated by a culture in motion. Mapping the spatial transformations in 1950s Los Angeles from freeways through the form and content of the final years of classical film noir reveals how personal mobility would underscore America's postwar future.

City of Flow

Private car ownership and the new road systems of freeways and highways reflected heightened personal mobility in the postwar era, and

nowhere in the United States was this more pronounced than in Los Angeles. When it came to freeways, the future of Los Angeles was sealed as early as 1940 with the opening of the Arroyo Seco Parkway. Known as State Route 110 and the Pasadena Freeway, it was the first limited-access highway in Los Angeles. Promising rejuvenating qualities, the scenic Arroyo Seco Parkway was forerunner to the construction of a road network in the 1950s that became the iconic signature of Southern California's built environment. As one of the defining characteristics of Los Angeles' urban form in the postwar decades, freeways promulgated centrifugal urbanism. The centralizing factors of development under centripetal urbanism previously concentrated American cities with dense downtowns and diminishing spheres of industrial and residential zones. Centrifugal urbanism describes processes of dispersal and the impact on cities from telecommunications, suburban expansion, branch office corporatism, shopping malls, cars, and freeways. Each of these centrifugal factors gathered pace from the 1950s in cities across the United States, but were amplified in Los Angeles and Southern California as a result of its historically decentered development patterns with lower urban densities.

The 1950s represent one of the most transformative decades for Los Angeles. A postwar boom witnessed the city's industrial expansion following wartime developments. California's aerospace industry had produced a third of the United States' warplanes during World War II, and Navy shipbuilding became the primary business of the Port of Los Angeles, employing 90,000 workers.[1] Suburban expansion was fueled by a mass housing industry, transforming domestic home construction in response to the demand from returning GIs seeking jobs and affordable suburban bungalow living in Los Angeles. Growth in new housing developments extended development of Greater Los Angeles in an outward push consuming land from the San Fernando Valley to Orange County.

As Los Angeles expanded physically and economically in the postwar era, its growth outpaced all other American cities and regions. Freeway infrastructure linking Los Angeles' counties across its vast geographical basin formed an unrivaled transportation network centered on the automobile. Bipartisan support from the Democrats led to Eisenhower's Republican administration enacting the Federal Aid Highway Act of 1956, which complemented state and local policies in California promoting freeways as the solution to the region's transport needs. The construction of city and interstate freeways was a national priority across the United States, and in Southern California, local, state, and federal authorities were united in their efforts to make up for the lost years of infrastructure development and postponed investment that had occurred as a result of World War II.

The scale of the Los Angeles basin and the distances involved traversing the Greater Metropolitan region meant transportation networks had

always served as a vital component to the city's development. Los Angeles, and California in general, had a long association with the private automobile, with the rate of car ownership in Los Angeles outstripping other American cities since 1915. The impacts from the personal car were determining key features of Southern California, where personal mobility informed so much of its urban development. According to the historian of modernity, Peter Conrad, 'the car forced us to recognize the cubistic mayhem of modern space. Arriving in motorized, structureless California, where perpetual motion in time atones for the incoherence of space, Gertrude Stein in 1935 wittily noted that when you got there you found there was no there after all' (Conrad, 1998, p. 95). Beyond providing the basis for yet another pejorative assessment of California, the kind of spatial experiences engendered through motion and the proliferation of private automobiles underscored a host of innovations adapting to the altered perception from moving landscapes.

In 1950s Los Angeles, the consequences of cars and the sense of life lived in perpetual motion began influencing the design and architecture of commercial 'linear districts' and residential living. Bungalow court living, the development of motels, and drive-through services from restaurants to banking positioned the car at the center of a Californian design ethos. Reflecting and contributing to how life was literally speeding up, filmmakers embraced the possibilities offered through car-mounted cameras and forms of mobile cinematography enabled by lightweight, portable film technologies developed during World War II.

Andre de Toth's *Crime Wave* (1955) opens with a night view of Los Angeles showing neon-lit streets through the windscreen of a moving car. A cut to a stationary shot still focuses on motion, but now it comes from within the frame, through a momentary shot of moving cars and night-time traffic. Returning to the POV windscreen shot, the film remains on this single shot as the credits conclude, and the car pulls into an all-night gas station. An anonymous male figure exits the car, which the POV camera captures by panning from the backseat. An attendant greets the man with a friendly smile. The economy of the sequence comprises just over one minute of screen time, yet it manages to set the tone of the film, provide background for the credit sequence, and sets up the action for the opening scene. By installing the camera inside the actual moving car, cinematographer, Bert Glannon and Director Andre DeToth rejected conventional back projection in order to replicate the realism of car travel. Like many other scenes in the film, the opening sequence is constructed through the affordances of a mobile camera. Opening the film in this way provided an alternative to the conventional two-shot for suturing the audience. Prolonging shots through a mobile space in this manner alters filmic formalism and redefines the descriptor of cinema as motion pictures.

Freeway Logics

Lefebvre's second order of spatial consciousness outlines how spatial representation plays key roles in configuring modern space. Specialist fields of modern space manifest in the disciplines of urban planning, urban geography, and design practices of architecture and infrastructure departments that oversee the resourcing and logistics that end up shaping urban space. Since the 1930s, the federal, state and local agencies had been putting forward freeways as the solution to the urban transport problems of Los Angeles and Southern California. Their repeated surveys and plans represent what Lefebvre describes as the 'discursive formations' that strive to propagate a cohesive spatial practice. But as Lefebvre maintains, this modern spatial practice and its instrumentalization of space, 'does not imply that it is coherent' (Lefebvre, 1991, p. 51). Rather, they are schematic and accumulative processes attesting to who and how spatial dominance is exerted through ideologies of space.

Spatial control and appropriation of lived space through such planning apparatuses and spatial policies also demonstrate the fundamental relations between knowledge and power as charted by Foucault. Forms of spatial practice reveal how the control of space is exercised through Foucault's 'dispositifs,' the knowledge structures as well as physical institutions in which, 'the formation of knowledge and the increase of power regularly reinforce one another in a circular process' (Foucault, 1995, p. 224). The federal and state freeway agencies operated in these terms by enmeshing the logics of freeway construction in anonymous agencies granted sweeping planning powers. Unlike previous urban transformations conducted in Paris and New York by major master-builders Baron Haussmann and Robert Moses respectively, the enormous undertaking of freeway construction in Los Angeles had no such central figure orchestrating such significant changes. Instead, as Avila recounts:

> There simply was no uberplanner to venerate as a champion of progress or despise as a villain of destruction. Instead, a byzantine hierarchy of "highly trained professional planners, engineers, traffic and right of way experts . . . whose only objective [was] the greatest public benefit" worked in a piecemeal fashion to coordinate the monumental task of building a regional network of freeways.
>
> (Avila, 2013, p. 38)

Since the 1930s, studies had been conducted by groups such as the Automobile Club of Southern California, which produced the fifty-one-page 'Traffic Survey' in 1937, detailing traffic patterns and movements across Metropolitan Los Angeles that covered the City of Los Angeles and 31 percent (1,235 square miles) of the coastal plain of Los Angeles

County. The Traffic Survey's key proposal came down to the single statement: 'Recommendation 1 – Motorways. It is recommended that a network of motorways be constructed to serve the entire metropolitan area of Los Angeles.'[2]

By the 1940s, ambitious plans for freeway construction were being drawn up at the federal and state levels that complemented local business proposals on how to tackle the growing congestion in Los Angeles. At the national level, planning for the Interstate Highway system was updated by the 1944 Federal-Aid Highway Act, with California initially allocated close to 2,000 miles out of a total of 40,000 miles of federally funded highway construction. In 1944, the California Highway Commission recommended 145 individual projects as part of an $80 million postwar construction program. Meanwhile, Los Angeles interest groups like the Central Business District Association commissioned the report *Transit Study 1944: Los Angeles Metropolitan Area*, soon followed by three more local plans for freeways. The 1946 Report, *Interregional, Regional, Metropolitan Parkways in the Los Angeles Metro Area*, and the 1947 studies, *Proposed Parkway Plan* by the Automobile Club of Southern California and the *Master Plan of Metropolitan Los Angeles Freeway*.

In 1947, the California state legislature passed the Collier-Burns Act in response to recommendations from the Joint Interim Commission on Highways, Roads, Streets, and Bridges. The Act weighted freeway construction in favor of Southern California by allocating 55 percent of construction funds, up from the previous 49 percent. The funding came from increased fuel taxes and registration fees that as Fulton observes, 'People wanted to drive cars so much that they willingly paid enough tax to build and maintain new roads' (Fulton, 2001, p. 134). Constructed over the 20-year period from 1950 to 1970, the freeway system of Southern California transformed the region and confirmed Los Angeles' reputation as the automobile and freeway capital of the world.

In contrast to the competing interests of the mass transit operators and the stalemate thwarting expansion of public transport options, the planning, funding, and construction of freeways generated the sense of concord across local, state, and federal jurisdictions, as well civic groups such as the Chamber of Commerce and motorist associations. The discourse surrounding freeways emphasized speed and efficiency, which enjoyed associations with personal freedom, hygiene, and most incongruously by today's standards, nature. The very term *parkway* originated from the concept that driving unimpeded along freeway-style boulevards was akin to enjoying time relaxing in parks. The value of urban parklands had origins in the 'back to nature' movement occurring at the end of the nineteenth century in response to the squalid conditions of American cities and urban life. Associated with such prominent figures as Frederick Law Olmstead, famously commissioned to design Central Park in New York City, the promotion of city parklands, landscape design, and

preservation of wilderness aimed to ameliorate city life with the rejuvenating qualities of nature.

Writing at the turn of the twentieth century, journalist, Charles Mulford Robinson emulated the values of the back-to-nature ideals in his classic study, *Modern Civic Art or the City Made Beautiful*. Robinson was an early advocate for aesthetic experiences that needed to underpin urban travels. '[T]here should at once be recognition that there may properly be two kinds of parkway – that which unites park and city, and that which joins separated parks. A third may be developed from these, to serve the ends of beauty and attractiveness alone' (Robinson, 1918, p. 311). From these lofty ideals, Robinson envisioned highways providing a form of urban cleansing capable of curing the ills of inner-city slums.

> It has been found that often there is no better way to redeem a slum district than by cutting into it a great highway that will be filled with through travel of a city's industry. Like a stream of pure water cleansing what it touches, this tide of traffic pulsing with the joyousness of the city's life of toil and purpose, when flowing through an idle or suffering district, wakes it to larger interests and higher purposes.
>
> (Robinson, 1918, p. 21)

The 'larger interests and higher purposes' providing the rationale for freeways, however, quickly centered on efficiencies regardless of the cost to the local communities on which freeways were imposed. As well as providing the means for transport, traditionally the street has served as the connective tissue between private and public space, while maintaining a relationship with the surrounding neighborhood. But with cars choking the streets of American cities, solving the problem of congestion through efficiencies in transportation meant communities with their crowded streets would either be bypassed or overlaid with freeways. In the case of the Cross Bronx Expressway, a legacy from New York's planning czar Robert Moses, neighborhoods were severely bisected when a freeway was mercilessly cut through them. Marshall Berman has recounted how the Cross Bronx Expressway wrought irrevocable damage on the neighborhood of his childhood (Berman, 1988). Dispensing with the pleasantries and ideals of Charles Robinson's views, Moses's approach to modern urban development was brutally unequivocal. 'When you operate in an overbuilt metropolis, you have to hack your way with a meat ax. I'm just going to keep right on building. You do the best you can to stop it' (Moses cited in, Berman, 1988, p. 290).

Urban planners contemplating major development across Greater Los Angeles did not have to contend with an 'overbuilt metropolis.' Instead, they were confronted with a unique set of problems to which the construction of freeways was presented as the most rational solution. The

Los Angeles basin hosted a relatively sparse population, but it was spread across a vast region bound by the Pacific Coast to the west, Santa Monica Mountains to the north/northeast, San Gabriel mountains to the east and Santa Ana Mountains and San Joaquin Hills to the southeast. The basin also serves as a transport corridor linking the Southland to the central and northern regions of California, covering distances in the single-state equivalent to journeying across four or five Eastern States. Urban freeways would provide direct connections to the expanding regional centers spread across Greater Los Angeles, while also providing access to California's Interstate Highway system.

The single focus of modernist planning logics on transport efficiencies neglected the impact freeways would have on local communities. The unequitable distribution of the freeway network that courses through Los Angeles along racial and ethnic lines highlights the spatial injustices of the era's planning logics. Local iterations of movements such as the 'freeway revolts' prevented their construction in highly privileged white neighborhoods, for example Beverly Hills, ensuring East Los Angeles, 'bore the brunt of the postwar push to build a regional highway infrastructure' (Avila, 2013, p. 45).

Spaces of Motion

Freeways are the supreme expression of functionalist urban planning in Los Angeles which, in prioritizing the exigencies of the automobile, created new spaces determined by motion. Promoting experiences centered around the personal car, 'regular rhythms of mobility, such as commuting . . . produces a sense of mobile place' (Edensor, 2010, p. 6). Simultaneously utilitarian and highly symbolic, the monumentality of American freeways serve as high modernity's horizontal equivalent to the skyscraper of early modernity. In tandem with the automobile, the freeway propelled new forms of urbanism and spatial organisation predicated on decentralization, regionalism, mobility, and telecommunications.

The functionalism of freeways may have promised a utilitarian transport system centered on the car, but their utopian promise was communicated through the seduction of their monumental scale. Highly elevated with sweeping dynamic forms as concrete thoroughfares, they offer the dream of unimpeded motion. Compressing time and space, freeway travel afforded all the comfort that comes with the atomized experience of individual car travel. The first modern freeway in Los Angeles, the Arroyo Seco Parkway, appears in popular culture as early as 1942 in Chandler's novel, *The High Window*, which opens with Marlowe driving out to Pasadena on the Arroyo Seco to meet his new client. Chandler's use of the Parkway is consistent with publicity celebrating it as the most direct and convenient means of traveling between Los Angeles and Pasadena. The Arroyo Seco

provides an efficient route, but more importantly it enables Marlowe to successfully evade another car that is attempting to tail him.

> I drove back towards the city. A dozen blocks later at a traffic stop, the sand coloured coupe was behind me. I shrugged and just for the fun of it circled a few blocks. The coupe held its position. I swung into a street lined with immense pepper trees, dragged my heap in a fast u turn and stopped against the curbing. The coupe came carefully around the corner. The blond head under the cocoa straw hat with the tropical print band didn't even turn my way. The coupe sailed on and I drove back to the Arroyo Seco and on towards Hollywood. I looked carefully several times, but I didn't spot the coupe again.
>
> (Chandler, 1977, p. 145)

The new Parkway provides the means of escape from the local streets, where Marlowe is highly visible and able to be tailed by another car. Once he is on the Parkway, the implication is that, through speed and anonymity, he can make an unimpeded escape back to Los Angeles. Like Chandler's fiction, classical film noirs set in Los Angeles soon began to reflect the lived reality of the city's mobility. This was a result of the rapid growth in car ownership and freeway construction that was gathering pace from the 1940s. Classical film noirs set in Los Angeles like *He Walked by Night* (Mann, 1948), from the title onward, reflected the pedestrian nature of centripetal spatial experience of such concentrated districts as West Hollywood, Bunker Hill, and downtown. Adapting to the shift in the urban milieu of Los Angeles, certain strains of 1940s and 1950s film noir reflected the city's burgeoning culture of mobility and its centrifugal logics.

Raoul Walsh's *They Drive by Night* (1940) explored the hazardous conditions of California's road network prior to construction of local freeways and interstate highways. With its narrative centered on the trucking business, the transport industry is shown as providing the potential for upward class mobility for Los Angeles' working class. Starring George Raft, with Humphrey Bogart in the supporting role, they play brothers trying to make their way in California's trucking industry. The opening titles of *They Drive by Night* (Walsh, 1940) commence with credits superimposed over close-ups of moving truck wheels that alternate with an animated still graphic featuring the headlight beam from a truck and traffic lights. There is no aerial photography featuring images of a cityscape that was the signature background for so many opening credit sequences common to classical film noir. Instead, the story opens on the mid-shot of a truck journeying along a two-lane highway with picturesque desert and mountains in the background before the truck pulls into a roadside gas station. *They Drive by Night* explores a working-class

world of labor struggles in the transport industry contrasted against the luxurious life led by trucking entrepreneur Ed Carlsen (Alan Hale) and his adulterous wife Lana Carlsen (Ida Lupino). Portrayed as a *nouveau riche* owner of a trucking company, Ed is fond of gadgets that his newfound wealth permits him to acquire. The recently installed electric garage doors in Ed's lavish home ultimately provides the means by which his wife Lana can murder him.

With the motif of transport immediately established from the opening credits of the film, Walsh depicts the everyday milieu of the transport industry and working conditions of truck drivers. The film's locales are auto repair shops, roadside diners, and the gas stations of Los Angeles' transport corridors, which are shown to be dangerous and ill-equipped for any growth in traffic. In just 15 years (1915–1930), the number of trucks in the United States had grown from 158,000 to 3.5 million (Gillham, 2002, p. 34). Produced in 1940 and predating the arrival of interstate highways and freeway development, *They Drive by Night* captured the interurban spaces of roadways that were struggling to keep pace with the growth of trucking transportation and the private car.

They Drive by Night is not quite a road movie in the vein of Edward Ulmer's film noir classic, *Detour* (1945); instead, it provides glimpses into a work-a-day roadside culture of all-night diners and truck-stop cafes populated by a constant stream of male truck drivers and female waitstaff who have to fend off sexual advances through wisecracking. Often reduced to being described as a 'trucker film,' it is an atypical film noir overshadowed by director Raoul Walsh's two other more highly celebrated productions, *High Sierra* (1941) and *White Heat* (1949). The virtues of *They Drive by Night*, however, stem from a social conscience that explores issues of exploitation and the difficulties confronting small businesses battling the monopolistic practices of California's transport industries.

The tension and conflicts experienced by the film's characters are shown arising from the pressures of making timely deliveries across California's road network, which appears ill-equipped for the growing demands placed on it by car and truck drivers alike. Treacherous single-lane roads are portrayed as dangerous and inadequate, responsible for taking the lives and livelihoods of struggling truck drivers. Aside from the interior scenes shot on soundstages at Warner Bros. Burbank Studios, the action sequences occur on tightly winding roads, precisely the kind that would soon be bypassed by multilane, interstate highways.

Drive – The Means Is the End

By the middle of the 1950s, as film noir was nearing the end of the classical cycle, such productions as *Kiss Me Deadly* (Aldrich, 1955) with its atomic age plot, and *Plunder Road* (Cornfield, 1957), a heist film enabled

by the interstate highway system, not only featured content involving themes of social and physical mobility, but also embraced production techniques that propelled the apparatus of filmmaking into real-time motion. Car-mounted cameras embodied the new dynamics undergirding the culture of mobility in Los Angeles and California more generally. Mobile cameras mounted on and in cars orientated viewers and audiences into perspectives through car windscreens. Increasingly in noir, remaining in motion conveyed contemporary spatial experience, and cinema more generally was contributing to the sense of perpetual movement.

In 1955, Robert Aldrich's *Kiss Me Deadly* was a film noir on the brink of neo noir self-consciousness. Straddling both forms of centripetal and centrifugal urbanism, the film captured a Los Angeles poised between the competing forces of urban dispersal and urban concentration. Private detective Mike Hammer conducts his investigations in the ruins of centripetal Los Angeles' Bunker Hill. Aldrich's film captures what Mike Davis has described as Bunker Hill's 'epic dereliction,' with its decaying boarding houses, and the crumbling Angels Flight funicular. In stark contrast, Detective Mike Hammer's home/office on the west side of Los Angeles is situated in an international-style apartment complex featuring an intercom and telephone answering service and occupies an entire city block on the corner of Wilshire Boulevard and Beverley Glen. With its theme of nuclear espionage and government conspiracy, *Kiss Me Deadly* portrays Los Angeles in the new centrifugal terms of ceaseless mobility dominated by cars and freeways – gleaming product of the atomic age that can stage the end of the world.

Kiss Me Deadly captures some of the defining issues shaping the postwar period: nuclear threat, the Cold War, consumer society, and the car as status symbol. The film represents a milestone in the classical era of film noir, owing to the rare combination of talents coalescing on a single project. Mickey Spillane's novel was adapted by established crime author and screenwriter, A. I. Bezzerides, allowing director Robert Aldrich to create a baroque noir for the atomic era. The locations used in *Kiss Me Deadly* record the residual centripetal spaces of Los Angeles amid an emerging centrifugal urbanism driving the city's spatial transformation.

In a similar vein to *They Drive by Night*, the opening images of *Kiss Me Deadly* feature a road at night. But instead of a fixed camera view simply recording onscreen movement, through a continuous tracking shot the camera is also in motion following Christina Bailey (Cloris Leachman) running barefoot down a darkened, rural highway. Three repeat sequences show her frantically trying to wave down passing traffic, to no avail. The success of her fourth attempt is conveyed by cutting to a dramatic point-of-view shot through the windscreen of a sports car heading straight towards her. The moving camera, supported by confrontational camera angles, constructs a first-person perspective, thrusting the viewer into the action and anxiety experienced by Bailey. It then rapidly

shifts to the point of view of Mike Hammer (Ralph Meeker) as he just manages to avoid driving into her. Far from any sort of heroic rescue, Mike Hammer's first words to her are, 'You almost wrecked my car.' After Christina climbs into Hammer's sports car, cinematographer Ernst Laszlo's camera is positioned behind the front seats, providing a third-person perspective through the car windscreen. Although suggestive of a point-of-view shot of the road, the rear of both Hammer and Bailey's heads remain in shot, albeit in silhouette. This single shot is held for close to two minutes, while the credits roll down the screen, and echo the movement from the dividing lines of the highway, which flows vertically down the center of the screen. Throughout the credit sequence, Christina whimpers beneath the Nat 'King' Cole track, 'Rather Have the Blues,' foreshadowing how diegetic and nondiegetic sound would be combined as part of the baroque approach to the noir stylistics applied throughout the film. From the moment *Kiss Me Deadly* opens, motion is used as the organizing principal. Through a mobile camera, form and content coalesce in a dynamic, often excessive visual style that also speaks to the growing self-consciousness of film noir productions in its transition to the genre of neo noir.

According to its press release, 75 percent of *Kiss Me Deadly* was filmed using exterior locations across Los Angeles: Hollywood, Malibu, Bunker Hill, Wilshire Boulevard, Beverly Hills, Sunset Boulevard, and Calabasas. The first three scenes comprising the opening nine minutes use Hammer's car as the central device, orientating the narrative with an outdoor road scene. Rather than being filmed through a conventional back projection on a studio soundstage, however, the scenes have been shot on location along a dark and desolate highway.[3] When Hammer and Bailey are captured at a roadblock, they are drugged by an anonymous-sounding official and beaten by hired criminals. Bailey is killed, but Hammer survives the car wreck used to mask his attempted murder. Later, he overcomes another attempt on his life when he is gifted a 1954 Chevrolet Corvette C1 that has not one, but two bombs hidden in it.[4]

In *Kiss Me Deadly*, cars serve as essential plot devices as well as offer key insights into character. Ever since 1922 in Sinclair Lewis's bestselling novel, *Babbitt*, about middle-class conformity amid the upheavals of American society after World War I, cars have been used to infer traits associated with American masculinity, freedom, and individual liberty. As Lewis (1922) wrote, 'To George F. Babbitt his motor car was poetry and tragedy, love and heroism. The office was his pirate ship, but the car his perilous excursion ashore'. Thirty years later in the context of another postwar era in America, cars had rapidly gone from a luxury to a necessity, especially in sprawling Los Angeles. The proliferation of car brands and competing styles positioned cars as middle-class status symbols and markers of individualism, features that remain the basis of all car marketing and advertising. Like most Los Angelenos in the

mid-1950s, Hammer's car is an indispensable necessity, but it is also one that assumes a symbolic function elevating it far beyond pure utility. Making such associations explicit, the two-seater, Jaguar sports car provides the basis for Christina's insightful observations about him:

Christina: I was just thinking about how much you can tell about a person from such simple things . . . your car for instance.
Hammer: What kind of message does it send ya?
Christina: You have only one real, lasting, love.
Hammer: Now who could that be?
Christina: You. You're one of those self-indulgent males who thinks about nothing but his clothes, his car, himself.

Bailey concludes the exchange with her damning assessment, 'You're the kind of person who never gives in a relationship, who only takes.' Despite struggling against such innate tendencies that imperils those closest to him, Mike Hammer ends up fulfilling Christina's low assessment of his character. Hammer fails to act beyond the terms of a classical film noir credo, 'What's in it for me?' – a line he actually delivers in response to Lieutenant Pat Murphy's (Wesley Addy) warning not to investigate Christina Bailey's death. Hammer proceeds with his investigation motivated by the belief he has stumbled onto something that is highly valuable. Interviewing Christina's associates, Hammer travels to the rundown boarding houses of Bunker Hill, where he encounters a failed opera singer, a broken-down former journalist, and the stock-standard, obstructive building superintendent who only offers disparaging remarks in place of any assistance. The boarding house where Christina Bailey had resided was like many former Victorian houses in Bunker Hill that had been divided up into small, self-contained rooms catering to the city's itinerant population. As discussed in Chapter 3, by the 1920s the former grand Victorian homes were in a constant state of disrepair and had long been earmarked for demolition. The specific Victorian house used as the location for Christina Bailey's residence was known as The Castle, located at 325 Bunker Hill Avenue, Bunker Hill. In 1969, 14 years after *Kiss Me Deadly*'s principal photography had filmed the house, it was one of two original structures set to be relocated as part of Bunker Hill's major redevelopment. Archival photographs show The Castle and another building, The Salt Box, awaiting final relocation to Montecito Heights in 1969 before arsonists destroyed both buildings and any possibility of preserving them.

 The location cinematography of *Kiss Me Deadly* captures the residual spaces of Los Angeles, and traces of the ways of life that persisted in areas like the downtown district of Bunker Hill. Filmed before it was entirely usurped by the emergent centrifugal energies transforming midcentury Los Angeles, spatial forces were about to sweep away all vestiges of the

Bunker Hill district, right down to its geographical topography. *Kiss Me Deadly* reveals how the two states, residual and emergent, synchronous and nonsynchronous, have been captured and shown to be momentarily coterminous. An emergent urban space remains suspended in *Kiss Me Deadly* because the attendant logics had not yet dismantled the deteriorating built environment of places like Bunker Hill, nor transformed its historical leftovers into forms of urban heritage.

The original Bunker Hill district exemplifies the compulsion within modernity to refuse acknowledgement of the past. Advancing progress at any cost, American urban planners and architects alike repeatedly failed to accommodate the heritage of urban built environments. Writing about twentieth-century American urban planning, Boyer notes,

> [n]ew architectural structures, spaghetti highway interchanges, and historic preservation projects are seldom integrated with the existing urban texture. Instead the historical centers of the city were dangerous to modern life; they had to be completely removed or reduced to museum pieces.
>
> (Boyer, 1983, p. 286)

Often leaving gaping holes in the urban fabric, unconstrained development produced the abstract spaces of modernity that came at the expense of community-bound place. The wholesale removal of such urban districts not only displaces their immediate communities, but also eviscerates the social and individual memory intertwined across their built environments.

In *Kiss Me Deadly*, the rooming/boarding houses, or flop houses, of Bunker Hill stand in stark contrast to Hammer's own apartment situated in a sleek, glass and steel, concrete box replete with answering machine service and an open-plan living arrangement combining home and office. The actual apartment building filmed for Hammer's residence was built in 1951 and features 149 units in an apartment complex that covers an entire city block on 10401 Wilshire Boulevard near the corner of Beverly Glen. This section of Wilshire Boulevard had recently been zoned for midrise apartment development designed to accommodate a growing residential district expanding westwards from Beverly Hills. Hammer's apartment/office on Wilshire Boulevard is a radical departure from the film noir convention of a downtown office festooned with the likes of venetian blinds. Despite his nefarious occupation as a private investigator, Hammer has all the trappings of success. Enjoying the fruits of postwar Los Angeles, he is ensconced in the midcentury design ethos of open plan that combines living space with work space along with all the convenience of the car.

The emergent spatial forces accompanying late modernity in Los Angeles are made visible in *Kiss Me Deadly* through the contrasting locations

used for the film's exterior photography. West Los Angeles and Wilshire Boulevard are a microcosm for mobile Los Angeles and were predictive of trends from the impact of automobiles from the time realtor A.W. Ross purchased 18 square acres surrounding Wilshire Boulevard in 1924. Anticipating the car would make the city's population less dependent on downtown for their shopping, Ross also believed that most people would not travel more than four miles from where they lived in order to shop. The center of his 18-square-acre parcel of land that became known as Miracle Mile, was a 1-mile stretch of Wilshire Boulevard between La Brea and Fairfax Avenues and situated within a 4-mile radius that spanned the most desirable neighborhoods in West Los Angeles: Beverly Hills, Hollywood, West Adams, and Westlake.[5]

In what could have proved a major setback for Ross's vision for his Wilshire business district, the area was zoned for residential development when it was later annexed to the City of Los Angeles. The rezoning was part of an effort to prevent Ross from competing against the interests of downtown businesses. The ability to zone an area exclusively for residential development was a legacy from 1910 when Los Angeles became the first major city in the United States to adopt planning laws that distinguished residential from commercial properties. Ross countered the residential zoning by paying close attention to all the respective building designs, seeking approval for each commercial development with the city's planning commission on a case-by-case basis. In 1928, construction of Bullock's department store cemented Ross's vision for Wilshire Boulevard to serve as a high-end shopping and commercial district to rival downtown. The Wilshire district along Miracle Mile became renowned for the art deco and modern streamlined architecture of its commercial buildings designed with the automobile firmly in mind. For example, the Bullocks store had two-thirds of its lot dedicated to a motor court featuring valet services and 375 free parking spaces. Wilshire Boulevard gradually attracted retailers such as C.H. Baker, Coulter's May Company, Desmonds, Silverwoods, Meyer Siegel, and Phelps Terkel and was identified as the world's first 'linear commercial district.'

Wilshire Boulevard and the Miracle Mile precinct inspired a spatial edict in Ross's thinking, premised on cars traveling down Wilshire Boulevard with a mobile perspective on the passing buildings. Ross prescribed that buildings along Miracle Mile be engineered to accommodate appropriately sized advertising and signage that could easily be viewed through a traveling car windshield. The concept and implication of such thinking would later be wholly inscribed into the urban design of Las Vegas and the popular vernacular of the strip celebrated by Robert Venturi, Denise Scott Brown, and Steven Izenour in their 1972 publication, *Learning from Las Vegas*.

Filled with point-of-view shots through car windscreens, *Kiss Me Deadly* evinces the altered spatial dynamics accompanying speed and

movement from automobiles. When Hammer travels from his Wilshire Boulevard apartment complex at the gleaming western edge of the city to the squalid remains of Bunker Hill and downtown, it is as if he is time-traveling through film noir itself. Returning to the primordial scene of film noir and the disappearing Los Angeles of Bunker Hill, the contemporary horizontal compositions of Wilshire and West Los Angeles become the traditional vertical maze supplied by the downtown district's rotting Victorian mansions turned boarding houses.

The plot of *Kiss Me Deadly* centers around the Pandora's Box of nuclear technology fueling tensions in the broader geopolitical landscape of the Cold War. It also offers unique insight into more local concerns arising from the proliferation of freeways and issues of social isolation posed by centrifugal Los Angeles. In the film, cars and the road systems are not presented in terms of efficient solutions to congestion, but instead are used to promote anonymity among the city's inhabitants and disconnection with the surrounding street life.

Maintaining the film noir tradition of supplying a corrective to the hyperbole of American triumphalism, *Kiss Me Deadly* stands in counterpoint to the utopian promise of cars and interstate freeways. This concept of mobility as freedom had been a staple of urban planning discourse since the General Motors' exhibit and ride, *Futurama*, produced for the New York World's Fair in 1939. Designed to showcase the benefits of America's national network of freeways and superhighways, *Futurama* now stands as a Robert Moses–endorsed relic of utopian modernity, while *Kiss Me Deadly* predicts the values and position of urban activist Jane Jacobs in *The Death and Life of Great American Cities* published in 1961. Both texts question the fervor and zealousness with which urban renewal in America was being pursued from the 1950s through the efficiencies posed by freeway construction. While *Futurama* marks how Americans were sold and marketed the promise of a utopian freeway future, *Kiss Me Deadly* reveals a skepticism towards the car and the path of progress that produced the atomic age. Film noir's like *Kiss Me Deadly* perform some of the few critiques of this period of affluence and complacency during the Eisenhower administration.

The high modernity of freeways and international-style apartment living is contrasted in *Kiss Me Deadly* with the remnants of centripetal Los Angeles through traditional film noir locations around Bunker Hill and the pedestrianism of downtown. *Kiss Me Deadly* chronicles the disparity from the confluence of an emergent urbanism amid a residual urbanism temporally bypassed by modern progress. This spatial dynamic testifies to periods of rapid urban development that produces nonsynchronous historical space. Over time, such districts either become entirely erased, as is the case with the original Bunker Hill district, or occasionally, preserved as forms of architectural simulacra through their assimilation into heritage precincts.

Kiss Me Deadly has excessive stylistic flourishes that qualify it as a baroque film noir three years prior to Orson Welles's *Touch of Evil*, which was consumed by such stylistics. Yet *Kiss Me Deadly* remains distinctly modern in both style and content by shifting the milieu of film noir out of its traditional criminal context into the wider social domain of intelligence agencies and politics, a direction that would be developed by the subsequent proto-neo noir of the 1960s, like, *The Manchurian Candidate* (Frankenheimer, 1962). In *Kiss Me Deadly*, we are presented with a midcentury Los Angeles as it transitioned from the walking city of modernity to the new centrifugal urbanism dominated by the automobile. Just like Christina Bailey's haunting epitaph – 'Remember me' – *Kiss Me Deadly* preserves a *lost* Los Angeles, one that still contained a residual 1940s urbanism amid the accelerating transformations from centrifugal space.

Perpetual Motion

Mobility has long been an essential component to everyday life in Los Angeles. By the 1930s, the vast distances spanning its urban sprawl was seen as a crippling burden if it had to be tackled by public transport. As hard-boiled novelist, James M. Cain observed about Los Angeles as early as 1933, 'The distances are so vast, the waste of time so cruel if you go by bus or street car, that you must have your own transportation. . . . Everybody has some kind of second- or third- or ninth-hand flivver; even the cook comes to work in her car' (Cain, 1933, pp. 266–280). The level of personal mobility afforded by the private car offered the hope of traveling on one's own terms. While, for Los Angeles native, novelist Joan Didion, power, freedom, mobility, and the West are bound together in a uniquely American mythology,

> [T]he secret point of money and power in America is neither the things that money can buy nor power for power's sake (Americans are uneasy with their possessions, guilty about power, all of which is difficult for Europeans to perceive because they are themselves so truly materialistic, so versed in the uses of power), but absolute personal freedom, mobility, privacy. It is the instinct which drove America to the Pacific, all through the nineteenth century, the desire to be able to find a restaurant open in case you want a sandwich, to be a free agent, live by one's own rules.
>
> (Didion, 2005, p. 62)

Absolute personal freedom and living according to one's own rules may form a quintessential part of American desire, yet they are also indicative of criminal aspiration. In film noir, escaping the constraints of society means beating it at its own repressive game, and the simplest way to

achieve this is through an illicit haul of cash. Heist films such as *The Killing* (Kubrick, 1956) are typically about robbing cash reserves, usually from banks, armored cars, or with Kubrick's film, a Los Angeles racetrack. But in the case of *Plunder Road* (Cornfield, 1957), it is about the theft of gold bullion.

Released two years after *Kiss Me Deadly* and one year before *Touch of Evil*, the 1957 heist film, *Plunder Road* was produced just prior to the end of the classical film noir cycle. With a plot influenced by California's freeway culture, the film reflects the transformations in California's road systems since World War II and the opening of the Arroyo Seco Parkway. From the very opening, motion provides the basis of both the form and content of the imagery. Similar to *They Drive by Night*, *Plunder Road* dispenses with the conventional aerial photography of a cityscape that was standard in 1940s film noirs. Instead, shots of a road in close-up, filmed from a traveling camera that features the center line and other highway markings, are used to punctuate the opening titles. A sequence featuring winding asphalt, followed by a montage of road imagery, anchor the motif signaled by the film's title. In the 1950s, a road shown in motion punctuates the visual grammar conveying criminality and pursuit. Decades later, the same kind of sequence would become the signature of countless road movie–style neo noirs, from David Lynch's *Wild at Heart* (1990) and *Lost Highway* (1997) to Oliver Stone's *U-Turn* (1997).

The first words heard in *Plunder Road* – "Seven minutes late . . ." – are part of an inner dialogue by Eddie Harris (Gene Raymond) as he sits in the cab of a truck being driven through rural California. As the architect of the heist at the center of the film's plot, Harris's words establish the inextricable link between time and motion that governs the tension of heist films. Acutely aware of the minutiae upon which his intricately planned heist depends, Harris orchestrates a daring $10 million gold bullion robbery from a U.S. Mint train bound for San Francisco. While the premise harks back to train robberies of the Wild West, *Plunder Road* firmly places the dynamics of the plot at the mercy of the logics of the freeway era. Aside from the actual theft of the gold from a derailed train, the entire narrative of *Plunder Road* occurs on interstate highways and within and among the roadside establishments that sprouted around the new road networks: gas stations, quick-stop diners, motels, truck weigh-in centers, as well as police roadblocks. Each site represents a hurdle to be overcome by the three trucks and their crew dispersed across the interstate highway network as they carry the stolen gold bullion. Avoiding capture involves each of the drivers monitoring police and news bulletins on their truck radios, which constantly play in their various roadside stops.

One of the biggest obstacles to the crew's successful escape is the materiality posed by the physical weight of the gold bars. Hauling the bullion from the train into the trucks requires an industrial crane mounted on

another truck that is quickly discarded. Two factors, police broadcasts and the weight of the gold bounty, lead to the capture of the first two trucks. Eddie warns his crew that intercepting the Mint train only represented the first hurdle. The real challenge to the heist lays in the modern network of freeways and communications producing enhanced levels of surveillance through a tightening police web.

> Eddie: Before we start congratulating ourselves, let's remember we've still got 900 miles to every cop between here and the coast.
> (Cornfield, *Plunder Road*, 1957)

The final details of the plan behind the heist are revealed in the last twenty minutes of the film when the gold bullion being transported by Harris and Chardon arrives in Los Angeles at a small factory with a smelting oven. The gold bars are recast into commonplace automobile parts like bumpers and hubcaps, then mounted onto an ordinary looking Cadillac that they attempt to drive to the Port of San Pedro using the Los Angeles Harbor Freeway (California 11). Adhering to heist movie conventions, in the final moments of the film, just when it seems that they have overcome all the obstacles preventing their escape, an innocuous fender bender accident on the Harbor Freeway culminates in their exposure and capture. When the driver behind Eddie's car is distracted by the scene from an earlier car crash, she accidently bumps into the rear of their Cadillac. The gold bumper (concealed through chrome plating) becomes entangled with her car. When the police try to assist by separating the cars they notice the gold beneath the scratched chrome plating. The combination of these minor car accidents on the Harbor Freeway prove more disastrous for Eddie than all the previous police interventions and lay beyond the scope of all of his careful planning and timing.

As suggested by its title, *Plunder Road* employs freeways in narrative terms that far exceed a simple background. In contrast to *They Drive by Night* filmed 17 years earlier, *Plunder Road* reveals how the spatial environment of Los Angeles and Southern California has become dominated by freeways and exerts influences far beyond transport industries. As the site of a new cultural milieu, the freeway network represents a spatial dimension that, despite its utopian promise, ultimately proves to be an unpredictable system. The culture of mobility in *Plunder Road* and the freeways overlaying local road systems linking Los Angeles into state and national transportation grids are already showing signs of overcrowding and traffic jams. Although they offer the temporary means of escape, in *Plunder Road* freeways combine with telecommunications into a system of increased surveillance with a ubiquitous police presence. Immobilized in a traffic jam, the film culminates in Eddie trying to flee an arbitrary police patrol and plummeting off the edge of the Harbor freeway to his death. As Baudrillard would later eulogize in *America* (Baudrilliard,

1983), freeways are a site of spectacle as much as a site of utility, and *Plunder Road* exploits them as a space of representation, where mundane congestion is shown to cripple the utopian promise of unimpeded mobility.

Conclusion

Stalagmite New York, with its vertical skyscrapers, finds its horizontal equivalent in Los Angeles with its ubiquitous freeways and their monumental horizontal form. As well as providing Los Angeles with its signature exoskeleton that Chandler had always accused the city of lacking, freeways multiplied the city's spatial physiognomies and the forces of centrifugal dispersion. The centrifugal energies shaping postwar Los Angeles continued to gather momentum in other American cities, but as a harbinger of things to come, Los Angeles actually managed to live up to some of its boosterism rhetoric. As it turned out, Los Angeles was the future. Classical 1950s film noirs like *Kiss Me Deadly* and *Plunder Road* captured the spatial dynamics giving rise to this future and sounded alarm bells about its shortcomings.

Pioneering the defining characteristics of postwar urbanism, Los Angeles foreshadowed how American cities would come to be dominated by decentralization, cars, freeways, and suburban expansion. Shopping malls, tract housing and lifestyles based on consumption reflected the growing service economy of postindustrialization under late capitalism. But as the postwar expansion of the American economy delivered on the promise of the American century, skeptical film noir faded from view. It would take an oil crisis, the Nixon Administration, an economic recession, and the intractable issue of the Vietnam War in the 1970s to give noir a renewed cultural currency. Before it could reemerge as neo noir and a mainstay of American cinema, however, the representation of Los Angeles and Hollywood's film noir heritage would have to be deconstructed then reconstructed.

Notes

1. Retrieved August 2019, from www.discoverlosangeles.com/things-to-do/historical-timeline-of-los-angeles.
2. www.scribd.com/document/289286115/1937-Traffic-Survey-Los-Angeles-Metropolitan-Area.
3. Retrieved October 2018, from AFI https://catalog.afi.com/Catalog/moviedetails/51550.
4. The actual black Corvette used in the production was one of only four built with a rare black paintjob. www.corvsport.com/making-history-famous-corvettes-time/.
5. Preservation Plan, Miracle Mile North, pp. 17–19. Retrieved November 29, 2018, from https://preservation.lacity.org/files/Miracle%20Mile%20North%20PP.pdf.

References

Aldrich, R. (Director). (1955) *Kiss Me Deadly*. United Artists.

Avila, E. (2013). All freeways lead to East Los Angeles. In W. de Wit & C.J. Alexander (Eds.), *Overdrive: L.A. constructs the future, 1940–1990* (pp. 35–48). Los Angeles: Getty Research Institute.

Baudrilliard, J. (1983). *America*. London: Verso.

Berman, M. (1988). *All that is solid melts into air: The experience of modernity*. New York: Viking Penguin.

Bottles, S. (1987). *Los Angeles and the automobile: The making of the modern city*. – ebook chapter 4 [paragraph 1, location 977] Berkeley and Los Angeles: University of California Press.

Boyer, C. (1983). *Dreaming the rational city: The myth of the American city planning*. Cambridge, MA and London: MIT Press.

Cain, J.M. (1933, March 28). Paradise: Civilization of Southern California. *The American Mercury*, *XXVIII*(111).

Chandler, R. (1977). *Raymond Chandler: Complete and unabridged*. London: Heinemann.

Conrad, P. (1998). *Modern times, modern places: Life and art in the 20th century*. London: Thames & Hudson.

Cornfield, H. (Director). (1957). *Plunder Road*. Twentieth Century Fox.

Dear, M. (1996). Intentionality and urbanism in Los Angeles, 1781–1991. In A.J. Scott & E. Soja (Eds.), *The city, Los Angeles and urban theory at the end of the twentieth century*. Berkeley: University of California Press.

De Toth, A. (Director). (1953). *Crime Wave*. Warner Bros.

Didion, J. (2005). 7000 Romaine, Los Angeles 38. In *Live and learn* (Omnibus). *Slouching Towards Bethlehem: Essays, the white album, after Henry*. London, New York, Toronto and Sydney: Harper Perennial.

Edensor, T. (2010). *Geographies of rhythm: Nature, place, mobilities and bodies*. Farnham, Surrey and England: Ashgate.

Fleischer, R. (Director). (1950). *Armored Car Robbery*. RKO.

Foucault, M. (1995). *Discipline and punish: The birth of the prison* (Trans. A. Sheridan). New York: Vintage Books.

Fulton, W. (2001). *The reluctant metropolis*. Baltimore and London: John Hopkins University Press.

Gillham, O. (2002). *The limitless city: A primer on the urban sprawl debate*. Washington, DC: Island Press.

Jacobs, J. (1961). *The death and life of great American cities* (Vintage Books ed.). New York: Vintage Books.

Kubrick, S. (Director). (1956). *The Killing*. United Artists.

Lefebvre, H. (1991). *The production of space* (Trans. D. Nicholson-Smith). Oxford: Blackwell.

Lewis, S. (1922). *Babbitt*. New York: Harcourt, Brace.

Lynch, D. (Director). (1990). *Wild at Heart*. Samuel Goldwyn Company.

Lynch, D. (Director). (1997). *Lost Highway*. October Films.

Ray, N. (Director). (1950). *In a Lonely Place*. Columbia.

Robinson, C.M. (1918). *Modern civic art or the city made beautiful* (4th ed.). New York: Putnam.

Stone, O. (Director). (1997). *U-Turn*. TriStar Pictures.

Ulmer, E. (Director). (1945). *Detour*. Producers Releasing Corporation.

Venturi, R., Scott Brown, D., & Izenour, S. (1977). *Learning from Las Vegas: The forgotten symbolism of architectural form* (Rev. ed.). Cambridge, MA: MIT Press.

Walsh, R. (Director). (1940). *They Drive by Night*. Warner Bros.

Walsh, R. (Director). (1941). *High Sierra*. Warner Bros.

Walsh, R. (Director). (1949). *White Heat*. Warner Bros.

Welles, O. (Director). (1958). *Touch of Evil*. Universal.

Appendix

Despite its reputation, the private car and freeways have not always dominated the transport logics of Los Angeles. Up until the 1920s, Los Angeles claimed to have the world's largest privately owned electric interurban system. Ever since 1873, Los Angeles County had been served by competing systems of public and private transit that included at least 220 companies and operators utilizing diverse forms of transport from horse cars, incline railway, steam trains, cable cars, electric streetcars, interurban cars, trolley buses, to gas- and diesel-powered buses. [www.tiki-toki. com/timeline/entry/49819/Metro-Transportation-Library-and-Archive-History-of-Transit-in-Los-Angeles/#vars!date=1985–10–28_00:00:00] However, through the cumulative effects of the Great Depression, World War II and growing affordability of private car ownership, public transport services across Los Angeles struggled to keep pace with the travel demands of the city's growing population.

Public transport in Los Angeles had been controlled by private enterprise consortiums that dated back to 1901, when Henry Huntington completed construction on his first electric rail line, which ran between Los Angeles and Long Beach. Huntington soon acquired controlling interests in the Los Angeles Railway (LARy) that serviced central Downtown and surrounding neighborhoods including Crenshaw, Boyle Heights, and Echo Park. In 1911, the year of the 'great merger,' eight separate transport companies were consolidated into another Huntington-controlled consortium, the Pacific Electric Railroad Company. As well as operating streetcars, the Pacific Electric Railroad Company operated bus services and an interurban network of electric carriages. The Red Cars, as they became known, operated lines connecting the downtown centers of Los Angeles and San Bernadino to the expanding areas of the surrounding Orange, Riverside, and Ventura Counties. A low-cost and convenient form of public transportation, the Red Cars traveled across the four-district network of the Northern, Eastern, Southern, and Western lines. Comprising an interurban network totaling 1,100 miles of track, Huntington's Red Cars spanned the 450 square miles of the Los Angeles

basin, stretching from San Fernando in the north to Redlands in the west, across to Newport in the south.

Although they were a loss leader, the Pacific Electric's interurban lines were central to the business model for land development across Los Angeles, which was Huntington's primary business interest. His land holdings led development of southern and beachside suburbs such as Redondo Beach and Newport, as well as his namesake suburb, Huntington Beach. His Pacific Electric lines were key contributing factors to the decentered development across the Los Angeles basin, determining patterns in the city's growth until the 1920s. But as land across the Los Angeles basin was exhausted for the purposes of development and suburban subdivision, the Pacific Electric rail network ceased serving the business interests of Huntington and his associates. The cost of maintaining its extensive network meant it was not long before it was soon neglected and falling into disrepair.

By the 1920s, one-third of the street car companies were bankrupt, and more followed during the Depression (Bottles, 1987). By 1922, according to Boyer, across most American cities, 'Rapid streetcar transit had had its heyday; now the automobile held sway and would continue to dominate every practical planner's regional transportation solutions' (Boyer, 1983, p. 180). By the end of the 1930s, the Red Cars had a reputation for unreliable service and overcrowded rail cars; losing their amenability, they were also mired in the growing traffic from cars plaguing downtown Los Angeles. To compound the problems facing mass transit options across Greater Los Angeles, competing interests among the interurban companies clashed with freight railroad and passenger companies. Between the 1920s and 1940s, the business interests of parties such as the Chamber of Commerce of Downtown Los Angeles and the industrial district of San Pedro Harbor were also at odds with each over a unified strategy for transport solutions straddling the Los Angeles basin. Intractable issues, including the construction of a shared central rail station in the downtown, elevated train tracks, and rail corridors through residential areas meant the private and public interests governing rail businesses had become deadlocked in disagreement.

The lack of cooperation and investment prevented improvements to Los Angeles' mass transit system, which seemed to pale in comparison to the benefits posed by the personal automobile. From as early as 1910, the residents of Los Angeles and Southern California had started turning to the automobile as their preferred transport solution to the city's vast distances. Excluding Detroit, the manufacturing center of the American car industry, nowhere in the United States was the popularity of the automobile more pronounced than in Los Angeles. In 1915, the mean rate of car ownership in the United States had been one car for every 43 people, but in Los Angeles this was closer to one car for every eight residents (Bottles, 1987). By 1925, there was one car for every two residents in Los

Angeles, this compared to the national average of one car for every six people (Bottles, 1987).

More than any other mass transit option, the car seemed designed for the geography of Los Angeles and its surrounds. Most significantly, the car offered freedom from the confines of the rail networks, and the time spent traveling via indirect routes in and out of the central nodes of the various rail networks and bus lines. Competing for space among pedestrians, trolley buses, and the electric railways, however, the car exacerbated traffic congestion in downtown Los Angeles, and as it became the preferred choice for transport in Los Angeles, it exerted pressure on the city's inadequate road infrastructure. By the 1930s, accommodating the personal car assumed top priority among all levels of urban planning in Los Angeles.

5 Neo Noirscape of Nostalgia

In the 1970s, the representation of Los Angeles in neo noir assigned new meaning to the city's past as imagined through decades of previous classical film noir productions. Los Angeles' noir heritage proved vital to the development of neo noir as it consolidated into a genre through the productions *The Long Goodbye* (Altman, 1973) and *Chinatown* (Polanski, 1974). In both these productions, and later in *Blade Runner* (Scott, 1982), the nostalgia of film noir infuses the Los Angeles setting that propels the dramaturgical role of the city to new semiotic heights. Nostalgia became a hallmark feature of the new genre of neo noir, with historical resonances supplying the representation of Los Angeles locales with a newfound, postmodern function as 'temporal signifier'. By activating the city's heritage drawn from hard-boiled detective fiction and film noir, Los Angeles settings draw upon actual, imagined, and production histories bound by its imaginary past and inseparability from *Hollywood*.

Understanding how the representation of Los Angeles can operate in temporal terms means approaching its semiotic functions within the sociohistorical context of postmodernity. Coincident with neo noir, by the 1970s postmodern aesthetics were reflecting the cultural logics of late capitalism and an altered modernity as famously charted by Frederic Jameson. Associated with the rise of the image, a fundamental of postmodernity is the waning of historicity. By examining key neo noirs – *The Long Goodbye* (1973), *Chinatown* (1974), and *Blade Runner* (1982) – the logics of postmodernism account for shifts in neo noir's representation of Los Angeles. Each film provides a key milestone in the consolidation of neo noir as a genre and are reexamined in terms of their reliance on the noir heritage of Los Angeles. Embodying postmodern strategies of representation, the three films employ Los Angeles as a temporal signifier, invoking an identity for the city premised on the nostalgia from an imagined past constructed from the fictions of film noir.

Out of the Past: Neo Noir as Genre

Following its predecessor, neo noir in film studies remains a contentious category, from its epistemology through to its current status.

Acknowledging changes in Hollywood's production environment and the self-awareness of film noir as a style, however, there is general consensus that neo noir commences in the early 1960s as classical film noir entered into, 'Hollywood's cultural memory' (Naremore, 1998, p. 135). Early neo noir titles are often referred to as *postnoir*, although *proto-neo* noir better describes a suite of 1960s productions that testify to film noir's gradual resurgence in: *Underworld USA* (Fuller, 1961), *Man-Trap* (O'Brien, 1961), *Cape Fear* (Thompson, 1962), *The Manchurian Candidate* (Frankenheimer, 1962) *The Killers* (Siegel, 1964), *Naked Kiss* (Fuller, 1964), *Brainstorm* (Conrad, 1965), *Harper* (Smight, 1966), *Seconds* (Frankenheimer, 1966), *Point Blank* (Boorman, 1967), *The Detective* (Douglas, 1967), *Bullitt* (Yates, 1969), and *Marlowe* (Bogart, 1969). In these early neo noir productions, the explicit use of noir stylistics and adherence to formal traditions confirm a self-consciousness indicative of genre developments. By the 1970s, they were also clearly responding to substantially different socio-political, cultural and spatial contexts from their film noir predecessors.

Neo noir reflects the political anxieties of the Cold War era and domestic tensions from the war in Vietnam, the civil rights and antiwar movements, oil crisis, economic downturn, and the Nixon Administration. The turbulence and uncertainty of 1970s restored the cultural currency of noir's inherent skepticism and pessimistic tone. One of the key changes to the new cultural context of neo noir was an expanding media environment and proliferating media industries, which led to what Debord characterized as 'society of the spectacle.' James Naremore observes how a neo noir like John Frankenheimer's *The Manchurian Candidate* (1962), foregrounds 'ubiquitous TV monitors' in scenes with discontinuous editing to '. . . create such a disorientating spectacle that nobody can tell image from reality or truth from fiction' (Naremore, 1998, p. 135). As a new genre coinciding with the rise of the media society, the intertextuality employed in neo noir highlights how strategies of self-reflexive postmodernism had made their way from fine art and avant-garde visual practices into mainstream Hollywood.

By the early 1970s, the film noir heritage of American cinema was well established, with noir traditions centered on Los Angeles looming large. After several decades of production that had produced hundreds of film noirs, audiences were as familiar with it as their creators, which forms the basis of a genre contract between audiences and filmmakers. A significant feature of neo noir operating as a genre is that it had to negotiate a sense of nostalgia, not for the Wild West nor the perceived simplicity accompanying America's agrarian and pioneer history, but its recent urban past. In order to maintain its cultural currency, part of the transition from film noir to neo noir meant adapting to Technicolor and unburdening itself from its monochromatic essence. Remaining connected to the tradition of film noir's dark urban fantasies, there was a renewed emphasis on Los Angeles settings, which rise to the level of a convention or trope. In

neo noir, a Los Angeles setting assumes this expanded level of meaning, becoming a site that registers traditions in both film noir and hard-boiled detective fiction.

Beneath the development of film genres lies a highly nuanced relationship between audiences and filmmakers. Genre studies identify how filmmakers must negotiate the delicate terrain of film genres by deploying a calculus delivering a quotient of comfortable familiarity with unanticipated variation (Neale, ed., 2000), (Grant, ed., 2012). Genre narratives are supported by new additions and innovating established sets of codes and conventions that make up the genre, while simultaneously operating alongside fixed and stable components that audiences expect to encounter within a specific genre. Audience expectations drive filmmakers to employ narrative conventions that are immediately recognizable through familiar motifs and tropes associated with a particular genre. At the same time, unanticipated narrative elements and variations on conventions in individual films sustain the genre by adding novelty and surprise. By successfully employing the many well-trodden conventions, audiences anticipate and associate with the genre; but simultaneously deploying innovations, filmmakers steer the genre into previously unexplored territory. The blending of conventions coupled with innovation also ensures established genres adapt to new social and political contexts, thereby maintaining contemporary cultural currency.

It is well documented that the original cycle of film noir writers and directors did not employ the term *film noir* during the time of their actual productions. Instead, the term *film noir* was applied retrospectively by French critics like Nino Frank, Raymond Borde, and Etienne Chaumeton (Borde & Chaumeton, 1955). It was only after World War II that critics identified the dark undercurrents that had taken hold in American filmmaking. Film noir was a thematic and literally dark style embedded in many genres labeled as thriller, intrigue, crime, and police procedural. Part of the uniqueness of film noir has always stemmed from this retrospective identification as a style that could permeate many other genres.

The same unconscious application of noir stylistics could never be said of the neo noir productions from the 1960s. In order for film noir to have traversed the cinematic spectrum from film style to film genre in neo noir, the corpus of film noirs spanning the 1930s to 1958 had to have established a wide set of codes and conventions, themes, characterizations, motifs, and tropes that could anchor both audience expectations and filmmaker proficiencies. The deliberate deployment of film noir stylistics and adaptation of hard-boiled conventions occurring in productions from the 1960s can now be looked back upon as representing the arrival of proto-neo noirs. In the 1960s, *The Killers* (Siegel, 1964), *Harper* (Smight, 1966), *Point Blank* (Boorman, 1967), *Marlowe* (Bogart, 1969), and *Bullitt* (Yates, 1969) connected to a film noir legacy by adapting hard-boiled

fiction novels and employing self-conscious stylistics spanning lighting, camera angles, and editing techniques.

The irony of the waning of film noir at the end of the 1950s was that its demise occurred just at the point that it had become a national American myth. Like the Western, film noir was a unique form of American cultural expression that was witnessing its wholesale appropriation by foreign filmmakers who retailed film noir into local variants. In the hands of French New Wave auteurs, film noir was popular culture code for a transgressive, urban America which, by the 1960s, saw film noir transcending national boundaries and appropriated for all kinds of purposes. La Nouvelle Vague directors such as Godard and Truffaut responded to the unbridled ascent of American mass media, and the dissemination of American power and influence that was expanding through an 'empire of signs' (Hughes, 1997). By appropriating American film noir, the mannerist noirs of Jean-Luc Godard – *Breathless* (Godard, 1960), *Alphaville* (Godard, 1965), and *Made in USA* (Godard, 1966) – deployed an intertextual strategy referencing popular American cinema as the means for critiquing Hollywood's historical dominance as a media industry.

When Godard casts noir directors and actors like Sam Fuller and Jack Palance to play themselves in his films, an intertextual play with the history of film noir is extended through an extratextual denoting of 'Hollywood' as an entire signifying system and discursive set of industrial and textual practices. Godard's films, like other French noirs, for example *Shoot the Piano Player* (Truffaut, 1960) and *Le Samurai* (Melville, 1967), can be seen as European filmmaking entering into a dialogue with American culture through the stylistic vocabulary supplied by film noir. Refracted through a European perspective, film noir was unexpectedly exported back to American audiences and filmmakers just at the time it seemed exhausted as a mode of local cinematic expression in the United States.

Despite film noir's mythical status and vibrant cultural currency with international filmmakers, the number of American productions continued to dwindle. Film noir appeared to be consigned to a historical period associated with postwar American malaise and, by 1960, it was disconnected from a rising youth and counterculture. The issue of cultural relevancy was not confined exclusively to film noir. The same issue of relevancy also applied to other Hollywood staples such as the Musical and the Western in the 1960s. For the key cinema-going demographic of 18–30-year-olds, Hollywood itself was appearing arcane and increasingly disconnected from their lives. Faced with the onslaught of television and unable to engage the vital youth market, Hollywood and the entire studio system underwent one of the largest structural changes in its history. At stake was the all-powerful studio system, with its contracted stars, writers, producers, directors, and vertical integration of production, distribution, and exhibition. Everything the studio system had developed for

over half a century that had become synonymous with 'Hollywood,' was unraveling as the American film industry was pulled into the post-Fordist economics accompanying late capitalism.

While the issue of relevancy may not have been confined to film noir in the context of the 1960s, it was certainly a form of filmmaking that had some of the greatest challenges ahead if it was to survive the industrial, social, and political uprisings of the times. The many challenges facing film noir productions after *Touch of Evil* (Welles, 1958) account for one of the most radical elements to be introduced into film noir – color. The introduction of color into film noir represents a development that could have jeopardized the very basis and definition of noir filmmaking, and, like all innovations, its implementation posed significant risks. The decision to employ color film in the 1960s productions, *The Killers* (Siegel, 1964), *Harper* (Smight, 1966), and *Marlowe* (Bogart, 1969) was undoubtedly the most significant innovation beginning the renovation of film noir that facilitated its transition into the recognizable genre of neo noir.

But if color formed the basis of a strategy each film employed as the means to renegotiate the film noir contract with contemporary audiences, then a Los Angeles location appears to have functioned as a familiar trope designed to offset this radical innovation. Don Siegel's remake of Robert Siodmak's original 1944 film noir starring Burt Lancaster and Ava Gardner, *The Killers* (1964), relocated the narrative from New Jersey to Los Angeles, which may also be seen as a simple budget consideration. But in other films, a Los Angeles setting was a clear way to connect to the city's heritage from film noir.

Harper (1966) is often cited as the first fully fledged neo noir, and features all the hallmarks of the new genre in its adaptation of Ross Macdonald's 1949 crime-mystery novel, *Moving Target*. It was the first novel in the series that established private detective, Lew Archer. By casting Lauren Bacall, *Harper* takes a cue from the French directors of the New Wave, exploiting Bacall's star iconography from the classical film noir era, while her character is even reminiscent of Vivian Rutledge in *The Big Sleep* (Hawks, 1946). Shot on location in Los Angeles and Santa Theresa, 90 miles north of the city, the Los Angeles locales of *Harper* feature Beverly Hills and Malibu and help to embed it in film noir traditions, despite the use of Technicolor. Similarly, *Marlowe* (1969) beginning with its very title evoked its hard-boiled and film noir heritage by adapting the 1949 Raymond Chandler novel, *The Little Sister*. By changing the title to *Marlowe*, it points to the marquee value of Chandler's central detective and reflects both the iconic and mythical status of the Los Angeles–based detective.

The subtle yet calculated adjustments that began to differentiate neo noir from film noir in the 1960s reveal how these productions began to renegotiate the genre contract with contemporary audiences. By marshaling the

vestiges inherited from the traditions of hard-boiled detective fiction and the original cycle of film noir, these early neo noirs were able to counterweight the use of color as a necessary innovation as part of the process of updating noir filmmaking. A Los Angeles setting in these proto-neo noirs performs a countervailing constant against the import of color and contemporary 1960s mores as filmmakers tried to appeal to a new generation of audiences. In early neo noirs, a Los Angeles setting is employed as a familiar, iconic element from the original cycle of film noir, functioning in concert alongside other essential film noir elements drawn from everything Chandleresque and hard-boiled detective fiction. In this respect, as the genre of neo noir was forming, Los Angeles becomes a trope in the same vein as private detectives, femme fatales, double crosses, and antiheroes that anchors traditions and continuity with film noir conventions.

Navigating the Future in Centrifugal Los Angeles

A Los Angeles setting may have assisted continuity between film noir with neo noir, but the city rendered onscreen would be markedly different from the city captured by film noir. The forces reshaping the built environment of urban America had long been gathering pace in Los Angeles as urban development progressed along centrifugal rather than centripetal lines. Between 1950 and 1960, as the urban population of the United States grew by 45 percent, the land it occupied grew by 200 percent (Rae, 1971, pp. 226–227). Centrifugal forces of decentralization – freeways, suburbanization, branch office corporatism, the shopping mall, and telecommunications – drove urban spatial dispersal that forever altered the traditional metropolis of concentrated density.

The urban spaces of traditional downtown districts in modern American cities shaped by centripetal forces had captured the imagination of the filmmakers responsible for the original cycle of film noir. Cavernous alleyways, looming bridges, desolate rail yards, the shadowy, concrete and metal bones of cities refracted through Dutch angle cinematography, and chiaroscuro lighting had shaped film noir representation. But as the centered city of modernity gave way to the decentered urbanism of postmodernity, classical film noir lost one of its defining characteristics.

Centripetal urban form had always been diluted in Los Angeles as a result of its competing regional centers, ensuring that, as a modernist city, Los Angeles was perceived and experienced as a metropolitan anomaly. In 1967, in Robert Fogelson's *The Fragmented Metropolis*, Los Angeles still represented a departure from established patterns of American urban development. Fogelson summarizes it as, 'The essence of Los Angeles was revealed more clearly in its deviations from (rather) than its similarities to the great American metropolis of the nineteenth and twentieth centuries' (Fogelson, 1993, p. 28). But as Greater Los Angeles became connected through its pioneering freeway system, this key driver of centrifugal

urbanism contributed to Los Angeles shifting from the centripetal anomaly of modernity to the centrifugal paradigm of postmodernity.

Under the impacts from what is now understood as the emergence of postmodernity, urban space in the United States was responding to what Dimendberg describes as, 'a vastly different set of spatial and cultural referents' (Dimendberg, 2004, p. 19). The cultural and spatial dynamics of the 1970s are captured in key aspects of neo noir in representations of Los Angeles. Registering the shift from modernity to postmodernity, neo noir evidences some of the earliest tendencies of postmodern cinematic expression. As outlined by Fredric Jameson, the cultural logics accompanying postmodernity is seen in terms of a 'dilemma' and premised on what Jameson argues is 'the incapacity of our minds . . . to map the great global multinational and decentered communicational network in which we find ourselves caught up as individual subjects' (Jameson, 1991, p. 44). Jameson and key commentators on postmodern experience such as Paul Virilio and Jean Baudrillard have focused on these crisis elements of postmodernity, and in terms of its spatial experience, postmodernity is interpreted as a disorientation. Literal spatial disorientation is recounted by Jameson in his wanderings inside the Bonaventure Hotel situated in downtown Los Angeles, which evoked for him a quintessential experience of postmodern space (Jameson, 1991, pp. 38–40).

Jameson, Virilio, and Baudrillard endeavored to chart aspects of the new condition of postmodernity, describing how specific shifts warrant recasting contemporary phenomena from modernism to that of postmodernism. Among the many competing perspectives tackling the conceptual reconfiguration of modernity, mediated cultural experience is understood as playing an instrumental role in the transformation from a modern cultural consciousness to a postmodern one. For Jameson, the cinema remains a preeminent system in the age of media, with its representations hollowing out history and leading to the surface fixations of postmodern forms. Jameson stresses how postmodern representation contributes to empty nostalgia that spells the end of the depth model of history. Under postmodernity, Jameson argues History has become little more than style, revealing, 'an alarming and pathological symptom of a society that has become incapable of dealing with time and history' (Jameson, 1985, p. 117). In their own critiques on postmodernity, Baudrillard and Virillio address the spatial implications of the ascendancy of the sign and the role of media and images in creating hyperreal simulacrums.

More often than not, criticism on the crises of postmodernism focuses on these disorientating and dislocating qualities, as mediated society facilitates the displacement of reality under the power of ceaselessly circulating images. For many critiques on postmodernity, a fundamental requirement of understanding culture after modernism is in "[r]ecognizing that the line between the real and the virtual has fundamentally eroded, and the two have become mutually constitutive . . ." (AlSayyad, 2006, p. 4). Charting

the implications of such phenomenon remains a critical endeavor in confronting the condition of postmodernity. Nevertheless, what is often not acknowledged as part of whatever disorientations arose in the shift from the modern to the postmodern are forms of cultural expressions that strive to maintain processes of reorientation. Rather than interpreting a cultural product such as neo noir as solely symptomatic of the confusion produced by the condition of postmodernity, formative neo noirs in the 1970s such as *The Long Goodbye* (Altman, 1973), *Chinatown* (Polanski, 1974), and *Blade Runner* (Scott, 1981) evidence the means for reclaiming temporal and spatial bearings.

In response to the reconfiguration of space under centrifugal urbanism in the 1970s, the representation of Los Angeles in neo noir forged appropriately postmodern sets of coordinates. Los Angeles starts to function in terms of a very particular spatiotemporal bearing, one that sees it become a central narrative constant in the most vital of neo noirs. As a generic trope in neo noir, Los Angeles begins to function in multiple terms: a setting, dramaturgical context, and in the most peculiarly postmodern manner, as a temporal signifier. Signifying a specific past as imagined through Hollywood history, the Los Angeles of neo noir maintains connections to the city's actual past through its production histories and invocation of a midcentury 'structure of feeling.'

At the literal and explicitly narrative level of an urban setting, Los Angeles provides neo noirs with a contemporary urban context for updated crime narratives involving conventional plots around blackmail, bribery, heists, kidnappings, double crosses, and murder. At another symbolic level, a Los Angeles setting can simultaneously orientate audiences towards established traditions that originated in film noir. In this symbolic mode, Los Angeles performs dramaturgically in plots involving very local preoccupations around the city's Hollywood inspired celebrity culture and the history involving urban rezoning, fraudulent land acquisitions and corruption stemming from the city's rapid urban development.

While complicity between corrupt individuals and bankrupt institutions may feature in other neo noirs set in other cities, there could be no comparable city so directly aligned with the machinations of image culture and the consequences of a 'society of the spectacle' (Debord, 1994). A persistent feature of Los Angeles–based neo noirs is the preoccupation with the image and mediated reality. The striving for social mobility and the pursuit of wealth through illicit means has historically fueled all of noir's desire-laden characters, but when set in Los Angeles, they coalesce around nefarious qualities of an image society. The machinations or power involving image are central to noir narratives set in Los Angeles and span noir titles from *The Bad and the Beautiful* (Minnelli, 1952) to *L.A. Confidential* (Hansen, 1997).

As host to 'Hollywood,' Los Angeles accommodates a highly image-laden economy hosting many media industries and public relations–style

businesses that deal in the abstract relations of marketing, branding, fame, and celebrity. As image-laden businesses, they form part of the industrial ecosystem of Hollywood. Collectively, these firms comprise a disproportionately large part of the city's economic Base, ensuring Los Angeles has become a premier world media city, one of only seven in the top 'alpha' group, out of a total of 284 cities surveyed in 2003 (Krätke, 2011, p. 152).

The power of the image translates into the symbolic economy of global media cities, which is seen to reverse the traditional dynamics operating between Superstructure and Base. Zukin (1991, 1995), Scott (1997), and Krätke (2011) have analyzed how economic relations in the cultural economy of global cities translates into 'cultural capital' responsible for cultural products in which, 'New York, Paris and Berlin operate in cultural and media spheres as "brand names" ' (Krätke, 2011, p. 182). In this sense, Los Angeles developed a preeminent film noir brand, one that was ostensibly at odds with its other associations with sunshine and a relaxed California lifestyle. In neo noir, with Los Angeles functioning as a temporal signifier, its representation is derived from a composite of historical imagery pitted in dialectical opposition to its imaginary noir past. Neo noirs reveal how intertextual meanings generated by Los Angeles the Dark City, as derived from classical film noir, performs in terms of Brooker's, 'active urban imaginary' (Brooker, 2005, p. 214) or what AlSayyad describes as 'cinematic urbanism' (AlSayyad, 2006). Both concepts outline how, through repeated cinematic representation, certain cities have become endowed through imaginary representation as sites that rehearse scenarios communicating the challenges of contemporary life and its future. Through revisiting *The Long Goodbye, Chinatown*, and *Blade Runner*, it is possible to trace how Los Angeles as temporal signifier serves the requisite function behind the concept of an imaginary urbanism and facilitates neo noir's particular treatise on urban postmodernity.

The Deconstruction of Film Noir

In Robert Altman's 1973 film version of *The Long Goodbye*, the period of Chandler's original story has shifted from the Los Angeles of circa 1949–1950 to contemporary 1970s Los Angeles. Replete with traditional noir preoccupations – murder, violence, vice and organized crime – Los Angeles is also shown hosting a hedonistic counterculture mixed in with Hollywood celebrity and beachside ennui. Unlike in traditional film noir, the violence and vice of 1970s Los Angeles no longer occurs in the shadows or is confined to the marginal denizens of Downtown or Bunker Hill. Instead, the moral turpitude of this 'city of dreams' has been legitimized through the city's promotion of an alternative 'lifestyle' that trades on the surplus value of its globalized entertainment industry.

The Long Goodbye opens with views of Los Angeles and Sunset Boulevard through the neo noir optics of a moving car darting across the city at night. Cutting to a disheveled bachelor pad, we are introduced to Elliot Gould's Philip Marlowe, whose apartment features large windows flooding the interior with daylight and views of the surrounding residents. A tone of incongruity is established in the following scene when Chandler's iconic detective wanders into a banal, all-night supermarket, the kind we are all required to inhabit in our daily lives, but which is a far cry from the nightclubs, casinos, and alleyways traditionally associated with Marlowe. Instead, a wide shot establishes an all-night supermarket bathed in fluorescent light that glows behind floor-to-ceiling plate glass windows.[1]

Space in these opening scenes is characterized by transparency and where the traditional private space of Marlowe's office is replaced with the domesticity and distinctly un-private, open space of his apartment. These scenes immediately establish a visual template for contemporary Los Angeles premised on a spatial logic of unabashed transparency and illustrating Walter Benjamin's observation on modern dwelling, 'The twentieth century, with its porosity and transparency, its tendency toward the well-lit and airy, has put an end to dwelling in the old sense' (Hanssen, 2006, p. 256). Confinement had previously characterized both interior and exterior spaces in classical film noir, but in Altman's film, all activities, illicit and otherwise, occur out in the open and are highly visible. Marlowe's neighbors party with illegal drugs and conduct naked yoga session on their balconies, and violent confrontations can happen anywhere and at any time, even social barbecues on Malibu beach in the middle of the day.

Marlowe's apartment is in the streamlined High Tower apartment complex constructed in 1932 and situated on High Tower Drive in Hollywood Heights, North Hollywood. The High Tower apartment complex had been featured in Chandler's 1942 novel, *The High Window*, and Hollywood Heights has been a fixture associated with Hollywood luminaries since the silent movie era. Perched on the edge of a steep escarpment of Hollywood Heights, High Tower features a five-story private elevator providing street access to the individual apartments. It literally elevates Marlowe above the city, which should also reflect his moral standing as Chandler's modern errant knight.

In the opening scenes, Vilmos Zsigmond's cinematography relays a panopticon-style perspective from the apartment complex, which provides uninterrupted views across the flatlands of Los Angeles as it stretches out to the horizon. The visual vista resembles views from the Stahl Residence, Case Study House #22, designed by Pierre Koenig above Hollywood Boulevard and imagery from the iconic black and white photograph by Julius Shulman in 1960. Shulman's photography of modern Los Angeles architecture established compositions based on geometric

juxtaposition that has served as a template for representing Los Angeles' horizon of urban infinity. In the iconic photograph of the Stahl house, Shulman's composition contrasts the distant view of the city and horizontal street grid against the vertical lines of the house with its illuminated glass and steel interiors. The image provides the house with a gravity-defying effect, as sheet glass windows on a concrete base float impossibly while hosting two women in the open plan lounge. In the distant street grid below, the dotted parallel lines of interconnecting streetlights abstract Los Angeles through a horizontal geometry, rendering it two-dimensional. The architectonics of modern Los Angeles were established by these dramatic aspects of the city that multiplied through the architectural photography featured in design and general lifestyle magazines. Schulman's compositions, like the views from Marlowe's apartment in *The Long Goodbye*, invert the visual dynamics induced by a traditional metropolis like New York and the verticality of its skyline. The image of the flat grid represents an indigenous Los Angeles spectacle celebrating its two-dimensional, horizontal urban form and Los Angeles as a centrifugal city in perpetual motion.

When the affordances of the city's freeway system in Altman's *The Long Goodbye* are combined with the cityscape views glimpsed from Marlowe's High Tower apartment complex, they come together to provide a visual account of what Michael Dear describes as, '[t]he apex of twentieth-century modernist urban planning in Los Angeles . . . a freeway rationality.' (Dear, 1996, p. 97). Capturing Los Angeles in this iterative moment, *The Long Goodbye* captures Los Angeles modernity manifesting as 'a flat totalisation' (Dear, Ibid). In what amounts to less than 13 minutes of screen time from the opening credits of the film, Altman's seemingly laconic style in *The Long Goodbye* masks rapid plot developments that rely on the affordances of Los Angeles' centrifugal freeway system. The scenes involving Marlowe and his journey to the supermarket are parallel cut with the character, Terry Lennox, driving alone through the Los Angeles night in his convertible Ferrari sports car. It is later revealed that Terry Lennox has fled a murder scene in the journey from his home in Malibu to Marlowe's bachelor pad/office in Hollywood, where he asks Marlowe to drive him to the Mexican border. The 200-plus-mile journey is completed in the remaining predawn hours since Lennox's 3:00 a.m. arrival at Marlowe's, evidenced by the fluorescent lights emitting a dim glow under the eaves of the border station building. The freeway system compresses all travel time to the extent that, despite the distances involved, when Marlowe arrives back at his High Tower apartment, it is still morning and the police are waiting to question him on Lennox's whereabouts.

By traversing the city's vast geographic and spatial distances, Lennox ensures Marlowe is an accessory to murder. The ease with which Marlowe is able to circulate and move across the City of Los Angeles

in *The Long Goodbye* undermines Marlowe's traditionally, 'privileged position' that Dimendberg argues enabled him to, 'grasp the social and spatial structure of Los Angeles. . .' (Dimendberg, 2004, p. 171). By casually agreeing to drive Lennox to Mexico, however, Altman's Marlowe has clearly *not* grasped the implications of mobility under the new social and spatial structure of 1970s centrifugal Los Angeles, but rather, has been ensnared by it.

In *The Long Goodbye*, Altman's Marlowe falls well short of Raymond Chandler's design for a modern detective as outlined in his essay, "The Simple Art of Murder" published in *The Atlantic Monthly* in April 1944. The quote is routinely used to illustrate the upstanding morality of Chandler's detectives, 'Down these mean streets a man must go, who is not himself mean, who is neither tarnished nor afraid' (Chandler, 1944). In Altman's film, Marlowe's journey down 'mean streets' becomes drives along Los Angeles freeways, and from the very first such journey his traditionally untarnished morality is brought into deep conflict. When Marlowe agrees to drive Terry Lennox to Tijuana, the decision initially reflects the Chandler value of a reliable man who simply assists 'a friend in need.' At the conclusion of Altman's film, however, Marlowe drives back to Mexico in order to shoot and kill Terry Lennox in cold blood. This shocking example of vigilantism completes Altman's overhaul of a central component of Chandler's mythology, that of the untarnished morality of his detective.

In contrast to the iconography of Los Angeles freeways and the geometry of its street grid signifying the apex moment of 1970s Los Angeles as a rational modernist city, 'Hollywood' signifies the countervailing, irrational city of the imaginary. Hollywood and film history in *The Long Goodbye* are constantly referenced through Altman's early use of intertextual, visual, and aural strategies that engage film noir heritage. At the very opening of the film, a dissonant melody of, 'Hooray for Hollywood' is laid over the United Artists logo that leads into the opening tracking shot establishing Marlowe's apartment. Nondiegetic and diegetic cinema space is bridged by the single-track melody through phonograph-style sound quality. The 'Hooray for Hollywood' music introduces an element of bygone cinema that is repeatedly inserted throughout the film by various aural and visual means. For example, the opening tracking shot culminates in the close-up of a wall-mounted bronze relief of palm trees and hills labeled 'Hollywood' that provides a nostalgic accompaniment to the soundtrack. Similarly, the attendant for the Malibu gated community performs impersonations of James Stewart and Barbara Stanwyck, echoing the dissonance from another import from the classical era of Hollywood, Marlowe's 1948 model Cabriolet Lincoln Continental convertible. A visual anachronism, the car clashes with the 1970s setting, exemplifying how Marlowe's values and personal mobility in the tradition

of classical film noir and detective fiction leaves him hopelessly ill-equipped in contemporary Los Angeles.

As a New Hollywood director, Altman was part of the post-Studio generation of filmmakers who were committed to updating the formal, aesthetic, and thematic principles beyond the classical dictates of traditional Hollywood filmmaking. The combination of the intertextual references to film noir and 'Hollywood' are by varying degrees modernist, discursive and self-reflexive, illustrating a poststructuralist strategy at play in Altman's filmmaking for which he is renowned. As Kolker observed about Altman, '[t]he well-made American film, with its steady, linear, and precise development of story and character, appears to Altman to be itself a dislocation and a distortion, a refusal to come to aesthetic terms with the centeredness and incoherence of modernity' (Kolker, 2011, p. 373). The incoherence accompanying this modernist apex is more reminiscent of a nascent postmodernity, and Altman's disruptive efforts to classical Hollywood narrative a strategy of deconstruction, employed to dismantle the cultural myths surrounding film noir. As Kolker observes, Altman was interested in, 'attending to different spaces, both visual and narrative, [so] he can reorient the ways an audience looks at films and understand them and the way they reflect cultural fantasies back to that audience' (Kolker, 2011, p. 373). Reorientating the audience's cultural fantasies means deconstructing it in *The Long Goodbye* through intertextual references to 'Hollywood' and classical film noir.

Compared to *The Manchurian Candidate* produced 11 years earlier, the distinction between the real and a mediated reality has become even more blurred in *The Long Goodbye*. There is no longer any clear demarcation between reality and Hollywood's image-laden version of it in Altman's deconstructed representation of noir Los Angeles. The seamless overlap between fact and fiction, myth and morality, Los Angeles history and Hollywood heritage, play out amid the negative dialectics belying the 'incoherence of modernity.' As a strategy to negotiate this incoherence, Altman not only immerses his characters in the flow of Los Angeles freeways, but also the semiotics of intertextuality.

The actual locales of Los Angeles clearly situate Altman's neo noir in the tradition of film noir, but the visual and aural references to an imaginary landscape from Hollywood function as the disassembling of noir mythology. As well as the 'incoherence of modernity,' Altman is responding to the irrationalities of postmodernity and its image culture. The altered spatial reality of centrifugal Los Angeles accelerates meaning as much as it does traffic with Marlowe's contemporary morality and actions stemming from the affordances of centrifugal Los Angeles circa 1973. Marlowe remains mobile in the classic, modernist tradition of hard-boiled detective fiction, but this is no longer a form of privileged mobility. As signified by his 1948 Cabriolet, his mobility is painfully outdated, unable to keep pace with postmodern reality and its

spatiotemporal distortions. Becoming adrift he ends up as a dupe, a victim, vigilante, and finally, a cold-hearted killer.

The complexities surrounding Marlowe's contemporary morality are contrasted with the mythical signification of 'Hollywood' and 'film noir,' which becomes a hallmark of neo noir. 'Hollywood,' an excessive, superabundant system of signification, becomes a central reference point underlining the unique function Los Angeles provides neo noir. The temporal signification of Los Angeles through its association with 'Hollywood' reflects the spatial exigencies of the city in the 1970s as the rationalities of the material become displaced by the irrationalities of the image. Indicative of postmodern logics, these intuitive tendencies would continue to reshape the representation of Los Angeles and 'Hollywood,' creating highly attuned tropes that characterize the generic rebirth of film noir. By capturing the city at such a pivotal moment, and engaging in such postmodern strategies as deconstruction and intertextuality, the neo noir film *The Long Goodbye* offers strategies for a spatial reorientation that subsequent neo noirs would continue to explore.

As a pivotal neo noir, *The Long Goodbye* dismantles the mythology surrounding film noir and hard-boiled detective fiction by capturing the 'flat totalization' of 1973 Los Angeles. Under the impacts of ubiquitous image-making that coincide with its apex moment through its vast network of freeways, centrifugal urbanism was altering the staging of everyday life. Not just a means to an end as they are in most other American cities, freeways in Los Angeles take on symbolic and social significance. In response to their symbolic status, Baudrillard has described Los Angeles freeways under the banner of 'astral America,' something he defined as, 'not social and cultural America . . . but the America of desert speed, of motels and mineral surfaces' (Baudrillard, 1983, pp. 52–53). For Baudrillard, Los Angeles freeways form a

> [g]igantic, spontaneous spectacle of automotive traffic. A total collective act, staged by the entire population, twenty-four hours a day. By virtue of the sheer size of the layout and the kind of complicity that binds this network of thoroughfares together, traffic here rises to the level of dramatic attraction, acquires the status of symbolic organization.
>
> (Baudrillard, 1983, pp. 52–53)

Twenty-one years after this reverie in 'America,' the neo noir *Crash* (Paul Figgis, 2003) would explicitly devote its entire narrative to the freeway-inspired themes Baudrillard eulogized. At the actual apex moment of modernist urban planning in Los Angeles circa 1973, however, Altman delivers a neo noir deconstruction of film noir as an urban mythology. Articulating postmodern strategies, *The Long Goodbye* expresses

the determining qualities of centrifugal space as it unfolded in journeys across Los Angeles, the ultimate, horizontally dispersed urban setting.

Chinatown and the Reconstruction of Noir

In the wake of *The Long Goodbye's* deconstruction of film noir, *Chinatown* emerged as its supreme reconstruction. Like many of the darkest classical film noirs, *Chinatown* is directed by a European, Roman Polanski, a director who was enjoying growing auteur status in the 1970s. Producer Robert Evans hired Polanski not only on the basis of his impressive track record but, in no small part, because he was an outsider who as a European, in Evans's words, 'sees America differently' (Evans, *Chinatown*, Special Edition DVD, Extras, 2007). Complementing this European/outsider perspective was an ultimate insider, Los Angeles native, Hollywood screenwriter, and veteran script doctor, Robert Towne. The combination of Towne's highly crafted script with Polanski's European vision resulted in a film that would transcend the former limitations of film noir previously imposed by its B-movie heritage.

Referred to as, 'more Chandler than Chandler' and, 'the film that Raymond Chandler *should* have made,' Towne's screenplay laid the foundations for a neo noir transformation of film noir. Rejecting conventions allowing justice or semblance of a personal victory, private detective Jake Gittes is confronted with a web of evil so far beyond his comprehension that all hope of containing it is obliterated. Compounded by the inability to overcome his own failings, the tragic ending sees the innocent destroyed and the incestuous Noah Cross escape to continue familial rape. *Chinatown's* ending exceeds that of *The Long Goodbye*, in that personal damnation becomes a sociohistorical condemnation, with a Shakespearean musing on 'the futility of good intentions' (Towne, *Chinatown*, 2007).

At the dark center of *Chinatown* lies the incestuous rape of Evelyn Mulholland (Faye Dunaway) by her father, Noah Cross (John Huston) – an act regularly discussed in the prosaic terms as a metaphor about the rape of Los Angeles as a result of rapid urban redevelopment in the 1970s. Indeed, Robert Towne did conceive the screenplay for *Chinatown* against a backdrop of tumultuous change in Los Angeles, but as discussed in Chapter 2, he was also motivated by resurrecting *Chandleresque Los Angeles*.

The second key influence on Towne's gestation process for a detective story set in Los Angeles was the historical study by Carey McWilliams's *Southern California: An Island on the Land*, (1946). The element of Los Angeles history chronicled by McWilliams's study that caught Towne's attention was the role played by water in the development and expansion of Los Angeles under the city's chief engineer, William Mulholland. As the central figure behind the Owens River aqueduct project, Mulholland is attributed with extending the city's boundaries, and altering the water

rights that led to the 1940s property boom in the San Fernando Valley. The final creative element arose from a chance encounter between Towne and a former Los Angeles vice detective. In a conversation, he revealed to Towne that his duties in the downtown district of Los Angeles' actual Chinatown were governed by the principle of doing, 'as little as possible.' The candid admission alerted Towne to the theme of powerlessness expressed as 'the futility of good intentions.'

Robert Towne's screenplay suffuses each element into an oedipal narrative on power shaped around an unconventional detective story. According to Towne, he did not want to write just any kind of detective story; instead, he wanted a 'detective movie not about those things that had traditionally been done in films but about something that is in front of your face every day like water and power and to make that a mystery, make a mystery out of the fact the reservoirs are being emptied – it's something you can follow through the city' (Towne, *Chinatown*, 2007. Towne's description of the plot evokes Kracauer's perspective on how the essence of film is about revealing what is visible right in front of us, yet has become invisible by virtue of being so over and abundantly present. Similarly, the physical infrastructure of water in Los Angeles and the omnipresence of the city in *Chinatown* conceals the crime of its origins.

In *Chinatown*, Los Angeles is one expansive crime scene, one in which everyone is so immersed they cannot see what is before their very eyes. Towne's innovative notion that a mystery be comprised from what is highly visible and embedded in the physical elements of the surrounding city seems to contravene the operations of almost every detective story preceding it. Traditionally, the dualistic construction of a mystery narrative requires a hidden story to precede the narrative investigation that commences when characters are confronted with the effects of the crime. In detective fiction, the equation of cause and effect is effectively reversed. The investigation pursues the persons (perpetrators) and reasons (motives) that constitute causes in the wake of effects. Beneath the investigation narrative is a chronological series of events that lay hidden among these effects. Once exposed, the causes will deliver the denouement that concludes both the investigation and the story. Exposing the hidden story requires the narrative to reveal what has previously transpired. The role of the Detective is to effectively uncover and expose the hidden story by way of the investigation that propels the narrative forward. Chandler himself describes the structural manifold of the detective narrative:

> In its essence the crime story is simple. It consists of two stories. One is known only to the criminal and the author himself. It is usually simple, consisting chiefly of the commission of a murder and the criminal's attempts to cover up after it. . . . The other story is the story which is told.
>
> (Raymond Chandler, in MacShane, 2006, p. 42).

In *Chinatown*, the causes for the hidden story lay in the history of Los Angeles. The city's boundaries and incorporation of the San Fernando Valley conceal the secrets that hide the origins of Greater Los Angeles.

Skillfully merging history with fiction, the significance of *Chinatown* is in its vivid reconstruction of a historical 1930s Los Angeles, but one that has been composited out of the heritage from hard-boiled detective fiction and film noir. Robert Towne and the authors of the original *L.A. Times* newspaper article about Chandler and Los Angeles were responding to what Calwetti describes as the, "temporal-spatial aura" with which film noir provides Southern California settings (Calwetti, 2012, p. 280). By his own accounts, Roman Polanski interpreted Robert Towne's screenplay through the direct lens of Chandler, stating, 'As a film, the style I wanted to give Raymond Chandler style [sic] when he writes his story in the first person' (Polanski, *Chinatown*, 2007). 'Style' is an all-encompassing notion for Polanski, the directorial key to reifying an imaginary Los Angeles for *Chinatown* derived from Chandler's formalism.

As part of his scriptwriting process, Towne had researched locales that could be used for the period setting of Depression-era Los Angles that reflected the city's historical origins. Principal and location photography commenced on September 28, 1973 and continued until November 1, 1973. The specific physical places chosen for all location photography function as metonyms for historical Los Angeles and its heritage within film noir: Evelyn Mulwray's Spanish Mission mansion; Echo Park; a restricted art deco retirement home; the water reservoirs; City Hall; Downtown; and of course the actual Chinatown itself. When a violent shootout occurs between private detective, Jake Gittes and some harassed farmers, the location utilizes the ultimate symbol of 'LA boosterism' – an orange grove plantation. Instead of representing nature's bounty, however, the parched farmstead serves as a maze leading to an explosive trap. Numerous locations in the film involve other natural spaces, for example, the dry bed of the Los Angeles River, the steep hillside cliff and rocky beach below where the water is being emptied out, and the dry fields in the Owens Valley that will surreptitiously become incorporated into the City. These vestiges of natural space function like memories from a lost Los Angeles prior to its urban sprawl and reflect Towne's acknowledged nostalgia for the city of his childhood (Towne, *Chinatown*, 2007). Each location ensures the real Los Angeles is heavily featured in the film, and in keeping with the thematics of Towne's screenplay, each locale conceals the truth like a bare-faced lie.

If Robert Towne was motivated by a sense of nostalgia for some version of a 'lost Los Angeles,' Roman Polanski certainly was not. In his directorial vision for the film, there would be no place for such sentiment. The production is renowned for the notorious disagreement between Towne and Polanski over the tragic ending involving the death of Evelyn Mulwray. But Polanski was also at odds with the original Director

of Photography, Stanley Cortez. According to Polanksi, Cortez was too traditional in his color and lighting choices, 'He was very much the old-fashioned, old-style DP, and his lighting gave this sort of '40's, '30's look to the film, this Technicolor look' (Polanski, *Chinatown*, 2007). Ruling out Technicolor and the sepia tones meant rejecting the explicit visual style of nostalgia dominating other productions concurrent with *Chinatown*: *The Godfather* (Coppola, 1972), *The Sting* (Hill, 1973), *The Great Gatsby* (Redford, 1974), *The Day of the Locust* (Schlesinger, 1975), and *Farewell My Lovely* (Richards, 1975). According to Polanski, his vision for a sharp, realist aesthetic also brought him into conflict with the Producer and Head of Paramount Studios, Robert Evans: 'I did not want any stylization . . . Bob Evans couldn't understand why I wanted to shoot on Panavision, he would like the film to be stylized like *The Godfather*, as far as the color was concerned that sort of brownish reddish tint, I didn't think it was necessary' (Polanski, *Chinatown*, 2007). Polanski's insistence on the cinematography, like his no-compromise approach to the tragic ending and death of Evelyn Mulwray, reveals his determination, like Altman, to demythologize key elements inherited from film noir. But in contrast to Altman's approach, Polanski was not just dismantling film noir, he was also striving to update it through *Chinatown*.

Resisting any explicit evocation of nostalgia, Polanski, through Cortez's replacement, Director of Photography John Alonzo, embraced contemporary film form through the technological innovations offered by Panavision's camera equipment. The lightweight Panaflex camera could deliver Polanski's realist approach achieved through location cinematography across Los Angeles, where even actual interiors could be exploited rather than soundstage recreations. Commenting on shooting *Chinatown* with the Panaflex, Alonzo stated, "[y]ou can put a Panaflex in a bathroom without taking the walls out and shoot scenes in there" (Cook, 2000, p. 372). The highly mobile cinematography occasionally bordered on a cinema verité, handheld style, and occurred many years prior to the development of Steadicam. Most importantly, the affordances of the Panaflex enabled the camerawork to capture the first-person perspective of Chandler's prose. The innovative choices in cinematography also saw Alonzo and Polanski dispense with the traditional low-key lighting from black-and-white, classical film noir in favor of high-key lighting. Combined with bright exterior photography, each visual element contributed to the contemporary style of *Chinatown* that resists its total recuperation into nostalgia.

Negotiating traditions inherited from film noir and hard-boiled detective fiction, the stylistic updates brought about by camera, color, and lighting choices also complemented Towne's screenplay and its renovation of film noir's plots, characters, and theme. As arguably the first thorough realization of neo noir, *Chinatown* saw a noir Los Angeles reconstructed in the wake of *The Long Goodbye*'s deconstruction of film noir a year

earlier. *Chinatown* stands as one of the strongest evocations of a noir 'aura' that Calwetti argues pervades Southern California settings. What-ever may constitute this noir 'aura,' it is clear from the accounts detail-ing the creative processes and decision-making behind the production of *Chinatown*, as well as its critical and popular reception, that it operates in quite tangible ways and in terms that have been previously discussed as the psychogeography of Los Angeles. Noir as an 'aura' is produced somewhere in the intersection between the Hollywood imaginary Los Angeles in film noir, the literary pulp of hard-boiled detective fiction, and actual places that resonate with the architectural, historical, and spatial dynamics that resonate the city's lost past.

Intertextual Los Angeles and Postmodern Visual Culture

The rich visual surfaces of *Chinatown* are composed from film noir sty-listics updated through the sharply defined color cinematography that relays a sense of contemporary realism never quite before seen in film noir. From its very conception, *Chinatown*'s 1937 noir landscape was one derived from the combination of historical events and figures recom-bined and reimagined through a noir lens that extended all the way back to what has been described as the first detective story, Sophocles' *Oedi-pus Rex*. Mining historical fact for the raw materials for narrative is nothing new among the craft set of talented historical fiction writers. The strong literary tradition is exemplified in the United States by such authors as E.L. Doctorow, who imaginatively reconfigured historical events and persons to form the literary genre of historical fiction. But finding a visual means to accomplish such an image-based interweaving of new and old, historical and imagined, reel and real, relies upon visual technologies and subjectivities that were only just coming to the fore in popular cinema in the 1970s. These subjectivities and technologies were responding to changes in modernity and propagating a postmodern sensibility.

Polanski's directorial sensibility mirrored those of his generation who were the leading filmmakers of New Hollywood. By casting actors like Jack Nicholson – *Easy Rider* (Hopper, 1969), *Five Easy Pieces* (Rafel-son, 1970), *Carnal Knowledge* (Nichols, 1971) – and Faye Dunaway – *Bonnie and Clyde* (Penn, 1967) – Polanski created a dialectic with old Hollywood through the casting of John Huston as Noah Cross. As a 'titan' of traditional Hollywood cinema, Huston was a larger-than-life figure renowned as the director of classical-era film noirs, *The Maltese Falcon* (Huston, 1941), *Treasure of the Sierra Madre* (Huston, 1948) and *Asphalt Jungle* (Huston, 1950). As a signifier of Old Hollywood, Huston appears as the living embodiment of film noir and who is seam-lessly integrated into *Chinatown* due to the meticulously recreated 1930s period setting.

In contrast to how intertextual meanings operate in Altman's *The Long Goodbye*, *Chinatown* employs processes of signification centered on 'Hollywood' that bind textual meanings rather than deconstruct them. *Chinatown* evidences a power of the image and image-making technologies identified in criticism by Jameson, Virilio, and Baudrillard as one of the central tenets beneath postmodern expression. By the 1970s, over half a century of mass circulation of images and mass-produced images had contributed to calling into question what film studies identified as the autonomy of the perceiving subject. The impact of sustained visual consumption across the twentieth century has resulted in the image informing subjective experience of reality on an unparalleled scale. In his chronicling of technologies of vision across the twentieth century, McPhee observes, '[i]n terms of appearances, the mass reproduction and dissemination of images is seen to have penetrated and formed the sensible world in a new and unprecedented sense, so that where modern culture came to see in visual experience the difficult task of discovering or producing form, appearances are now understood to have already been organized or 'pre-formed' (McPhee, 2002, p. 64). This notion of 'pre-formed' appearances characterizes the shift from modern presentation to postmodern *re*presentation, and is unmistakable as one of its earliest iterations of postmodern aesthetics and communication. In fine art, for example, preformed objects formed the basis of the avant-garde's ready-made. While it may date back to Duchamp's Bicycle Wheel of 1913, 1950s Pop Art took the concept to new heights by employing the commonplace objects of mass-produced consumer culture, with Warhol's iconic Campbell Soup cans the most glaring example. Unleashed by referencing, quoting, and appropriating preexisting textual forms, postmodern representation is premised on a subject's knowledge and awareness of preexisting imagery and forms that can be taken from the shelves of everyday life and reappropriated for artistic and aesthetic purposes. A by-product of the mass circulation and consumption of images, of course the widespread impacts from this phenomenon formed the basis of Walter Benjamin's seminal essay, *The Work of Art in the Age of Mechanical Reproduction* (Benjamin, 1936).

The reconstitution of a noir Los Angeles in *Chinatown* from a suite of hard-boiled and film noir tropes and conventions exemplifies what McPhee's describes as 'pre-formed' visual appearances. Real Los Angeles locales circa 1973 were composited alongside an assortment of preexisting components derived from Los Angeles' film noir heritage. From the formal elements of Chandler, like the first-person point-of-view of a private detective, to the physical embodiment of John Huston, *Chinatown* is a generic reformulation of the established elements of film noir. Further, the representation of Los Angeles as a noir city in *Chinatown* is not just enabled by detailed production design involving period furnishings and costumes that have been carefully lit and shot. Through

intertextual operations, the genre of neo noir is responding to the logics of postmodernism and meanings that have been generated by pre-formed visual experience.

In the convergence of filmmaking technologies, postmodern sensibilities, and signification processes enabled by a temporal Los Angeles, *Chinatown* marks an irrefutable turning point that delivers something full-blown and distinctly neo noir. *Chinatown* presents a version of Los Angeles as chimera – part real, part imagined, part historic. By dispensing with noir's conventional plot elements and replacing them with tragic ones, employing color in place of black-and-white, and imprinting real Los Angeles locations with a reconstituted, sunshine noir, *Chinatown* produces a contemporary, multidimensional, neo noir prism. The view constructs Los Angeles as a place activated by its unofficial noir heritage, capable of allegorizing the crises of American politics and capitalism that were etched into the turbulent 1970s by Watergate, the Vietnam War, and the energy crisis. As a cultural product of the early to mid-1970s, *Chinatown* looks to its 'here-and-now' through an allegorical and cinematic 'there-and-then,' merging fact, fiction, real, and imagined temporalities. In 1974, *Chinatown* inaugurated neo noir proper with deep intertextual and extratextual dimensions, defining characteristics of not just neo noir, but what would go on to become hallmarks of postmodern expression amid an empire of signs.

Quiet on The Set of Simulacra – The Noir Heritage of Los Angeles and *Blade Runner*

The production of Ridley Scott's *Blade Runner* represents a formative milestone in neo noir and the film heritage of Los Angeles. What were once disparate histories between the real Los Angeles and the celluloid cities constructed on its studio backlots converge in the production of *Blade Runner*, where sites of real artifacts and reel heritage merge. *Blade Runner* not only draws upon the film noir heritage of Los Angeles, but also the city's production heritage and its ability to construct cinematic versions of other metropolises. Set in the Los Angeles of 2019, initially *Blade Runner* was to be set and shot in New York, where it would be represented as, 'a megalopolis . . . the kind of city that could be where New York and Chicago join' (Sammon, 1996, p. 75). Confronted with budget constraints, a Los Angeles setting was reinstated, principal photography commenced in March 1981 and lasted until June 1981. *Blade Runner* combined location cinematography, for example, the 2nd Street tunnel in Downtown and the noir icon Bradbury building, with elaborate sets constructed on the Warner Bros. backlot in Burbank. Despite the Los Angeles setting, the old New York street on the Warner Bros. backlot supplied the basis of the sets used for exterior photography. Revealingly, a backlot is perhaps the only site where New York and

Chicago *can* actually be joined along with any other city that Hollywood chooses to construct and merge in its cinematic representation of cities.

The old New York Street on the Warner's backlot in Burbank has a long and venerable noir history. Built in 1929, the New York Street has rich provenance in terms of film noir and Hollywood heritage. The site of multiple film noirs, it was where New York settings were regularly constructed, providing the basis of such classics as *The Maltese Falcon* (Huston, 1941) and *The Big Sleep* (Hawks, 1946). Adapted to convey *Blade Runner's* 2019 version of Los Angeles, the New York street on the Burbank backlot was retrofitted to create a future Los Angeles by using the remnants from celluloid New York. Retrofitting Burbank's New York street by applying new technological add-ons to the preexisting architectural facades conveyed a twenty-first century urbanism in overdrive. Upon completion of the retrofit, the backlot was referred to as 'Ridleyville,' after the detailed vision and art direction of Director Ridley Scott. According to Sammon, 'the Old New York Street/Ridleyville set comprised recognizable (although considerably altered) characteristics of Hong Kong, New York, Tokyo's Ginza district, London's Piccadilly Circus and Milan's business area' (Sammon, 1996, p. 101). In effect, Ridleyville was the place where imaginary cities coalesced according to the spatial logics of postmodernism, a site of representation, composited from 'pre-formed' imagery that existed first and foremost on cinema screens, and in the imagination of filmmakers and audiences.

Real Los Angeles locales used for the location cinematography in *Blade Runner* contain deep film noir and hard-boiled detective histories that extend back to Chandler's fiction and the classical era of film noir. The cavernous interior of Union Station in downtown Los Angeles employed to house *Blade Runner's* police headquarters has previously featured in Chandler's novels *The Little Sister* and *Playback* as well as the film noirs *Criss Cross* (Siodmak, 1949), *Union Station* (Maté, 1950), *Cry Danger* (Parrish, 1951), and *Marlowe* (Bogart, 1969). The Bradbury Building at 304 South Broadway, where the final showdown occurs between Deckard and the Replicant, Roy, has featured in the film noirs, *D.O.A.* (Maté, 1949), *M* (Losey, 1951), and *Marlowe* (Bogart, 1969), while the 2nd Street Tunnel has been used since *The Big Sleep* (Hawks, 1946) and continues to be a regular location for car commercials, also appearing in the subsequent retrofitted science fiction film *Gattaca* (Niccol, 1997).

An unmistakable element that defines the Los Angeles of *Blade Runner* is the analogue form of its representation. *Blade Runner* represents one of the final, big budget Hollywood science fiction productions dreamed, designed, and imagined using models, miniatures, sets, and backlot cinematography refracted through a vast array of camera-based visual effects. The processes and effects employed by *Blade Runner* would be rendered obsolete within a few years through the steady advance of Computer

Generated Imagery (CGI), the digital-based special effects upon which the genre of science fiction would quickly become dependent. The analogue physicality that was captured in *Blade Runner* is essential to the urban spectacle created by director, Ridley Scott, comprising a component of the film's continued allure. Upon seeing prerelease footage of the city created in *Blade Runner*, Philip K. Dick, author of *Do Androids Dream of Electric Sheep,* which *Blade Runner* adapted, commented "It isn't even science fiction . . . this is a new art form. It's like time travel. . . . It isn't like anything that has ever been done" (Meehan, 2008, p. 168). At the time of its production in 1981, despite the constraints imposed by analogue nature of its production, the future as styled by the past was groundbreaking. Little in Dick's original novel loaned itself to Scott's bold interpretation that dispensed with the minimalism from conventional science fiction aesthetics.

All manner of retro- and noir-influenced science fiction films have arrived since *Blade Runner,* to the extent they now form subgenres, from Steam Punk to Tech Noir. Prior to 1981, however, there was little, if any evidence of the kind of retro science fiction pioneered by *Blade Runner.* Envisioning the future was dominated by the previous template for design aesthetics, *2001: A Space Odyssey* (Kubrick, 1968), and subsequently, *Star Wars* (Lucas, 1977), where polished white environments conceal the mechanics of a future relying on technology and uninterrupted progress. *Blade Runner*'s recycling of a noir aesthetic, with its attendant moody, dark lighting and retro design, was not only a major departure from the design conventions of the science fiction genre, but also articulated an entirely new perspective on the future. In the aftermath of *Blade Runner,* cinematic representation of the future in science fiction reflects the condition of historical dynamic that Raymond Williams described in terms of the emergent, the dominant, and the residual. Like the expiration of modernity itself, the future in *Blade Runner* is envisioned in terms of a complex cacophony of styles and technology from the past and the present that compete with notions of progress as an ever-expanding horizon of possibility.

As a director renowned for his visual emphases, Scott is unabashed in prioritizing design over other cinematic elements. According to Scott, "sometimes the design is the statement" (Sammon, 1996, p. i). A key image for designing the noir aesthetic of *Blade Runner* was the Edward Hopper painting, *Nighthawks* (1942), an urban scene that signaled a dramatic shift in American modernity in the lead up to World War II. Ridley Scott states, "I was constantly waving a reproduction of this painting under the noses of the production team to illustrate the look and mood I was after in *Blade Runner*" (Sammon, 1996, p. 74). The atmospheric painting, depicting the urban denizens of an all-night diner in New York's Greenwich Village in the 1940s, conveys moody urban

alienation that was far removed from all previous and conventional science fiction design aesthetics.

Despite location cinematography occurring in some of Los Angeles' most iconic noir sites, *Blade Runner* bears little resemblance to the actual City of Los Angeles or how it could evolve in the terms dictated by the DNA of it centrifugal urban form. *Blade Runner* replaced Los Angeles' signature horizontal built environment with a New York style verticality and skyscraper monumentality that confines the denizens of *Blade Runner* to narrow, cavernous, and decaying urban spaces of rain and shadow. Decades of imaginary spaces constructed on the New York street of the Burbank backlot saw it crammed with the production histories of celluloid New York and appear to have imposed determining logics on the spatial configuration of *Blade Runner's* 2019 Los Angeles.

As the various design elements were brought together to create *Blade Runner's* Los Angeles circa 2019, Scott ensured that a technological future was synthesized with a very specific noir past, as opposed to an explicit historical era. Like the Hopper painting, *Nighthawks*, this was the past as imagined by film noir, while a neo noir sensibility was driving the scriptwriting process. David Peoples had been hired to assist with the rewriting of the screenplay that had first been adapted by Hampton Fancher. According to Peoples, during the rewriting period, 'Ridley was sort of heading toward the spirit of *Chinatown*' (Sammon, 1996, p. 59). By the time the final script was delivered, the narrative, characterizations, and production design saw neo noir colliding with science fiction in an entirely unprecedented way. The unmistakable film noir underpinnings prompted the actress Sean Young, who plays the character of Rachel, to state in a 1982 *Blade Runner* press kit, 'I didn't approach it as science fiction. It's a romantic thriller, like *Casablanca*. But instead of Africa, we're in the future' (Sammon, 1996, p. 125). Young's comments are revealing, because in referring to *Casablanca*, Young clearly intends to refer to the all-time Hollywood classic with its film noir undertones more than any actual city in Africa. But by stating how *Blade Runner* shifts from 'Africa' to 'the future,' geographical and temporal displacement becomes equivalent. The collapse of distinctions between space and time through reference to a film like *Casablanca* reveals how this intuitive understanding had become commonplace under the spatial logics of postmodernity.

The visual spectacle of *Blade Runner* that so impressed Philip K. Dick, now situates the film at the end of a period when the cinema was comprised out of the realist elements celebrated by Kracauer. Despite the fantastical qualities of *Blade Runner*, there remain quintessential vestiges of realist representation through its camera-based special effects that anchor the film in analogue reality. For famed Italian director Bernardo Bertolucci, echoing theories of realism explored by Kracauer and Bazin, 'to create the language of the cinema, more than any other form

of expression, you have to put your camera in front of reality, because cinema is made of reality' (Nowell-Smith & Halberstadt, 2000, p. 248). By capturing artifacts from reality, for Bertolucci film provides, 'the language through which reality expresses itself' (Ibid, 2000). Perhaps more than any other genre, the cinema-reality dyad in science fiction has since been decoupled by CGI.

The impact of technological advances on the representation of the city under postmodernity sees the virtual continuing to displace the real. The shift in the aesthetic and audience interpretation of CGI, as opposed to physical cinematography, could parallel the transformations that location filming brought to classical film noir and broader representations of the city. Indexed to the physical world, the optics and photochemistry of analogue filmmaking remain fundamentally different to digital effects. Contemporary digital filmmaking and CGI bears a quantitatively different relationship to that of filming physical reality, as explored by Sobchack (1996), Manovich (2001), and Grainge (2003). The implications of CGI and computer-based filmmaking reflect broader developments in new media, affecting the popular reception of history and its role in social memory. CGI and digital-based filmmaking, comprised from binary numerical code rather than anything physically and photochemically captured by light on celluloid emulsion that is drawn and captured from the real, alters the basis of cinema and its indexicality to reality. As Grainge argues, '[d]igital technology has raised new questions about the ideology of cinematic representation and referentiality and the status of memory is embroiled in these cultural and critical transformations' (Grainge, 2003, p. 216). In the 1990s, such films as *The Fifth Element* (Besson, 1997) and *The Matrix* (Wachowski Bros., 1999) exemplified how digital effects could make the cinematic city boundless. Temporal-spatial representation through CGI enabled a concept such as 'bullet time' in *The Matrix* to depict impossible physical maneuvers in virtual cities revealed to be little more than streaming binary code.

Just as CGI was set to reconfigure the representation of time and urban space beyond anything that was previously recognizable, the representation of Los Angeles in *Blade Runner* offered a multilayered rendering of cinema's analogue city. Descended from both the physical and textual noir heritage in which Los Angeles is immersed, the bricolage comprising *Blade Runner*'s 2019 Los Angeles is uniquely historical. *Blade Runner* was not only comprised from analogue technologies; its logics are bound by them. As Manovich observes, 'it is interesting that fifteen years after *Blow-Up*, *Blade Runner* still applies "old" cinematic logic in relation to the computer-based image. In a well-known scene, the hero uses voice commands to direct a futuristic computer device to pan and zoom into a single image' (Manovich, 2001, p. 291). Despite its analogue basis, the future, Los Angeles and *Blade Runner* remain inextricably bound through its enduring presence in popular and critical discourse as the formative

expression of a postmodern dystopia. Through *Blade Runner*, the Los Angeles setting performs what AlSayyad describes in terms of 'cinematic urbanism,' wherein 'reel cities' are assigned, 'the principal function of anticipating changes in real space' (AlSayyad, 2006, p. 238). In *Blade Runner*, 2019 Los Angeles became emblematic of urban degradation in the face of global environmental catastrophe. Thirty-eight years later, *Blade Runner* still stands as a prescient forecasting of the challenges issuing from accelerating climate change, mass extinctions, and social inequality.

In the early 1970s, if *The Long Goodbye* represented the deconstruction of film noir and *Chinatown* marked the moment film noir was reconstructed into the genre of neo noir, then *Blade Runner* mobilizes the postmodern potential of a neo noir Los Angeles to be projected across the city's entire spatio-temporal spectrum. Beyond visions of the past as an articulation of the present, the Los Angeles of *Blade Runner* defined urban representation of an uncertain future. In doing so, *Blade Runner* created a new horizon for neo noir – one that would usher in the science fiction and neo noir hybrid, Tech Noir, that would reshape the representation of Los Angeles into the 1990s and beyond.

The development of neo noir as genre in the 1970s highlights cinema's ability to use its own histories of representation teleologically. Los Angeles as temporal signifier of a noir imaginary enables it to function as a central reference point in postmodern constructions premised on cinematic as well as literary predecessors. By merging history and fiction within the heightened context of Los Angeles and its Dark City alter ego, films such as *The Long Goodbye*, *Chinatown*, and *Blade Runner* make explicit key phenomenological functions of cinema under postmodernity – one that enables a collective past to be composited out of memory and history; fact and fiction; and past, present, and future imaginings.

As one of the supreme forms of image-led expression, the cinema is approached by such writers as Jameson, Virilio, and Baudrillard as a major contributor to the phenomenon of a postmodern simulacrum and complicit in propagating what David Harvey proclaimed as the 'condition of postmodernity' (Harvey, 1990). In contrast to these positions, and combatting the disorientation associated with postmodern space, is a cinema evocative of psychogeographical dimensions, and Los Angeles as temporal signifier in neo noir alerts us to its possibilities. Notwithstanding the idiosyncrasy that accompanies private cognitive maps, they can nevertheless aid in challenging the omniscience of a postmodernism of repression and surrender. Place and texts are more prone to complement rather than cancel each other out in processes of cognitive mapping that orientate subjects in the altered spatial realities accompanying postmodernity. The future assigned to a 'reel city' like the Los Angeles of 2019 in *Blade Runner* visualizes a dystopian scenario that focuses our collective attention. Almost immediately upon its release, the label *Blade Runner*

became shorthand for all that could go wrong in urban planning and entered critical discourse on the city conducted by urban geographers like Edward Soja, Mike Davis, and David Harvey. Serving as a 'predictive treatise' (AlSayyad, 2006) on our global urban future, *Blade Runner* has continued to inform specialized and popular discourse on the challenges facing cities in the twenty-first century.

As individual texts, the three neo noirs, *The Long Goodbye*, *Chinatown*, and *Blade Runner*, demonstrate how Los Angeles as temporal signifier underpins its representation in the rebirth of film noir as neo noir. The classical cycle of film noir originally incorporated the new spaces generated by the modern metropolis in response to such modern urban issues as alienation, anxiety, and transgressive liberation. As film noir transitioned to the genre of neo noir, the cultural shift associated with postmodernity informed its representation of Los Angeles and its dispersed urban form. In tandem with the city exemplifying centrifugal urbanism, Los Angeles can be seen assuming a function in neo noir where representation of the city serves as a temporal signifier, rendering the past out of Hollywood's cinematic imaginary. Together, *The Long Goodbye*, *Chinatown*, and *Blade Runner* cemented the ability of Los Angeles to function as temporal signifier that is emblematic of the intertextual and extratextual semiotics informing postmodern representation. Under the altered logics of postmodernity, texts regularly operate intertextually alongside other texts, and extratextually against their signified realities. Neo noir demonstrates how signification of the corpus of film noir can occur both inside and outside individual texts to either disrupt or unify narrative meaning by activating Hollywood histories and a film noir past embedded in the real City of Los Angeles.

In *The Long Goodbye*, Altman's approach was to employ extratextual strategies as a disruptive act. The contemporary Los Angeles of 1973 is juxtaposed with references to 'old Hollywood,' and Altman's strategy with these extratextual references produces discursive interventions that amount to processes of narrative deconstruction. In *Chinatown*, the extratextual and intertextual elements are inconspicuously sealed within its lustrous visual surfaces. The narrative is hermetically sealed and distilled across its images by the totality of its vision. After the deconstruction of film noir in *The Long Goodbye*, *Chinatown* saw the arrival of neo noir as a wholly reconstructed genre. By returning to classical conventions of formal and aesthetic unity, its generic reconstitution enabled illusionistic immersion in the most venerable Hollywood tradition. Interlacing fact and fiction, *Chinatown* sinuates a history of Los Angeles within a Hollywood imaginary – the Dark City as invented by film noir. *Blade Runner* subsequently collapses distinctions between real and reel cities by merging the spatio-temporal coordinates of a past and future Los Angeles on the physical sites of the Burbank backlot and locations steeped in film noir heritage. *Blade Runner* reified an imaginary Los Angeles under the

logics of postmodernism that were enabled by a veritable pastiche of past, present, and cinematic cities. Intertextual and extratextual strategies composited real and imagined Los Angeles out of a noir vocabulary originating with Edward Hopper's 1942 painting, *Nighthawks*. While Ridleyville has been erased from Warner Bros.' Burbank backlot, the Los Angeles of *Blade Runner* forever pulses across the city's psychogeography, leading to its long-anticipated sequel released in 2017.

Neo noir sees the history of Los Angeles supplemented by the memory of its noir past. In the 1970s, the representation of Los Angeles was reconfigured in the key neo noir titles, *The Long Goodbye* and *Chinatown*, not as a first order sign denoting Los Angeles, but a second order symbol, a temporal signifier connoting its filmmaking past and noir heritage. Rather than interpreting this kind of phenomenon in terms of crisis, notions ranging from 'structures of feeling,' 'cinematic urbanism,' and 'active urban imaginary' through to psychogeography can assist with reconciling mediated textuality and its impacts on history under the experience of postmodernity.

The work of Raymond Chandler, hard-boiled detective fiction and film noir provide Los Angeles with, what in psychogeographical terms, can be identified as the city's recalcitrant history, one that produces an essential 'past-ness' that defines Los Angeles more along the lines of subjective memory than abstract history. In the 1970s, neo noir mobilized the traditions and meanings that resided in the textual histories of noir and detective fiction scattered across the imagined topographies of Los Angeles's noirscapes. As vital milestones in the development of neo noir, *The Long Goodbye, Chinatown*, and subsequently, *Blade Runner*, chronicle how a temporal Los Angeles can shape official and unofficial histories of the city. Actual historical events, the corpus of film noir, hard-boiled fiction, and the psychogeography of place jostle in each film to construct a discursive history of Los Angeles. Constructing visions of the city out of a composite of noir renderings with the actual Los Angeles sees each film operate intertextually and extratextually. Los Angeles as a spatiotemporal signifier activates production and film noir histories embedded within its Hollywood heritage, which combined with the physical city and its actual history in ways that were unprecedented under modernity.

If New York was the Celluloid City of modernity, a city comprised out of location cinematography and Hollywood backlots, then Los Angeles is the cinematic city of postmodernity. The distinction here between *celluloid* and *cinematic* is poignant. As a celluloid city, New York was dreamed and imagined and finally rendered onscreen to emulate its lived excess under Modernity. As a celluloid city under modernity, the perforated sprockets on the edge of the acetate strip of film clearly delineated where celluloid New York finished and the actual New York commenced. In contrast, from the mid-to late 1960s, Los Angeles is the postmodern, cinematic city. It is the city that is sometimes as tangible as the combined

materiality of the essential components of cinema: studios, production facilities, soundstages, backlots, lights, cameras, actors, theatres, and audiences. But cinema is equally the intangible and the immaterial, those elements that structure its psychological and psychoanalytical dimensions: desire, the imaginary, subjective identification, the sutured experience, the gaze, the gendered, and the Oedipal. Between the material and psychological layers of cinema are its symbolic dimensions: the signs, brands, franchises, genres, and celebrities that underpin the global consumption of filmmaking. All things Cinema may seem disparate, yet they can seamlessly come together in heightened, subjective experiences informing the basis of individual psychogeography and fandom all the way up to the structures of national film industries.

Charting how film noir as a style moved into the genre of neo noir recognizes the shift from film noir representations of the modern city to neo noir representations of postmodern urbanism. By exploring the historical circumstances under which film noir transitioned into fully fledged neo noir, Los Angeles can be seen to have performed an influential, and conceivably, a determining role, in the formation of this new genre. The transition from film noir into neo noir identified in *The Long Goodbye*, *Chinatown*, and *Blade Runner* reveals semiological processes of deconstruction and reconstruction and the ability for representations of Los Angeles to function as a temporal signifier. A hallmark feature of postmodern expression, these kinds of semiotic registers are more familiar as intertexuality but are accompanied in neo noirs with Los Angeles settings through the specific use of extratextuality registering the production histories of Hollywood. Los Angeles becomes a spatiotemporal signifier in exchanges between extratextual and intertextual references and a city that is inextricably bound to its Hollywood alter ego. Through intertextual and extratextual features, neo noir emerged as a postmodern genre, delivering one of the earliest, mainstream cinematic expressions of postmodernism.

Conclusion

While neo noir has developed many of its film noir predecessor's traditions and conventions, it is the genre's ongoing relationship to the City of Los Angeles that illustrates its significant postmodern dimensions. *The Long Goodbye*, *Chinatown*, and *Blade Runner* each configure unique neo noir dynamics that fuse Los Angeles the actual city, with Los Angeles the Dark City of film noir *and* Los Angeles the home of Hollywood. Each film renders a historical moment of both Los Angeles and Hollywood history, as well as forming vital milestones in both the representation of the city and postmodern expression.

As historical developments, neo noir as a genre and centrifugal Los Angeles testify to the spatial and symbolic ways cinema both informs

and responds to urbanism. If postmodern representation reconfigured indexes to the real and our experience of it, then intertextual and extra-textual meanings operated as a tactic to employ our stored knowledge and understanding of the past through cinematic renderings to help differentiate forms of historical representation. Challenging the hollow simulacrum that writers such as Jameson and Baudrillard have focused upon, the relationship between Los Angeles and neo noir suggests how generative, psychogeographical-like possibilities enable informed renego-tiations of an altered postmodern geography.

The representation of Los Angeles' unique spatial elements in neo noir evidence the earliest aesthetic and representational correctives to the disorientating effects of postmodernity. Coinciding with the histori-cal development of centrifugal urbanism in Los Angeles, neo noir as a genre emerged as a space of representation in response to the cultural log-ics of postmodernism. By representing real and imagined histories from film noir as well as the surrounding urban environment of Los Ange-les, *The Long Goodbye, Chinatown*, and *Blade Runner* articulated new spatial relationships affecting the experience of time and place, history, and memory under postmodernity. At the time of these convergences, nostalgia was the label applied to the ensuing collapse in meaning. The reduction of the depth model of history to the surface model of the image was seen by Jameson and others as cause for an epistemological crisis in historical consciousness. In *The Long Goodbye, Chinatown*, and *Blade Runner*, however, nostalgia operates beyond the simple negation of his-tory. Instead, each reveals how nostalgia could be employed in the service of Los Angeles as temporal signifier with its noir heritage functioning as a strategy to navigate the altered spatial and temporal coordinates of postmodern reality.

Note

1. The Coen Brothers satire on all things noir, *The Big Liebowski* (1998), opens similarly in a Ralphs, referencing the incongruous noir locale of all-night supermarket and the blanc noir from bleached white fluorescent lighting.

References

AlSayyad, N. (2006). *Cinematic urbanism: A history of the modern from real to reel*. London and New York: Routledge.

Baudrillard, J. (1983). *America*. London: Verso.

Benjamin, W. (2008 Reprint, 1936). *The work of art in the age of mechanical reproduction*. London: Penguin.

Borde, R., & Chaumeton, E. (1955). *A Panorama du film noir American: 1941– 1953*. Paris: Les Editions de Minuit.

Brooker, P. (2005). Imagining the real: Blade Runner and discourses on the post-metropolis. In W. Brooker (Ed.), *The blade runner experience. Legacy of a science fiction classic* (pp. 214–225). New York: Wallflower Press.

Calwetti, J.G. (2012). Chinatown and generic transformation in recent American films. In B.K. Grant (Ed.), *Film genre reader IV* (4th ed., pp. 279–297). Austin, TX: University of Texas Press.

Chandler, R. (1944, December). The simple art of murder. *The Atlantic Monthly*, Boston, p. 53.

Cook, A. (2000). *Lost illusions: American cinema in the shadow of Watergate and Vietnam, 1970–1979*. Berkeley and Los Angeles: University of California Press.

Dear, M. (1996). Intentionality and urbanism in Los Angeles, 1781–1991. In A.J. Scott & E. Soja (Eds.), *The city, Los Angeles and urban theory at the end of the twentieth century* (pp. 76–105). Berkeley: University of California Press.

Debord, G. (1955, September). Introduction to a critique of urban geography. *Les Lèvres Nues # 6*.

Debord, G. (1994). *Society of the spectacle*. New York: Zone Books.

Dimendberg, E. (2004). *Film noir and the urban spaces of modernity*. Cambridge, Ma: Harvard University Press.

Evans, R. (Producer), Polanski, R. (Director), Towne, R. (Writer). (2007). *Chinatown*. Extras [DVD] Paramount.

Fogelson, R. (1993). *The fragmented metropolis: Los Angeles 1850–1930* (3rd ed.). Cambridge, MA: Harvard University Press.

Grainge, P. (2003). *Memory and popular film*. Manchester: Manchester University Press.

Grant, B. (Ed.). (2012). *Film genre reader IV*. Austin, TX: University of Texas Press.

Hanssen, B. (Ed.). (2006). *Walter Benjamin and the arcades project*. London: Bloomsbury Publishing

Harvey, D. (1990). *The condition of postmodernity: an enquiry into the origins of cultural change*. Cambridge, MA: Blackwell.

Hughes, R. (1997). *American visions: The epic history of art in America*. London: The Harvill Press.

Jameson, F. (1985). Postmodernism and consumer society. In H. Foster (Ed.), *Postmodern culture* (pp. 111–125). London: Pluto Press.

Jameson, F. (1991). *Postmodernism, or the cultural logic of late capitalism*. Durham: Duke University Press.

Kolker, R. (2011). *A cinema of loneliness: Penn, Stone, Kubrick, Scorsese, Spielberg, Altman*. Oxford and New York: Oxford University Press.

Krätke, S. (2011). *The creative capital of cities: Interactive knowledge creation and the urbanization economies of innovation*. Chichester, West Sussex: Wiley-Blackwell.

MacShane, F. (2006). *The notebooks of Raymond Chandler*. New York, London, Toronto and Sydney: Harper Perennial.

Manovich, L. (2001). *The language of new media*. Cambridge, MA: MIT Press.

McPhee, G. (2002). *Architectures of the visible, technology and urban visual culture*. London and New York: Continuum.

Meehan, P. (2008). *Tech noir: The fusion of science fiction and film noir*. Jefferson, NC: McFarland.

Naremore, J. (1998). *More than night, film noir it its contexts.* Los Angeles: University of California Press.

Neale, S. (Ed.). (2000). *Genre and Hollywood.* London and New York: Routledge.

Nowell-Smith, G., & Halberstadt, I. (2000). Interview with Bernardo Bertolucci. In F. S. Gerard, T. J. Kline, & B. Slarew (Eds.), *Bernardo Bertolucci: Interviews* (p. 248). Jackson: University Press of Mississippi.

Rae, J.B. (1971). *The road and the car in American Life.* Cambridge, MA: MIT Press.

Sammon, P. (1996). *Future noir: The making of blade runner.* New York: Harper.

Scott, A.J. (1997). The cultural economy of cities. *International Journal of Urban and Regional Research,* 21(2), 323–339.

Sobchack, V. (1996). *The persistence of history: Cinema, television, and the modern event.* New York: Routledge.

Zukin, S. (1991). *Landscapes of power: From Detroit to Disney World.* Berkeley and Los Angeles: University of California Press.

Zukin, S. (1995). *The cultures of cities.* Oxford: Blackwell.

6 Through a Glass Darkly

Global Los Angeles and Postmodern Noirscapes at the End of the Twentieth Century

The Los Angeles noirscapes reconfigured in the 1980s were impelled under two interrelated forces: the shifting spatial coordinates of globalization and the altered cultural logics of postmodernism. Both forces are symptomatic of late capitalism at the end of the twentieth century and transformations in what conventional Marxism understood to be Base economic elements and its relationship to the Superstructure of social and cultural relations.

In order to assess the global and postmodern dimensions of Los Angeles noirscapes from the 1980s, neo noir is examined in terms of the cultural response to the city's spatial reorientation towards the Pacific Rim, postindustrialization, and the media spectacle of consumer society. During the 1980s and 1990s, a recoding of the city's rich heritage in film noir and hard-boiled detective fiction saw neo noir representations of Los Angeles proceed in two key yet divergent movements. In one movement, the neo noir of nostalgia, films were inwardly propelled by looking back to the classical era of Hollywood film noir, and referentially engaging in an explicit evocation of the city's imaginary past. In another distinct movement, a return to the real, the city's suburbs and industrial fringes were reincorporated into the Los Angeles noirscape as the evacuated spaces of postindustrialization. Both movements signaled specific responses to what can be seen as the altered spatiotemporal logics exerted by the socioeconomic forces of globalization and the condition of postmodernity.

In the nostalgia movement of neo noir, the heritage of hard-boiled detective fiction and classical cycle of film noir is overtly referenced in a number of productions: *Reservoir Dogs* (Tarantino, 1992), *Pulp Fiction* (Tarantino, 1994), *Devil in a Blue Dress* (Franklin, 1995), *Mulholland Falls* (Tamahori, 1996), *Lost Highway* (Lynch, 1996), *Freeway* (Bright, 1996), *L.A. Confidential* (Hanson, 1997), and *Twilight* (Benton, 1998). The layers of intertextuality steeped in references to 'Hollywood,' hard-boiled fiction, and classical film noir construct versions of Los Angeles encased in a temporal semiotic system. This leads to a double binding of past representations of Los Angeles enclosed in the historicized version

of classical film noir. Organized by logics of nostalgia, this iteration of '90s neo noir retreats into the city's imaginary past created by Hollywood. As a distinct movement within neo noir, it encapsulates the waning of history Fredric Jameson identified as emblematic of the condition of postmodernity.

In contrast, the return to the real movement resists the nostalgia tendency and sees neo noir productions drawn to locations across the city that had previously occupied peripheral spaces across Los Angeles. From the suburbs of outlying desert districts to its ports and the industrial fringes of the city, the neo noirs *To Live and Die in L.A.* (Friedkin, 1985), *The Morning After* (Lumet, 1986), *52 Pick-Up* (Frankenheimer, 1986), *One False Move* (Franklin, 1992), *Heat* (Mann, 1994), *The Usual Suspects* (1995), *Se7en* (Fincher, 1995), and *The End of Violence* (Wenders, 1997), incorporated the city's flatlands mapping the diverse impacts of late capitalism across the noir topography of Los Angeles.

The two movements, the return to the real and postmodern nostalgia, see neo noir negotiate the representation of Los Angeles amid the simulations of a mediated society. Building on Guy Debord's *Society of the Spectacle*, Jean Baudrillard argues Western society has come to exist in a state of hyperreality where the real has been overtaken by simulations producing a simulacrum and the annihilation of meaning. The concepts of simulation, simulacrum, and hyperreality are explored in terms of the cultural logics determining the neo noirscape of Los Angeles from the 1980s. In the spaces of representation produced by 1980s and 1990s neo noirs, the neo noirscape exhibits a correlating hyperspace to hyperreality. Operating through layers of intertextuality, the neo noirscape of Los Angeles contains representations negotiating the collapse in hyperreality of critical distance that Fredric Jameson postulated was another symptom of postmodernism. In doing so, intertextuality sees neo noir employing the complex sign connoted by 'Los Angeles' and 'Hollywood' to negotiate processes of representation itself in the midst of hyperreality and the simulacrum.

Lefebvre's notion of the production of space is a stark reminder of how social space, when framed by a such constructs as globalization and postmodernity, is delineated according to symbolic as much as material dimensions. Approaching the real as hyperreal and space as hyperspace repurposes aspects of Lefebvre's triumvirate conception of space that as a three-dimensional analysis describes the processes by which space is *produced*. At once material and concrete as well as abstract and symbolic, understanding the dynamics beneath the production of space relies on combining a phenomenological framework with linguistic models in Lefebvre's dialectical schema for spatial relations. Lefebvre's approach accounts for the mental *and* material dimensions that underpin the social interactions and activities beneath the simultaneities of space. In Lefebvre's approach, space and history are intrinsically relational, so that

conceived space such as the global functions as the repository of compet-
ing forces. As the global exerts normative processes in the production
of space that shapes the everyday of local lived experience, the forces
derived from social and economic drivers combine with historical pro-
cesses to undergird perceptions of social reality.

Accompanying Los Angeles' ascension as an international megalopolis,
the conceived spatial horizons of the city's physical, symbolic, and imag-
ined networks became more internationalized than ever. As transforma-
tions unleashed by the historical tides of late capitalism, the impacts of
these international dimensions on the local spaces of the city resulted in
new economic opportunities as well as social tensions. The confluence of
space and time under the notion of the global displaces local cause-and-
effect logics and therefore resists understanding it in the context of single
place or specific social context. Nevertheless, employing Lefebvre's model
for the production of space, global space can still be traced in terms of the
phenomenological processes: 'spatial practice,' 'representations of space,'
and 'spaces of representation,' In Los Angeles, these can be seen to form
dialectical 'moments' in the production of sociohistorical space. In the
1980s, the 'spatial practice' issuing from globalization operated in con-
junction with the interpolation of neo noir into Los Angeles' 'representa-
tions of space' and 'spaces of representation.' As representational space,
neo noir simultaneously informed and reproduced transformations of the
city's spatial dimensions under globalization, both recording and contrib-
uting to the postmodernism dimensions of Los Angeles.

Los Angeles as media spectacle configures the city in terms of medi-
ated simulations symptomatic of what Jean Baudrillard describes as the
era of hyperreality. Images reverberated globally out of Los Angeles in
the 1990s that superseded those from Hollywood, forcefully erupting
out of the postmodern intensities from video of the Rodney King beat-
ing and relentless news coverage of the LA Riots and O.J. Simpson trial.
The ability of endlessly circulating mediated images to displace the real-
ity of what they once represented, 'have marked and underscored the
fragmented meaning of basic ideas such as justice, equality and the like'
(Manning, 2002, p. 496). The extreme events around Rodney King, the
LA Riots, and O.J. Simpson testify to how the real of social crises in
global Los Angeles were subject to processes of hyperreality and contor-
tions in meaning generated by the image saturation of media spectacle.

In the 1990s, the logics shaping the fictional neo noir landscape of
Los Angeles under postmodernity and globalization forcefully intersected
with the racial tensions in the social realm. The explosive riots sparked
by video of the beating of Rodney King highlight how the racial encod-
ing from an unauthorized image in the age of electronic media could
unleash the city's racial tensions. The infamous amateur video captur-
ing the Rodney King incident exploded across the social realm, and in
semiotic terms, quickly attained the level of the paradigmatic. Powerful

noir aesthetics resided in the Rodney King video with high contrast chiaroscuro lighting, deep shadows, and ominous figures outnumbering and brutalizing a lone, African American male. While such aesthetics were certainly inadvertent in their origins from amateur video, the imagery resonated themes of physical brutality, an unjust and corrupt world that had long underpinned representations of noir Los Angeles.

Two years after the Rodney King video, on June 13, 1994, the discovery of the bodies of Nicole Simpson and Ron Goldman led to the O.J. Simpson murder case and what is argued to have been the most intense real-time media event in American history. The media spectacles surrounding King and Simpson exposed how the real is converted into mediated intensities that can displace the actual events once they are overtaken by processes of representation. For Baudrillard, the incessant reproduction and circulation of images that stand in for the real, means,

> there comes into being a manifold universe of media that are homogenous in their capacity as media and which mutually signify each other and refer back to each other. Each one is reciprocally the content of another; indeed, this ultimately is their message – the totalitarian message of a consumer society.
>
> (Baudrillard, 1967, p. 230)

In theorizing the complexity of our postmodern age, Baudrillard and Jameson have been accused of erasing any sense of agency or resistance amid the semiotic barrage of a society of the spectacle unleashed by the forces of late capitalism. One of the central challenges of postmodernism for Jameson is the loss of distantiation that is required for critique that enables forms of aesthetic resistance. Both Jameson and Baudrillard have suggested a total immersion in simulation may be the only strategy remaining as a response to its 'totalitarianism.' Jameson refers to this immersion as a 'homeopathic' (Jameson, 1991, p. 409) response to the ills of the postmodern. For Jameson, ' "Representation" is both some vague bourgeois conception of reality and also a specific sign system (in the event Hollywood film), and it must now be defamiliarized not by the invention of great or authentic art but by another art, by a radically different practice of signs' (Jameson, 1991, p. 123). The 1990s neo noir, *The End of Violence* (Wenders, 1994) forges the kind of representational space called for by Jameson. Wenders's film explores how image-making and mediated violence is implicated in social violence, examining how the circulation of violence on screens, whether from popular culture or surveillance systems, advances the logics of hyperreality and the procession of the simulacrum. In the representational space of the Los Angeles noirscape, *The End of Violence* combines aspects of the return of the real as well as nostalgia movements and provides one example of how intertextuality may serve in terms of 'a radically different practice of signs' (Ibid, 1991).

This chapter directly responds to Jameson's call for a process of cognitive mapping that he sees as an essential step required to navigate the new coordinates between the social, cultural and economic relations of postmodernity. Responding to the 'crisis of representation' characteristic of postmodernism, Jameson's and Baudrillard's theories of simulations and hyperreality offer valuable insights into the structural relationships occurring at the intersection of a Los Angeles of the real and a Los Angeles of mediated simulations. Tracing the postmodern noirscape of Los Angeles across the swirling surfaces of 1980s and 1990s neo noir reveals how as a genre, key films extended the noirscapes of the city's dark imaginary to the physical edges of the city, while others engaged Los Angeles as a signifying system. In tandem with neo noir cinema, a resurgence in crime writing also featured a Los Angeles intertextually reconstructed from the city's noir heritage, which combined into a veritable pastiche of past, present, and future Los Angeles. More than ever, the neo noirscapes of postmodern Los Angeles blurred the boundaries between fact and fiction, history and memory, as the material city joined the mediated city in the procession of simulacra and hyperreality's disavowal of the real.

Global LA and Local Los Angeles

In terms of perceived, conceived, and lived space, by the 1970s the perception of Los Angeles as a new kind of metropolis brimming with utopian promise had long receded. Amid the general U.S. economic malaise of the mid-1970s – rising inflation and unemployment, the OPEC oil crisis, and Watergate – Los Angeles was also struggling with very local issues stemming from pollution, congestion, housing affordability, rising crime rates, and the destruction of Southern California's natural habitats. In 1978, Proposition 13 marked the end of an economics borne out of a belief in the region's boundless opportunity and potential for urban growth. A citizen-led rejection of property taxes (the very title of Proposition 13, *People's Initiative to Limit Property Taxation*) declared it as an unmistakable popular revolt against the-business-as-usual public revenue raising that historically fueled the region's growth machine.

In restricting how local governments across Greater Los Angeles and Southern California could increase property taxes, the amendment to the Constitution of California exposed how public revenue collection functioned like a 'Ponzi Scheme' (Fulton, 1997, p. 17). Relying on an expanding middle-class tax base to provide the revenue to build the infrastructure and provide the services expected from a growing population required increasing expenditures on infrastructure and services. That in turn required even more funding from increased taxes, creating an unsustainable upward fiscal cycle. By 1978, the provision in Proposition 13 to limit any annual increase in property tax to 1 percent of the property's value cut property taxes by two-thirds. This dramatic cut was in response

to rising real estate prices producing increased property taxes perceived to have the potential to price people out of their own homes, especially the retirees who had funded the expansion of Los Angeles in previous eras. Frustration with tax-based revenue also followed years of discontent with the inadequate provision of services that seemed unable to keep up with the growing population. According to William Fulton,

> Above all else, the passage of Proposition 13 reasserted the anti-urbanism of most Southern California urbanites. And it marked the beginning of an era of xenophobic hunkering down. Throughout the 1980s, most Southern Californians wrapped themselves up in a self-centred political cocoon. Spread across a vast landscape by eighty years of sprawling development patterns, cut off from one another fiscally and socially, weary of sharing their space with fifteen million other people, and fuelled by an enduring anti-urban ideal, Southern Californians simply ceased to be citizens in the larger sense and withdrew into their subdivisions.
>
> (Fulton, 1997, p. 18)

The anti-urban ideal described by Fulton manifested in the spatial dynamics of sprawl that had become synonymous with Los Angeles and Southern California. Aerial cinematography became the staple visual means for conveying the vastness of Los Angeles, with its iconic freeways as the centrifugal mechanism dispersing the city across the flatlands of the basin and beyond. From such films as *Colors* (Hopper, 1988), to the neo noirs *The Player* (Altman, 1992) and *Heat* (Mann, 1994), the imagery from aerial cinematography reduces Los Angeles to a series of horizontal abstractions rather than neighboring communities. Dislocated from one another, the atomization of communities reflected the end of the social contract that had previously sustained the economics beneath the region's growth machine. Amid the seemingly endless sprawl, a countervailing social contraction reflected the demise of an ever-expanding modernity.

The retreat of Los Angeles' middle classes into the private and domestic space of gated communities critiqued by Mike Davis in *City of Quartz* (1992) was, in part, a response to the region's balkanized local politics in the face of some 160 municipalities and five counties. For Baudrillard, social developments characterized by a retreat into the private domain at the expense of the public sphere highlights the West's inward implosion, characterized by the cool dissolution of meaning that "inverts the received scenario" (Gane, 2015, p. 142). In contrast to Fulton, Baudrillard's interpretation of the ensuing disconnection from politics is not just a withdrawal, but symptomatic of how an inward turn is also an active form of negation, with depoliticization still functioning as a political stance.

In 1992, old-fashioned heated resistance exploded with the LA Riots. In an echo of the Watts Riots in 1965, on April 29, 1992, South Central Los Angeles and parts of East Los Angeles were engulfed in fiery rioting that lasted for six days, decimating inner-city communities. According to writer, Tim Rutten, who describes the 1992 LA Riots as America's 'first multiethnic riot' (Rutten, 1992, p. 52), the multicultural dimensions of the riots formed significant distinctions from the Watts Riots. For Susan Anderson, the multiracial tensions colliding with the inner city's disenfranchised black community, means the riots and 'violent events in April belong – as nearly all else in Los Angeles – in a global context' (Anderson, 1996, p. 358). The economic privations and unemployment experienced in South Central Los Angeles descended from structural adjustments in the broader US economy issuing from 'Reaganomics'. Decreased public funding and diminishing living standards fueled the sense of injustice and frustration with excessive police force. The phenomenon of a working poor, characteristic of large segments of the Latino population, has also been attributed to the incendiary conditions that ignited on April 29, 1992 (Pastor, 1995).

In the aftermath of the LA Riots in 1992, Los Angeles was consigned to the basket case of urbanism, and South Central Los Angeles replaced the Bronx as an urban cautionary tale. Globalization, the post–Cold War environment, and the Reagan, Bush, and Clinton Administrations all seemed to have taken their toll on the local economy of Los Angeles. A direct effect came from the dismantling of the Soviet Union in the 1990s through the deescalation of U.S. military spending, which the Clinton Administration declared was the era's 'peace dividend.' The decommissioning of military projects was supposed to redirect funding and resources to civilian products and services, although the amount forecast for the redirection was never quite realized. Nevertheless, federal spending on defense and aviation in Los Angeles was cut by $6 billion and estimated to have eliminated three hundred thousand jobs (Siegel, 1997, p. 117).

As America's postmodern city of the future, Los Angeles appeared to have failed. It had not integrated its multicultural urban population as a result of the structural inequalities that drove a wedge between the newer communities descending from South East Asia, the growing Latino population, and the established African American communities.

The representation of a failed Los Angeles in films focused on racial tensions as well as a disenfranchised white population. Extending beyond the confines of neo noir, the tensions in race relations became the subject of melodramas, police procedurals and coming of ages films set in Los Angeles, including *Colors* (Hopper, 1988), *Boyz n the Hood* (Singleton, 1991), *Menace II Society* (Albert & Allen Hughes, 1993), and *Falling Down* (Schumacher, 1993). In conjunction with neo noir, however, these 1980s and 1990s films set in Los Angeles reinscribed many of the city's

spaces that had previously fallen outside Hollywood's version of the city's self-image. As fictional Hollywood interpretations engaging the issues erupting in the Los Angeles of the real, these films attempted to engage the city's urban crisis head-on. Watts, Compton, and South Central in particular are configured in terms of 'the hood' in *Boyz n the Hood* (Singleton, 1991) and *Menace II Society* (Albert & Allen Hughes, 1993). Both films made by black directors represented black communities and by making their communities visible, these films strived to represent Los Angeles' inner-city neighborhoods beyond the dominant image of 'the ghetto.'

A concerted effort to rebuild Los Angeles followed in the wake of the 1992 riots, but produced mixed results. A light industrial sector known as the Alameda Corridor comprised 21 miles of factories and food processing plants that flourished along the eastern edge of South Central Los Angeles, connecting downtown to the Port of Los Angeles. Many of these traditional, light industries provided employment in South Central that had long fled other urban centers like New York, eradicated under the currents of globalization. Across the flatlands of South Central, however, as a manufacturing cluster they were worth an estimated $50 billion (Siegel, 1997, p. 116). As low-skilled, low-paying jobs, they seemed a poor substitute for vanishing well-paid blue collar jobs from traditional heavy industries.

While far from a phenomenon unique to the 1980s, globalization has been argued by historians and economists alike to have been gathering pace since the colonial era that underwrote the expansion of European power and influence. Nevertheless, by the 1980s, global economic restructuring had facilitated an international interconnectedness that was transcending all previous constraints on globalization. It extended its reach to a far larger proportion of the worldwide population than ever. From increased trade and investment flows, travel and leisure activities, to migration and employment patterns, the pace of globalization accelerated through technological advancements and the economic principals of neoliberalism advanced by the World Bank and World Trade Organization (WTO). These international frameworks and free market principles were complemented domestically in the United States through policies of market deregulation and the 'small government' philosophy of the Reagan Administration.

By the end of the 1980s, further consolidation of the geopolitical landscape occurred across the global economy, with the collapse of the Soviet Union marking the end of the Cold War. In response to this paradigm shift in geopolitics, in 1992 Francis Fukuyama famously declared the end of history. The hyperbole of Fukuyama's position was based on the triumph of Western liberal democracy that concluded a century of ideological struggle. The supposed conquering of capitalism promised a new era of unilateral cooperation through the rise of transnationalism promoting

worldwide trade, commerce, and cultural exchange (*The End of History and the Last Man*, Fukuyama, 1992).

As the spatial logics of globalization journeyed from the abstract into the material, they entered the social domains of the everyday through various symbolic and representational means that transform timespace and the everyday. 'Timespace' as developed by May and Thrift (2001), is a concept that parallels Lefebvre's linguistic dimensions of spatial relations. While 'timespace' is informed by Lefebvre, it also builds on Torsten Hägerstrand's ideas on time-space geography from the 1970s. Timespace is a useful concept signifying the unity of perceived, conceived and lived space when space and time are combined and approaching them as 'analytically inseparable' (Jiron, 2010, p. 132). Timespace also offers a succinct concept in which to understand how the global marks an important shift in relations between the local and the international. As global economic restructuring became synonymous with the processes of globalization, the perception of a 'global timespace' takes on significant new meaning. Positioned as a key node on the Pacific Rim, in the 1980s, the timespace of Los Angeles became increasingly aligned to South East Asia.

By the 1990s, free-trade policies and geopolitical cooperation saw the breakdown of time and space imposed by the economics of globalization. The speed of the physical flows of goods and services was enabled by the rise of a financial data stream. Eliminating the previous confines of timespace surrounding trade, commerce, and consumption, the instantaneous processing of electronic transfers through international financial institutions mirrored physical trade moving around the globe at heightened speeds. Computer-based logistics and the affordances from containerization led to the standardization of freight-handling procedures across ports, shipping, trucking, and warehousing. Affecting the everyday across an unprecedented number of the world's population, spatial relations in the increasingly networked world of globalization was characterized by the activist motto, 'think global, act local' in a reification of McLuhan's 1962 concept of the 'global village' (McLuhan, 1964).

This kind of domestic economic contraction and growing trade with the Asia-Pacific region was developing in conjunction with the rise of an Asian middle class. The geographical location of Los Angeles meant globalization intersected physically in local spatial terms through trade across the Pacific Rim. Envisioning the future of Los Angeles as a capital of the Pacific Rim economy, the longest-serving Mayor of Los Angeles, Tom Bradley (1973–1993), proclaimed it would finally provide Los Angeles with an appropriate downtown worthy of a capital of the twenty-first century. Bradley oversaw what has been described as the consolidation of Los Angeles' neighborhoods and edge cities into what he envisioned could be a world-class metropolis.

In the 1980s, leveraging Japan's trade surplus with the United States, Los Angeles financed tax breaks to attract significant Japanese investment

capital. In 1989, Japanese finance directly impacted Hollywood with the Sony Corporation's purchase of Columbia Pictures for $3.4 billion. But the majority of Japanese capital flowing into Los Angeles was aimed at financing the construction boom of downtown Los Angeles (DTLA). Determined to turn DTLA into a world-class district, Mayor Tom Bradley promised, "just as New York, London and Paris stood as symbols of past centuries, Los Angeles will be the city of the new century" (Siegel, 1997, p. 117).

No matter the source of its investment flows, however, Los Angeles never seems to stray too far from economic cycles of boom and bust. In 1989, the effects of a mild U.S. national recession coincided with a financial bubble bursting in the Japanese economy, which produced a real estate bust across Los Angeles that was compounded by overbuilding in downtown. Entering the 1990s, the economic turbulence from domestic and international contractions in capital investment, combined with reductions in federal military expenditure from the 'peace dividend,' saw wages drop across the local Los Angeles economy, 'a stomach wrenching 14.5 per cent between 1990 and 1993' (Siegel, 1997, p. 117).

The Pacific Rim marks a significant reconceptualization of Los Angeles, and California more broadly, against the spatial footings of an Asian diaspora. Beyond providing the means for a world-class downtown that the city's history had somehow always denied, the Pacific Rim distils how the conceived space connects to perceived and lived aspects of global Los Angeles. The Pacific Rim is premised on a network of fifteen countries with coastal urban centers spanning the Pacific Ocean and intersecting with the advanced economies of Japan and the United States. It represents a web of international trading linked by air and sea, increasingly supported by uni-lateral and multi-lateral free-trade agreements. Since the 1980s, global trade from South East Asia has grown from the established economies of Japan, Singapore, Hong Kong, and South Korea joining with the 'tiger economies' of Taiwan, Malaysia, and Thailand. Global economic output from South East Asia rose from 4 percent in the 1960s to 25 percent in the 1990s, 'while the average resident of a non-Asian country in 1990 was 72 percent richer than his parents were in 1960, the corresponding figure for or the average Korean is no less than 638 percent' (Sarel, 1996, p. 2). Amid the economic rise of Asia, Los Angeles emerged as a vital American node, networking the U.S. economy into emerging transnational flows of trade and commerce that now continues with the 'rise of China.'

The integration of shipping, air freight, and passenger services across the multiple economies of the Pacific Rim highlights the spatial role of physical connection points between Los Angeles and trade flows and economies of the Pacific Rim. San Pedro Bay is host to the Port of Los Angeles and Port of Long Beach. As adjoining ports, they straddle the largest human-made harbor in the world and handle the majority of the

United States' TransPacific trade with Japan and nations in South East Asia. With the exception of Dubai, the world's top ten busiest container ports are situated in Pacific Rim nations, and by 2000, Los Angeles had the two largest ports by volume of trade in the United States, accounting for a combined total of 25.6 % of trade conducted through American ocean freight.[1]

The spatial reconfiguration from globalization exerted a shift in the construction of Los Angeles as the Turner-ian endpoint to the frontier, the West, and American expansion. The booster logic of attracting capital to Los Angeles from the established economic centers in the American Northeast was characteristic of how the conceived space of the East was seen to hold the keys to the prosperity of Los Angeles and its future. But in the 1980s, with international trade networks across the Pacific Rim unleashing exchanges with Southeast Asia, globalization ushered in a new sense of timespace and a concomitant flattening of difference. By integrating into the international trade flourishing throughout Pacific Rim nations, the Pacific Ocean became less of a border for Los Angeles and more of a liquid highway. As global trade and investment from Asia opened the local Los Angeles economy to new investment flows, it prefigured the United States' twenty-first century pivot away from the Atlantic.

Since the 1980s, the emphasis on Asia and the Pacific Rim supplied by a global Los Angeles has been the forerunner to what, in the new millennium, became the official foreign policy of the United States. In 2011, Foreign Secretary Hilary Clinton authored the article, *America's Pacific Century* in the journal, *Foreign Policy*, stating, 'President Obama has led a multifaceted and persistent effort to embrace fully our irreplaceable role in the Pacific, spanning the entire U.S. government' (Clinton, 2011, pp. 56–63). In 2012, the broad engagement of the United States with the Pacific Rim resulted in the Obama Administration formally announcing its 'Pivot to Asia' shifting U.S. foreign policy, trade, security, military, and diplomacy efforts away from Europe and the Middle East, toward Asia. As the United States transitions from the twentieth century – the American century – to the twenty-first – the Asian century – trade flowing from the Pacific Rim has helped California grow into one of the largest global economies. Despite its status as a single U.S. state, in 2018, California with a population just under 40 million people, overtook the United Kingdom to rank as the world's fifth largest economy.[2]

Postmodernity, Postindustrialization, and the Neo Noirscape of the Real

In 1984, Fredric Jameson's *Postmodernism, Or, The Cultural Logic of Late Capitalism* was published in The New Left Review, no. 146 (July-August: 59–92) and marked the beginning of one of the most sustained critical efforts to examine the specific traits of postmodernism by

questioning what was either distinct or represented a continuation of the modern. The essay formed the basis of the extended book subsequently published in 1991. Jameson summarizes the difference between the status of postmodernism in 1984 compared to 1991: 'The more fundamental modification in the situation today involves those who were once able to avoid using the word, out of principle, not many of them are left' (Jameson, 1991, p. xv). Entrenched by the end of the 1980s, whomever had critical reservations surrounding usage of the term 'postmodernism' had either succumbed or surrendered to it.

The postmodern, both as lived phenomena and critical framework for interpreting social and cultural transformations adheres to Raymond Williams's model of how history is shaped by the emergent, dominant, and residual. Emerging since the 1960s, postmodernism was functioning as the dominant paradigm by the 1980s, but as the 'post' to modernism, its boundaries and distinctions separating it from modernity have always been opaque. As Jameson points out, however, looking back at postmodernism in 1991, it was also demonstrating Williams's 'structure of feeling' by encapsulating forms of expression that embodied, as well as negotiated, the waning of historicity at the end of the twentieth century.

For Jameson, the crisis inherent in postmodernity lay in our inability to comprehend the scale on which social interactions and everyday life intersect with the global forces unleashed by late capitalism. As the manifestation of vast networks of information and trade flows, globalization marks a spatial expansion of capital across international borders. Postmodernism is the corresponding cultural logic accompanying late capitalism and its unrivalled expansion. As a cultural logic to the seismic shifts produced by late capitalism, postmodernism gets expressed in contradictory terms, which is why it so often appears paradoxical. Jameson's analysis since the 1980s revealed how postmodernism exhibited continuities with modernism, while also marking clear departures, and operated in paradigmatic terms far beyond any level of a style that it was initially mistaken for. For Jameson, 'every position on postmodernism in culture whether apologia or stigmatization – is also at one and the same time, and necessarily, an implicitly or explicitly political stance on the nature of multinational capitalism today' (Jameson, 1991, p. 3). As a cultural logic, postmodernity was reorganizing social, cultural, and economic relations in a paradigmatic manner, as capitalism entered what Ernest Mandell outlined as capitalism's 'long wave,' or Max Weber's Third Stage Capitalism and what is now generally referred to as late capitalism.

Late capitalism, third-wave capital, multinational capitalism – all describe an era commensurate with the 1970s, in which capital began to transform alongside social and economic relations. Driving developments in global trade and geopolitical interactions they coalesce under the descriptor of globalization. As in previous eras, the economic consequences from something as paradigmatic as globalization, as a manifestation of late

capitalism, carries into everyday lived experience, impacting social life as the cultural anxieties reverberating across the American psyche. Representing the diminishing power of the nation state that was bound tighter under the strictures of modernity, globalization certainly posed different, more abstract threats to the United States from that of previous eras like the Depression, World War II, and the Cold War. Processes of globalization exerted new pressures and social dislocations as a consequence of the United States economy opening up to increased international competition and the economic displacements from postindustrialization. The countervailing rise of service industries in Western economies such as the United States and the developed world could not alter the fact of reduced employment levels in shrinking manufacturing sectors. This situation was compounded by corporate downsizing and outsourcing practices that relocated jobs and factories to lower-cost developing countries.

From the 1980s into the 1990s, processes of postindustrialization that emerged in response to globalization manifested in different ways in different regions across the urban landscape of the United States. The geographical and industrial region that became known as 'the rust belt' entered the economic and social lexicon to describe the decline of steel, manufacturing, and heavy industries that once dominated states from New York to Wisconsin. Meanwhile, since the late 1960s, the Sun Belt identified parts of the United States characterized by the rise of a consumer society spanning from Florida across sixteen states and into the Southwest, including California. The Sun Belt designates a region experiencing population and economic growth based on what political scientists Perry and Watkins argued was not strictly the job creation factors of economic orthodoxy. Instead, they were in response to the new urbanism comprising the six pillars of post–World War II economic growth in the United States: agriculture, defense industries, advanced technologies, energy (oil and gas), real estate and construction, tourism, and leisure (Perry & Watkins, 1977). The rise of the sunbelt economies testify to how the effects of postindustrialization were far from linear across the United States and how different regions exhibited contradictory economic shifts since the postwar boom.

The six pillars of the post–World War Two U.S. economy had long been traditional drivers intrinsic to the local economy of Los Angeles throughout the twentieth century. In the 1980s, however, structural changes permeating the United States economy were also affecting industries across Los Angeles, which entered a downturn. In the evacuated spaces of traditional industrial districts of Los Angeles, 1980s and 1990s neo noir created spaces of representation that provided the basis for an opposing movement to the neo noir of nostalgia. Functioning in terms of a return to the real, a series of neo noirs featured a Los Angeles setting without engaging in the pronounced intertextual dialogue with film noir and its imagined histories of Los Angeles. Titles such as *To Live and Die in L.A.*

(Friedkin, 1985), *The Morning After* (Lumet, 1986), *52 Pick-Up* (Frankenheimer, 1986), *Heat* (Mann, 1995), *Se7en* (Fincher, 1995), *Freeway* (Bright, 1996), and *Fight Club* (Fincher, 1999) signaled how Los Angeles' neo noirscape had shifted towards the fringes of the city. Capturing the urban spaces reflective of the city's postindustrial landscape,'90s neo noir revealed a Los Angeles caught in the crosscurrents of globalization.

As outlined in Chapter 4, the spatial dimensions from roads and transportation began to figure in terms of a space of representation in classical film noir that contributed to the noirscapes of 1940s and 1950s Los Angeles. The spatial transformations brought about by freeways and cars that signified individualized mobility entered the mainstay of film noir, and by the 1980s, industrial transport hubs were taking center stage in neo noir. LAX (Los Angeles International Airport), the Port of Los Angeles, Port of Long Beach, and the flatlands surrounding San Pedro Bay began to feature far more prominently in comparison to the classical cycle of film noir. Occasionally, these industrial locales featured in films such as *The Street With No Name* (Keighley, 1948) and *Somewhere in the Night* (Mankiewicz, 1946), but in classical film noir, San Pedro and its port are represented in the conventional terms of an eerie, foghorn-laden space, easily substituted by the studio backlots to provide the dark atmospherics that literally shrouded the narrative in dimly lit mystery. In stark contrast, when featured in neo noir, Los Angeles' industrial precincts, ports, and airports signify the vast, brightly lit, and abstract spaces of globalization.

As a physical site, the Port of Los Angeles at San Pedro had embodied the power struggles of the growth machine that dominated the city's development at the turn of the twentieth century. The Port is one of the most significant city-building undertakings of its time. Prior to its construction on the shallow mudflats of San Pedro Bay, ships arriving into Los Angeles for freight unloading had to beach or anchor far offshore. The history of the port's construction, chronicled as the Free Harbor Fight, involved a 7-year battle to locate the port in San Pedro, 20 miles south of Los Angeles. The San Pedro location was another victory for *Los Angeles Times* publisher Harrison Gray Otis and the Los Angeles Chamber of Commerce. With support coming from U.S. Senator Stephen White, Otis and his supporters defeated efforts by Henry Huntington to transform his long wharf at Santa Monica into the official Port of Los Angeles. In 1899, with the support of federal funding, construction commenced on what would become the Port of Los Angeles. Surpassing San Francisco in the 1920s, the Port of Los Angeles became the busiest port on the West Coast.

As the city became a key node on the Pacific Rim in the 1980s, the increased volume of trade and traffic across Los Angeles' ports and airports saw these industrial sites continue to expand like distensions of the local economy. With the increased emphasis on location cinematography that accompanied the rise of neo noir, the actual Port of Los Angeles, Port

of Long Beach, and Los Angeles International Airport (LAX) began to be incorporated into the city's neo noirscape. The industrial spaces facilitated the physical linking of Los Angeles to the global economy, which in the 1980s were taking on a new significance in the spatial dynamics of the city. Correspondingly, these large trade and transport hubs became endowed with expanded meaning through neo noir's encompassing them as spaces of representation.

In *To Live and Die in L.A.* (Friedkin, 1985), the beige, featureless, postmodern interior of LAX's lounge areas replace the mean streets and alleyways of traditional noir settings. In a foot chase, secret service agent Richard Chance (William Peterson) pursues Carl Cody, (John Turturro) arresting him in a sterile lavatory. In *Heat* (Mann, 1994), the exterior ramps and barren fields of LAX, pulsing with blinding illuminations, provides the setting for the film's climactic showdown. In the 20-minute sequence, Neil McCauley (Robert De Niro) and Lt. Vincent Hanna (Al Pacino) conduct their shootout across the light-straddled tarmacs of LAX that serve as the postindustrial badlands of a globalized, technological Wild West.

Whether they functioned centrally to the plot or as background locales, the industrial spaces of Los Angeles stand in stark contrast to the ICT (Information and Communications Technology) dimension of globalization affecting postindustrialization of the American economy. Classical film noir depicted telecommunications and phone networks like the tentacles of modernity, with shots of telegraph wires spanning the breadth of the United States like a spider web and signifying an interconnected continent. Rabinowitz describes the telephone poles of modernity as part of, 'the straight lines . . . rising with regularity – connecting city to city and city to small town wires [that] are dotted with hidden dangers' (Rabinowitz, 2002, p. 14). Prior to contemporary smart phone technologies that have degrees of materially visual elements through their LED or LCD touchscreens, ICT during the postmodernity of the 1980s and early 1990s remained inherently abstract and far from conducive to cinematic imagery. Reduced to phone conversations and telegram style messages, ICT remained beyond the purview of postmodern representation. In contrast, the materiality of the physical sites of manufacturing and industrial zones readily signified the city's spatial interconnectedness to the rest of the world, enabling neo noir to construct global Los Angeles as the gateway to an illicit America.

Los Angeles as a Pacific Rim node serves part of the global grid that physically interlocks the United States with the world economy. Located on the geographical edges of the city, LAX and the Port of Los Angeles occupy sites that denote the city's boundaries, albeit ones that are constantly expanding and metonymic of Greater Los Angeles. Expansion of the Port of Los Angeles has been occurring since 1912 when dredging and widening of the main channel capitalized on its proximity to the

Panama Canal. In 1985, the port handled a million containers for the first time (Sowinski, 2007). In 2017, that figure climbed to 9.3 million. The Port of Los Angeles continues to transform San Pedro Bay by occupying 7,500 acres with 43 miles of waterfront, hosting 25 cargo terminals that include passenger, container, breakbulk, dry bulk, liquid bulk, and automobile terminals.[3]

On April 27, 2000, completion of the Pier 400 Program concluded the largest landfill and dredging project in the United States. A monumental feat of engineering, the project created a 590-acre island in San Pedro Bay. Dredged from the ocean floor, it physically enlarges Los Angeles and literally sees the city expand outwards into the Pacific Ocean.[4]

The past and present operations of the Port of Los Angeles features in *Colors* (Hopper, 1988). A raid-and-seizure operation coordinated by the Sheriff's department targets drug importation routed through the Port of Los Angeles via Taiwan and on a ship bound for the Panama Canal. In *The Usual Suspects* (Singer, 1995), San Pedro Bay is a narrative framing device featuring a docked cargo ship that contains the only witness who can identify the notorious Keyser Söze. The ship ultimately explodes, leaving 27 dead bodies floating in the water. In *Heat* (Mann, 1995), Berth 202 on Mormon Island is used by Neil McCauley (Robert DeNiro) and his heist crew to reverse the optics of undercover police surveillance by tricking the squad of Los Angeles detectives, led by Lt. Vincent Hanna (Al Pacino), who inadvertently expose their investigation as well as identities in broad daylight. But it is the 1985 production of director, William Friedkin's *To Live and Die in L.A.* that the Port of Los Angeles and the city's heavy and light industrial zones, the transport spaces of freight yards and warehousing infrastructure, come into their own as key spaces of representation.

Like the classic film noir, Boris Ingster's *Southside 1–1000*, the neo noir, *To Live and Die in L.A.* is centered on counterfeiting, and rather than LAPD Detectives, it features agents from the Secret Service. Described in online film sites as "the best movie you never saw,"[5] in *To Live and Die in L.A.* the Port of Los Angeles, the Vincent Thomas Bridge, and the industrial spaces of San Pedro Bay and South Central Los Angeles constitute some of the forty-seven locations featured in the film, many sourced by production designer, Lilly Kilvert.

> *To Live and Die in L.A.* was my first "Hollywood" movie. Billy Friedkin had seen something in my first small films and hired me, I was totally shocked! With me was the brilliant Robby Muller, as DP. Though the script was written to be shot in the valley, I asked Billy if I could use the LA that fascinated me, the edges of LA: the bridges of Long Beach, the hills above the "wrong side" of LA, etc. . . . He was totally open and gave me the freedom to find my LA.
>
> (Lilly Kilvert)[6]

To Live and Die in L.A. centers on two Secret Service agents, Richard Chance (William Petersen) and John Vukovich (John Pankow), and their attempts to capture a master counterfeiter, Eric Masters (Willem Dafoe). Director William Friedkin employs the same kind of gritty, documentary realism he used in *The French Connection* (1971) in this taut neo noir that has been routinely overlooked in the annals of Los Angeles noir. *To Live and Die in L.A.* expands the visual vocabulary of Los Angeles through color-saturated visuals dominated by an intense palette of deep reds and oranges drawn from the city's famed sunsets, and turns them into a blistering inferno fueled by the desert winds of the Santa Anas. In the same way Chandler paid attention to the city's weather atmospherics, Friedkin and cinematographer, Robby Müller (Wim Wenders' Director of Photography on *Paris, Texas* [1984]), have rendered onscreen the air quality produced by desert heat, and what, in the 1980s had become the city's signature – thickly laden air asphyxiating Los Angeles from polluted, choking smog. Montages consisting of time-lapse photography in extreme wide shot present, what Reyner Banham labeled as the city's 'plains of ID,' transforming the city's idyllic palm trees into charred silhouettes that punctuate a vision of hell straight from Hieronymus Bosch.

To Live and Die in L.A. depicts the city reeling under Reaganomics, as a blistery cauldron devoid of a moral center. The opening scene features audio from an offscreen President Reagan delivering an actual prerecorded speech on tax reform in the Beverly Hilton Hotel off Wilshire Boulevard. Onscreen, Secret Service Agents Richard Chance (William Petersen) and his partner, Jim Hart (Michael Greene), prevent a lone-wolf terrorist attack by a suicidal bomber who attempts to assassinate Reagan by leaping off the top of the Hotel to advance the cause of Palestine. Hart manages to scale the exterior of the building and pulls the terrorist over its edge just at the point of self-detonation, killing him by exploding in midair. Clinging onto the rooftop edge of the hotel, Hart barely survives and decides to pursue retirement. The marked difference between Hart and Chance is set up in the comparison to the next scene which features Chance willingly hurting himself of a great height for pure thrills.

Driving out to the barren wastelands of a secluded desert warehouse, Hart is killed investigating a lead on the city's preeminent counterfeiter, Rick Masters (Willem Defoe), and Chance is joined by new partner, John Vukovich (John Pankow). Determined to kill or capture Masters at any cost in retribution for the slaying of Hart, Chance pits himself and the reluctant Vukovich against the bureaucracy and procedures of the secret service, and their law enforcement counterparts in the FBI. As for the criminals themselves, Masters is a painter as well as a counterfeiter, while his accomplice/girlfriend dances in one of the city's experimental dance troupes in an update of the burlesque clubs of film noir. Together, their artistic practices mask criminal turpitude by providing convincing cover for the

studio processes required for their counterfeiting operations. The art galleries, dance clubs, and printing presses in *To Live and Die in L.A.* are all situated within the light industrial landscape evocative of the Alameda Corridor, but during a fallow period in the mid-1980s when these spaces were still empty, vacated by industry and sporadically repurposed as part of a bohemian art scene.

When Chance and Vukovich are prevented by Secret Service regulations from providing a $50,000 down payment that Masters requires when commissioned to print counterfeit U.S. currency, they resort to financing the deposit by conducting their own robbery. Chance's police informant, junkie-stripper, Ruth Lanier (Darlanne Fluegel) passes on information that provides the opportunity for the robbery, highlighting Los Angeles as a pan-Asian gateway to the United States.

Ruth: A dealer from San Francisco is coming into L.A. next week with fifty grand to buy some diamonds, the stuff that was lifted from the Bel Air Hotel.
He's a Chinaman and he's connected to people in Hong Kong.

 (Friedkin, 1985)

The Port of Los Angeles in San Pedro Bay and the Vincent Thomas Bridge provide the industrial settings to launch the narrative in *To Live and Die in L.A* after a prologue and credit sequence. Opening with the low-angle shot of a plane soaring through empty blue sky and leaving a condensation trail in its wake, this all too-familiar shot does not usually signify very much beyond helping one scene transition to another. In this moment, however, the image of the soaring plane lasts longer than usual and establishes the sense of boundless, empty space. The next image cuts to a mid-shot of Richard Chance staring offscreen with the green towers of the Vincent Thomas Bridge included in the frame looming up behind him. Crossing Los Angeles Harbor, the suspension bridge links San Pedro to Terminal Island, a largely artificial island expanded by dredging and leased to the Port of Los Angeles. The structural tower of the bridge soars skyward behind Chance in a visual repeat of the plane in the former shot. Meanwhile the diegetic sound features low-level industrial noise accompanied by a single piano key that builds tension in an audio echo of the bridge's suspension cables. Cutting to the next image reveals a wide shot of an enormous tanker slowly passing the oil refineries of Mormon Island as it heads out of the East Basin Channel of the Port of Los Angeles. In the haze of the distant horizon, flames from oil refinery flare stacks pierce a pale blue sky. The industrial mise-en-scène opening this sequence in *To Live and Die in L.A* is the real-life corollary to *Blade Runner's* opening Hades scene. Exposed to the glare of daylight, however, it is reduced to the mundane rhythms of a working port. The framing reduces all industry to a flat expanse surrounded by the blue of boundless sky and ocean.

In a sudden change of pace, the slowly moving content of the fixed-angle shots are abruptly replaced with a vertigo-inducing, low-angle jib shot. The camera travels rapidly up the body of Chance, nervously swaying his body from side to side and revealing his precarious footing on the edge of the bridge. The camera arches above his head, then swings and tilts down to provide a point-of-view perspective of the water hundreds of yards below. Cutting to another low-angle shot beneath the bridge, Chance is now in long-shot, screaming as he hurls himself off the bridge and appearing to freefall into the watery depths below. Miraculously, his fall decreases in speed as he erupts in laughter when the safety line becomes visible, and he swings like a pendulum under the bridge to the cheers of colleagues applauding above. The character-developing scene sets up his high-adrenaline nature, which will put him at odds with his superiors in the Secret Service, his new partner, John Vukovich, and the FBI as an allied law enforcement agency.

Contrasting with the terrorist falling from a great height in the opening prologue, in the bungy jumping scene with Chance the voluntary threat of death is averted and he swings harmlessly beneath the false gallows of the Vincent Thomas Bridge. In symbolic terms, however, both plunges from great heights are a test of human will. In the case of the terrorist, violent intent causes his own ill-fated destruction. In Chance's, the test of self-preservation is posed as extreme risk conveyed to the audience through the strong sense of vertigo communicated by the carefully choreographed camera work.

More than a third of a century after it was filmed, the location cinematography in *To Live and Die in L.A* not only provides a documentary-style rendering of some of the rhythms of the Port of Los Angeles, but the action on the Vincent Thomas Bridge deploys the infrastructure of the Port in terms of a literal precipice. In symbolic terms, functioning as the city's dizzying edge, the Port engenders a vertigo-inducing vista from Los Angeles that coincides with the city's reorientation westward. Situated on the edge of the Pacific Rim, instead of being at the end of American expansion, Los Angeles is represented bridging the watery expanses of the Pacific to Asia and beyond.

The Neo Noirscape of Postmodern Nostalgia

The cultural response to the transformations of late capitalism and the perceived or actual threats posed by its upheavals have been argued by Jameson to manifest in nostalgia and the desire to return to a simpler past. One of the crises of postmodernity is the inability to comprehend the present through adequate representation. By retreating into the past, representation through postmodernism expression is seen as a flight from contemporary issues. This withdrawal is exacerbated by its entanglement

in the deceptive surfaces of images long divorced from any connection to history or sense of the real that Baudrillard defines as hyperreality.

For Jameson, the experience of postmodernism equals a phenomenological disorientation in the wake of the collapse between Superstructure and Base, and the exponential expansion of culture. As the semiautonomous sphere of culture and meaning-making have become thoroughly commodified and integrated with processes of exchange and mass production, the whole of society has become 'cultural' (Jameson, 1991, p. xxi).

The implications of such a phenomenon extend to every facet of social reality that forms the basis for Jameson arguing that postmodernism transcends anything like a style and is as all-encompassing as Modernity. The ensuing spatial collapses impact at the conceptual level through the end of a distantiation affecting critical distance. Jameson demonstrates this through his critique of Macrae-Gibson's assessment of Frank Gehry's house on 22nd St & Washington in Santa Monica, Los Angeles. In his evaluation, Macrae-Gibson resorts to employing the dialectical logics of modernity in order to account for the aesthetic and spatial dynamics of Gehry's house. This is an approach Jameson refutes, since such aesthetic values are located in the shock tactics of a modernist imperative and the ability of art to sharpen our perception, something that is essentially meaningless, when, as Jameson argues, "to put it crudely and succinctly, why, in an environment of sheer advertising simulacra and images, we should even want to sharpen and renew our perception of those things" (Jameson, 1991, p. 122). The questions remain however: Precisely where and how do we regain meaningful understandings through critique and systems of representation amid the altered spatial coordinates of postmodernity?

In opposition to the implosion of meaning under Baudrillard's concept of the hyperreal, Jameson states, 'the dissolution of an autonomous sphere of culture is rather to be imagined in terms of an explosion: a prodigious expansion of culture throughout the social realm, to the point at which everything in our social life – from economic value and state power to practices and to the very structure of the psyche itself – can be said to have become "cultural" in some original and yet untheorized sense' (Jameson, 1991, p. 48). Together, Baudrillard's implosion of meaning and Jameson's explosion of culture center around the crisis of representation and our ability to comprehend the global space of late capitalism. Charting postmodernism sees Jameson respond to the 'Althusserian (and Lacanian) re-definition of ideology as the representation of the subject's Imaginary relationship to his or her Real conditions of existence' (Jameson, 1991, p. 151). Jameson's objective then becomes a project of cognitive mapping, something that can be pursued by expanding the notion from Kevin Lynch's *The Image of the City* (1960).

For Lynch, the modern city erases the human and social coordinates by which people could make the kind of meaningful connections within their urban environment through processes of cognitive mapping. Lynch's view on cities echoes Jane Jacobs's identification of the street as the essential level offering a perspective on the urban and our relationship to it. Materially and architecturally, modernism sought to abolish the street and sidewalks of cities, something Lynch and Jacobs decried in equal measure. For Jameson, postmodernism 'went on to abolish something even more fundamental, namely the distinction between the inside and the outside' (Jameson, 1991, p. 98). Compounding contemporary social disorientation, Jameson reflects on the bewildering hyperspace of the Bonaventure Hotel in Los Angeles with its 'strange new feeling of an absence of inside and outside' (Jameson, 1991, p. 117). Cognitive mapping of postmodernity on the scale Jameson proposes will 'enable a situational representation on the part of the individual subject to that vaster and properly unrepresentable totality which is the ensemble of society's structures as a whole' (Jameson, 1991, p. 51). Essentially, Jameson is calling for a new form of class consciousness that Marx was able to identify in the eighteenth century with the proletariat.

In opposition to any processes of cognitive mapping, nostalgia functions in what Debord describes as a 'recuperative strategy'; propelled inwards, it contributes to the disorientation of postmodernism, by reducing history to the depthless surfaces of the past as representational style. Nostalgia appears as a movement in both crime fiction and neo noir that operates from the 1980s through pastiche and intertextuality. Contemporary referencing of classical film noir and hard-boiled detective fiction illustrate Baudrillard's point about media mutually signifying each other, and operating as a 'totalitarian message of a consumer society.' Baudrillard's position echoes Debord's argument that consumer society performs recuperative strategies that see all forms of resistance eventually incorporated back into the dominant ideology.

The original cycle of film noir sprung out of the marginal production spaces of Poverty Row studios and the B-movie system and greatly influenced by such cultural outsiders as the famed German expatriates Fritz Lang, Billy Wilder, and other European exiles, including Bertolt Brecht. These exiles provided a cultural distance that enabled a critique of Hollywood, and scrutiny of American values. Combined with the cynicism from its hard-boiled fiction antecedents, film noir constituted a form of cultural resistance, wherein it is routinely interpreted as a big NO to the Yes of American triumphalism. In a momentary parallel to its victory after World War II, the United States achieved a new level of hegemonic power as the triumphant and sole superpower in the aftermath of the Cold War and collapse of the Soviet Union. In the same way, the classical cycle of film noir stood as a corrective to the triumphalism of the post-war era, and resisting what Debord identifies as cultural recuperation,

neo noir and postmodern crime fiction can be seen supplying new forms of cultural resistance in the final decades of the twentieth century. Key differences in the social, political, and spatial contexts from film noir, however, meant neo noir and the new crime fiction were not only products of postmodernity and the phenomenon of cultural nostalgia but actively had to negotiate them.

Neo noir as a genre had been emerging since the end of the 1950s, when the tropes and stylistics of film noir began to be consciously employed in fully fledged generic terms in American crime cinema. By the 1980s, a fully realized neo noir was accompanied by a resurgence in crime fiction that revived the traditions from hard-boiled detective fiction and original cycle of film noir. Together, the crime writing and neo noir of the 1980s renewed Los Angeles' status as the paradigmatic site of noir. The Los Angeles noirscape of pulp detective fiction informs the crime writing of James Ellroy, Walter Mosley, and Michael Connelly, each of whom has focused on crime narratives set in Los Angeles, extending the hard-boiled tradition inherited from Chandler. James Ellroy mines the pulp and cinematic noirscape of Los Angeles by drawing on the city's true crime history as part of his prodigious efforts to document Los Angeles in both fiction and nonfiction. Ellroy's L.A. Quartet: *The Black Dahlia* (1987), *The Big Nowhere* (1988), *L.A. Confidential* (1990), and *White Jazz* (1992), along with his autobiographical *My Dark Places* and *LAPD '53*, and the Lloyd Hopkins Triology, span over 50 years of crime and corruption drawn from the history of Los Angeles.

In a similar engagement of Los Angeles history, Walter Mosley has chronicled aspects of African American history in Los Angeles through his Marlowe-inspired detective, Easy Rawlins, who has featured in fourteen novels, commencing with his debut in 1990 in *Devil in a Blue Dress*. Set in Watts and 1948 postwar Los Angeles, Mosley's novel captures a moment of the city's economic contraction prior to the boom of the 1950s. As an African American, Rawlins is one of the first employees let go by the aviation company he works for. Mosley combines these kinds of historical elements with familiar tropes straight out of Chandler. Rawlins becomes a private investigator on a Chandleresque case involving a missing woman and fallen blue bloods. Entanglements with political corruption and the city's crooked police force was inspired by the actual state of affairs in the LAPD inherited by Police Commissioner, William H. Parker in 1950. But Mosley's portrayal of an African American private detective reinvigorates the familiar terrain inherited from Chandler. Easy Rawlins is a vessel of Los Angeles history with a backstory based on the migration of blue-collar African Americans lured to Southern California by its expanding manufacturing sector in the 1940s. Fueled by the national war economy, $70 billion of federal wartime funding provided over 500,000 jobs in shipping, steel, and aviation that for many African Americans held out the promise of a middle-class life in California.[7]

Michael Connelly's debut novel in 1992, *The Black Echo*, introduced police detective Sergeant Harry Bosch, who materializes out of the pulp noirscape of Los Angeles as a Marlowe-esque character. Bosch has since appeared in 21 more novels and adapted into the seven-season Amazon television series *Bosch* (2014–). The extent to which Connelly is informed by the noirscapes and psychogeography of Los Angeles is not only evident in the hard-boiled qualities of Bosch as a character and the various plots of many novels, but perhaps more poignantly by Connelly's account of when he arrived in the city to write crime fiction full-time and sought to move into the High Tower apartments featured in Robert Altman's adaptation of *The Long Goodbye*.[8]

The resurgence in crime fiction set in Los Angeles added another pulp layer to the city's noirscape as crime fiction combined the city's true crime history with its fictional past, as imagined in the annals of 1940s hard-boiled detective fiction and film noir. The blurring of the boundaries between an imaginary Los Angeles and the city's actual history in Ellroy, Mosley, and Connelly, reveals how the noirscapes of Los Angeles continue to accumulate through crime fiction that reconfigures real and imagined histories. Functioning in terms of a textual and symbolic register across Los Angeles, the city and noir exists as a space of representation that enables the city's heritage to fuse the historical with the imagined in uniquely penetrating ways.

By the 1990s, many neo noir films were engaging the history of Los Angeles in a manner that signaled a retreat into a nostalgia for the imaginary past supplied by the heritage surfaces of the original cycle of film noir. The layered associations from film noir and Hollywood filmmaking conventions, more generally, clearly provide the basis of the intertextuality beneath the nostalgia operating in the neo noirs *Reservoir Dogs* (Tarantino, 1992), *Pulp Fiction* (Tarantino, 1994), *The Usual Suspects* (Singer, 1995), *Devil in a Blue Dress* (Franklin, 1995), *Lost Highway* (Lynch, 1996), *Mulholland Falls* (Tamahori, 1996), *L.A. Confidential* (Hanson, 1997), and *Twilight* (Benton, 1998).

Arguably, neo noir, by default, is always in some form of historical and textual dialogue with the original cycle of film noir, and therefore as a genre, structurally intertextual. But whether this means neo noir is also inherently nostalgia laden is a different question. There are ways in which the coding of film noir and the past, as constructed from the conventions of Hollywood, are more explicit as opposed to implicit, thereby altering the ways in which audiences engage individual titles. Tarantino, for example, stands out as a director with an acute postmodern sensibility and at ease with filmmaking that employs layers of intertextuality. Producing films that celebrate pastiche, Tarantino's oeuvre is deeply intertextual by virtue of his films being immersed in styles associated with classical Hollywood, combined with elements from exploitation filmmaking, Hong Kong, and Asian cinema. Meanwhile, a neo noir director such as David Fincher pursues a new classicism in neo noir filmmaking that seamlessly

blends generic neo noir elements with little, if any, explicit referencing and intertextual play with the history of film noir.

Jameson argues postmodern nostalgia sees films engage in a play of historical signifiers confining itself to the recycling of past styles that operate at the level of surfaces only. This results in the depth model of history bypassed in favor of ceaselessly flowing images that stand in place of any sense of history itself. Nostalgia rehearsed as history appears central to Curtis Hanson's *L.A. Confidential* (1997), with its narrative addressing the history of Los Angeles as the product of image-making, and the manipulation of seductive surfaces. Despite *L.A. Confidential* displaying aspects of what Jameson identifies as the sense of nostalgia that organizes postmodern texts, it also attempts to construct a representation of noir Los Angeles based on a discursive visual strategy that resists recuperation.

James Ellroy's 1990 novel *L.A. Confidential* comprises the third instalment of his 'L.A. Quartet series,' and was adapted by Curtis Hanson and Brian Helgeland into the screenplay for the 1997 film of the same name. Set in Los Angeles circa 1953, the opening prologue narrated by tabloid magazine editor and publisher, Sid Hudgens (Danny DeVito), provides audiences with a crash course in Los Angeles booster history. Emphasizing the image saturation beneath the promotion and selling of Los Angeles in the middle of the twentieth century, the film of *L.A. Confidential* enters into a complex dialogue with the city's actual past and noir heritage. It features such prominent historical figures as Los Angeles Police Commissioner William H. Parker and crime boss Mickey Cohen and his associate Johnny Stompanato, addressing the city's image construction as symptomatic of the codes of signifying systems produced by the Hollywood Studio system and television, celebrity, and tabloid magazines. Film stars comprise the basis of the simulacra of Fleur de Les, a prostitution ring run by Pierce Patchet (David Strathairn) made up of lookalike (mostly noir) celebrities from Veronica Lake to Rita Hayworth. The actual TV series *Dragnet* becomes *Badge of Honor*, while the infamous tabloid *Confidential* becomes Sid Hudgens's *Hush-Hush* magazine.

Postmodern logics have informed the period realism sought in the cinematography of *L.A. Confidential*. Director of Photography, Dante Spinotti avoided what he and director, Curtis Hanson, interpreted as 'traditional noir stylistics.' In an echo of Roman Polanski's approach to *Chinatown* (Polanski, 1974), Spinotti and Hanson dispensed with any sense of what Spinotti referred to as a 'nostalgic haze,' in favor of the 'Light of Los Angeles' (Williams, 2018, in *American Cinematographer*, May 03, 2018). Seeking to recreate the period of 1950s Los Angeles from visual aesthetics divorced from the polished surfaces of Hollywood representations, Hanson and Spinotti searched out the pictorial qualities used to document everyday America circa 1955–1956, in the celebrated photography of Robert Frank's *The Americans* (Frank & Kerouac, 2008). Spinotti's cinematography incorporated elements from Frank's gritty

catalogue of 1950s America, including lighting that has been sourced from 'practicals' (light sources that are featured in the frame or mise-en-scène) to Frank's 'strong selection of elements, his way of bringing symbols into the shots' (Spinotti quoted in, Rudolph, 1997, in *American Cinematographer*, October, 1997).

Robert Frank's *The Americans* is a milestone exercise in photographic realism, considered to convey a kind of visual sociology of midcentury America. Since the 1930s, realism constituted a shift in photography away from the former influence of pictorialism. The raw imagery captured in Frank's photography conveys the everyday noir of midcentury America, a nation still caught in the throes of anxiety from the economic uncertainties of the Great Depression, compounded by the traumas of the World War II. As Rabinowitz has argued, midcentury America exhibits a pulp modernity, the first mass society operating according to the logics of a disposable, untethered culture that has been articulated through noir as an America with a population continuously 'on the make' (Rabinowitz, 2002, p. 14).

Pulling in the opposite direction of *L.A. Confidential's* realist aesthetic informed by the gritty imagery of Frank, however, are visual elements drawn from Hollywood inspired pictorialism. Hollywood's impact on image-making designed to sell and promote Los Angeles is a core thematic of the film. Thus Hanson and Spinotti employed realism as a visual strategy to contrast noir and Hollywood visuals. Shot in Super 35 widescreen format, the cinematography and lighting for scenes concealing the truth behind the glamour of appearances was designed to recreate a style of filmmaking associated the Golden Era of Hollywood. In terms of the decisions informing the film's overall aesthetic having the visuals implicate the role played by filmmaking and Hollywood in the city's pernicious past, Hanson and Spinotti effectively pursued a self-reflexive strategy of form following content.

The careful selection of visual elements by Spinotti and Hanson, drawn from the historical representations of America contrasted with those of Hollywood, are strategies employed in a critique of the seductive surfaces of the image. Cognizant of the traditions shaping the image of Los Angeles, *L.A. Confidential* attempts to resist the overtly nostalgic tendencies operating in the neo noirs *Mulholland Falls* (Tamahori, 1996) and *Gangster Squad* (Fleischer, 2013). Both films are set in the same period in Los Angeles and address similar themes of police and civic corruption. In these and other neo noir films where the sense of nostalgia dominates the representation of Los Angeles, the imagery is saturated in a pictorialism that overwhelms the recreation of any sense of a historically authentic Los Angeles. The visual codes of Hollywood image-making expressed in highly stylized noir lighting, through to the intricacies of costume design, ensure the representation of history in these neo noirs is condemned to the period surfaces of nostalgia. Often compounded through

a narrow representation of an historical era, every object and style present in the depiction of, for example, the year 1953, all too resoundingly denote "*1953*." The effect is that the visuals denote a specific period but resonate with excess from the kind of attention to detail that can only be the result of a dedicated production design team. Confined to such specific registers of a period, the narrowness of history reduced to such a faithfully reproduced moment in diachronic time comes at the expense of the 'residual' leftovers from previous years, even decades, that steep any moment in time in an assortment of competing fashions and styles. In other words, faithfully recreating a period on the basis of the diachronic ignores the complexity of the synchronic and competing elements that constitute spatial experience. Freezing the flow of the diachronic accounts for why the surfaces of nostalgia are more representative of period fetish rather than authentically historical.

Curtis Hanson's production of *L.A. Confidential* (1997), similar to director Carl Franklin's adaptation of *Devil in a Blue Dress* (1994), traverses historical Los Angeles while simultaneously engaging the 1940s stratum of the noirscape created by the original cycle of film noir. The inclusion of actual events denotes the historical period in Los Angeles in which the narrative is set, but evocation of the city's past is gained through visual stylistics associated with the realism conveyed in the photography of Robert Frank. Hanson and Spinotti were clearly pursuing period detail in the terms articulated by Williams's 'structure of feeling,' and separate to what is registered by classical Hollywood film noir. On the issue of nostalgia, Hanson was unequivocal when he affirmed, 'When people hear of 'early Fifties' and 'Los Angeles' they think about *The Big Sleep, Chinatown* and the world of Philip Marlowe from the thirties and forties. Our goal with *L.A. Confidential* was to be faithful to the period without telling the story through the lens of nostalgia' (Hanson quoted in, Rudolph, 1997, *American Cinematographer*, October, 10).

The realism of Frank's photography was adopted as an aesthetic strategy to combat the visual clichés associated with classical film noir as the means for depicting 1953 Los Angeles. *L.A. Confidential* pursues a visual strategy that underscores the theme of the seductive image and strives for something more multilayered and authentic. Blending elements from the actual history of Los Angeles with a visual strategy aided by Frank's photography, *L.A. Confidential* attempts to negotiate the imaginary past connoted through film noir. Effectively, Spinotti and Hanson sought to employ visual and stylistic strategies that strived to efface the fetishized nostalgia associated with postmodern expression.

As an overall textual strategy, *L.A. Confidential* engages in a critique of image-laden surfaces. By contrasting historical visual styles as a representational strategy, *L.A. Confidential* negotiates the hall of mirrors shrouded in the depiction of historical Los Angeles and Hollywood filmmaking. Hanson and Spinotti's decision to employ a visual strategy,

positions realism and Hollywood-style pictorialism in dialectical opposition, something that ensures the intertextuality of *L.A. Confidential* operates discursively in a self-reflexive critique of its own system of representation.

Yet, despite this concerted effort to efface nostalgia and fetishization of the image, the strategy of self-reflexivity remains caught in the contradictory logics of postmodern representation. Jameson argues the collapse of critical distance that has imploded in Baudrillard's simulacrum dooms such self-reflexivity which has expired alongside other modernist strategies of visual intervention that resisted cultural recuperation and commercial assimilation. After all, realism is just one more photographic style, and the photography of Robert Frank is emblematic of specific realist aesthetics derived from the logics of the 1950s. Just because they appear 'more real' than images from classical era film noir, does not mean they are any more capable of conveying the 'real' of 1950s America. Realism is a system of representation constructed from codes and conventions that prioritize the effacement of pictorialism among many other factors that are considered to be artifice. Nevertheless, realism is still imbued with aesthetic values, positions, and decisions that end up coding its message and signifying its striving for authenticity. But the invisibility of its form cannot erase the formal dimensions of realism; it simply becomes harder to detect, despite any discursive aesthetic practices that become just one more expression of a closed system of signification indicative of Baudrillard's simulacrum that perpetuates hyperreality.

When Hanson and Spinotti employ the photography of Robert Frank in an effort to depict the real of 1950s Los Angeles, they succumb to what Jameson identifies as

> the dynamics of so-called photorealism, which looked like a return to representation and figuration after the long hegemony of the aesthetics of abstraction until it became clear that their objects were not to be found in the "real world" either, but were themselves photographs of that real world, this last now transfigured into images, of which the 'realism' of the photorealist painting is now the simulacrum.
>
> (Jameson, 1991, p. 30)

Jameson attributes this postmodern dilemma to the collapse of distantiation. Forming part of the crisis of representation, an intertextual approach using images to deploy discursive strategies can attempt to resist the pastiche operating in fetishized nostalgia, but ultimately succumbs to the all-encompassing logics of the simulacrum. The constraints imposed by postmodern representation reveal how the coordinates of the real have shifted so irrevocably that the space required for modernist style discursive practices has collapsed and is simply no longer available.

Simulations in the Neo Noirscape of Los Angeles

The launch of Ted Turner's Cable News Network (CNN) on June 1, 1980 brought about the dawn of the 24/7 news cycle as cable television spread across the United States. In an amplification of the deleterious effects of the image-flows circulating from mass media, the 24/7 news cycle increased the pressure to supply news driven by visual content. 'In television journalism, straight news narratives must be "written to video." That is, as a visual medium, television demands that pictures be an integral part of the narratives newsworkers construct and circulate' (Hunt, 1999, p. 94). As a primary driver in the circulation of images hollowing out meaning, television is described by Andreas Huyssen, 'as the apparatus and machinery of simulation, television as a network that integrates flows of signification and information with that of commodities and out of events, reducing them to so many images on screen that refer only to other images' (Huyssen, 1989, p. 13). As principles of communication theory, they extend back to Marshall McLuhan and his famous dictum from 1964: 'the medium is the message' (McLuhan, 1964, 2013). Television as the repeated circulation of ceaseless images in the flows of electronic mass media has been fundamental to the altered relations of meaning-making.

The phenomenon that results in signs only referring to other signs, rather than operating as a referent to reality is the effect that Baudrillard describes in his theory of simulations. As the basis of modern media spectacle, simulations describe the semiotics beneath meaning-making that sees the sign displace its actual referent (the signified) in an endless interplay between signifieds and signifiers. A former student of Lefebvre, Baudrillard focused on how consumer society has produced an age of simulations due to the loss of the symbolic, 'the order of strong, immediate, fully present relations, evidenced in primitive societies and eclipsed in, but not completely lost to, our own' (Merrin, 1999, p. 128). Through systems of exchange mediated by the sign, Baudrillard outlines how simulations and the loss of the symbolic mean we have entered the era of the hyperreal, a period in which the reproduction of real life has become so complete that it has overtaken what was once the first order of reality itself.

> Abstraction today is no longer that of the map, the double, the mirror or the concept. Simulation is no longer that of a territory, a referential being or substance. It is the generation by models of a real without origin or reality: a hyperreal.
>
> (Baudrillard, 1983, p. 2)

Baudrillard's theories and concepts are complicated by writing that oscillates between clarity and obfuscation as part of 'fatal strategy' thinking

and writing. Pitting the measured against the extreme, fatal strategy is the pursuit of a discourse that straddles the reasoned and the poetic and is designed to operate as a mode of resistance in itself. Baudrillard has been consistent in engaging the repercussions of excessive modes of communication accompanying consumer society, and according to David Clarke et al., 'It is no accident that the notion of "simulation" introduced by Baudrillard in *Symbolic Exchange and Death* has come to figure amongst his most celebrated concepts' (Clarke, Doel, Merrin, & Smith, 2009, p. 3).

Baudrillard's critical oeuvre, which emphasizes simulations, hyperreality, and the simulacrum, addresses the implications of mediated images taking on a life of their own once divorced from their original context. Indeed, the context provided by the real itself is what Baudrillard argues has been lost upon entering the hyperreal and the arbitrary nature that now defines the relationship between signifier and signified. Consumer culture's boundless exchange relations define the postmodern political economy of the sign as commodity. As a result, the fundamental binaries that once enabled society to engage in rituals and social relations premised on irrefutable distinctions between, for example, the sacred and the profane, have collapsed to create what Baudrillard argues is the implosion of meaning.

The implications of Baudrillard's ideas on everyday life can be found in the video of the Rodney King beating and its reception. The amateur video footage shot by George Holliday recorded the events occurring at the intersection of Foothill Boulevard and Osbourne Street in Lake View Terrace in the San Fernando Valley on March 3, 1991. George Holliday had recently acquired his personal camcorder and used it to see what was happening adjacent to his apartment in the dark of night. Holliday's video famously captured the beating of Rodney King by four white LAPD officers as several other officers looked on. Holliday offered the video to the LAPD two days later, but when they showed no interest, he sold the footage to local news station KTLA. Cutting ten seconds out of the blurry opening of the amateur video for its news broadcasts, the footage was soon circulating globally. Packaged into teasers, promotions, banners, and stills, imagery from the video began to assume a life of its own through its repeated airing across news and media services around the world, increasingly divorcing it from the actual events that had been captured.

Baudrillard's theory of simulations argues that these processes of duplication and recombinations from image-editing means that the referent becomes the footage rather than event. The sign that is the video image overtakes any sense of the real that had been captured through processes of multiple reproduction, ensuring it becomes overburdened with excessive connotations that displace the real of the event. Despite these semiotic dynamics of simulations, it still seems difficult to comprehend how

'the real' of an event and its meaning, with content so potent as that in the Rodney King video, can be erased from what has been captured and represented. Yet, the most repeated question in response to the Simi Valley jury's decision to acquit all the officers involved was: How could they have arrived at this decision in the face of the Holliday video, which seemed to have recorded such incontrovertible evidence against the LAPD? Indeed, the disbelief in the inability of the overwhelming video evidence to convict the accused ran all the way to the White House. President George Bush, in his live address to the nation on May 1, 1992 after the LA Riots stated:

> I spoke this morning to many leaders of the civil rights community and they saw the video as we all did. For 14 months they waited patiently, hopefully they waited for the system to work and when the verdict came in they felt betrayed. Viewed from outside the trial it was hard to understand how the verdict could square with the video. Those civil rights leaders with whom I met were stunned and so was I.
>
> (L.A. Riots: President Bush's Reaction)[9]

As the mediated event becomes a stand-in for the real event and what most people experience, the selected images end up contaminating the real in what Baudrillard labels the 'structural unreality of images and their proud indifference to the truth' (Baudrillard, 1995, pp. 46–47). The substantial reliance on the video footage by the prosecution in the case against the four LAPD officers meant it functioned in terms that Patton describes as an, 'informational entity' derived from a 'virtual media event' (Baudrillard, 1995, p. 10). The prosecution had relied heavily on the evidence presented by Holliday's video, which enabled the defense team to destabilize meanings communicated by the images and any sense of its 'truth claims.' When the defense team exposed the jurors to the opening moments of the Rodney King video, disclosing footage not widely aired by news media, as the infamous segments showing King on the ground being beaten by the officers, it revealed King resisting arrest by running at police. The seemingly incontrovertible evidence represented by the entire video became drastically undermined by this segment of the footage being placed in opposition to the officers beating a defenseless King. The fragility of connotative meaning hovering over virtual media events was exposed by the defense. They capitalized on the 'structural unreality of images,' combined with the exigencies of video-based news reporting that trims down all footage to what is believed to be its essential elements.

Virtual media events like the arrest of Rodney King are, according to Patton, a 'new kind of entity, qualitatively different to 'real' or 'imaginary' events as these were understood prior to the advent of modern

communications technology. . . . These are informational entities and one of their defining characteristics is to be always open to interpretation" (Baudrillard, 1995, p. 10). This is the implosion of meaning pointed to by Baudrillard's theory of hyperreality, demonstrating how the 'real' of the events – Rodney King's actual beating – is erased when replaced by the sign: the video of the beating and endless edited versions of it played in all manner of contexts. The sign then competes for connotative meaning, leaving the interpretation of the events to be widely open-ended. In stark contrast to the perceived unity of meaning the video presented to the wider population, the defense employed the Rodney King video in the service of open-ended interpretation to drive speculation and unravel any consensus the jurors may have maintained in their interpretation of the video footage.

The decision of the mostly white jury in Simi County on April 29, 1992 to acquit all officers involved in the Rodney King case incited segments of the black community already disenfranchised from prolonged exposure to excessive police force and economic disadvantage. Turning on their own neighborhoods, looting raged across the small businesses of new arrivals from South Korea and Vietnam, and the riot became the basis of yet another virtual media event as live broadcasts relayed the ensuing violence in 'real-time':

> "[r]eal time" information loses itself in a completely unreal space, finally furnishing the images of pure, useless, instantaneous television where its primordial function irrupts, namely that of filling a vacuum, blocking up the screen hole through which escapes the substance of events.
>
> (Baudrillard, 1995, p. 31)

Edited imagery from the riots was then routinely combined with the Rodney King video as part of daily news bulletins to imply race-based behaviors and violence. Images reproduced and combined in this way lead to the construction of the false narratives of hyperreality. For example, segments of the Rodney King video were used to draw comparisons with news footage gathered on the LA Riots, such as images of Reginald Denny, the white truck driver dragged out of his cab at the intersection of Florence and Normandie Avenues by four African American rioters. The juxtaposing of imagery conceals the collapse of historical time, along with the context surrounding the events, and invites misleading comparisons. In this instance, the violence enacted on a black male issuing from white, armed police officers entrusted with upholding the law in a relatively controlled situation, against violence imposed on a white man by black civilian males erupting from the anarchy of a riot and separated in time by more than a year. False comparisons enabled by imagery functioning as simulations ignores spatiotemporal contexts and

conflates cause and effect relations. The Rodney King video may have initially destabilized the general population's perception of the LAPD and their methods by so clearly demonstrating a brutal use of force. But news reporting attenuated the affect of the Rodney King video in the wake of the April 29, 1992, verdict of the Simi Valley jury that acquitted the four LAPD officers involved. By repeatedly juxtaposing the amateur video footage of the Rodney King beating against news footage of black rioters attacking a white truck driver, as Swenson argues, 'In the case of Reginal Denny, the video images of young male African Americans exacting a retributive justice were appalling. The emotional argument it offered served to reify the Simi Valley jury verdict as sound' (Swenson, 1995, p. 78).

For Baudrillard, this constant recombining of images that end up referring back to themselves rather than the actual events, constitutes the 'procession of simulacra' and the ahistorical collapses that emanate from the hyperreal. Creating false linear narratives through omissions and juxtapositions supplied by media simulations enables forms of resistance and threats to hegemony to be appropriated for the purposes of coercive strategies that, in the case of the Rodney King video, end up reinforcing the dominant discourse surrounding race.

> Information has a profound function of deception. It matters little what it "informs" is about, its "coverage" of events matters little since it is precisely no more than a cover: its purpose is to produce consensus by flat encephalogram. The complement of the unconditional simulacrum in the field is to train everyone in the unconditional reception of broadcast simulacra. Abolish any intelligence of the event.
>
> (Baudrillard, 1995, p. 63)

Los Angeles as the site for staging a global media spectacle reached new heights during the pursuit, arrest, and trial of O.J. Simpson in the murder case of Nicole Simpson and Ronald Goldman. Widely described as one the most publicized events in American history, the media spectacle generated by the O.J. Simpson trial unfolded in real time, producing, 'the focal point of a first-order *media event*, a societal-wide celebration *and* contestation of dominant knowledge about reality' (Hunt, 1999, p. 249). The media spectacle surrounding Simpson commenced on June 17, 1994, when he resisted arrest by fleeing a home in Encino. The pursuit by the LAPD was captured live by helicopter news crews, creating a real-time media event that drew large crowds onto the actual streets to catch a glimpse of the 'slow pursuit.' Watched by an estimated 95 million Americans – exceeding the television audience for the Super Bowl – NBC cut from Game 5 of the NBA finals to the chase, and countless people across the world watched the event live on television screens.

The *L.A. Times* reported, 'The O.J. Simpson "white Bronco" chase was one of the most surreal moments in the history of Los Angeles criminal justice.'[10]

The 'surrealism' of the pursuit derived from it negating the conventions of Hollywood car chases. Rather than any kind of high-speed chase, it appeared that Simpson instead had a police escort, reversing the logics of any kind of police pursuit. NBC's cutting to the chase highlights the essential dynamics of media simulations that flatten all difference once they enter the flow of television, where any aspect of the real can be reduced to some form of spectatorship. The reference points provided by noir and the trash of popular culture supplied the essential means for interpreting this particular incident. As the L.A Times reported, 'our first mass-watched reality show was part soap opera, part film noir and part farce, as a Heisman trophy-winning American hero wanted for double murder led a phalanx of police in tow.'[11]

The End of Violence – Reconciling Postmodern Representation

Antecedents for the representations of South Central Los Angeles, in films such as *Boyz n the Hood* (Singleton, 1991) and *Menace II Society* (Albert & Allen Hughes, 1993) extend to such blaxploitation films of the 1970s as *Sweet Sweetback's Baadasssss Song* (Van Peebles, 1971) and *Shaft* (Parks, 1972) as well as the 1960s black cinema movement that flourished under the LA School. Oppositional in nature, LA School and blaxploitation cinema were responses to the Civil Rights movement and Watts Riots that portrayed black empowerment, distinct from Hollywood films that featured deracinated black characters that became synonymous with Sidney Poitier.

In the wake of the 1992 LA Riots, *Boyz n the Hood* and *Menace II Society* were significant African American incursions into mainstream Hollywood representation of black issues and black neighborhoods. Ostensibly, both films are coming-of-age narratives, but they also map issues of mobility and power relations stemming from the geographical boundaries of inner-city neighborhoods afflicted with the spatial dynamics of contained communities. The ability of these films to function in terms of an oppositional culture sees them compete against the recuperative strategies of mainstream Hollywood filmmaking. The clearest distinction dividing each film is the Hollywood-style happy ending in *Boyz n the Hood* that the Hughes brothers refused to supply Caine, the central protagonist in *Menace II Society*.

Recuperative strategies are the means by which Guy Debord warned how the Society of the Spectacle is able to diffuse dissent by incorporating and commodifying cultural forms of resistance. Begging the question, how is any recuperative strategy to be avoided in the era of hyperreality

amid the procession of simulacra? Baudrillard, like Jameson, adheres to forms of resistance through increased levels of yet more simulacrum. More simulations, more intertextuality is Jameson's 'homeopathic' cure to postmodernism, when confronted with how even the space enabling critical distance has collapsed against the logics of the postmodern. In Jameson's example of Macrae-Gibson's analysis of Frank Gehry's Santa Monica house, the tendency, similar to the visual strategies pursued by Hanson in *L.A. Confidential*, is to resort to strategies and analysis premised on the dialectics of modernity. Ultimately proving inadequate amid the onslaughts of hyperreality and the simulacrum, these failed interventions are consistent with the end of modernity's autonomous sphere of culture that heralds the spatial collapses of postmodernism.

> This proposition is, however, substantively quite consistent with the previous diagnoses of a society of the image of the simulacrum and a transformation of the "real" into so many pseudoevents. It also suggests that some of our most cherished and time-honored radical conceptions about the nature of cultural politics may thereby find themselves outmoded. However distinct those conceptions – which range from slogans of negativity, opposition, and subversion to critique and reflexivity – may have been, they all shared a single, fundamentally spatial, presupposition, which may be resumed in the equally time-honored formula of "critical-distance." No theory of cultural politics current on the Left today has been able to do without one notion or another or a certain minimal aesthetic distance, of the possibility of the positioning of the cultural act outside the massive Being of capital, from which to assault this last . . . [D]istance in general (including "critical distance" in particular) has very precisely been abolished in the new space of postmodernism. We are submerged in its henceforth filled and suffused volumes to the point where our now postmodern bodies are bereft of spatial coordinates and practically (let alone theoretically) incapable of distantiation.
>
> (Jameson, 1991, p. 48)

Wim Wenders's 1997 neo noir, *The End of Violence*, engages the issues of hyperreality and the simulacrum by examining the relationship between violence, images, surveillance, and Los Angeles. While there is no direct reference to the violence erupting in the city as a result of the Rodney King beating, LA Riots or the media frenzy accompanying the O.J. Simpson murder trial that coursed across the social fabric of Los Angeles, each event amplified and distorted by the effects of media saturation resonate beneath *The End of Violence* like a structured absence.

The central plot of *The End of Violence* involves Hollywood action film producer, Mike Max (Bill Pullman), who gets caught up in a pilot project trialing ubiquitous surveillance of Los Angeles by an anonymous

national security agency. The city is subject to 24/7 observation through
CCTV operated by the lone technician, Ray Bering (Gabriel Byrne), who is
conducting the trial inside the Griffith Observatory. The surveillance pro-
ject pursues the utopian dream of reversing the social impacts from violent
imagery by turning the real into a never-ending stream of urban surveil-
lance. Through its central protagonist, Mike Max, *The End of Violence*
is able to frame Los Angeles through the competing lenses of the real and
the imaginary. The real is signified through the streaming CCTV imagery
populating the monitors inside Bering's concealed lab. Routine muggings,
property damage, and police arrests unfold in real time across multiple
surveillance screens. Skeptical about the benefits of the surveillance opera-
tion, Bering leaks its details to Max, which leads to his attempted mur-
der captured on one of Bering's screens. The imaginary is represented in
terms of 'Hollywood' itself and the production landscape of soundstages
and location sets of Max's latest film, *Seeds of Violence*. The business of
film production is conveyed through production and home offices riddled
with the incessant communications between Los Angeles, Japan, and New
York that underpin the global flows of finance investing in Max's films.

The representation of Los Angeles in *The End of Violence* centers on
screens and the role of vision and the image in perpetuating power rela-
tions and violence. Actual violence and its images induce fear and anxiety
generated by Hollywood and is capitalized on by the State. Hollywood is
presented as a site attracting the new capital flows from Japan, while the
geographical position of Los Angeles on the edge of the Pacific is initially
constructed in terms of fear and paranoia. In the opening moments of the
film, the voice-over narration from Max articulates the sense of unease
and vulnerability California's open border on the Pacific Ocean posed to
him in his childhood.

Mike Max: Something about that day, reminded me when I was a kid.
We lived by the sea, a tiny town, lots a fishing boats. One
movie theater. My brother fished. I watched movies. They
got me wondering what we would if we were ever attacked?
We suddenly seemed so vulnerable to killer sharks, nuclear
submarines, an alien invasion. The enemy could come
from anywhere – the land, the water, the sky, the Chinese.
Couldn't trust any of them anymore. Guess I've been kind
of edgy ever since. Looking over my shoulder. Always ready
for that sudden attack.

Max overcomes his fear of 'the other' by becoming a Hollywood pro-
ducer and mastering the means of representation that has turned his par-
anoia into a profitable business.

When I was a kid, movies scared the shit out of me, so then
I grew up, I went into the movie business. Turned what you

would call a basic fear of strangers . . . into a multimillion-dollar enterprise. After all, paranoia is our number one export. It's only now I've come to understand that there are no enemies or strangers . . . just a strange world.

Over this narration, an aerial shot makes it way up over a dry and barren hillside, and timed to the line, 'just a strange world,' reveals the hazy sprawl of Los Angeles suburbia. A cut to another shot as it pans down from above reveals Bering overlooking Los Angeles from the hilltop of the Griffith Observatory. Both central characters – Max the Hollywood producer and Bering – are introduced in terms of having privileged perspectives that afford positions of power through their control over visual technologies.

Los Angeles is represented in *The End of Violence* as a city affording privilege to those perched on the edge of its sprawling suburbs or granted unfettered visual access to its horizontal vistas. Max's house has a swimming pool and garden overlooking the expanse of the Pacific, and despite his childhood anxiety about invasion coming from this unprotected boundary, the further he moves into the interior areas of the city, the more vulnerable he becomes. After visiting an actress in hospital after she was injured on the set of one of his films, Max is abducted, and the would-be assassins attempt to kill him beneath an inland freeway interchange. The kidnappers are mysteriously executed by an unseen sniper, and Max is able to disappear by joining the Mexican community, members of which were previously on the margins of his life, cleaning his pool and tending to his garden. The idyll of the community presented by the Mexican families and workers where he finds a peaceful life of acceptance is in stark contrast to the alienation he experienced as a film producer. Negotiating via phone and an early internet with unseen studio authorities in Japan and lawyers in New York, Max also isolated himself from his wife, Paige (Andie MacDowell), to the point where she has to call him from a cell phone while inside their home in order to speak to him in the back garden.

In the beginning of the film, Paige wants to flee to Guatemala to escape her depression and her isolating marriage to Max, but she ends up finding success in taking over Max's film business. In a reversal of fortune, Max happily walks away from film producing, and finds a new life in the comfort and security of the localized third-world of Los Angeles' Mexican community.

Inverting the social dynamics of Los Angeles in this way enables *The End of Violence* to depict a utopia premised on the collapse of the city's spatial divides separating its Mexican, Latino, and white communities. At this level, the representation of space in *The End of Violence* is structured along the racial and class lines that dominate the reality of daily life in Los Angeles. By transplanting himself from the world of Hollywood filmmaking and coastal privilege into the workaday world of the

Mexican proletariat, Max effectively journeys from the imaginary to the real, and in a highly idealistic imagining, is liberated in the process.

Judging from its theme, plot, characters, and casting (legendary director Samuel Fuller plays Ray's father, Louis Berin as part of an extratextual strategy inherited from Polanski's casting of John Huston in *Chinatown*), *The End of Violence* foregrounds Hollywood filmmaking and the mediated processes by which Los Angeles becomes an image and enters the procession of simulacra. In doing so, Wenders interrogates *The End of Violence*'s own form of representation through strategies descending from French Nouvelle Vague and Brechtian-styled, self-reflexive modernist cinema. Despite these sophisticated strategies, however, these forms of critique also adhere to conventional modernist strategies that Jameson argues have been made redundant by postmodernism. But in a true postmodern manner, these representational strategies can also be seen functioning as residual modernist strategies that coexist alongside an emerging practice of signs that speaks to a new form of representation in precisely the manner called for by Jameson's plea for a 'new practice of signs.'

Amid all of its discursive and modernist strategies, interrogating images and image-making, a key scene in *The End of Violence* presents an image that performs one of the most succinct renderings of the crisis of representation. Moreover, the scene constructs a dialogue between eras of representation and modes of spatial dynamics in a cinematic parallel to Gehry's Santa Monica house, which articulates postmodern architectural space. The scene occurs between a detective and an actress on the set of the film-within-the-film, *Seeds of Violence*, being shot on a Hollywood soundstage. The intertextual layers comprising a form of mise-en-abyme are premised on Jameson's notion of 'wrapping'– a phenomenon distinguishing some of the spatial dimensions of postmodernity that operate in a different way from juxtaposition and modernist approaches premised on shock, montage, and dialectics. In order to map the intertextual layers of this cinematic space in Wenders's mise-en-scène, it is necessary to detail each layer, where what signifies the real and what signifies the imaginary concertina down into various reproductions of themselves. Indeed, it is as if the cinematic spectator is situated somewhere in the middle of a transparent Russian doll, able to look up and out into various transparent layers of imagined reality that reveal larger frames of itself or down into ever-receding, smaller copies.

The scene opens with a woman approaching a countertop. Behind her is reflective glass and beyond there is nothing but darkened studio space. In the reflection of the glass we see another angle of the woman as well as a set construction worker laboring on the flat of a set. The lighting of the woman and the architectonics then signify the space as a film set, and the woman is an actress. A boom mic drops into the top

frame to confirm this, although for the briefest of moments it could also possibly be interpreted as an accidental, 'real life' boom-in-shot mic. But when the woman repeatedly states her name in different ways, 'I'm Ruby.' . . . 'Hi I'm Ruby.' . . . Hi . . . I'm Ruby,' it confirms we are indeed seeing an actress practicing her lines on a Hollywood film set. The actress then turns toward the camera and poses a question slightly off-axis from direct address, asking, "What now?" As final confirmation that we are indeed on a film set, we cut to a shot revealing a director and an assistant huddled behind a monitor next to a 35 mm camera operator.

While actress and director discuss the contents of her next line, on the other side of the glass window of the diner set a detective approaches from out of the darkness. In the next shot we cut to a view of the actress suggestive of a POV shot from the approaching detective. This image renders a definitive postmodern space. Deploying a chain of intertextual layers, Wenders constructs an image that conveys the experience of postmodern space with its hyperreal coordinates. In what amounts to layers of analogue compositing, the scene uses a series of noir-styled imagery to depict how overlapping simulations manifest as a blurring of spatial boundaries premised on temporal disorientation.

Descending into the layers of this scene and its imagery, the spectator remains aware that this scene is taking place on a film set inside a Hollywood soundstage. As a coordinate registering the distinction between the imagined and the real, the physical production space of the soundstage constitutes the outermost layer of the real; like the skin of reality, it denotes the largest frame of the real. Contained within this soundstage reality, various other layers of reality are framed in terms of different levels of simulation. On the set of the soundstage, the actress performs her role. Adjacent to her, the director and crew film her performance, but are also in the space of the soundstage set. Looking into the set of the film, *The Seeds of Violence*, the detective character is outside the set but inside the soundstage. And as we only see his reflection in the window for the diner set, he is neither inside nor outside of the imagined space of the film set.

The detective's line of vision provides the scene's point-of-view, but the position of the camera relative to the glass of the diner set affords no space in the mise-en-scène. The camera angle flattens the people and objects through the glass and causes them to compete with the reflection of the detective. To compound this complex visual arrangement, the monitor that the director was using on the set is also visible through the semitransparent reflection of the detective in the glass of the diner set, serving as a thumbnail image of the diner set with the actress performing.

All representational space in the mise-en-scène of this scene is flattened and conveys what Jameson describes as the 'depthlessness' of

postmodern representation. The sense of false perspective from reflections and sheets of glass from the diner set adds to the disorientation, because the viewing subject has to interpret the layers of images that are competing with objects and reflected objects. Yet, what is striking is our ability to process these many layers of visual information almost instantaneously, ensuring whatever disorientation occurs is only momentary. What is crucial to remember, however, is that the entire mise-en-scène is built on the imagined space of the diner film set. It is not just any diner either, but a film set that has reified Edward Hopper's famous 1942 painting, *Nighthawks*.

The construction of the imagery in the scene featuring the *Nighthawks* set in *The End of Violence* corresponds to a postmodern logic that Jameson describes as 'wrapping,' and by which he interprets Frank Gehry's house in Santa Monica. The visual wrapping occurring in this scene in *The End of Violence* is composited from imagery derived from traditions in American realism extending from Hopper to film noir. The process of wrapping flattens the space within the mise-en-scène when it culminates in the reflection of the detective gazing toward the actress on the set. In the next moment, however, through the simplest cinematic movement we are reorientated when the camera slowly tracks back once again, creating the illusion of three-dimensional space in the mise-en-scène. By moving the camera just a few inches, it reveals the detective situated in a space like a vector, where the spectator now sees him both as an object in space as well as his reflection, which clarifies how the mise-en-scène is constructed through and next to the glass of the diner set. In one simple camera movement then, our bearings as spectators have been fully restored as the two-dimensional reflections open up, concertina-like to reveal the three-dimensional space of the film set. What reprieve there is, however, is fleeting in terms of orientation because then Wenders reimmerses the spectator into the purely two-dimensional representational space of cinema. Evoking classical film noir, the scene then cut backs into the diegetic space of the film *Seeds of Violence* through a sudden close-up shot of the actress appearing through a monochromatic blue filter as she lights a cigarette. The scene ends when the actress, in a direct address down the lens of the camera, shatters the fourth wall of cinematic illusion, by seeming to pose a question to us as spectators - "Are you still rolling?"

In summary, there is no vestige of any real space whatsoever represented in the imagery of this remarkable scene in *The End of Violence*. All the spaces contained within all the frames are built on representations of representations. Depthless and intertextual, the simulacrum becomes momentarily coherent through the deceptive spaces of representations comprised out of reflected objects residing next to images derived from a film-within-the-film that descends down to a thumbnail

image of the *Nighthawks* set contained on the director's on-set monitor. As the metaframe providing the basis for the representation of a three-dimensional reality, the soundstage serves as an in vitro space for the literal construction of the real on a film set based on Hopper's two-dimensional painting. By reifying the two-dimensional imaginary space of the painting and turning it into the three-dimensional set for *Seeds of Violence* (the film-within-the-film in *The End of Violence*), Wenders unveils the architectonics of the simulacrum, demonstrating how representation functions as the ontology of postmodern space (see Figure 6.1).

The End of Violence demonstrates how the logics of postmodern representation sees the coordinates of the real constantly shift in response to the empire of signs circulating in hyperreality that can be reified in terms of the simulacrum. In the collapse of the inside and outside, images and space can fuse to simultaneously function as skeleton and exoskeleton of the real. Wenders's neo noir mobilizes the meanings inherent in the real of Los Angeles and Hollywood's signifying systems in order to represent the altered dimensions of postmodern space. Spatial representation in

Figure 6.1 A definitive postmodern space. Detective Dean Brock (Loren Dean) watches Cat (Traci Lind) on a movie set based on Edward Hopper's *Nighthawks* (1942), in the film-within-the-film in *The End of Violence* (Wenders, 1997).

Wenders's neo noir is premised on Jameson's argument that postmodern space is characterized by a depthlessness and flattening issuing from simulations and intertextuality. Yet Wenders also pursues what Jameson describes as a 'homeopathic' strategy as a way to push through the postmodern – to in effect, combat its disorientation in a strategy that dissolves pastiche by employing even more pastiche.

As a filmmaker, Wenders is a progenitor of the slow cinema movement, nowhere more visible than in the remarkable *Paris, Texas* with some scenes built on a single, unedited shot that can extend anywhere up to ten minutes. *The End of Violence* unfolds with a similar sense of real-time duration, and this deliberate strategy seeks to deliver on Kracauer's call for a cinema that constructs spaces 'to be dwelt in.' The key postmodern spaces that we as spectators 'dwell in' while watching *The End of Violence* are Hollywood signifying systems denoted by the sites of filmmaking. The viewing practices inaugurated by nearly a century of cinema and the subject position effects it generates are paralleled to the power relations inherent in state-based surveillance systems.

Conclusion

Under modernity, the original noirscapes produced across Los Angeles were generated by the city itself after intersecting with representation in crime fiction and film noir. Under postmodernity, neo noirs reproduced a noirscape based on the city's Hollywood screen heritage and hard-boiled traditions. By succumbing to the recuperative co-optations of nostalgia, many neo noirs fetishise the surfaces Jameson ascribes to a depthless history. Complicit in the culture of simulations and procession of the simulacrum, 80s and 90s neo noirs nevertheless evince other tendencies more indicative of strategies expressing cultural resistance.

In pursuit of a Los Angeles steeped in authentic experience, the neo noirscape of the 80s and 90s was extended to include the post-industrial and other marginal edges of the city. Neo noirs like *To Live and Die in L.A* and *Heat* eschewed nostalgia tendencies by engaging their problematic present and have mapped the tensions emanating from global space at the end of the twentieth century. In an entirely different approach, *The End of Violence* abandoned the entire notion of representing an actual Los Angeles. Instead, Wenders' neo noir engaged in a strategy of intertextuality advocated by Jameson and Baudrillard, one that could serve as a kind of homeopathic cure to the ills of postmodernism. As violence erupted across the city, from South Central to Brentwood, the distortions emanating from simulations posing as the 'real Los Angeles, supplanted Hollywood as the city's shadowy optic. By circumventing the dominance of

nostalgia with its glossy period surfaces, however, the neo noirs, *To Live and Die in L.A, Heat*, and *The End of Violence*, inverted the neo-noirscape of postmodernity and interceded in the disorientations of hyperreality and its simulations.

Notes

1. www.icontainers.com/us/2017/05/16/top-10-us-ports/
2. Retrieved February, 9, 2019, from www.businessinsider.com.au/california-economy-ranks-5th-in-the-world-beating-the-uk-2018-5?r=US&IR=T
3. Retrieved March 19, 2019, from https://kentico.portoflosangeles.org/getmedia/adf788d8-74e3-4fc3-b774-c6090264f8b9/port-master-plan-update-with-no-29_9–20–2018
 [NB:] The Port's sea channels continue to be deepened in an effort to accommodate ever-larger ships.
4. Nation's Largest Dredging and Landfill Project Complete at Port of Los Angeles. Business Wire, April 27, 2000. Business/News Editors
5. Retrieved October 22, 2018, from joblo.com
6. Retrieved February 2, 2019, from https://cinephiliabeyond.org/to-live-and-die-in-l-a-the-intelligent-authentic-thriller-as-one-of-the-highlights-of-friedkins-career/
7. RetrievedMarch19,2019,fromwww.kcet.org/shows/departures/brief-history-of-the-ports-of-los-angeles-and-long-beach
8. Retrieved March 20, 2019, from https://bookpage.com/interviews/8140-michael-connelly#.XKASc6iB10v
9. Retrieved November 9, 2019, from www.youtube.com/watch?v=KD_3NOIEk-0
10. L.A. Times, June 17, 2014 "O.J. Simpson white Bronco chase: How it happened minute by minute" – retrieved May 9, 2019, from www.latimes.com/local/lanow/la-me-ln-oj-simpson-white-bronco-chase-20140617-story.html
11. Retrieved May 19, 2019, from www.latimes.com/newsletters/la-me-ln-essential-california-20190613-story.html

References

Anderson, S. (1996). A city called heaven: Black enchantment and despair in Los Angeles. In A. Scott and E. Soja (Eds.), *The city. Los Angeles and urban theory at the end of the twentieth century* (pp. 336–364). Berkeley, Los Angeles and London: University of California Press.

Baudrillard, J. (1967, July–September). Marshall McLuhan: Understanding media. *L'Homme et al societe, 5*, 230.

Baudrillard, J. (1983). *Simulations*. New York: Semiotext[e].

Baudrillard, J. (1995). *The gulf war did not take place*. Bloomington: Indiana University Press.

Clarke, D., Doel, M., Merrin, W., & Smith, R. (Eds.). (2009). *Jean Baudrillard: Fatal theories*. London: Routledge.

Clinton, H. (2011). America's Pacific century. *Foreign Policy, 189*, 56–63.

Davis, M. (1992). *City of Quartz: Excavating the future in Los Angeles*. New York: Vintage Books.

Frank, R., & Kerouac, J. (2008). *The Americans* (1st Steidl ed.) Germany: Steidl.

Fukuyama, F. (1992). *The end of history and the last man.* New York: Free Press.

Fulton, W. (1997, 2001). *The reluctant metropolis: The politics of urban growth in Los Angeles.* Baltimore and London: Johns Hopkins University Press.

Gane, M. (2015). *Baudrillard critical and fatal theory.* London: Routledge.

Hunt, Darnell, M. (1999). *O.J. Simpson facts and fictions: News rituals in the construction of reality.* Cambridge, UK: Cambridge University Press.

Huyssen, A. (1989). In the shadow of McLuhan: Jean Baudrillard's theory of simulation. *Assemblage*, (10), 7–17.

Jameson, F. (1991). *Postmodernism, or, the cultural logic of late capitalism.* Durham: Duke University Press.

Jiron, P. (2010). Repetition and difference: Rhythms and mobile place-making in Santiago de Chile. In T. Edensor (Ed.), *Geographies of rhythm* (pp. 129–143). London: Routledge.

Lefebvre, H. (1991). *The production of space* (Trans. Donald Nicholson-Smith). Oxford, UK and Cambridge, MA: Blackwell.

Lynch, K. (1960). *The image of the city.* Cambridge, MA: MIT Press.

Manning, P. (2002). The sky is not falling (pp. 490–498). In M. Flaherty, N. Denzin, P. Manning, & D. Snow (Eds.), Review symposium: Crisis in representation. *Journal of Contemporary Ethnography, 31*(4), 478–516.

May, J., & Thrift, N. (2001). *TimeSpace: Geographies of temporality.* London: Routledge.

McLuhan, M. (2013, 1964). *Understanding media: The extensions of man.* New York: Gingko Press.

Merrin, W. (1999). Television is killing the art of symbolic exchange: Baudrillard's theory of communication. *Theory, Culture & Society, 16*(3), 119–140.

Pastor, M. (1995). Economic inequality, Latino poverty, and the civil unrest in Los Angeles. *Economic Development Quarterly, 9*(3), 238–258. https://doi.org/10.1177/089124249500900305

Perry, D.C., & Watkins, A.J. (Eds.). (1977). *The rise of the sunbelt cities.* Beverly Hills, CA: Sage.

Rabinowitz, P. (2002). *Black & White & noir: America's pulp modernism.* New York: Columbia University Press.

Rudolph, E. (1997, 10). Exposing Hollywood's Sordid Past: Director Curtis Hanson and cinematographer Dante Spinotti AIC add a realistic touch to the film noir world of "L.A. Confidential." *American Cinematographer: The International Journal of Film and Digital Production Techniques, 78*, 46–48, 50, 52–55.

Rutten, T. (1992, May 14). A new kind of riot. *New York Times Review of Books*, 52–54.

Sarel, M. (1996). *Growth in East Asia: What we can and what we cannot infer.* Washington, DC: International Monetary Fund.

Siegel, F. (1997). *The future once happened here: New York, D.C., L.A. and the fate of America's big cities.* New York: The Free Press.

Silver, A., Ursini, J., & Ward, E. (2005). *L.A. noir: The city as character.* Santa Monica, CA: Santa Monica Press.

Sowinski, L. (2007). Portrait of a port. *World Trade, 20*(2), 28.

Swenson, J. D. (1995). Rodney King, Reginald Denny, and TV news: Cultural (Re-) construction of racism. *Journal of Communication Inquiry, 19*(1), 75–88. https://doi.org/10.1177/019685999501900105

Williams, D.E. (2018, May 3). Wrap shot: L.A. confidential. *American Cinematographer: An International Publication of the ASC*. Retrieved December 9, 2018, from https://ascmag.com/articles/wrap-shot-l-a-confidential

Conclusion

In the twentieth century, the city has been the eye of the storm of rapid change, uncertainty, and anxiety. As the realization of modern, and subsequently postmodern consciousness, the city is where lived experience collides with the social perception and interpretation of cultural, political, and economic life. The representation of cities and the intertextual relations between imagined and actual cities (symbolic and physical) permits contemporary urban theory to be open to cinematic assignations. By seeking to comprehend how exchanges between actual cities and their image impacts everyday life and our experience of the city, urban theory appears to have come full circle, accommodating the imaginary city alongside considerations of the rational city.

Throughout modernity, cinema has been drawn to the spatial dynamics of the metropolis. Countless films have in effect, mapped both the lived and imagined dimensions of the modern metropolis. With the advent of film noir, however, a style emerged uniquely accustomed to American modernity and the manifold tensions of its urban spaces. When this new style of filmmaking began representing Los Angeles, the city's unique urban form was finally articulated through noir and its newfound spaces of representation. After more than half a century of intertwining, film noir and Los Angeles now manifests as a series of spatiotemporal noirscapes that have recorded the city's pioneering urbanism, its history with Hollywood, and its relationship to hard-boiled detective fiction.

In the twenty-first century, as we enter the age of what the renowned urban geographer, the late Edward Soja, labels 'planetary urbanization,' contemporary megacities like Los Angeles now ring the planet. From Sao Paulo to Guangzhou, the stakes for understanding urban experience have, undoubtedly, never been higher. What commenced at the turn of the twentieth century as an exhilarating intellectual expedition into the new ways of living made possible by the modern metropolis is now an urgent undertaking. As the urban economist, Edward Glaeser asserts, 'How well we learn from the lessons our cities teach us will determine whether our urban species will flourish in what can be a new golden age of the city' (Glaeser, 2011, p. 2). Posing some of the largest environmental and social

challenges, cities and urban living, nevertheless, offer some of the most promising solutions for sustainable livelihoods on a fragile planet.

Like other global megalopolises of the twenty-first century, the fate of Los Angeles is tied to the fate of its urban communities. Developing ways of understanding how quotidian urban life unfolds is far from a historical curiosity, it is also essential to improving it. Lefebvre's pioneering work on spatial thinking articulates the intuitive, assumed, and hidden dimensions of urban space and continues to mobilize perspectives striving for an emancipatory urbanism. History may teach us valuable lessons from the past, but the kind of spatial dynamics investigated by Lefebvre reveals how time and space are intricately bound, and can forcefully impact our everyday and lived reality. The spatial can be the site of change, upheaval, or continuity and where urban possibility is actually experienced. The spatial plays out on the ground in people's actual lives and urban space is shaping more of those lives than in any other moment in history.

Responding to the many trials of urban life, critical and urban theory in the wake of Lefebvre's insights has been expanding across interdisciplinary pathways in an effort to keep pace with the challenges posed by global urbanization in the twenty-first century. Practices of urban planning inherited from the heights of modernity continue to be overhauled and scrutinized as the values that commenced as grassroots urban activism have shifted decisively from the periphery to the center of urban discourse. As the hegemony of abstract, top down, modernist urban planning seems to have been dismantled, issues of livability and sustainability now dominate urban planning agendas that drive twenty-first century design principles and environmental movements. Acknowledging the local, historical, and ecological dimensions of cities sees contemporary approaches to urban living prioritize issues such as air quality, pedestrian transit, public transport, and greenspace solutions. Today, each of these urban attributes continues to be advanced in Los Angeles. Emerging from the crisis-laden era of the 1990s, Los Angeles has proven to be a far more robust and resilient megalopolis than many have given it credit for.

Coinciding with Los Angeles emerging as a metropolis in the middle of the twentieth century, film noir mapped Los Angeles' spatial logics as they responded to the upheavals wrought by modernity. Emerging in the 1970s as a key node in globalization, Los Angeles was similarly mapped by neo noir. The corpora of film noir and neo noir now offer a unique perspective on Los Angeles as the harbinger of postmodern urbanism. As a postmodern lens, the city's noirscapes reveal how the noir heritage of Los Angeles has actively challenged the dominant spatial practices occurring beneath the city's lived reality.

Unleashing social, economic, and political forces driven by international trade, communications, migration, and technological development, Los Angeles as a global city is a product of the vast and multilayered

networks of late capitalism. Abstract in the extreme, the urban syncopations of this global, postmodern megalopolis continue to be interrogated through neo noir. As the real city of modernity was displaced by the sign cities of postmodernism, the representation of Los Angeles in neo noir negotiated the surface images of nostalgia supplied by film noir. Depicting urban space against the tensions of globalization, Los Angeles neo noir also enabled representation of the postindustrial and evacuated urban spaces of postmodernity.

As a discursive field, contemporary urban theory tackles postmodern dimensions of cities by acknowledging the impacts from representation. Notwithstanding the complexities of urban processes in the twenty-first century, interdisciplinarity is a feature of urban theory and symptomatic of the convergences occurring in postmodern criticism. Postmodernism has problematized the construction of knowledge through its critique of metanarratives, while discourse analyses and epistemological examinations of power recasts critical interrogations of the project of History. Irrespective of debates on whether, as Frederic Jameson has explored, postmodernity is an expansion of modernity or constitutive of something much more distinct, neither position diminishes how the objective vantage points from which modernity was once assessed has irretrievably collapsed under postmodernity. As the modernist foundations upon which detached and empirically aligned perspectives have given way, a diversity of viewpoints cast in heterodoxy continues to resist the absolutes of former modernist hegemonies. Developments in urban and critical theory embody the shift from narrow and specialized discourse to a plurality of perspectives that mirrors the multiplicity of its object of study – twenty-first urbanism and the postmodern city.

The lenses employed to examine urban phenomena not only reveal data and insights about the object of study, they also expose the assumptions underpinning its critical framework. Noirscapes have been employed as a critical lens privileging cinema and the role of representation in response to a revision of Los Angeles exceptionalism, an inescapable notion when it comes to the city's relationship to film noir and hard-boiled detective fiction. Although noir only offers a highly delimited perspective on the rich history of this remarkable city, the interdisciplinarity beneath Los Angeles noirscapes reflects the conviction that, not only do cities matter more than ever, so too does the critical means by which we approach them.

Reference

Glaeser, E. (2011). *Triumph of the City: How urban spaces make us human.* London: Macmillan.

Appendix I
Classic Film Noirs (1940–1960) Featuring Bunker Hill in Location Cinematography

Act of Violence (1949). Richards, R.L. (Writer), Zinnemann, F. (Director) & Wright, W.H. (Producer). [Motion picture]. Los Angeles, CA: Metro-Goldwyn-Mayer.

Armored Car Robbery (1950). Felton, E. (Writer), Adams, G. (Writer), Fleischer, R. (Director), & Schlom, H. (Producer). [Motion picture]. Los Angeles, CA: RKO.

The Asphalt Jungle (1950). Maddow, B. (Writer), Huston, J. (Write/Director/Producer), & Hornblow Jr., A. (Producer). [Motion picture]. Los Angeles, CA: MGM.

Backfire (1950). Marcus, L. (Writer), Goff, I. (Writer), Roberts, B. (Writer), Sherman, V. (Director) & Veiller, A. (Producer). [Motion picture]. Los Angeles, CA: Warner Bros.

The Bigamist (1953). Marcus, L. (Writer), Schor, L. (Writer), Young, C. (Writer/Producer), Lupino, I. (Director), & Eggenweiler, R. (Producer). [Motion picture]. Los Angeles, CA: Filmmakers Releasing Corporation.

The Brasher Doubloon (1947). Bennett, D. (Writer), Praskins, L. (Writer), Brahm, J. (Director) & Bassler, R. (Producer). [Motion picture]. Los Angeles, CA: Twentieth Century Fox.

Chicago Calling (1951). Reinhardt, J. (Writer/Director) & Berneis, P. (Writer/Producer). [Motion picture]. Los Angeles, CA: United Artists.

Crime Wave (1954). Gordon, B. (Writer), Wormser, R. (Writer), DeToth, A. (Director) & Foy, B. (Producer). [Motion picture]. Los Angeles, CA: Warner Bros.

Criss Cross (1949). Fuchs, D. (Writer), Siodmak, R. (Director) & Kraike, M. (Producer). [Motion picture]. Los Angeles, CA: Universal Pictures.

Cry Danger (1951). Bowers, W. (Writer), Parrish, R. (Director), Frank, W.R. (Producer) & Wiesenthal, S. (Producer). [Motion picture]. Los Angeles, CA: RKO Pictures.

Cry of the Hunted (1953). Leonard, J. (Writer), Wolfe, M. (Writer), Lewis, J.H. (Director), & Grady Jr, W. (Producer). [Motion picture]. Los Angeles, CA: MGM.

Down Three Dark Streets (1954). Gordon, G. (Writer), Gordon, M. (Writer), Schoenfeld, B. (Writer), Laven, A. (Director), Gardner, A. (Producer) & Levy, J. (Producer). [Motion picture]. Los Angeles, CA: United Artists.

Finger Man (1955). Lipsius, N. (Writer), Lardner, J. (Writer), Schuster, H. (Director), Burrows, J.H. (Producer) & Parsons, L. (Producer). [Motion picture]. Los Angeles, CA: Allied Artists.

Hollow Triumph (1949). Fuchs, D. (Writer), Sekely, S. (Director) & Henreid, P. (Producer). [Motion picture]. Los Angeles, CA: Eagle-Lion Films.

I Want to Live! (1958). Gidding, N. (Writer), Mankiewicz, D.M. (Writer), Wise, R. (Director) & Wanger, W. (Producer). [Motion picture]. Los Angeles, CA: United Artists.

The Indestructible Man (1956). Russell, V. (Writer), Dwiggins, S. (Writer), & Pollexfen, J. (Producer/Director). [Motion picture]. Los Angeles, CA: Allied Artists.

The Killing (1956). Kubrick, S. (Writer/Director), Thompson, J. (Writer), Harris, J. (Producer) & Singer, A. (Producer). [Motion picture]. Los Angeles, CA: United Artists.

Kiss Me Deadly (1955). Bezzerides, A.I. (Writer) & Aldrich, R. (Director/Producer). [Motion picture]. Los Angeles, CA: United Artists.

M. (1951). Raine, N.R. (Writer), Katcher, L. (Writer), Losey, J. (Director) & Nebenzal, S. (Producer). [Motion picture]. Los Angeles, CA: Columbia Pictures.

My Gun Is Quick (1957). Collins, R. (Writer), Powell, R. (Writer), Saville, V. (Director/Producer) & White, G. (Director/Producer). [Motion picture]. Los Angeles, CA: United Artists.

Night Has a Thousand Eyes (1948). Lyndon, B. (Writer), Latimer, J. (Writer), Farrow, J. (Director) & Bohem, E. (Producer). [Motion picture]. Los Angeles, CA: Paramount Pictures.

Once a Thief (1950). Conway, R. (Writer), Kolpe, M. (Writer), Wilder, W.L. (Producer/Director) & Stephens, W. (Producer).[Motion picture]. Los Angeles, CA: United Artists.

The Set-Up (1949). Cohn, A. (Writer), March J.M. (Writer), Wise, R. (Director), Goldstone, R. (Producer), Schary, D. & (Producer). [Motion picture]. Los Angeles, CA: RKO.

Shockproof (1949). Deutsch, H. (Writer/Producer), Fuller, S. (Writer), Sirk, D. (Director) & Simon, S.S. (Producer). [Motion picture]. Los Angeles, CA: Columbia Pictures.

The Sniper (1952). Brown, H. (Writer), Anhalt, Edna. (Writer/Producer), Anhalt, Edward. (Writer/Producer), Dmytryk, E. (Director) & Kramer, S. (Producer). [Motion picture]. Los Angeles, CA: Columbia.

Somewhere in the Night (1946). Dimsdale, H. (Writer), Mankiewicz, J.L. (Writer/Director), & Lawler, A. (Producer). [Motion picture]. Los Angeles, CA: Twentieth Century Fox.

Southside 1–1000 (1950). Ingster, B. (Writer/Director), Riason, M. (Writer), Brown, C. (Writer), Townsend, L. (Writer), Gardner, A. (Producer), King, F. (Producer), & King, M. (Producer). [Motion picture]. Los Angeles, CA: Allied Artists.

Sudden Fear (1952). Coffee, L. (Writer), Smith, R. (Writer), Miller, D. (Director) & Kaufman, J. (Producer). [Motion picture]. Los Angeles; CA: RKO Pictures.

The Turning Point (1952). Duff, W. (Writer), Dieterle, W. (Director) & Asher, I. (Producer). [Motion picture]. Los Angeles, CA: Paramount Pictures.

The Unfaithful (1947). Goodis, D. (Writer), Gunn, J. (Writer), Sherman, V. (Director) & Wald, J. (Producer). [Motion picture]. Los Angeles, CA: Warner Bros.

Where the Sidewalk Ends (1950). Hecht, B. (Writer), Trivas, V. (Writer), Rosenberg, F. (Producer/Writer), Kent, R. (Writer) & Preminger, O. (Producer/Director). [Motion Picture]. Los Angeles, CA: Twentieth Century Fox.

While the City Sleeps (1956). Casey Robinson, C. (Writer), Einstein, C. (Writer), Lang, F. (Director), Friedlob, B.E. (Producer). [Motion Picture]. Los Angeles, CA: RKO/Warner Bros.

Woman on the Run (1950). Campbell, A. (Writer), Foster, N. (Writer), Tate, S. (Writer), Foster, N. (Director), Welsch, H. (Producer) & Sheridan, A. (Producer). [Motion Picture]. Los Angeles, CA: Universal.

Index

Angels Flight funicular 90, 111
Arcades Project, The 19–20, 37
Arroyo Seco Parkway 103, 108–109, 118

Banham, R. 26, 96, 174
Base and Superstructure 37, 39–40,
 73, 81, 134, 158, 177
Baudelaire, C. 17, 20, 48
Baudrillard, J. 39, 119, 132, 139, 145,
 151, 159–161, 163, 177, 185–187,
 189, 191
Benjamin, W. 6, 14, 16–17, 19–24,
 26, 35, 37–38, 41, 48, 59, 145
Berlin 9, 15–17, 21, 38, 81, 134
Berman, M. 25, 107
Beverly Hills 63, 83, 90, 108, 112,
 114–115, 130
Big Sleep, The 7, 46, 51–54, 61, 63,
 93, 130, 147, 183
Blade Runner 7, 126, 133–134,
 146–155
B-movie 2, 85–87, 97, 140, 178
Bonaventure Hotel 132, 178
boosterism 3, 46, 51, 74, 76–78, 81–82,
 96, 98–99, 120, 142, 168, 181
Borde, R. 85, 128
Bosch 3, 174, 180
Bronx, The 25, 107, 164
Bunker Hill 57, 89–93, 98, 109,
 111–114, 116, 134, 205
Burbank 78, 110, 146–147, 149,
 152–153; *see also* Warner Bros.
Burgess, E. *see* concentric zone model

Cain, J.M. 46–47, 117
centrifugal urbanism 7, 41, 92–94,
 102–103, 109, 111, 113, 116–117,
 120, 131–133, 136–140, 149, 152,
 154–155, 163

centripetal urbanism 90–93, 98–99,
 103, 109, 111, 116, 131–132
Certeau, M. de 26, 30, 34–36, 38, 59
Chandler, R. 2–4, 6–7, 46–55,
 57–66, 68, 73, 76, 78–79, 83, 91,
 108–109, 120, 130, 134–135, 137,
 140–143, 145, 147, 153, 174, 179
Chaumeton, E. 85, 128
Chicago 3, 13, 15, 24, 27–29, 42, 46,
 67, 75, 90
Chicago School 13–14, 24–25, 27, 29, 35
Chinatown 7, 51, 65–67, 83, 94, 126,
 133–134, 140–146, 149, 151–155,
 181, 183, 194; *see also* Polanski, R.
cinematography 73–74, 86–89,
 96, 98, 104, 112–113, 131, 135,
 143–144, 146–148, 150, 153, 163,
 171, 174, 176, 181–183
Cold War 95, 111, 116, 127,
 164–165, 170, 178
Columbia Studios 85–86, 167
concentric ring theory *see* concentric
 zone model
concentric zone model 13, 27
Connelly, M. 2, 179–180
Crime Wave 102, 104

Dark City 95, 99, 134, 151–152, 154
Davis, M. 5, 26, 28, 89, 11, 151, 163
Dear, M. 5, 26–29, 40–41, 136
*Death and Life of Great American
 Cities, The see* Jacobs, J.
Debord, G. 26, 47–48, 190; *see also*
 society of the spectacle
Double Indemnity 7, 46, 85–86, 88,
 93, 94–95

East Los Angeles 108, 164
Ellroy, J. 2, 60, 179–181

End of Violence, The 159, 161,
191–194, 196–199
EPIC (End Poverty in California) 82–83
Evans, R. 140, 143

Farewell My Lovely 46, 51–52, 143
film noir 2, 3, 6–7, 57, 74, 84–85,
98–99, 128–129, 138, 141;
cinematographers 86
Florida, R. 33, 40–41
Foucault, M. 30, 41, 105
Frank, R. 183–184
Frankfurt School 19, 37
French New Wave *see* Godard, J. L.

Gehry, F. 177, 191, 196
globalization 7, 29, 41, 158–160,
164–166, 168–172, 198, 203–204
Godard, J. L. 129
Great Depression 51–52, 55, 56, 74,
82, 91, 95, 97, 123, 182

Hammett, D. 47, 54
Hanson, C. *see* L.A. *Confidential*
Harper 127–128, 130
Harvey, D. 26, 31, 40–41, 151
Heat 159, 163, 171–173, 198
High Tower apartment complex
135–136, 180
High Window, The 46, 57, 60, 91,
108, 135
Hitchcock 57, 84
Hollywood Hills 61, 81, 94
Hopper, E. *see Nighthawks*
Huntington, H. 123–124, 171
Huston, J. 67, 140, 144–145, 147, 194

Interstate Highway system 102, 108,
111, 118

Jacobs, J. 25–26, 33, 41, 92, 116, 178
Jameson, F. 58, 126, 132, 145, 151, 155,
159, 161–162, 168–169, 176–178,
181, 184, 191, 194–198, 204

King, R. 160–161, 186–189, 191
Kiss Me Deadly 92, 102, 110–118, 120
Kracauer, S. 6, 14, 16–17, 19, 21–24,
26, 35, 41, 88, 141, 149, 198

L.A. Confidential 94, 158, 180–184,
191, 198
Lady in the Lake 46, 51

Lang, F. 80, 178
La Nouvelle Vague 194; *see also*
Godard, J. L.
LAPD 82–83, 173, 179, 186–187,
189
LA Riots 7, 160, 164–165, 187–188,
190–191
late capitalism 29–30, 36, 39–41, 43,
120, 126, 130, 158–161, 168–169,
176–177, 198, 204
Lefebvre, H. 6–7, 15, 30–32, 34, 36,
39, 41, 47, 64, 75, 105, 159–160,
166, 185, 203
Little Sister, The 46, 60, 63–64, 78,
130, 147
London 4, 15–16, 26, 38, 51, 52, 66,
81, 147, 167
Long Goodbye, The 7, 46, 126,
133–140, 143–144, 151–155, 180
Los Angeles basin 28, 68, 103, 108, 124
Los Angeles School of Urbanism 5,
15, 26–29, 42
Los Angeles Times 66, 76, 87, 171
Lynch, K. 26, 177–178

Manchurian Candidate, The 117,
127, 138
Manhattan 25, 34, 62, 80; *see also*
New York
Manifest Destiny 51, 76, 96–97
McLuhan, M. 166, 185
MGM 62, 85–86, 128
Miracle Mile *see* Ross, A. W.
modernism 17, 25, 95, 132, 169, 178
modernity: American 5, 27,
56–58, 61, 63, 68, 95, 108, 114,
136, 172, 182, 202; economic
transformations 6, 15–16, 19;
experience of 4, 7, 14, 20, 22–24,
31, 34–35, 37–38, 48, 104, 116,
138, 153, 170; paradigm shift 25,
41, 43, 60, 126, 131–132, 144,
148, 169, 177, 199; urban 2, 6, 14,
16–17, 21, 29, 39, 42, 59, 93, 98,
117, 163, 203–204
Moses, R. 25, 105, 107, 116

Naremore, J. 56, 85, 95, 127
neo noir: genre 1, 2, 3, 6–7, 92, 98,
102, 111–112, 120, 126–128,
130–135, 139–140, 143, 145–146,
149, 151–155, 158–160, 162, 164,
170–172, 178–181, 198–199,

203–204; productions 85, 94, 118, 127–128, 130–131, 133, 138–139, 143, 152–153, 158–159, 161, 163, 170, 173–174, 180, 182, 191, 197–198
New Hollywood 3, 7, 138, 144
New York 2–3, 13, 15–16, 25–26, 38, 46, 73, 75, 77–81, 84, 90–91, 95, 99, 105–107, 116, 120, 134, 136, 146–149, 153, 165, 167, 170, 192–193; *see also* Manhattan
Nighthawks 95, 148–149, 152, 196, 197
noirscapes 2–4, 6–8, 16, 47, 66, 68, 74–75, 87, 98, 153, 158–159, 161–162, 171–172, 179–180, 183, 185, 198, 202–204

Pacific Rim 159, 166–168, 171–172, 176
Paramount Studios 79, 85–86, 88, 94, 143
Paris 4, 14–17, 19, 26, 29, 38, 48, 51, 81, 105, 134, 167
phenomenology 1, 23, 38, 47, 49–50, 68
Philadelphia 3, 13, 46, 75
pictorialism 182, 184
Playback 46, 147
Plunder Road 102, 110, 118–120
Polanski, R. 140, 142–144, 181, 194; *see also Chinatown*
Port of Los Angeles 103, 165, 167, 171–173, 175–176
postindustrialization 33, 120, 158, 168, 170, 172
postmodernism 7, 33, 42, 126–127, 132, 145–146, 154, 161, 169, 179, 183–184, 186, 197
postmodernity: experience of 42–43, 126, 132–133, 138–139, 144, 151–152, 159, 180–181, 194–196, 198–199, 202; Los Angeles paradigm 27, 29, 153, 155, 158, 160, 162, 164, 172; urbanism 13–15, 17, 28, 31, 36–41, 150, 154, 203–204
postwar: anxiety 97, 129; boom 34, 74, 103, 106, 108, 120, 170; era 102–103, 111–112, 178; Los Angeles 114, 120, 179
Poverty Row 2, 7, 85–87, 97, 178
Production of Space, The see Lefebvre, H.

Proposition 13 162–163
proto-neo noir 3, 117, 128, 131
psychogeography 4, 48–50, 54, 64–68, 144, 153–154, 180, 198

Rabinowitz, P. 5, 56, 95
realism 55, 88, 104, 144, 149, 174, 181–184, 196
Ross, A. W. 115, 130

San Fernando Valley 78, 103, 124, 141–142, 186
San Francisco 3, 13, 39, 46, 76, 90, 118, 171, 175
San Pedro 119, 124, 167, 171, 173, 175
Santa Monica 61, 78, 81, 108, 171, 177, 191, 194, 196
Scott, A. 28, 40
Seitz, J. 86, 88; *see also* cinematography
Simmel, G. 6, 14, 16–19, 20, 23–24, 26, 35, 41, 59, 63
Simpson, O. J. 160–161, 189–191
simulacrum 35, 94, 132, 151, 155, 159, 161, 184, 186, 189, 191, 196, 197, 198
society of the spectacle 127, 133, 159, 161, 190; *see also* Debord, G.
Soja, E. 5, 26, 28, 30–31, 33, 40–41, 151, 202
South Central Los Angeles 52, 164–165, 173, 190
spatial turn 15, 30
Strip, The 84, 115
structure of feeling 7, 47–50, 52, 54–55, 64, 66, 97, 133, 169, 183; *see also* Williams, R.
studio system 7, 85, 94, 129, 181
Sunset Boulevard 83, 85, 94, 112, 135
Sunset Boulevard 85–86, 93–94; *see also* Wilder, B.
symbolic economy 37, 39–41, 43, 134

Technicolor 127, 130, 143
temporal signifier 126, 133–134, 139, 151–155
They Drive By Night 109–111, 118–119
timespace 166, 168
To Live and Die in L.A. 94, 159, 170, 172–176, 198
Touch of Evil 84, 102, 117–118, 130
Towne, R. 66, 140, 142

United Artists 85–86, 137
Urban Revolution, The see Lefebvre, H.

Virilio, P. 30, 132, 145, 151

Warner Bros. 78, 85–86, 110, 146,
 153; *see also* Burbank
West Los Angeles 115–116
Wilder, B. 88, 94, 178
Williams, R. 7, 47, 52, 97, 148, 169;
 see also structure of feeling

Wilshire Boulevard 63, 90, 111–112,
 114–116, 174
Wirth, L. 24, 27
*Work of Art in the Age of Mechanical
 Reproduction, The* 19, 145
World War II 14, 46, 52, 55,
 74, 84, 87, 95, 103–104,
 112, 118, 123, 128, 148, 170,
 178, 182

Zukin, S. 5, 39, 40